The Grip Book

The Studio Grip's Essential Guide

SIXTH EDITION

Michael G. Uva

Routledge
Taylor & Francis Group

NEW YORK AND LONDON

Sixth edition published 2018
by Routledge
711 Third Avenue, New York, NY 10017

and by Routledge
2 Park Square, Milton Park, Abingdon, Oxon OX14 4RN

Routledge is an imprint of the Taylor & Francis Group, an informa business

Library of Congress Cataloging-in-Publication Data
Names: Uva, Michael, author.
Title: The grip book : the studio grip's essential guide / Michael G. Uva.
Description: Sixth edition. | New York : Routledge, Taylor & Francis Group, 2018. | Includes index.
Identifiers: LCCN 2017044440 (print) | LCCN 2017046161 (ebook) | ISBN 9780203702864 (E-book) |
 ISBN 9781138571389 (hbk) | ISBN 9781138571396 (pbk) | ISBN 9780203702864 (ebk)
Subjects: LCSH: Cinematography—Handbooks, manuals, etc. | Grips (Persons)—Handbooks, manuals, etc.
Classification: LCC TR850 (ebook) | LCC TR850 .U93 2018 (print) | DDC 777—dc23
LC record available at https://lccn.loc.gov/2017044440

ISBN: 978-1-138-57138-9 (hbk)
ISBN: 978-1-138-57139-6 (pbk)
ISBN: 978-0-203-70286-4 (ebk)

Typeset in Times New Roman
by Apex CoVantage, LLC

Visit the companion website: www.routledge.com/cw/uva

Printed and bound in the United States of America by Sheridan

Dedicated to:

This book is dedicated to all the "Newbies" who want to learn it all, to all the great production people who work so hard that they can't possibly know it all, and, last but not least, to the old salts who invented it all. Thank you, one and all.

—Mike

Contents

3 Expendables 99

16 Precision Cadillac Track and Chapman Lencin 283

17 Fluid and remote heads 287

18 Field operation 299

Warning

Before you decide to use, buy, or order any product listed in this latest book, always check with the manufacturer or supplier for any and all latest revisions, warnings, or updated requirements.

There is no excuse if you are not 100% sure! Let me say it here and a few times more in this book:

IF YOU HAVE TO DECIDE IF IT IS RIGHT OR WRONG . . . IT IS WRONG!

You don't decide if your car's brakes will stop you; you're confident they will. You enter a restaurant believing the food is tasty and safe. You would not put your child in a crib or high chair that looked unsafe. Go with that gut instinct.

There are cell phones, the Internet, carrier pigeons, and many other ways to "check it out" first. "Don't be "dead wrong." "We're just making a freaking movie here!" Don't make the evening news!

—Mike

Contributing companies, manufacturers, and suppliers

Not by choice of one company over the next, just alphabetical. Believe me, they are all good!

Aerocrane
9824 Glenoaks Blvd
Sun Valley, CA 91352
Phone: (818) 252-7700
Cranes: Enlouva IIIA, Felix, Jib Arms, Phoenix, and Super
Dollies: Aerobase, Barby, and Magnum
Accessories: Power Pod, 3 Axis, Aerohead, Gazelle, Graphite, Kuper, Lynx, Motion Control, and Zebra
www.aerocrane.com

American Grip
8468 Kewen Avenue
Sun Valley, CA 91352
Phone: (818) 768-8922
Grip equipment
www.americangrip.com

Backstage Equipment, Inc.
8052 Lankershim Blvd
North Hollywood, CA 91605
Phone: (818) 504-6026, (800) 692-2787; Fax: (818) 504-6180
Electric, grip, and prop carts
www.backstageweb.com

Barber Boom/Camera Booms
P.O. Box 248
Sun Valley, CA 91353
Phone: (818) 982-7775
Booms: 20 ft. Barber Boom and Barber Baby Boom accessories (camera car shock mount and remote focus and zoom)
www.ezprompter.com

Bill Ferrell Co.
10556 Keswick St.
Sun Valley, CA 91352
Phone: (818) 767-1900
www.billferrell.com

Branam Enterprises Inc.
9152 Independence Avenue
Chatsworth, CA 91311
Phone: (877) 295-3390, (818) 885-6474; Fax: (818) 885-6475
Trusses, motors, cables

Bullet Grip, Inc.
11970 Borden Avenue
San Fernando, CA 91340
Phone: (818) 832-8707
www.bulletgrip.com

Cable cam International, Inc.
PhotoShip One, LLC

Mesa, AZ
(602) 743-5768
www.cablecam.com
Accessories: Cable-suspended camera tracking systems and mounts

Champion Crane Rental, Inc.
12521 Branford Street
Pacoima, CA 91331
Phone: (818) 781-3497, (323) 875-1248; Fax: (818) 896-6202
Cranes: 40 ft. to 265 ft. reach
Accessories: Camera baskets, light bars, and rain bars
www.championcrane.us.com; e-mail: championcr@aol.com

Chapman/Leonard Studio Equipment, Inc.
12950 Raymer Street
North Hollywood, CA 91605
Phone: (818) 764-6726, (888) 883-6559
www.chapman-leonard.com

Cloud|
Avatar Grip Services Inc.
18425 Bryant St.
Northridge, CA 91325
(818) 266-8755
www.avatargrip.com

Concept Lighting
11274 Goss Street
Sun Valley, CA 91352
(818) 767-1122

Egripment U.S.A., Inc.
7240 Valjean Avenue
Van Nuys, CA 91406
Phone: (818) 989-5222
www.egripment.com

Filmair
51 Auckland Street
P.O. Box 537
Milnerton, Cape Town 7435
South Africa
Phone: (021) 511-5579; Fax: (021) 511-2812
www.filmairinternational.com

Filmotechnic International Corp.
18314 Oxnard Street, Suite 2
Tarzana, CA 91356
Phone: (818) 342-3392; Fax: (818) 342-3572
Cranes: Russian arm crane with 14 ft. vertical reach, cross country crane with 21 ft. reach, and scissor crane with 30 ft. reach
Accessories: Action arm, Flight Head III and IV, and shock absorber system
www.filmotechnic.net

Genie Industries
18340 NE 76th Street
P.O. Box 97030
Redmond, WA 98073–9730
Phone: (425) 556-8620, (877) 436-3456; Fax: (425) 556-6535
www.genielift.com

Geo Film Group, Inc.
7625 Hayvenhurst Avenue, Suite 46
Van Nuys, CA 91406
Phone: (818) 376-6680; Phone 2: (877) 436-3456; Fax: (818) 376-6686
Arms: Jan Jib and Maxi Jib
Cranes: Javelin, M.T.V., Scanner, Skymote, Super Aerocrane, Superskymote, Technocrane, and VIP
Accessories: Hot Head II Plus, Libra III, Megamount, Mini Shot, Power Pod Plus,
www.geofilm.com; e-mail: info@geofilm.com

Gyron Systems International, Ltd.
39 E. Walnut Street
Pasadena, CA 91103
Phone: (626) 584-8722; Fax: (626) 584-4069
www.danwolfe.com

Hollaender Manufacturing Co.
10285 Wayne Avenue
Cincinnati, OH 45215-6399
Phone: (800) 772-8800, (513) 772-8800; Fax: (800) 772-8806, (513) 772-8806
www.hollaender.com

HydroFlex
5335 McConnell Avenue
Los Angeles, CA 90066
Phone: (310) 301-8187; Fax: (310) 821-9886
www.hydroflex.com

Jack Rubin & Sons, Inc.
523 Flower Street
Burbank, CA 91502
Phone: (818) 562-5100; Fax: (818) 562-5101
www.wirerope.net

J.L. Fisher, Inc.
1000 Isabel Street
Burbank, CA 91506
Phone: (818) 846-8366; Fax: (818) 846-8699
www.jlfisher.com

Matthews Studio Equipment, Inc.
4520 W. Valerio Street
Burbank, CA 91505
Phone: (818) 843-6715
www.msegrip.com

Modern Studio Equipment
7428 Bellaire
North Hollywood, CA 91605
Phone: (818) 764-8574; Fax: (818) 764-2958
www.modernstudio.com

Staton Jimmy Jibs
2223 E. Rose Gardenloop
Phoenix, AZ 85204
Phone: (602) 493-9505; Fax: (602) 493-2468
www.jimmyjibs.com

Tyler Camera System
14218 Aetna Street
Van Nuys, CA 91401
Phone: (818) 989-4420, (800) 390-6070; Fax: (818) 989-0423
www.tylermount.com

VER Sales, Inc.
2509 N. Naomi Street
Burbank, CA 91504
Phone: (818) 567-3000; Fax: (818) 567-3018
www.versales.com

Z-Jib (Zero-gravity boom arm) K-Hill, Inc.
Fort Worth, TX
Phone: (817) 800-4455
Email: ken@khill.com
www.khill.com

Note from the author

Hi, and thank you in advance for buying my book. With this book I have tried to accomplish something I learned from the author Zig Ziglar: *"If you help enough people get what they want, you'll get what you want."* I want to help as many folks who want to get into the film industry as I can. By the way, I absolutely love my jobs. Yes, I did say jobs. Because of my career in the film business as a grip, I have been able to explore my other passions as well. I love to write, and I love to train students at my seminars.

In this newly completely revised sixth edition grip handbook, I have added more need-to-know information about basic grip equipment. I have subtracted some items as well. Change is good! I have been asked by many students and other folks that I've met along the way, would you include some basics about some tools? So I have. As you thumb through my latest "New and Improved" *Grip Book*, I'm sure that you will come across some things that you already know. Good for you! But there will also be many other readers out there for whom this material is entirely new and who will benefit from the "need-to-know" material provided in the text. So, sit down, peruse the book, and learn something that may help you on set!

Stuff!

My latest *Grip Book* is about helping you, the reader. First off, the old saying: there are usually ten ways to do a job. Not true! There are sometimes only a few; other times there may be more than ten. The bottom line being, you USUALLY may have alternative ways. My major concern as with anything is safety first. Sure you may know what you're doing, but do the unsuspecting know? I always tell my students to think, what if/ whatif/ what? The process will most likely cover your bum in life.

Perception

Ah no! I do not walk on water. I can hold my own. What I am saying is, perception is everything in this industry. An example, you are on your smartphone writing feverishly, trying to get your required equipment list in to the rental facility. The producer you are working for with a few other executives "looks" across the stage. All he sees is some technician, texting his or her girlfriend, on his time. Make all your actions on set look, feel, and be like you want to be there and are doing your best to help the project. Now you ask,

*How were you getting out the order?
*What should you have done?

Perfect question! You tell me. I bet you can think of at least two to three different ways of getting that order placed and still appear to be working to any onlooker. Oh look, one of ten ways to do a job . . . and get that next one, I might add.

Straight scoop package

I know my craft fairly well. Am I the best? NO! There are so many great technicians around the world. But that is not enough. You must learn all the aspects in moviemaking. Well, heck, that statement holds water in any job. Basically I am not much more than a used car salesperson in some respects!

Let's compare!

Have you ever purchased a new or used car? Every time I go to a dealer's car lot, I always notice:

The salesperson is always smiling.
They have an eager and positive attitude.
They always dress for the job.
Their answer is usually, "Yes, we can look at that!"
They are on "your" side!
They are there to help, not hinder.

Now imagine what a producer (the buyer) may feel like if he gets that same treatment from you . . . the used car salesperson. Notice, I have not spoken one single word of your technical abilities. (That is part of the package. You are the PACKAGE!)

This edition

A fast way to see what a piece of equipment looks like and a bit about it.

Plus, I threw in a bit of "set lingo" so you don't look like a newbie.

What if you had to go and fetch a piece of movie grip equipment? How the heck would you know what to get if no one is around and you're in a hurry? Basically you could be screwed, but not if you have the *Grip Book*! (Do I hear angels singing my name?) Or maybe that's the Key Grip singing your praise. Either way you win! Get the *Grip Book*! (Heaven knows it might help you!)

Last! This and so much more information can be found in the *Grip Book* online from Routledge!

Best to all of you,
Mike Uva

Last, but not least

I am always asked, "How come you do not give step-by-step instructions on gripping?" That is a really good question. Let me answer using an example. Say you are driving a Ford automobile. The car next to you is a Peugeot. You both run over some debris and both get a flat tire. The procedures to change the tires are very different, but both achieve the same result. That being said, I can give you the hammer and the nail, but you must use it as wisely as possible to achieve a good, fast, and safe result.

Thanks again,
Michael G. Uva

About the author

Michael Uva is a highly motivated self-starter. In only a few years he created a large privately owned fleet of grip rental trucks full of equipment. He learned his business strictly through on-the-job experience. He never attended any formal motion picture or cinema-related schools or classes. (Funny, now he teaches at UCLA and for several State Film Commissions from his real-life experience about how it really is in the moviemaking industry.) He was also invited to teach a few classes at the Dawn Workshop at Kerry ETB Training Center in Ireland. This shows you one of the hundreds of opportunities to achieve your dreams, if you try, and try again.

When Michael began his career as a grip, no specialty books regarding his craft were available. After several years of learning his craft from other key grips, grips, and anyone who he could learn

from, Michael wrote the first edition of this book to share the knowledge he had gained to date. That edition proved very useful to new and experienced grips alike, so Michael wrote a second edition. Not being satisfied with getting the knowledge out there fast enough, he has taught at the University of California at Los Angeles on several occasions. Michael's goal in writing this edition of *The Grip Book* is to help students, other grips, and production members by providing a firsthand, fingertip reference guide to the grip equipment currently used daily in the industry.

Acknowledgments

I would like to take a few moments of your time to share with you the names of people I want to thank. The only reason you should read this section is because, if and when you do make it to Hollywood, these are the types of people you want to work with.

These people are some of the best grips and other personnel still working in the business, and they still help me on a relatively routine basis.

First and foremost is Doug Wood, key grip, I.A., Local 80. Doug gave me that first proverbial break in the business of making movies. He was a giant of a man in stature (his nickname was "King Kong"), but he was also probably one of the best, if not the very best, dolly grips you would ever see. In fact, I looked up the word "smooth" in the dictionary, and next to it was his picture. All kidding aside, he really was good. I loved him like a brother. (Doug has since passed away and is most likely teaching how to be a dolly grip in heaven.)

Next on my list is Gary Welsh, key grip, I.A., Local 80. Doug Wood taught me the trade of the business, but Gary taught me the business of the business. I have nothing but respect and admiration for this man. If he hadn't let me go (he fired me), my career may have been a whole lot different.

Then there is John Stabile, key grip, I.A., Local 80. This man is one of Hollywood's hottest key grips. This guy has volumes of knowledge and experience. My humble hat is off to you, John.

These guys are only a few of those I consider to be the greats of the business. Look them up yourself when you hit Hollywood. I have worked with so many good grips, but if I listed them all, this book would be really boring and the only people who would read it would be those listed here. (There is no shortage of ego in this industry . . . perhaps that is why there are so many greats!)

Before I get on with the show, I really must say a special thanks to someone who has been my sidekick and is a cofounder of Uva's Grip Truck Service, Mr. José A. Santiago. I met José in 1980. He was sweeping floors at the place where I was working part-time while establishing my career as a grip. He had come to the continental United States from the Virgin Islands only three years earlier. At that time, José only spoke broken English, but he had, and still has, flair. He swept the floor with a smile, cleaned toilets, whatever was required of his job. He showed me then, as he continues to do so now, that he could do any job assigned to him. You just need to show him how to do the job, dirty or glamorous, and give him the chance to prove himself. After only a few years in this country, he was driving a nice car, had bought a home with a pool, and was then helping his mother back in the Virgin Islands. José is now one of Hollywood's most sought-after grips. Just another success story, I guess, but one we're both living.

Good luck to all of you who venture down this road. I would love to hear from readers who have gotten the breaks and are making the big bucks.

What could happen on your way to the throne!

Nobody that I know of studies to be a janitor. Even fewer people in film school study to become a grip. But alas, the world has many good janitors and many, many good grips. The one biggest difference right off is that an average janitor can probably receive wages in the range of $20,000 to $40,000 a year. Grips will, could, and have broken the $100,000 a year salary mark. Well, I digress. You may

have purchased this book for one of many reasons. Let's say, for argument's sake, that you're studying to be the greatest director of photography the world has ever seen. Good for you. You have bought this book to aid you in your knowledge to enhance your camera abilities. Smart! But like my grip rap song on YouTube says, "Buy the grip book, study real hard, soon you'll be givin' out your grip card." Let's say that you have graduated from one of the best film schools in the country. You are primed, you are primped, and you're probably unemployed! Ah! What to do? What to do? Then the light comes on in your cinematic head. "I will just get a 'temporary' job on any movie set until I get my big break."

Well, over my years of learning the business, I have run into many temporary technicians. Not everyone starts out at the top, as we all know! I know this is going to sound like your father talking now: "You could be anything or anyone you want to be"; no truer words have ever been spoken, especially in the film industry. But there seems to be something missing. Oh yeah, "It will most likely take a while!" So why not "earn as you learn," as I did? I am still learning and will be until the very day that I can become what I really want to be.

A bit of encouragement

I have included the photo below to encourage my readers. These words were discovered cast in stone (okay, cement) in Hollywood at the Dolby Theater (the venue where the 2017 "WRONG ACADEMY AWARD" was given out for Best Picture), located close to the world famous Grauman's Chinese Theatre. All the images are part of the artistic statement designed by Erica Rothenberg and titled "The Road to Hollywood." This concrete "Red Carpet" includes many quotes from directors, producers, actors, and now, of course, a key grip. Who knew? If you turn back to the acknowledgments section of this book, you will learn that this key grip is my good friend José Santiago that I spoke of. Besides being very, very proud of José, I am telling you about him to let you know that you can also make it here! (PS: Look, Mom . . . I have arrived!) I'm telling you, you just can't make this stuff up!

Figure OFM.1 Mike Uva's "words in stone"

The Grip Book companion website

Visit www.routledge.com/cw/uva for exclusive video content.

Videos include

Apple Box	Putty Knife
Baby Plates	Tube Hanger
Bar/Furniture Clamps	Side Arm
Bead Board Holders	Step Blocks
Branch Holders	Jr. Wall Plate
C-Clamp	Set Wall Bracket
Cribbing	Gaffer Grip
Cucoloris	Stand Extension Pin
Cup Block	Stand Adapter Pin
Drop Ceiling Clip	Tent Peg
Flex Arm	T-bone
Grip Clips	Wall Spreaders
Grid Clamps	High Roller
Furniture/Sound Pads	C-stand and Operation
Offsets	Flags and Cutters
Pipe Clamp	Combo Stands
Chain Vice	Scrims
Parallels	What You Don't See
Taco Cart	Expendables
Wedges	Knots
Empty Frames	Fisher Dolly
Sandbags	The Grip Rap song
Mafer Clamp	

1 *Introduction*

What this book is about

This book is designed to teach you about the equipment you will need and use on a daily basis in the moviemaking industry. I will also lightly touch on some stage terms, tricks of the trade, and procedures. With this book, perseverance (and I mean lots of perseverance), and just plain old hard work, you can become a successful grip and it will help you on your way to many of the technical fields behind the lens. I challenge you to do it. But let me get off my soapbox (later changed to an apple box . . . you'll see what I am speaking of later in this book) and get back to teaching you how to become a grip. I am writing this book based on my experience and the experiences of other grips with whom I have worked. There is a saying among grips that there are ten ways to do the very same job – and usually they all work. This book will help you learn the names of basic grip equipment and if explainable and safe enough, ways to use it. Plus, every so often I will also throw in the nickname of a piece of equipment.

About the equipment

In this book I have selected a cross-section of only the most professional equipment. I have not by any means listed all the super equipment available. First, such a book would be too costly to produce, and second, I just want you to get a feel for what tools are available. I recommend that you go to any and all technical trade shows concerning the film/television industry. You are no doubt aware of the industry's widespread and growing use of computers, with each new application being better, faster, and more readily available than the one before. There are several fantastic remote control film and television heads (fluid, remote, and geared heads), as well as many new cranes and dollies, new and improved grip equipment, and redefined methods of gripping. I will try to cover a little of each of these aspects to let you, the reader, know what is available out there. I will be providing the knowledge for you to go out there and make your own decisions. I am not just going to tell you what equipment to get; instead, I am going to help you figure out for yourself what equipment to get based on your needs and the situation. The goal is to make sure you realize that such a discussion is more than a catalog of parts!

If I don't show you a picture of a piece of equipment, I have probably explained it either somewhere else in the book or in the glossary. Once again, this book is not the end-all of grip books, but it is a leap in the right direction. If you learn one thing and use it to improve your skills, others will notice, and it might just get you called back, which is one of the many things I have aimed for in this book.

A professional's tips on the trade

In this book, I will be passing along to you some very important "professional's tips on the trade." You may have heard the old saying, "It's the little things that mean a lot." Well, that certainly holds true in this business.

Self-test

I have made up a self-test for you. When you take the self-test (near the end of this book), you will find that a lot of the questions I ask come from the "professional's tips on the trade" sections.

Let's get going!

So you want to get into the movies. Well, so did I. Now I am in, and you can get in, too. It doesn't take a college education (but it helps) or even a high school diploma (but who the heck wants to walk around without one – not any grip I know). If you are halfway intelligent and can count to at least seven (two out of three times), I believe you can learn about the basic tools of gripping.

Let me begin by promising you the same thing I promise all my students: **nothing**. You don't need someone to tell you that you will get rich, be famous, and live happily ever after if you buy this book. But if you like traveling and working with a group of highly skilled technicians, actors and actresses, directors, and producers, this is the job you should try to pursue. I don't want to say it is the greatest job, but to give you an idea of how good it can be, I started writing the first edition of this book while I was on location for the movie *The Big Easy* in New Orleans – sitting in a room on the 15th floor of the Iberville Hotel overlooking the Mississippi River. (Not too bad a job at all!)

When people ask what my job is like, my answer is unconventional: it's almost pure freedom, like a singer singing a song. Singers must know all the words, but they put their own style and twist to it. For example, I must sometimes mount a $500,000 camera setup on a $300,000 car, and how I do that is a challenge. As a grip, you are kind of like an on-set designer, engineer, and administrator and worker, all rolled into one person. You are needed! You are one major support system. It is a great job. Give your all to whatever you do, and the future will develop itself. Trust me on this.

First and foremost, start by figuring out just what job you think you may want to do in the film industry. I use the word "think" because you may find that, after you have reached that coveted position, it is not as fulfilling as you thought it might be, would be, or should have been – but that's another story. For now, let's assume that you are absolutely, positively sure beyond a shadow of a doubt that you have made the right career decision. Good, let's get started. Because gripping is the profession you have chosen to learn, let me tell you what a grip is. A grip is the person who, as we grips like to think, solves other people's problems. A cameraperson might turn to a grip and say, "I'd like to rig a camera on top of a car . . . or on top of a mountain . . . or off the side of a building." As grips, we are the guys and gals who have to figure out how to rig it safely and as quickly as possible because of the tight shooting schedules we usually have to work with.

Grips in general

As you may know, gripping can be physically demanding and the hours extremely long but, what a rush! You will sometimes collect an instant gratification like none other for a job you have just accomplished. It is very rewarding.

In the USA, a grip can be either a lighting grip or a rigging grip.

Grips have two main functions. One is to work closely with the director of photography (DP) to provide camera support, if the camera is attached to a crane or dolly or mounted someplace that is unusual.

Some grips may specialize in being a dolly/crane grip. They are usually very good at this skilled craft. Dolly grips usually move the camera as seamlessly as possible.

Just a note here! The DP or a camera operator will usually want his or her own hand-selected key grip and Dolly grip. (Think of it as a dance partner.)

Another function for grips is to aid the electrical department. Simply put, the juicers put in lights; the grips "shape" the light with flags, nets, and diffusion.

The name "grip"!

Some say that a tool bag, sometimes referred to as a "grip bag," is the origin of the name for these technicians. I say . . . Okay!

Like a lot of terms in this industry, there are "many origins" to many items. To this, I say . . . Okay! I really don't care where the name originated from; I just care that you, the reader, know the manufacturer's name (or many names/nicknames) of the item of equipment. For all I care, you can call a C-stand "Bob"! Just make sure you bring a sandbag with Bob to me when I call for one!

Grips come in assorted sizes and colors. There are a lot of big, macho-type grips. You can recognize them right off. They are the guys with the heavy moustaches who usually walk like small apes (joking), myself included. Grips can also come in the form of women. Gripping does not really take a lot of body strength, although it does require a lot of mental strength to outsmart the object you are working on.

Let me illustrate. When I am asked (as I often am), "What is a grip?," I like to tell this story. First, imagine that you're in your home, say, in the early 1960s, at Christmastime. Uncle Milton suddenly runs into the room as the family is about to open the gifts that have been lovingly placed around the tree by Mom. Well, good old Uncle Milty does not want to miss a single moment, so out comes the new 8 mm camera. He wants to save this special moment for all posterity. He flips on the switch, and a huge blinding light from the twin lamps mounted on the camera is now burning the retinas out of everyone's eyeballs. Everyone in the room, almost in unison, raises a hand to cover what's left of their vision. Tight-lipped smiles quickly emerge (which say, "You're blinding me with that stupid light!"), and everyone gives a quick wave (which says, "Okay! Enough already. Film the next person!"). The twins, seeing this great fun, jump to their feet and dance a jig for their now most favorite uncle. Yes, they are on film. Their overlit, bright faces smile joyfully, while their harsh, heavy, dark shadows dance like huge monsters on the rear wall, aping their every move. Aunt May (Milty's wife of 30 years) fans herself to relieve the tremendous heat from the camera lamps. Ah! The joys of home movies.

We have all seen this type of home film. Professional moviemaking could be very much the same; even though it costs a whole lot more, it could be just as boring. Now enters the grip department. We are the folks who place different materials in front of those huge light sources to make them a bit more flattering, or softer, or even colder looking.

One could say, "Grips shape light."

We have a million different tricks up our sleeves (okay, not really a million, but a bunch).

Grips usually do not decide what material to put in front of a light; that is usually the job of the cameraperson, along with the gaffer (you will learn what a gaffer does in a minute). On many occasions, though, we can suggest something that will work for the shot. (Believe me, folks, it is a team effort.) Besides the soft materials in front of the lamp, we may also use a flag and cutter (I will explain later) or maybe a net to change the texture or the intensity of the lamp.

A grip is like an expert handyman – kind of a jack-of-all-trades and, we like to think, a master of all as well. Most grips usually find they can do just about anything, but after a few years in the business you will find that you begin to specialize. For example, you may become a camera dolly grip (I'll teach you more about camera dollies later). The dolly grip does all the pushing and wheeling. Then there's the rigging grip, which mounts cameras and lights anywhere they are needed (which I like to do). And then there's just the everyday grip, which does, you guessed it, just about everything else. In this book, we are going to be focusing on the basic tools of gripping.

As a grip, you will be working with the gaffer. This is the person who is in charge of the lighting. You will also work with the director of photography, usually called the DP. The DP is the person who may tell us what light goes where or who just tells the gaffer what sort of light mood he or she would like to see, for example, a night scene, a day scene, rain, and so forth. Basically, the DP tells the gaffer what he or she wants, and then the gaffer has the electricians who work with him or her go out and set up the lights where needed. You will also work with a host of other technicians, sound people, makeup artists, and so forth, and you'll learn something about their specialties as you go along.

To be a grip, you must believe in yourself and be prepared to work long hours and sometimes under not-so-Hollywood-glamorous conditions. It is not an easy task to become a film technician. You must have determination and you must learn the equipment. If you know what a piece of equipment looks like by name and can be fast to retrieve it when called for, then you're well on your way to being a good grip.

A little grip history

Before I tell you more about what a grip is, let me tell you how the word "grip" came to be. Legend (and there are many of them in this industry) has it that in the heyday of film, the basic film crews consisted of a director, a cameraperson, a few assistants, and workers. The workers set up all the equipment, lights, cable, stands, and so forth, so they were like the handymen on the set. The worker/handyman carried his tools in all sorts of containers, such as a tool tray, a box, or a carpetbag (sort of like a doctor's bag, only larger). The bag that contained the tools of the handyman's trade was called a grip. (Starting to get the picture?) Over time, these workers developed special talents. Some developed skills in building or rigging things. The originally unspecialized workers eventually separated into specialty groups: electricians did all the wiring and lighting, and workers with the tools grabbed their tools or grip bags and built or rigged whatever was needed.

Who knows where it really came from? It only matter now on how **_you_** become one.

The modern-day grip is still the physical backbone of the industry. Trust me – all the other departments bust their butts, too, but it always seems like the grips are lifting or carrying something. They're sort of handy people to have around. The standing joke among grips is, "We fix other people's problems."

A cameraman I sometimes work for has given me what I consider the best description of a grip: an intelligent muscle. This does not mean you have to be over six feet tall, weigh 280 pounds, and be built like a football player to do the job. What it does mean is that you are smart enough to move a mountain, if need be, because you know who to call to get the job done, quickly and safely.

The grip department

The grip department has the following positions:

Key grip (boss)
Best boy grip (could also be a best girl grip)
Grips (workers)

Key grip

The key grip is the head guy, the big cheese, the main man, the bwana, and the keeper of the keys. The master who knows it all (and that's just what he thinks of himself). (You should see what the rest of the crew thinks of him.) The job of a key grip is to gather a crew consisting of a best boy (second grip) and as many grips as needed to get the job done. If there are any preproduction meetings before the sched-uled shooting day, the key grip will attend these. During location scout meetings, the key grip will also have to determine what additional special support equipment (extra dollies, cranes, mounts, etc.) will be needed, if any. After the location scout, the key grip will determine the production needs and whether or not any additional special support equipment (a second four-wheel-drive truck, a couple of snowmobiles, boats, etc.) is needed for the particular terrain in order to get the company's film equipment to a certain spot. Once on location, the key grip works with the gaffer (head electrician) and starts directing what grip equipment goes where. While all this work is in progress, the key grip will begin to plan what will be

needed for the next series of shots, based on his or her years of experience and what has been derived from meetings with the producer, director, and cinematographer during preproduction meetings.

A professional tip

Always keep your eye on the key grip and the director of photography. Learn to listen for their voices in the middle of a crowd. Try to remember what style of lighting they do and anticipate if a flag or scrim is needed. (NICE TO KNOW)

Best boy grip

The best boy is an extremely important position in the grip department. He (or she) is the direct link between the key grip and the other grips. The best boy is like a foreman on any job. The key grip tells the best boy grip what she or he wants and where and why. The best boy grip directs the grips, giving each an assigned task to complete and instructions on when to report back upon completion of the task. The best boy grip is also in charge of all the grip equipment and expendables (tape, gels, nails, etc.) on the grip truck. He inventories the equipment when it leaves the truck and when it returns, ensuring that the company does not run out of expendables in the middle of a shoot. The best boy grip also gives a status report to the key grip on the works in progress, along with an honest estimate of how long each job will take to complete. He must be accurate within three to five minutes, because time is money in this industry.

Grips

Grips are the workhorses of the industry. This is not to imply that the rest of the technicians do not work hard; they do. It is just that grips tend to do the dirty work, along with their electrical brothers and sisters. Grips usually do most of the rigging of light support equipment (securing the lights in place). They mount the cameras in every imaginable place under the sun (and moon), and they are responsible for the safety of all the equipment they rig. When a stunt coordinator asks the grip department to help build a ramp or a safety stop (we're talking about a person's life or limbs here), the stunt department, as well as the film industry, is placing its trust in the grips' ability to do it right.

Grip zones

The working grip department on most TV working crew sets is divided into zones. Say you're working on a TV show. You'll most likely be assigned to the "bull pen." This is where the grips in waiting hang out during a take or rehearsing. (Never congregate in one location . . . Spread out, otherwise it can look like the crew is overmanned . . . even if you're not.) When you're called into action, you'll head for the set, with your tools at the ready, on your hip.

High person

This grip will work in the perms or on the catwalks over the movie/TV set, always at the ready to lower, move, or adjust something from that station.

Hip pocket grip

This grip is always next to the key grip. The key will relay his instructions to this person. If additional grips are needed at that point, the hip pocket grip will "call it out" over his radio on the way to his assignment.

A professional tip

Develop what I call "set ears." Tune your hearing to the voices of the director, the camera-person or director of photography (DP), the gaffer, and your boss (the key grip), as well as the best boy. If you hear that any one of them would like something, you as a grip should call out that it is on the way or that you will retrieve it. This shows that you have set consciousness and are willing to work. (NICE TO KNOW)

Call time

A lot of folks have feelings about the time one should be ready to work on a movie set. Some say that, if the call time is set at 7:00 a.m., for example, then this is the time you begin your work. I fully agree with this statement! If the call time is, in fact, 7:00 a.m., this means to me that you have arrived at the set's location, parked your car (if necessary), put your tool belt on your hip, and are ready to swing your hammer at 7:00 a.m. This is my personal philosophy. I will tell you the same thing that I have told newbies (new personnel just starting out) for years: "If you arrive early, you're on time; if you arrive on time, you're late; if you're late, you're fired!" I know in this politically correct world this won't happen, but recognize this: I am not required to call you back for the next job. I am not trying to be a hard-nosed, intolerant, key position person with a huge ego. I am just hoping that you understand my thoughts on the matter. There are many, many people who would give their eyeteeth for a chance to be in this business. I want you to stay. (I really would not fire you.)

So, getting back to this time-of-day stuff, you are supposed to be ready to start work on the set at the call time; the call time is not the time to show up. Most production companies usually have a self-serve sort of breakfast, maybe hot or maybe just donuts ("grip steaks") and coffee. This meal is usually served a half-hour prior to call time. Remember, call time means you have had breakfast and are ready to work.

The key personnel for each department will usually have done their homework, which means they have already discussed what will (should) be accomplished that day. The key grip will gather his or her personnel and explain what the day's work will be; then each grip will be assigned his task. Be ready to work, with both your tool belt and your radio on.

A typical day for a grip

For a grip, a typical day on a film or television set goes sort of like this.

Setting up a shoot

Your first time on a stage will be something like this, or close enough for you to look like you know your way around. The movie set has been built by the construction set-building crew in a studio or sound stage. When you walk in, you will notice that above the set is a series of walkways that are built close to the ceiling. There will be a set or two of stairs mounted on the sidewalls of the stage leading up to these raised walkways. These walkways are permanently built into the stage, so they are called perms (short for permanent walkways or catwalks). The perms usually range from around 25 to 100 feet above the ground, and they are spread about 25 to 35 feet from each other, crisscrossing the entire stage. The perms are used to mount lights, which are hung from the system of rafters and trusses that support the roof of most stages. From these

perms we will also mount items such as rags and set walls, which are usually supported by rope or sometimes cable.

The grips will now build a second set of catwalks or portable walkways that hang by chains underneath the perms and over the newly erected set. These temporary walkways are called green beds because they are usually painted green. They hang above the set wall height and along the entire edge of the set. This portable scaffolding usually consists of walkways that are about 3 ft. wide and about 10 ft. long, although these can be longer or shorter, as well as narrower (about 2 ft. wide). The green beds also have cross-catwalks.

Safety rails guard all the walkways. Between the walkways is a series of heavy-duty lumber boards ranging from 2 × 8 ft. and 2 × 12 ft. to 4 × 4 ft. and 4 × 8 ft. The space between the walkways is referred to as the "ozone." You never, no matter what the old salts may say, climb onto boards in the ozone area without wearing a full body harness and fall protection strap. The reason you might have to climb over the safety rail and balance-walk the lumber in the ozone would be to install a "stick," or cross, from which to hang a lamp or set wall. This is one part of the grip job where you do not try to fake it until you make it. Be honest, and above all, be safe.

The greens (as we call the green beds for short) are also used for lighting, as well as special effects or whatever items need to be "flown," or hung, just above the set. Because they are sometimes just about a foot above the set walls, they offer a great vantage area for lighting or effects. The greens are sometimes braced to the top of the set wall as well as from the perms. They are usually accessed from a ladder mounted from the floor to the beds, and they are also accessed from the perms.

Sometimes a backing will be flown or hung from the beds. These scenes are placed behind the set, so it looks as though the movie is really being filmed at a given location. These backings, which are also called drops and translights (translights are huge slides, as for a projector), are also sometimes flown from the perms. They may even be flown or hung from sailboats (long adjustable poles, raised like a mast on a sailboat, that are welded to a very heavy base on wheels). These drops, backings, or translights will be seen through the windows or doors of an interior set or behind the edge of a building on an exterior set. They will add depth and dimension to the film.

After all the green beds are built and the backings are hung, the lighting crew will start to add lights. Grips work with the electricians and put up any hardware (grip equipment, such as baby plates, set wall brackets, or whatever) that is needed to support the lights. After the lights are secure, safe, tied, and pinpointed in the proper direction, the grips will add the necessary gels (diffusion or color). The gobos (flags, nets, silks, etc.; for a definition, see p. 439) will also now be placed by the grips. This process contributes to creating a feeling of reality that can be captured on film or video.

A Bit of my Personal Philosophy

That's "Hollywood" Life

Song:

> I've been a puppet, a pauper, a pirate, a poet, a pawn and a king
> I've been up and down and over and out and I know one thing . . .
> Each time I find myself flat on my face, I pick myself up and get back in the race.
> —Frank Sinatra, from the song "That's Life!"

These words just seem fitting to explain my rise to the want-to-be grip.

In life, you're either existing, or living! I choose to live life to the fullest. Now I am living the dream as they say.

Here is a simple question for you? What do I have that you don't have?

Answer: NOTHING!

I have no special skills, can't sing, can't dance, can't type, and I can't even spell. On top of all that, I have no command of the English language whatsoever. So how the heck did I end up here making movies? May I offer you a bit of information? SO WHAT! You're not me; you're you.

So quit wishing and become Yoda, like: "No Wishing – Just Do!" No more, I could have, I would have, or I should have. "*Just do it.*" (Oh, that is the Nike logo.) So, welcome to Hollywood! Let me tell you this. It will happen if you want it bad enough. Plus, here at this very moment, I am going to reveal the "Secret Password . . . the Golden Ticket" to get into Hollywood!

It will open the magic door . . . I promise you this. Only one word: WORK HARD! (Like I said, I have no mathematical skills either.) But, I have noticed a strange event in my own life. ***The harder I work, the luckier I get***.

Truly, if you knew me at the beginning of my life, coming from a busted family much like a lot of folks. No real connections straight to Hollywood, you may say to yourself, WOW! I simply say, **WORK HARD!**

BTW, if you do want to see and read about how I made it, pick yourself up a copy of my other book. It is called *Breaking Into Hollywood* (Amazon). It's a fun read/audio of my adventures, including some seemly tragic accounts that shows the payoff of perseverance.

Parting words: yes, you can!

Trust me, if I can make it . . . so can you! **WORK HARD!**

The schmooze

Welcome to Hollywood, once again. Everybody will schmooze! The actors, the technicians, the production assistants, all the way up the ladder to the top in the entertainment business.

I have personally laughed at a joke that I have heard a dozen times before, especially when the boss is telling it. (I should win an award for my acting abilities.)

Now I will follow up my uproarious laughter with, "that was really funny, boss!" Then I will follow it with, "why yes I'm available for work all next week . . . why do you ask?"

So there, I have schmoozed! People do it all the time, in all jobs! In my particular case, I am a known commodity. I am known as a hard worker! I will always give 110% . . . no matter what! People notice very quickly. You do at your school or place of work every day. Be observant. Now go out there, learn, work hard, and get really lucky.

My following words of wisdom are from my personal experience. No, my way is not the only way, but my way has worked for me for many, many, many years. A lot of folks learn very young in life about copying the greats of the world. The greatest basketball player, the best golfer, or even a popular singer.

We all (well, maybe just some for the most part) copy others, either knowingly or innocently. Me, I personally cherry-pick others' work. I pick out what I can use that works best for me. Then I use it like I invented it.

Like I said earlier, welcome to Hollywood.

Now go eat, drink (water), and be merry!

BTW, you're now an official Hollywood hypocrite! (Welcome to my club!)

Note: In the interest of political correctness, I hope you understand that I joke . . . And yes, I am available for that next job . . . M.

Call sheet

In this section I will refer to an example of an empty call sheet (Figures 1.1 and 1.2). A call sheet, as the figures show, has all the information that the technicians and actors will need for the next day's work. I have numbered each item on the call sheet that I feel should be explained. This sheet of paper is a very important item in the everyday life of a grip. When you learn to read it, you will see how it aids you in preparing for your job.

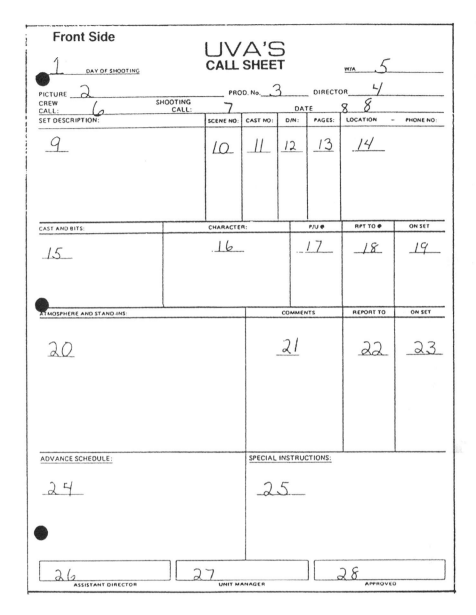

Figure 1.1 Call sheet

Front side of call sheet

1. Day of shooting: For example, day 1 of 50 days
2. Picture: Name of the film or commercial
3. Production no.: Identification number for a film or commercial
4. Director: Name of the director
5. Extra line for additional information
6. Crew call: The "call" or "call time" is the time to report to work; "set" describes whatever or wherever you are shooting (a stage or even a forest can be called a set – after all, it has been said that "all the world is a stage")

Figure 1.2 Back side of call sheet

CAMERA	Time	No.	MAKEUP	Time	No.	RESTAURANT	Time
Camera Pkg.			Makeup Artist			From Commissary	
Other Cam. Pkg.			Extra MU			From Caterer	
Cameraman			Extra MU			Breakfast for:	
Operator			Body MU			Lunches for:	
Extra Operator			Hairstylist			Dinners for:	
1st Asst. Cam.			Extra Hair			Gals. Coffee	
Xtr 1st Asst. Cam.			Extra Hair			Doz. Donuts	
2nd Asst. Cam.						Tables & Chairs	
Xtr 2nd Asst. Cam.						POLICE	
			WARDROBE			Flagman	
			Costumer			Set Watchman	
SPECIAL PHOTOGRAPHIC			Mens Wardrobe			Night Watchman	
Cameraman - Process			Ladies Wardrobe			Uniformed Police	
Matte Supervisor			Extra Wardrobe			Studio Firemen	
Port. Proj.							
Moviola							
1/2/3 Head Proj.			SOUND				
Projectionist							
Stereo Mach./Proj.			Mixer			HOSPITAL	
			Mikeman			1st Aid Man	
			Cableman			MUSIC	
TECHNICAL			System			Piano/Player	
Key Grip			Playback Mach./Oper.			Sync Man	
Best Boy			Batteries/Hookup			Sideline Musicians	
Dolly Grip			Radio/Mic.			LOCATION	
Comp. Grip			Walkie Talkie			Location Manager	
Dolly			Electric Megaphone			Police	
Greensman			Wigwags/Phone			Fireman	
C.S.E.						Permits	
Painter							
Plumber							
Propmaker Constr.						TRANSPORTATION	
Special Effects Foreman			STILL			Trans. Coord.	
Effects			Still Man/Still Equip.			Trans. Capt.	
Single Dr. Rm.			EDITORIAL			Sedan	
Mtsple. Dr. Rm. No.			Film Editor			Station Wagon	
Makeup Tables						Mini Van	
Wardrobe Racks for: No.			PROPERTY			Crew Cab	
Schoolroom for No.			Property Master			Buses	
Tables & Benches for No.			Asst. Prop Man			Pick-up Truck	
Heat Stage No.			Lead Man			Picture Cars	
Heaters			Swing Gang			Prod. Van	
			Draper			Honey Wagon	
			AHA Representative			Grip Trk/Trlr	
ELECTRICAL			Animal Handler			Prop Trk/Trlr	
Chief Light Technician			Wranglers			Ward Trk/Trlr	
Best Boy			Live Stock/Animals			Sound Trk	
Lamp Opers.						Elec. Trk/Trlr	
Gen. Operator						Generator Trk/Trlr	
Wind Mach.			PRODUCTION			Crane & Oper.	
Wind Mach. Oper.			1st Asst. Dir.			Water Wagon	
Local No. 40			2nd Asst. Dir.			Make Up Trlr.	
Batteries			2nd 2nd Asst. Dir.			Greens Trk/Trlr	
Camera Mechanic			Addtl. 2nd A.D.			Insert Car/Lights/Gen.	
Air Conditioning			D.G.A. Trainee			Construction	
Booster Lights			Script Supervisor			Special Effects	
Work Lights			Prod. Coord.			Motor Homes	

Back Side

W/A _____

PICTURES PRODUCTION REQUIREMENTS — PICTURE _____

DIRECTOR _____ 1 PROD. No. 2 CALL TIME 3 DATE 4

7. Shooting call: When the lights, camera, and actors should be ready to shoot
8. Date
9. Set description: Explanation of the shot (day or night, interior or exterior) and a brief summary of what action is to take place
10. Scene: Numbered scene from the script (you can turn to this scene number in your script and know exactly the dialogue and the action that should take place)
11. Cast numbers: Numbers assigned to cast members, from the lead person (usually #1) to whatever bit (smaller part) player is in the shoot, which allow everyone to see which character (actor/actress) is playing (acting) with another player (actor/actress)
12. D/N: Day or night

13. Pages: How many pages or eighths of a page will be shot for a certain scene (a script page is usually broken down into eighths of a page)
14. Location and phone: The street address and phone number of the place (location) where a film or part of a film will be shot
15. Cast and bits: The actors' and actresses' real names (and assigned numbers, as mentioned above); bits are bit parts of a usually small scene
16. Character: Character name from the script
17. P/U or pickup: The time at which an actor or actress is to be picked up from his or her hotel, if on location, or from his or her home if necessary (actors and actresses usually have very busy schedules and may need those extra few minutes while being driven to the set to study their parts)
18. Report to MU (report to makeup): Scheduled to allow the extra time it sometimes takes for makeup to be applied to an actor or actress
19. On set: The time the actor/actress is to report to the set in costume, with makeup on, knowing their lines, ready to rehearse and then shoot
20. Atmosphere and stand-ins: Actors' doubles who will stand in for lighting the scene; extras or background people are the atmosphere
21. Comments: Pertains to transportation (what vehicles are due where at what time)
22. Report to: Where to go
23. On set: When to report to the set
24. Advance schedule: Tells the crew what to be prepared for on the next day's shoot
25. Special instructions: Alerts crew if special rigs, rain gags, mounts, and so on will be needed
26. Assistant director: Names of assistant directors
27. Unit manager: Name of unit manager
28. Approved: Signed by the unit production manager (UPM) or first assistant director (AD)

Back side of call sheet

1. Director
2. Producer
3. Call time
4. Date

A number categorizes each department (column marked "A") and time (column marked "B"). The department ("A") column is used to list the number of camera packages required, the camera operators required, and so on for that one day of shooting (for example, there might be an action stunt requiring as many as six cameras, camera operators, grips, etc.). The time ("B") column indicates the time the crew is to report to the set. This column may show the time when only one person is due on the set or when many people are due at the set at the same time or at different times. For example, a camera package due time may be 7:00 a.m., and the first assistant camera operator due time may also be 7:00 a.m., but the rest of the crew may not be needed for half an hour, so the grip department due time may be 7:30 a.m. Get the picture?

Warehouse stages

With the rental cost of stages on the rise, a lot of productions are turning to warehouses as stages. This is a very economical way to make a film yet keep the cost down. This is also where you, as a grip, really have to put in extra effort. The warehouse stage will probably not have a high enough or strong enough ceiling to support a catwalk or perm system for lighting from above, so you will usually have

to build and suspend a pipe grid system from the roof. You must be aware of the strength rating (sometimes referred to as the snow load in cold climates) for the truss supporting the roof. If you suspend too much weight from the rafters, you can and will cause damage.

Problems also arise in the area of tying off ropes, such as for hanging a light. You will have to find a place to nail a wall cleat. Look for wood vertical support beams or wall rings. If there is no place to nail into, you may have to use a large pipe face C-clamp and bite onto a metal vertical support pole. I recommend using a pipe face and cranking (tightening) it down, as you do not want anything falling due to slippage. I will usually use two-pipe face C-clamps per pole in order to create a safety. If no tie-off is available, you can use a huge number of sandbags. Use enough sandbags to ensure that the weight on the other end of the rope will not move. If it is not 100 percent safe, don't do it.

How it may go on the set

The day has now begun. The lights are all set, and the flags, nets, or silks have been adjusted or tweaked. The actors will now come to the set and rehearse, first for themselves, as well as for the director and the director of photography. At that point, a director may not like what he or she has seen and may order a complete change of script, a new mood for the scene, and different lighting. What I am trying to emphasize here is that things change. When things change, and they often do, you may even hear some crewmembers grumble and say, "Why do we have to move everything again?" The reason is very simple: it's our job! As I always say, "Hey, it's their football, so we play by their rules." Translation: filmmaking is a work in progress. That's what makes it an art form. There are many ways to achieve the end goal, and we are hired to help do that. We collaborate with others to make this happen.

Okay, now let's assume that nothing really has to be moved, and just a little more tweaking is necessary. There, we are set. The grips will once again come into play during a film take (filming the action). A highly skilled dolly grip will move the camera at the exact times necessary during the filming on a camera dolly (a smart cart of sorts that travels fore, aft, and sideways as well as in a circular motion). All the pushing power is supplied by the dolly grip. The dolly grip must also anticipate the actors' moves and know the film's dialogue. These cues will prompt certain actions, such as arming (lifting of the center post with hydraulic air pressure) as the cameraperson and camera raise up to a high-angle shot while pushing the dolly so it will end up in the right spot at a given time. (This is an art form in itself.) A huge team effort is now in play. Meanwhile, an entire additional group of grips and electricians might be pre-lighting another set (placing more equipment in place to expedite the next filming to be done), which may be used for shooting later in the day or the next day.

When you're working on a set for the first time, you will hear many terms that you may not know. I will clue you in to some of these throughout this book. Even though they do not directly pertain to the grip department, these terms do pertain to the project or film that you are working on. When you hear these terms, you will know what to do. For example, "Check the gate" means the camera assistant insures that the last take was good. Of course we know it's all digital filming now but there's are carry over terms. If he calls out "Hair in the gate!" that means the grip department should not move anything. The phrase "hair in the gate" means that there was a small chip of film or debris caught in the corner of the camera gate (also called the pressure plate, which holds the film flat as it moves through the camera), possibly causing a small scratch. (We have all watched old movies with white lines or little wiggly things passing through.) Of course with the latest cameras we're now using it should make any sense . . . but it does. Just roll with it until things change. Either way, a "hair in the gate" means "do over" to the grip department. Which means, "Don't move anything. We have to reshoot the last take." If you are working on a set and the director of photography (DP) says, "Drop a double into that lamp," you're not supposed to (if you're union), so quickly look both ways for an electrician. If one is not close by, drop in the double, then tell the gaffer or the first electrician that a double has been dropped into the light. This will inform the gaffer that the light value has been reduced and ensure that they get another light reading before shooting begins. On non-union shoots, it seems like everyone sort of helps

everyone else. There is nothing wrong with helping. The union rules have been put into place to protect the worker. I was non-union for over sixteen years. Now I'm union with great health insurance and a good retirement plan. That may mean a lot in later years to you.

Moving on . . .

Grip job description

(*What you have to be able to do to work as a grip*)

The following job description for a grip comes from a union's letter I received once. I include this information because it gives one a perspective of the grip's physical job requirements and what tools to own. It's the basic requirements in a nutshell. Of course, this is just a broad overview. I'll start off with tools (short list).

Tools

By union contract, the grip tools will include at least the following: claw hammer, screwdriver, wire cutters, pliers, crescent wrench, and a tape measure, all of which are normally carried on a tool belt along with nails, screws, wire, and other supplies of the grip's choice. The typical tool belt when loaded will weigh from 11 to 24 pounds, depending on the requirements of the assignment. In addition to having to operate various power tools, the grip also must be able to safely operate dangerous machinery, such as chain motors, hoists, camera cranes, and various types of powered lifts and aerial work platforms.

Physical requirements

Grips will work "on" and "off" productions. "On" production means working directly with the director and cinematographer. "Off" production means doing necessary preparation or follow-up work at another site.

As a grip, you will move set walls. These walls may weigh anywhere from a dozen pounds up to several hundred. Even though an individual grip is generally not expected to lift much over 150 pounds, the work can be grueling: these walls are commonly carried, pushed, dragged, levered, or otherwise moved about manually due to space considerations that preclude the use of power-lifting machinery. The irregular and awkward shapes of many set walls often make proper ergonomic lifting impossible. So, if you're not ready, don't become a grip. All other grip work is comparatively heavy and strenuous: there are no reduced capacity or light-duty grip jobs. Added to the physical difficulty of grip work is stress, induced by the shift-work schedules of the motion picture industry. The typical minimum workday for a motion picture worker working production can be at least 12 hours, with one break for a meal. If the workday runs longer than 12 hours, meal breaks are scheduled at intervals of 6 to 6-1/2 hours. There are no coffee breaks on production. Longer workdays, including days that may exceed 24 hours, have happened in the past. However, you end up with one huge paycheck.

Plus you help out the government with added taxes. It's a win-win . . .

Off production workdays are usually, though not always, shorter. Shifts normally begin later on each successive day of a production schedule, starting very early (often before dawn) on the first day of the workweek and very late on the last day, resulting in very short weekends. Any five of the seven days may be a scheduled workweek (or any six of seven if the work is on location). The workweek itself may be shifted during the course of production, so that weekends do not always fall on the same day of the week. The grip's work will include, among other things, the erecting and striking of both ground-based and suspended scaffolds; chain, cable, and a wire rope rigging; rough light construction; the handling of set walls and units; and the handling of tarps in tents for weatherproofing of sets or for photographic

purposes. Also included on this partial list are the operation of camera dollies and cranes, including the laying of camera dolly or crane track; the handling of photographic backings; and the diffusion or other modification of light for photographic purposes. Physical strength, agility, balance, alertness, and mental acuity are necessary to safely carry out the majority of the tasks that might be assigned to a grip in the course of any given day. Normal grip working includes stair and ladder climbing, standing, kneeling, crawling, bending, squatting, and (though rarely) sitting. These motions and postures are usually performed in conjunction with the use of manual tools, or while handling various types of construction materials and supplies, set lighting-related equipment, and/or camera dollies and cranes.

A grip's day may include hammering, pulling, pushing, twisting, and overhead lifting for all common repetitive hand and arm motions. Grip work entails extensive use of a ladder or scaffold, or working in the perms of soundstages. It is my suggestion that the grip will also carry a roll of 2 in. black photo tape, half a dozen clothespins, a few metal binder clamps, a set of good work gloves, a couple of sharpie markers (1 red, 1 black), a #1 grip clip, a small flashlight, a bubble level, and anything else you want to hump around on your belt. Be a good scout (boy or girl) and always be ready. Remember, it is only a suggestion, but I have seen it day after day for the last 30 years. You decide. Well, have I scared the living . . . out of you yet? The upside: this job is a really exciting, well-paid life. (Leastwise so far.)

What to expect; the unexpected

A lot of times (and I mean often) you are in a hurry to get a piece of equipment the boss has called for. You race from the set and run smack dab into several people who seem to be just standing around. You may find it difficult to get to the equipment with all those people in the way. Plus you want to return to the set as quickly as you can. Let me tell you right now that this will happen a lot; "just roll with it." If you find this sort of situation to be a big problem, though, you have a couple of choices. The first one is to work your way through the throng by channeling Bugs Bunny and repeating "Excuse me, pardon me, excuse me" and then on the return trip politely urging the crowd to "Watch your eyes or back" (as if that were possible). I personally call out, "Knee caps and ankles!" when I am carrying C-stands so people will look down. The second alternative is not to take up this line of work.

Other obstacles you will find in your way include:

- People standing in the only doorway.
- People sitting on stairs blocking your access.
- People sitting on the ice chest full of cold drinks on a hot day.

What I'm trying to convey is, don't get mad and don't get even. Be polite – and get the callback! I have a saying. "Every Thursday (payday), I go to my favorite bank teller and say, 'Please cash this enormous paycheck.'"

Pace on the set

You will also notice that it seems to take a little more time to do things at the beginning of a workday, but as the daylight starts to drop off you work like crazy. As one director I work for said, "It's like shooting *Gone with the Wind* in the morning and the TV series *Modern Family* in the afternoon."

(You have got to finish the day's work before the sun goes down.)

What key grips like

I have spoken to several other key grips to research this grip handbook, and almost all of them stated that they wanted a newbie to be a person who is seen and not heard unless spoken to or there is a safety issue. A lot of key grips will readily take the suggestions of a newbie, and they may even ask for

suggestions, but be sure your timing is good and that you know what you're talking about. Sometimes you may just have to stay quiet until you get your chance to speak up. No one likes to be upstaged, including you. I'm not saying you should not suggest anything, but try to phrase it correctly. You might try something like, "Hey, boss [key grips love to be called boss], do you think it would work this way?" Every person loves the help now and then, but few like a know-it-all, especially if you are new. (It's sort of like driving a different car and you have to get the feel of the gas pedal.) Like most things in life, practice, practice, practice. Trust me, when you're the new person on anything, you will probably be asked to follow and fetch. I know it sounds cold, but this is the reality. After all, they don't let a brand-new doctor just out of school do brain surgery. (Thank goodness gripping isn't brain surgery.)

A professional tip

Looking good in this business is almost as important as being good. I am not saying you have to dress like a model in *GQ*, but I am saying you must be neat and clean (without any holes in your clothes) if you want to get a start. Who would you give a break to first, if the choice were between two people you didn't know? A clean-clothed, intelligent-looking person or a slob? You choose! You don't have to have a short G.I. haircut or spit-shined shoes, but give yourself a chance. You need every advantage over the next person applying for the job. Get in, get the job, and prove yourself – then let your hair grow. (NICE TO KNOW)

Now, back to other ways of getting that job. Check to see if any motion picture and television studio equipment rental companies are in your area. You see, a movie studio or television company may not own all the equipment they use. They sometimes rent their equipment from different vendors. So check it out. Another way to learn how to be a grip is to check out the television stations in your area. They do not always call their workers grips; they usually call them stagehands or stage managers. Then there are the local playhouses that might need an intern.

Nowadays, a few colleges can hook you up as an intern. I will be teaching at a college (when I retire) that places interns on major studio lots after they complete their training. I actually learned of the program from an intern on the Fox studio lot. (That's how I found out about the job I will be doing, from a graduate student.)

Remember, folks, you have got to learn how to walk the walk and talk the talk. Get around the entertainment industry and get a feel for it. This may sound foolish right now, but "You will know when you know." It's sort of like that first day at a new job or when you move to a new place. At first it is all so strange; then, slowly, quietly, it somehow changes and you are the old salt. This business is just the same.

Now, this last bit of advice is only for the really, really, really determined people who will do just about anything to get into this business. All others may skip this advice! Say that there is not a film commission in the area where you live. Does Hollywood know your city as well as you do? Possibly not. So, start your own film commission for your area. Sure, you should check with the city fathers and mothers. Get any necessary permits. Then call your state film commission and tell them who you are and what you are doing and how they can get in touch with you. As I have been trying to tell you, if it were easy, anyone could do it. All the same, I truly wish you the best of luck. (You will find that the harder you work, the "luckier" you will be. It just seems to happen that way.)

Warning/disclaimer

This book was written to provide pictorial information only on the subject matter that is covered. It has not been written or is to be sold to give legal or professional service. If you need a legal expert for

assistance, then one should be sought. Also, before you try to grip, find an experienced grip that is well qualified to train you properly. This book is a great aid, but it is in no way the final word on this subject.

This book does not reprint all the information that is available to the publisher and author. It has been written to complement and/or supplement other texts. This book is intended as a guide to help the reader identify a piece of equipment by sight and by the manufacturer's proper name. It was written to be as complete as possible in that regard, without attempting to train the reader to do this sort of work. I take responsibility for any mistakes, whether they are typographical or substantive.

This book is intended to be used as a pictorial reference only. The authors and the publisher will not accept any liability for damage caused by this book. It is highly recommended that the reader work with a highly skilled, highly trained motion picture film technician first. The sole purpose of this book is to entertain and educate. As they say on television: "Kids, don't try this at home." Buying this book will not make you a grip. It merely shows you the tools of the trade, not how to use them. Work only with a trained professional.

Remember, safety first and foremost.

Safety is the number one concern of all persons who work on a movie set.

Take it personal!

Make it personal!

Thanks! And, once again, good luck.

The big break *(strictly for the brand-new grip!)*

By Ron Dexter

MIKE'S NOTE: Ron Dexter has been a camera operator/DP/director since ever. He is a member of the National Association of Broadcast Employees and Technicians Election Board, a union negotiator, a director of television commercials (since 1972), a member of the Directors Guild of America, and the owner of a television commercial production company (since 1977). He is also an equipment designer, mechanic, and teacher. His short commercials have aired in 20 foreign countries and 35 US states. Ron inherited his business philosophy from his dad: "He said to give people more than they bargained for, and they will be so relieved about not being robbed that they will gladly pay the bill and not question it the next time." I have had the pleasure of working for this acclaimed director-cameraman since the very start of my career. Consider this master's words of advice to be almost gospel. He truly knows the complete ins and outs of the commercial studio business.

I can promise you this, if you study the following words and put them in to your day-to-day work ethic, you will be a long-term success, no matter what position you aim for.

That being said, it gives me great pleasure to pass on some of Ron's knowledge. Let me introduce to you, director Ron Dexter, also a cameraperson, a super inventor. The first "Yoda" of studio knowledge: "May his force be with you."

Ron's words

Most people prepare and wait for the chance to move up the ladder. Often that next chance is just a trial step to see whether you are ready. That chance usually is given when the opportunity-giver believes you are almost ready, not when you think that you are ready. In the following pages, I will offer a little advice on how to be a professional on the job that should serve to help you get ready to move up the ladder in your field.

Talking about moving up may be taken as normal ambition or a swelled head. Once you've been given a chance, don't assume too soon that you have made it. You may have to step back down to your

old job for a little longer because you are not quite ready or just because there is no need for you in that new position at the moment. Breaks are often given on less demanding jobs so you will have a better chance of succeeding.

Too often a break goes to one's head. You cannot become an old pro in just a few weeks. Knowing the mechanical skills of a job is only part of the job. Every advancement requires additional communication skills. This is where people often have trouble when they advance to the next level. Sometimes both the mechanical and personal skills suffer for a while. Running a crew is a skill that takes time to learn. The way you give orders is very important. The following pages will offer advice on how to be a good boss when you have advanced to a leadership position.

It is wise to take on smaller challenges first before tackling the big ones. Getting the best help is also wise, as is asking for help from a more seasoned crew. Often the opportunity for the next step up the ladder comes not from the boss for whom you have tried to make a good showing but from a coworker who has noticed your honest effort and hard work. A recommendation from a coworker who has credibility is worth more than the observations of bosses who do not have time to notice much about the working situation.

The following sections cover set etiquette, good and bad bosses, equipment, and health on the set; they also offer some professional advice, reflection, and sources of further information.

Set etiquette

At one time or another, most people in the entertainment business have a problem with set etiquette. For a newcomer on a set, it is like being dumped in a foreign country. The language alone is a struggle. People moving up the ladder experience problems, and even old-timers can lose their bearings. The rules are often different from those in the real world, and the glamour factor can distort one's views.

The following is a compilation of issues raised by various professionals in the industry. These are not elaborate theories but rather observations and opinions gleaned from many years of working in the business. Things are done differently on different sizes and types of shoots. Without a carefully defined structure, a large shoot would be absolute chaos. On small shoots, departmental lines can become blurred, but certain rules of etiquette still apply. Newcomers should keep all the rules in mind until they are sure which ones apply. Here are a dozen universal rules for any set:

1. Show up a bit early for the call.
2. Be polite. Say "please" and "thanks."
3. Let people do their job.
4. Be humble.
5. Ask questions about assignments if in doubt.
6. Watch what's going on in your department.
7. Make your superior look good.
8. Don't embarrass anyone.
9. Don't be a "hero."
10. Listen very carefully before you leap.
11. Learn and use coworkers' names.
12. Work hard and willingly.

The following discussion elaborates on some of these areas in more detail.

Call time

Call time means the time to go to work or be ready to travel. It is not the time to pour a cup of coffee and catch up on the gossip. If you want to socialize, come a bit early and enjoy the coffee and donuts that are usually there.

New on the set

If you are new on a job or production, it is best to let your knowledge be discovered slowly as you work with people. They will be more impressed if you do not try to show them everything you know right away. Some outspoken people really do know a lot, but it is the big mouths that make the truly knowledgeable ones suspect. For every outspoken knowledgeable worker, there are ten who are full of baloney.

Offering expert advice

If you have experience in a special skill, offering advice can be tricky, especially if you are new on a set. Humbly offer your advice to your immediate superior and let him offer it to the group so it will more likely be heeded. If he gives you credit, good. If he takes the credit, he will remember that you made him look good. Try (very softly), "I worked construction for a few years and, well, you know, it might work here."

Offering a hand

When should you offer to give workers outside your department a hand? When it does not threaten their job and your helping will not do more damage than good. Helping someone carry equipment cases is often allowed if permission is given. Spilling or dropping things is help that is not appreciated nor, usually, is setting a flag for a grip. A camera assistant who builds a good relationship with the grips may be allowed to adjust a flag as the sun moves if the grips know the camera assistant is not trying to make them look bad or eliminate their jobs and if the assistant knows what he or she is doing. Getting a feel for what is appreciated and what is not is the key. Do not assume that people want help, and respect their refusal when they don't. Maybe they simply do not have the time to explain how to do it right just then.

Can we help?

Our business is not an exact science, and there are often many ways to do things. A wise boss will listen, but some bosses (especially directors) are not secure enough to solicit help when they should. They are afraid to look dumb and can blunder ahead trying to be "the director." Crews have to be careful how they offer help. Asking "What are you trying to do and can we help?" sometimes breaks the ice and opens up a dialogue when things have stalled, but sometimes even that is taken as doubting the director's ability.

Don't be a hero

For every mistake, a "hero" discovers there is someone who made that mistake. Don't let that person be blamed publicly. If you see something that appears to you to be a mistake, say something quietly and humbly to your immediate superior. "This may sound stupid, but is the word 'stupid' on that sign spelled wrong?" Let your boss go to her boss so she can quietly say something to the next person up the ladder. The sign might be out of frame or be so small that it won't make any difference, or it may have already been decided that it is really okay. If you run out and yell something, trying to be a "hero," you are taking a big risk. The person at fault will remember for a long time the public embarrassment created by the young "hero" on the set. The worst thing would be to go over your immediate boss's head to the director, assistant director (AD), or a different department. You won't hear, "Who is that smart kid?"

Titles

People are often very concerned about their job titles. A title is an objective measure of success. Respect people's titles. People who are the most secure with what they are doing usually couldn't care

less about their titles. For others who may be less secure, it costs you nothing to call a prop person a prop master, if that's what that person prefers. Take a cue from what people call them. You may give coworkers a boost by using a title when introducing them, even if they don't seem to care about their title. Here are some examples:

Rather than Cameraperson, use Cinematographer
Rather than Prop person, use Prop master
Rather than Gaffer, use Lighting director
Rather than Script clerk, use Script supervisor
Rather than Wardrobe, use Stylist
Rather than Someone's friend, use Associate producer

These are always out of line for crews

Inappropriate sexual jokes and talk around women, political, religious, or racial jokes and slurs.

- Having such a good time at night on location that safety and performance are compromised the next day
- Alcohol or drug abuse
- Negative criticism of anything or anybody within the hearing of clients, producers, visitors, cast, and locals (keep your opinions to yourself)
- Bad-mouthing other production companies, equipment houses, and crews
- Loud talking on the set
- Radical wardrobe on location (make your personal statements in your own neighborhood)
- Accepting conflicting jobs in the hope that you will somehow work it out
- Replacing yourself on a job without warning
- Not saying anything when you see a dangerous situation evolving
- Even if people are dumb enough to take unnecessary risks, if you see danger evolving, you are morally obligated to say something. People often rely on others as a measure of how safe something is. Your concern may make people think twice. In our business, there are many ways to make things look exciting that are not necessarily dangerous.

Wrap time

Wrap time means just what it says: wrap it up. It is not time to break out the beer and slow down. Although beer is a nice touch, alcohol or drug use invalidates most company insurance policies on the set and on the way home.

Being a professional crew member

An eager attitude

Acting eager to work not only is a sign that someone is fresh out of film school but also says that work is a two-way deal. Eagerness shows that one is willing to make an effort for a good day's pay. Sometimes old-timers think it's not cool to look eager, but it really makes a difference when a crew seems eager: "What can we do for you?" "Yes, sir!" "We're on it!" "You got it!" Eagerness is a key factor in getting a callback from a production company. The following two sections give you more tips on what to do – and what not to do – to get hired again.

How to get hired again

Show up early for the call and be ready to work.

- Give a 110 percent effort.
- Be honest and straightforward.
- Assume that people are honest and good until they prove otherwise to you. (You may have heard only one side of derogatory gossip.)
- Cheerfully help others if asked.
- Cover your immediate superior's interests.

How not to get hired again

- Demanding Hertz rental rates for your ten-year-old car.
- Demanding full equipment rental rates for your sideline rentals (negotiate and ask "what's fair?").
- Putting more on your time card than the rest of the crew without approval.
- Increasing your rate after you are booked (don't say, "By the way, my new rate is . . . " during the job).
- Obviously having just come off another job at call time.
- Spending too much time on the phone.
- Not observing what's going on in your department.
- Talking too loudly.
- Fraternizing above or out of your category.

Personality problems

We are never the cause of unpleasant events on the job. It is always the other guy who has "personality problems." In most disagreements, both parties are usually right to some extent. Usually, the "rightness" or "wrongness" has little to do with the job and a lot to do with our egos.

Winning an argument can lead to losing the war. If two people who do not get along have to be kept separate, one or both will lose work. If one of them has anything to do with hiring, it can be a disaster for the other.

Don't risk your future over making a personal statement. Tempers cool off when a job is over and pressures are gone. Then it is wise to be humble and apologize, even if you are sure that you were right. Sometimes two people will fall all over each other claiming who was more at fault.

Good friends will not blindly support everything that we do. They should whisper in our ear that maybe, possibly, we are out of line. Advice on the spot in the heat of anger is sure to be rejected. If you see a coworker who is losing perspective, think about it a bit and even write down what you think. Making it clear on paper may make it more understandable. Even if you do not show your coworker the paper, look at it after the job to see if you still agree with your observation. If it still seems appropriate, you may show it to the other person or talk about it.

Approach any discussion about behavior with caution. Listen first. You will be much more able to tailor your questions or comments to what the person already feels. Often, just that person's telling you about something, with a few questions from you, will help them understand a problem.

Sometimes we all have personal problems that are difficult to leave at home. Both production and fellow crewmembers should take this into consideration. There is an intimate relationship between work and personal life. If someone is unhappy on the job, it is difficult not to take it home, and vice versa.

Résumés

Unfortunately, some people exaggerate their experience on their résumés. That makes all résumés suspect. Personally, I throw most of them away. Most of my hiring is based on personal

recommendations. It is much easier to bring in a person known by at least part of the crew. Most of my crews are hired by the department keys and the rest by the AD, producer, or coordinator.

Peer evaluation

Many jobs come from recommendations from established crew members. They know when someone is ready to move up. They also know when a certain project is over someone's head and when someone else with a bit more experience is needed.

Your voice mail message

People often do not want callers to know whom they have reached on a voice mail, and leave cryptic or incomplete message for the caller. For friends who recognize the voice, it can be entertaining. But, for the stranger (or person who wants to hire you) who wants to leave an important message, it creates caller distress. Is the person I'm trying to reach a nut case? Was this the right number? Should I look for another person? Is he or she in town? Will he or she show up on the set at call time? Is that an outgoing message nickname? Is that his or her child, spouse, or dog?

Make it simple to hire you.

Try this instead: "You have reached 123-4567. This is William, known as Will. I will return your call if you leave your name and number. If you need me immediately, call me at 234-5678 (if second number). Please leave your phone number after the beep. Thank you for calling.

Keep it simple, smart!

Company vehicles

Being professional also includes how you treat production vehicles (by the way, these hints apply to any vehicle, even your own):

Don't abuse a company or rental vehicle just because it is not yours.

If you hear strange sounds, find out what they are. Occasionally turn the radio down so you can listen for knocks and grinds.

Don't drive a vehicle until it dies. If you suspect a problem, tell someone in production or transportation so things can be fixed. If you are on the road, stop and get it checked. Call production immediately.

When you get gas, check the oil and radiator fluid (engines die for the lack of either one). Check the tires for proper inflation.

If the radiator requires a lot of water, check the antifreeze mixture (engines rust up with too little antifreeze). Let someone know.

Watch the gauges and warning lights.

If a vehicle steers strangely and shimmies, drive below the shimmy speed and tell production or transportation about it.

Don't trash a good vehicle with props and equipment. Protect the floor, roof, and upholstery.

If a vehicle just clicks when you try to start it, check or have someone else check the battery cables.

Lock up the vehicle when you are not in it.

Remove props, tools, and equipment from the vehicle at night if your driveway, street, or parking garage is not perfectly safe. Stolen articles can mean disaster at the next day's shoot.

Examples of bad bosses

They start making improvements in someone's work as soon as she starts reading it.

Their improvements will ensure that they take credit for saving the project.

Their contributions must look good in the eyes of their superiors, no matter what the effect on the project.

Any mistakes have to be covered up to avoid embarrassment, even if the results hurt a project.

They don't give examples of what they want, and they avoid commitments by saying they will know when it is right when they see it.

They never show up on time to a meeting of subordinates. They must always appear to be busy to justify their position.

They schedule extra inconvenient meetings to make their staffs work harder.

They are never available to approve works in progress that might save people some work.

They never inform others about possible problems.

They save problems as ammunition for criticizing their crews.

They never blame outsiders for problems. By saying, "You should know better," they keep the blame at home.

They never give praise, raises, or titles, for doing so would build too much confidence.

They use the threat of firing to keep people in line.

My, my, my

A "my crew," "my set," "my shoot" attitude by a production manager or production coordinator rubs most people the wrong way. Along with the "my crew" attitude is often an attitude that future jobs are dependent on making that production person happy: "Do things my way, treat me right, and I will see that you work in this town again." First of all, people are very uncomfortable working under such conditions. Directors, producers, directors of photography (DPs), key grips, and gaffers can call their crews "my crew," but not the assistant director (AD) or production coordinator who only puts out the work calls. The crew is usually selected by the director, DP, and others. The coordinator is just making the calls.

Often accompanying this me-my-I attitude is never admitting to a mistake. A scapegoat for any mistake must be found and admonished – often with a job security threat: "If you want to work for me, you must make me look good in the boss's eyes." On the other hand, DPs or department heads may talk affectionately about "my crew." They are saying, "You had better take care of them," "Don't abuse them," and "Talk to me before you try to take advantage of them."

If people congratulate you for doing a good job, give your crew credit for making it possible. Credit every good idea and effort so people hear it. It costs nothing but can pay off in terms of loyalty and good feeling.

Being a good communicator

Let's say a director has very carefully researched and planned how to do something mechanical. Instead of telling the crew exactly what to do, he might start with, "I'm sure that you have a better way of doing this, but I had to plan this before you were on the job," or "I didn't get a chance to ask you about this. Let's get through it and see if my idea will work at all." You can reduce their resistance to your offering expert information by being humble. Even if your way is best, a crew may be able to add shortcuts and ensure safety. Do listen and let them do their jobs.

Be sure to listen to and communicate clearly with runners and assistants as well. Confirm that they understand your instructions. Instruct them to call back if there are problems finding something or if things cost much more than expected. Sometimes limited availability will require finding substitutes, and often suppliers can offer better solutions. Tell runners and assistants to call in as things change. Take the time to explain what you want so the runner has some idea of whether something will work, but warn runners not to make major changes unless they call first. Giving a priority to items can help. Simple things may seem insignificant, but they could be crucial for the first shot. Ask for forgiveness if you have to repeat things or explain things that your crew or assistants may already know.

Teachers and students

This last point is worth elaborating. Like almost every seasoned person in the business, I am happy and feel obligated to pass on what I know to the younger generation. When there is time, I like to explain not only how to do something but also the principles behind how it is done. Unfortunately, sometimes people are insulted when they are told something they already know. Perhaps I forgot that I told them the same thing before, or I have no way of knowing what they already know. My intent is to pass along useful information. Prefacing information with "You probably already know . . ." will help avoid any suggestion of insult. I start a job with a new crew with "Forgive me if I repeat myself or tell you things that you already know."

On the other hand, I never expect people to know more than what I know they should know. Asking me how to do something or how to approach a problem or situation only makes me, the teacher, feel better in passing along my infinite wisdom. Being asked again how to do something, even if I have already explained it before, never bothers me. On the other hand, if someone does not ask the second time and does something wrong, I am perturbed. I know that people cannot absorb all the information that is thrown at them. When things are not understood, I give people the benefit of the doubt and assume that I was the one who failed to make myself clear.

There is so much to learn about our business that few on-the-job situations can teach us all that we have to know. One has to eat, sleep, and live the film business to keep ahead of the competition. The grip must learn mechanics; the electrician, the theory of light; the camera operator, photography – and they must know how to operate all the equipment besides. In our business there is always something or someone waiting in the wings that will cause us to falter if we do not keep up with the times. It is when we feel secure that we have it made that the competition catches up.

Being professional when you're boss

The morning of the shoot

Arrive before call time and assist the AD or transportation captain in placing the grips' electrical generator far enough from the location, yet close enough not to impede a fast setup and departure.

Bring a shot list and confer with the AD to check if there have been any last-minute changes.

Inform the best boy what equipment will be needed first and any additional equipment that may be needed later. Try to get a jump on the next shot.

Key grips should have their ears keenly tuned to at least three voices: those of the director, the director of photography, and the first assistant director. This minor eavesdropping will allow the key grip to keep abreast of this trio's desires and of changes as they occur during the course of the shoot.

Always in line for production

Uniform deals for the whole crew:

- Paying per diems promptly
- Paying for a wrap dinner
- Prompt equipment rental checks
- Keeping crews informed about job scheduling.

Always out of line for production

- Booking crews when a job is not yet firm
- Not sharing cancellation fees with canceled crews
- Holding checks or time cards
- Filling out the time card.

"Don't ever hire Fred again!" "Why?" "He pads his time card."

What really happened: the crew went into meal penalty by 420 minutes. The production manager went to three "almost staff" people and asked them to waive meal penalty. This means that the crew did not stop filming to eat on time. Usually, six hours after call time, they are paid a penalty for the time that they did not eat until the meal is called to break. With that concession the manager went to the rest of the crew with "everyone is waiving meal penalty" and got concessions from everybody but Fred, who was in the darkroom. Fred feels that rules are rules; he was the only one who put in for meal penalty, and he was blackballed for it.

Yes, this happens too often. If the rules of filling out time cards are being bent in any way, it has to be a group effort so that no one has hours that are different from the rest. Production will use all kinds of reasons to keep the hours down. If the department works as a group, talk to the contact with the producer to reach a fair settlement. Fewer problems will arise.

Some producers have no idea how many extra hours camera assistants, prop persons, and production assistants (PAs) put in. (That's why PAs with no clout often have to work for a flat rate.) Warning your contact with production ahead of time that there will be extra hours on a given day will take the burden off your back. If you do not clear putting in extra hours, it might be wise to "eat" some of those extra hours.

For example, let's say you find out that a turnaround is necessary to complete a job for tomorrow's shoot. You had best get permission to do so. Production may decide that putting on another person to finish the job might also solve the problem. You should have some idea of how long it should take to do a job.

Turnaround is not a device to pad your time card; instead, it is a device to prevent producers from working people so long that it becomes dangerous. You need your sleep. It is your responsibility to get enough rest and to plan your work to avoid too many hours.

Crew issues to address

The following is a list of things to think about for the crewmembers on a film set:

Film students and relatives on the set: always ask first
Renting every new toy to try it out: don't
Old pros that ration their own efforts, teaching younger people not to hustle and thus making everyone look bad (there is a balance between abuse by management and featherbedding by crews)
Who is responsible for safety? (Everybody)
Turnaround, meal penalty, overtime, kit rentals, travel pay
Flat rates
Key grips picking seconds (best boys), including producers, coordinators, PAs (be sure they are qualified)
Loyalty ("You paid me peanuts when you didn't have money. Now that you have a big budget you are hiring all expensive professionals")
Crews who test new directors and DPs
Crews who always want more help
Unqualified assistants hired by production
Seeing that the director or DP could do things differently to make it easier
Crew invited to dailies
Knowing the time and place for appropriate conversations (such as a PA who is asked about his aspirations by a director he is driving home one night and is ignored the rest of the shoot; he or she may harbor ill feelings) and remembering that loose lips sink ships – maybe yours
Definitions of terms such as call time, wrap, kit rental, booking a job, replacing yourself, flat rate, union, P and W, OT, turnaround, and meal penalty (a new person on the set needs to know these terms; see the Glossary)

"All producers care about is money."
"We'll take care of you next time."

From other departments

Check with all departments that may appear to need support from the grip department.

Location etiquette: getting along with locals

Whether you are the leader of a crew or working on the crew, do not think that just because you are in the television or movie business you are something special. To a local person, you may be a once-in-a-lifetime opportunity for fame or an emissary from hell. Your success on a location – and the success of future crews on that location – depends on your behavior. Everywhere you go you are treading on someone's turf. Tread lightly. The locals' opinions of you will determine how cooperative they will be. The first impression is often the most important.

The first contact should be made by the crewmember who is the most diplomatic person and who has the most in common with the people who live in the area. Say, "Hello, how are you? You might be able to help us. We are trying to find out who owns . . . " Don't say, "We're here from Hollywood and we're going to . . . " They may see Hollywood, television, movies, and big cities as the reasons their children are tempted by drugs and sin. Or you might be the first convenient person they can vent their anger on about something that you have nothing to do with. To a shopkeeper, you could be either a potential customer or a shoplifter. Clothes appropriate to the area make you stand out less.

Start any conversation with a perturbed local with, "I'm sorry, let me get these people out of your way." Don't say, "We'll be a minute . . . " Being there legally or having permission from a higher authority may not carry a lot of weight locally. The local residents may have a battle going on with that same higher authority.

Drivers should not park in people's driveways or parking spaces. Get permission. Do not block traffic. When it is time to leave, get directions to the next location, get oriented, and be ready to roll.

Treat motels and lodgings with respect. Use heating, cooling, and lights as needed. Do not take towels for your own or company needs. Close the door and turn off the lights when you leave. Be quiet, especially early and late. Park in the stalls. Keep a low profile with the camera gear. Word gets around a small town about your behavior.

An obvious effort to protect people's property will soften the blow when the unavoidable damage does occur. Make a vocal effort to remind your crew to be careful. Cover floors, and ask people whose homes or businesses you are using to put away their valuables. Your crew is probably very honest, but bystanders may not be.

Some thoughts on equipment

Crews and their own equipment

Buying equipment to supplement your income can be wise, but do not assume that it will help you get work. Would your employers be glad to rent from you and would you then become competition to your own regular suppliers? If a camera assistant buys filters and batteries to rent, she is cutting into one of the moneymakers for the camera rental house. Rental houses lose money on camera body rentals but make it up on accessories such as batteries and filters. You might jeopardize your own standing with the rental houses.

It is tough deciding how to charge for equipment that you happen to bring along to the job. If something is requested, a rental price should be agreed upon. If you happened to bring along something that saved the day, be careful about how to collect for it. Some producers are fair and some are not, no

matter how much time and money you might have just saved them. Sometimes your future job may be at risk. It could be assumed that because you are not in the rental equipment business, what you bring along might be regular tools of the trade.

Asking for a little something is better than demanding it. First save the day, then humbly ask for compensation. Try, "What's fair?" I know, production rarely scrimps on their own comforts. But it is your job to make a good film and their job to save money. In collecting for your equipment, don't "nickel and dime." Let people feel they are getting a bargain: "Give me regular rates for X and Y and I will throw in Z." "As used" deals (where an employee gets paid for equipment only if it is used) are generally welcome, if you can live with them.

Remember that your garage operation is in competition with the established businesses that have more overhead to support (insurance, rent, employees, etc.). In short, be cautious with your sideline business. Do not let it interfere with your job, which is your major source of income. It is better to give something away than to lose work. If your toys make you a better technician, they are worth the cost, even if you do not make a lot on them.

Your job performance should in no way be compromised by your equipment rentals. You should deliver your equipment as any other rental house would do and not get paid to deliver it. You cannot spend all your time on the set just watching out for your equipment. It is there just like anyone else's stuff. Everyone's equipment should be taken care of. If you show concern for everyone's equipment, then others are more likely to respect yours, too.

Do not bother a company about equipment checks. Many rental companies have to wait for money, as do producers of commercials.

The professional look

There is a good reason to use professional-looking tools and equipment: to protect yourself if things go wrong. If you have the accepted standard equipment, you can always blame the equipment. If your equipment looks homemade, problems can become your fault for not ordering the right thing. Although saving the day with a tool jury-rigged on the set can be heroic, bringing those same tools to the set can look unprofessional. I have watched crews with chrome-plated tools in fancy cases make expensive mistakes and then charge the client an arm and a leg with a smile. I have also seen some bare-bones riggers do wonders with surplus junk for peanuts and then watched them have to argue over a few real extra dollars after saving the client thousands. Yes, the impression is important. A coat of paint and some painted boxes might be a good compromise. Your knowing how to make your rigs work will cover for some lack of flash, but do consider the impression. People are impressed by fancy-looking equipment even if it does not work very well.

Health on the set

To survive in a world full of germs and viruses, we have to build an immunity to them. If we were raised in a sterile environment, we would die from contact with the first germ. Less sanitized societies have a stronger resistance to germs. Our over-purified food and water may even increase our susceptibility to sickness. We are a society obsessed by cleanliness, but with the spread of new and powerful diseases, our health should be everyone's concern. Cleanliness on the set should be maintained at a level at which even the most fastidious will feel comfortable.

Soft drinks

All actors should have their own bottles for soft-drink casting. During the shoot with the hero bottle or glass (the bottle or glass to be filmed), each actor's bottle or glass should be refilled or washed in a sanitary washing system. Restaurant supply houses sell disinfectant washes.

Coffee

Steaming coffee is always a problem. Liquid hot enough to steam is too hot to drink. A – B smoke (simulated smoke made with two chemicals by a special effects team) is pretty strong to sniff. One solution is to add steam to the film or video in postproduction, which is not difficult nowadays.

Kissing

How do you cast and shoot a close-up toothpaste commercial? Check with SAG (the Screen Actors Guild) for rules about kissing, and do not push actors to do something they are not comfortable with.

Colds and flu

Infecting fellow crewmembers is somewhere between careless and criminal. In Japan, people wear masks when they have a cold. It is a badge of concern for even a stranger's health. We have magic medicines to hide cold symptoms, but we are no less infectious. Keep your distance if you have a bug or think you might be getting one. Some say that colds are more infectious when you first get them. Many people find that vitamin C helps prevent colds but does not do much after you have one. Do keep warm.

Smoke masks

There is much debate about created fog or special-effect smoke. If masks are used, everyone should be provided one if they so request. Problems arise when one grip has a Darth Vader-type, industrial-strength mask and makes a big deal about health risks. It looks like everyone else is less well protected. Production has told us so much about health-safety problems that it is difficult to draw a clear line on what smoke is safe and how much. Some crewmembers are more fatalistic about their safety and ignore the concerns of the more sensitive.

Spray paints

The smell of spray paints is strong, and efforts should be taken to protect cast and crew from having to breathe those fumes. Outside, with a little breeze, an actor can simply hold her breath if only a little dulling is necessary. Ask whether the spray paint is okay. Do not tell the actor or actress that it is okay.

Camera eyepiece

We can catch infections through the eyes. Some people have very sensitive eyes. Assistants should be protective of the camera operator or DP who says he has such a problem. A separate cup or cover should be standard procedure if requested. Eye problems can put people out of work.

Hot weather

People often do not drink enough water. Sipping quite cold water may not be good for us, but lots of slightly cool or air-temperature water should always be available. Personal plastic jugs with the names of the crewmembers written on them are wise on hot shoots. Everyone should be encouraged to drink water.

Cold weather

Any day can turn cold and wet. It is smart to bring clothes for a wet, cold day (or even a hot day). Get in the habit of carrying a bag with rain gear and a change of clothes.

Bee stings

Many people are allergic to bee venom. Parks, where the food table can attract bees and wasps, are particularly bad. Be sure to cover the meat, especially. A can of stinky cat food some distance from the shoot may lure bees away.

Makeup and hair products

The Directors Guild of America and Screen Actors Guild have rules covering many makeup and hair products with regard to any pyrotechnical procedures.

Last thoughts and parting advice

"Juices"

We talk about creative juices in our business. Here are some (very unscientific) thoughts on the matter.

The best juice is adrenaline. It flows into our systems when we skydive, bungee jump, downhill ski, or finish a great shoot day. It flows when we see good dailies or the ultimate, a great cut.

Adrenaline keeps us young, with an upturned mouth and a continual smile. Every smile releases a little adrenaline, a laugh even more, and keeps us well. Have you heard about laugh therapy? It works. We only become ill after a hard shoot when our adrenaline releases are down.

Adrenaline accelerates the creative process and helps the mind to think clearly and see things that we normally wouldn't. It puts us on a roll. We pump more adrenaline on shoot days. Our efficiency is three times that of a prep day. At the end of a shoot day, it takes a couple of hours to come down from the adrenaline pumped up. At dinner, we can fall asleep over the soup. At the end of a shoot, it takes a few days to rebuild our stores. Relaxing too much is dangerous. Without a cut to see or a new job to start, we relax and don't pump adrenaline. This is when we succumb to the cold that we suppressed during the shoot. We can also get addicted to adrenaline. We need to do something exciting or creative. Is that why we become workaholics?

The worst juice is bile. We pump it when no one listens. A good idea dies just because it was not someone else's. Bile flows when last-minute changes arrive or the rig doesn't work. When we have bile in our systems, our brain grinds to a halt. Solutions do not pop up like they did with adrenaline. All we want to do is get it over with. We give up: "If you insist on garbage, I'll give you garbage." Bile turns our mouth down and makes us old.

How about other juices? It is said that not many creative juices flow during a $200 lunch. True, but we can discover that others can be reasonable about baseball, babies, movies, and food. Maybe after lunch we can also be reasonable about a storyboard and each other's ideas. The juices needed to digest lunch may also buffer the ego juices, and the delivery of ideas may be less charged with emotion or the need to defend one's precious ideas may be a bit dulled. For more on this kind of thinking, try reading Kurt Vonnegut.

Success and the ego

Success in the entertainment business can be rocket propelled, but DPs and directors often do not know how to handle success any better than a rock star, a politician, or a whiz kid. Making big bucks and having everyone desire one's services can go to a person's head. Gandhi kept himself humble by doing humble things every day. We often do not have the time or inclination to practice being humble. It is human nature; power corrupts. A formerly humble worker can become a tyrant in a new job that has a little power. One of the casualties of the demise of the studio training system was gradual advancement through the ranks. Now people can move too fast, sometimes from the bottom to the top

in one or two steps. Be humble. Do not be a threat to people. Let them feel worthwhile. Let them succeed. Give them plenty of credit for their efforts.

Financial responsibility

One measure of success is the ability to buy things that we could not afford on the way up. All the goodies out there to buy sometimes strap the technician, camera assistant, or budding director with payments that can be a chain around the neck when the real break arrives. One often has to work for a lot less money – or none at all – when taking the next big step up the ladder. Lots of vans, boats, and even houses are lost for nonpayment when the economy slows. Losing hard-earned possessions is a blow to one's self-esteem. You can blame the economy, some union out on strike, or changes in the business, but how far you extend yourself financially is your own decision.

Ron Dexter's suggested book and source list

Birns and Sawyer, (213) 466–8211, carries a good stock of motion picture and television technical books. Still-camera stores, such as Sammy's, (323) 938–2420 and (800) 321–4726, carry many books on still photography, but the stock varies. Op-amp Technical Books, (323) 464–4322 and (800) 468–4322, orders and ships anything in print with a credit card order, as does Book Soup, (310) 659–3110. For used books, try Book City, (818) 848–4417, and Larry Edmunds, (323) 463–3273. Try Barnes and Noble, as well as Amazon.com on the Internet.

Whew!

Let me just say this to you. I have earned over my 30 plus years a boatload of pay by simply using this advice. Let's just say, "It's million-dollar advice!" (CRYPT SPEAK) (If you get my drift).

Publishers

Focal Press has a very informative collection of books on photography, film, and video. The books are quite well edited, focused on particular subjects, and aimed at specific levels of readers. They contain gold mines of material.

Mike's note: The preceding lists suggest just some of the many sources out there in the world. If you want to learn, start asking questions. Go to your local library. Call bookstores. Visit bookstores, ask colleges, and just keep trying to find what you're looking for until you are satisfied.

Finally – your new career

Let me give you two words that will absolutely . . . positively . . . without a doubt . . make your career. They are: "Shut Up!"

I've seen more people open their big mouths and sink their careers in a heartbeat. Like the famed Judge Judy always relates: "God gave you two ears and one mouth for a reason!"

So, cool your jets until you really know what you are doing!

I don't say that to be rude. But you will lose your career, and your standing, with the crew by engaging in idle bullshit . . . especially about another crewmember.

Trust me when I say it will always get back to the person you were yammering about.

2 *Essential equipment*

Apple boxes

An apple box is a wooden box. Why it is called an apple box I can only guess, but legend (and there are many) has it that the forerunner to this modern-day box was, in fact, a box used to carry apples. Grips would just flip the open side down and stand on it. (Most likely not, but a still an entertaining story.) An apple box has multiple purposes. It can be used for sitting, standing, elevating props, and leveling off uneven heights. Apple boxes come in four common sizes, as illustrated in Figure 2.1.

Full apple boxes are 12 in. × 20 in. × 8 in.
Half apple boxes are 12 in. × 20 in. × 4 in.
Quarter apple boxes are 12 in. × 20 in. × 2 in.
Eight apple boxes are 12 in. × 20 in. × 1 in.

The eight apple box is also called a pancake. The nickname for the apple box is the man-maker (kind of an inside joke, as it will make a person taller). Apple boxes are usually made of a strong wood that is glued or nailed together. In the center of the better-built boxes is a stiffener or center support that enables the boxes to withstand a heavy load.

They also come in half sizes: 12 in. × 10 in. × 8 in. and so on.

Baby plates

Baby plates are used for holding down small lighting fixtures or grip heads. They can be nailed to the top of set walls or to practically any surface into which a nail or screw can be driven, such as a tree or apple box. Baby plates are available in three sizes: 3 in., 6 in., and 12 in., plus a right-angle version. There are plenty of other sizes as well, but those are the most common. The pin's diameter is 5/8 in. (make a note of this size). The 5/8 in. pin has a small hole through it, near the end, for a safety pin or wire to go through. Something should be slipped through this hole and secured to prevent a light from falling off in an underslung or inverted position. The pin has a recessed area near the end in which the lamp's locking pin/knuckle rides. This allows the lamp to rotate on the pin without falling off when the light is being panned.

Bar clamp adapter pin

This pin is a mounting accessory that was initially intended to slide onto the bar of a furniture clamp in order to affix small lighting fixtures or grip equipment. Another application of the bar clamp adapter is to insert the 5/8 in. pin into a grip head and employ the locking shaft opening to secure a particular device. The 5/8 in. pin is about 3 in. long. The pin slides on a bar clamp (also known as a furniture clamp).

Note: The pin works great (sliding) on a gobo arm (C-stand arm).

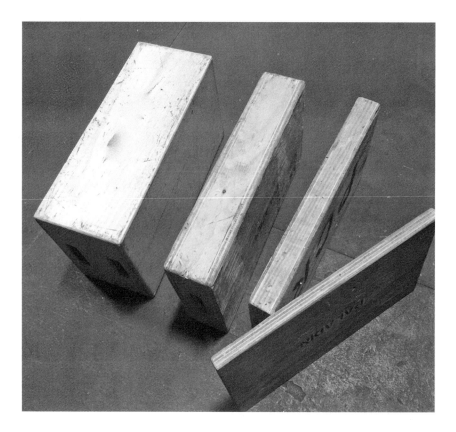

Figure 2.1a What they look like

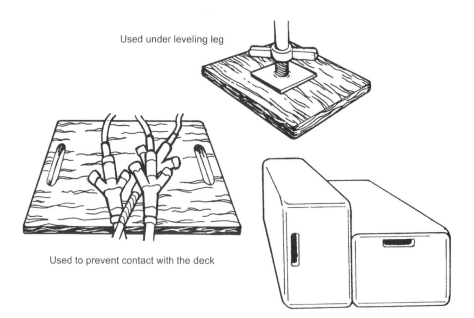

Used under leveling leg

Used to prevent contact with the deck

Figure 2.1b What they look like

Tapered area for locking/nonslip knuckle on lamp base (allows rotation of lamp without slipping off stem).

Safety pin hole

5/8" pin

Nail or screw-up to a 16 double head nail

Figure 2.2a Example of a baby plate with pin

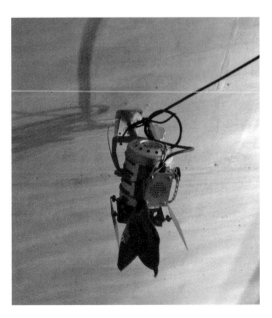

Figure 2.2b Example of a baby plate with light hung in inverted position

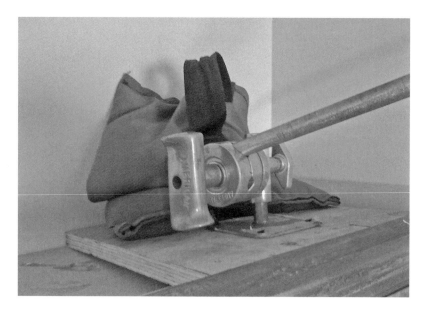

Figure 2.2c Example of a baby plate with a gobo-head and arm on a beaver board (notice knuckles on "right-hand side")

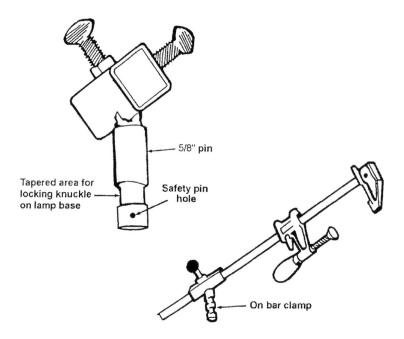

Figure 2.3 Bar clamp with adapter pin (what they look like)

Basso block

The basso block works like a smaller version of an apple box. It is very handy and stores easily. Basso blocks come in several sizes: full, half, and quarter. A full basso block is equal to a half apple box in height (4 in. high) and a half-basso block (2 in. high) is equal to a quarter apple box.

Bazooka

A bazooka is a device for mounting lighting fixtures onto studio catwalks. Along the floor of a catwalk, spaced roughly every 18 in. apart, is a series of holes measuring 1-1/8 in. in diameter into which lighting fixtures or grip accessories may be inserted. A bazooka has a 1-1/8 in. receiver on one end, which is called the junior receiver end.

At the other end is a 1-1/8 in. pin that fits into the deck of the catwalk or perm. A 90-degree plate, which is attached to the bazooka, hooks over the perm handrail. The plate has several holes drilled through it for nailing or screwing it to the handrail, as a safety. The bazooka has a knob for one riser on it. This is used to make minor adjustments to raise a light just high enough to allow its beam of light to focus through the perms.

Note: *Always safety the light separately to the safety rail.*

Secondly, there is **another piece of film equipment named by the same name**. It's used much like a camera tripod, to mount a camera on. Sort of a monopole mount, with a three-leg base.

Figure 2.4 Basso blocks (what they look like)

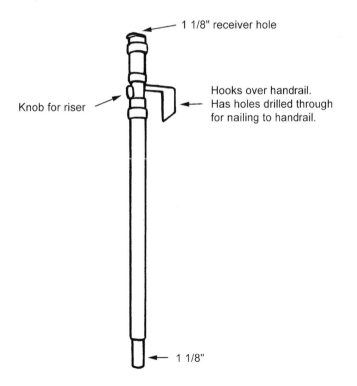

Figure 2.5a Bazooka for use in perms and green beds (what it looks like)

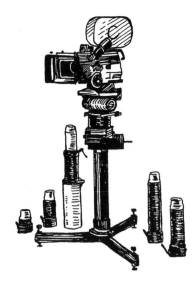

Figure 2.5b Bazooka for stationary camera mounting

Figure 2.5c Bazooka for camera

Bead board holder

The bead board holder is a vise grip with two large plates attached to the grippers.

The plates provide a larger surface area that allows the bead board to bite tightly without breaking the material. *Other names for the bead board holder are onkie-bonk and platypus or even duckbills.*

Big Ben clamp

One end of this clamp will accept any junior receiver. The other end will fit onto a pipe or tube with a diameter of 1-3/4 to 3-1/4 in.

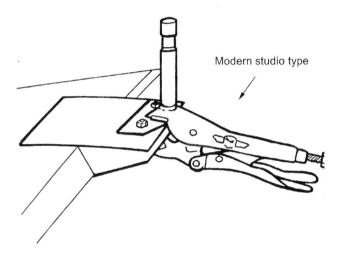

Figure 2.6a Bead board holder

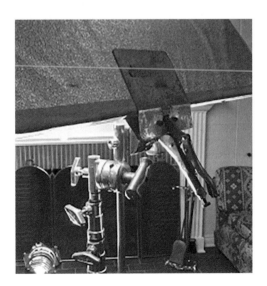

Figure 2.6b Bead board holder in action

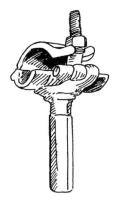

Figure 2.7 Big Ben clamp

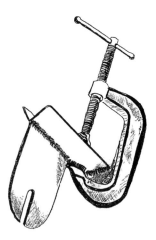

Figure 2.8a C-clamp branch holder

Figure 2.8b C-clamp branch holder in action

Branch holder

Sliding a limb of a small branch into the receiving end of the mechanism of the branch holder. It employs a clamping action to tighten the knob, which can be adjusted to smaller branches. The two types of branch holders are the C-clamp type and the tree type.

C-clamp branch holder

The C-clamp branch holder has a 4 in. to 6 ft. iron plate welded at a 90-degree angle to one face of the C-clamp. This type of C-clamp has a small 2 in. angled plate welded to its opposite face, which makes it more versatile and gives it a better biting action on the tree branch. The bottom of the C-clamp has a spade (an attachment bracket) welded onto it, which allows the clamp to fit into a high roller.

Tree branch holder

The tree branch holder is no more than a simple tube, either 2 in. or 3 in. in diameter, into which a small branch slides. A 5/8 in. pin is welded to the outer case, and the branch is locked into place by a small knuckle. The small branch holder has a 1-3/8 in. inner diameter (ID) that is fitted with a 5/8 in. exterior pin, and the large branch holder has a 2-3/4 in. ID fitted with a forked receiver for the 4-1/2 in. grip/high roller head (Figure 2.9).

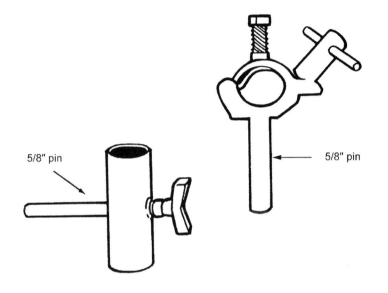

Figure 2.9 Tree branch holder with pin

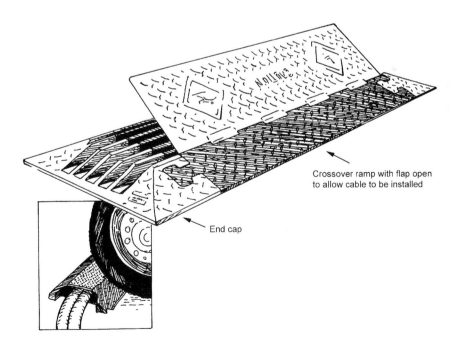

Figure 2.10a Cable crossovers

1.5"

1.25" 1.25"

End cap

Shows how they fit together

Figure 2.10b Cable crossovers slots or valleys

Although the tree branch holder is not as versatile a branch holder as the C-clamp type, this handy device may be used to conveniently position a multitude of other items.

Cable crossovers

Cable crossovers are necessary on any shoot in which a car may have to drive over electrical cables or a heavily people traveled area. A crossover has a hinged heavy-duty polyurethane cover that opens to expose four to five valleys for cables. These covers make it safe for cars to drive over the cables and for people to walk over them without tripping when closed. Be sure that either the grip or the electrical department has cable crossovers on their trucks. They come in several sizes, ranging from two channels (or valleys) to five channels. They are sometimes called yellow jackets (a company brand/name).

C-clamps

C-clamps are used when an extremely secure quick mount is demanded. A lot of C-clamps for motion picture use come fitted with two 5/8 in. pins. They also come in many sizes. We use them as small as 1 in. all the way up to 12 in. The type we use in the film industry has either (a) *a pipe face* or (b) *a flat face*. The pipe face has a small 1 in. to 2 in. piece of iron or channel iron welded to the flat face at a 90-degree angle. This gives the clamp a better clamping action when it is attached to a pole or pipe.

Figure 2.11 C-clamps with baby pin

Figure 2.12 Camera wedge

Most of the C-clamps that grips use have either a 5/8 in. baby pin or a 1-1/8 in. junior receiver mounted vertically or horizontally (Figure 2.11). Both clamps come in either pipe face or flat face.

Note: *Never use a pipe face C-clamp on a wood surface*; the edges of the face will create indentations on the wood surface. If no flat face clamps are available, you can use a pipe face with two pieces of cribbing sandwiched between the surface you are working on and the clamp.

Camera wedge

A camera wedge is the same as a regular wedge except that it is smaller and fits into tighter places (Figure 2.12). It is usually about 4 in. long and tapers from 1/2 in. to 1/16 in. wide.

Cardellini clamp

This clamp is excellent. It is quick, lightweight, fast, and has many designs.
End jaw, double pin, and a few more (Figure 2.13).

Replacement pads

Double spud

Mini-mike mount

Center spud

Long jaw

End jaw

Figure 2.13 Cardellini clamps

Chain vise grips

The chain vise grip can be used on any pipe with a diameter of 6 in. or less. The back of the chain vise grip has a 5/8 in. pin welded onto it (Figure 2.14). The tightening knob also has a 5/8 in. pin welded onto it. If need be, several chain vise grips can be "locked" together. *After the chain vise*

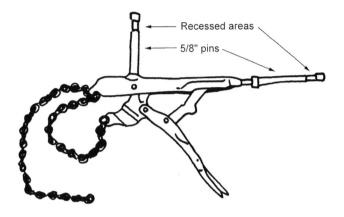

Recessed areas

5/8" pins

Figure 2.14 Chain vise grips

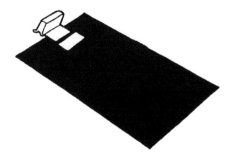

Figure 2.15 Clipboard

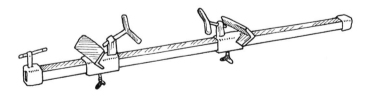

Figure 2.16a Condor bracket (modern equipment)

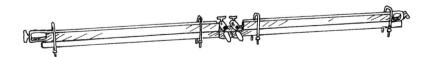

Figure 2.16b Condor bracket (Matthews equipment)

grip has been locked into place, it is a good practice to wrap a piece of gaffer/cloth tape around both handles to secure them together. This prevents the locking action from "popping" or accidentally unlatching.

Clipboard

Clipboards are lightweight, wooden devices that are designed to be clipped to the barn doors (light shapers attached to a light fixture) of a light in order to provide an additional plane or degree of control. This sometimes eliminates the need to set a flag.

Clipboards come in three sizes:

Baby. Small
Junior. Medium
Senior. Large

(*Note*, the use of the word senior is not used as much, but it sometimes refers to a junior.) Albeit; there are senior and junior lighting fixtures.

Confused yet? Back to clipboard . . .
The clip rotates on the board tightly so you can use it in several directions.

Condor bracket

These brackets are designed for use in a condor (cherry-picker). They usually fasten directly to the front or the edge of the condor basket or bucket and leave room for an operator. SAFETY: (Remember: *Never exceed the weight restriction of the basket.*)

Cribbing

Cribbing consists of short boards used to elevate, level, or block a wheel or chair or other pieces of equipment (Figure 2.17). Cribbing is made from 1 in. × 3 in. (or 4 in.) × 10 in. or 2 in. × 4 in. × 10 in. lumber. All though it is called a 2 × 4 it is really a 1-1/2 by 3-1/2 in. in size. Usually the edges are rounded to prevent splintering.

Note: Cribbing can be any length, but 10 in. fits nicely into a legal milk crate perfectly.

Figure 2.17a Cribbing

Figure 2.17b 2 × 4 cribbing

Figure 2.17c 1 × 3 cribbing

A professional tip

A legal milk crate is one that is either rented or bought. (Thievery of milk crates: Two words: **DON'T!**)

This is a very small industry/business. Trust me, you don't want to be the person suspected as being a pirate (crook). Sure, "I might" think about stealing it, if I could live off it for the rest of my life and not go to jail. Other than that . . . **DON'T!** (second word)

(The word on you will spread faster than you can think.)

A professional tip

Cut pieces of 1/8 in. plywood to line the sides and bottom inside a milk crate. This will prevent equipment from protruding and getting jammed. (NICE TO KNOW)

Crowder hanger/no nail hanger

The Crowder hanger is similar in design to a set wall bracket. The Crowder hanger can mount onto a 2 in. × 4 in. or 2 in. × 6 in. piece of lumber without nailing. It will accommodate a stand adapter, or it can work as a 1-1/8 in. receptacle only.

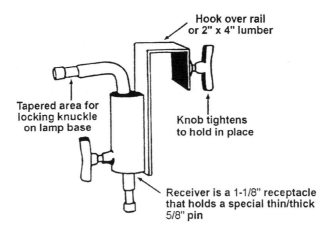

Figure 2.18 Crowder hanger/no nail hanger

Cucoloris

The cucoloris is used to create a shadow pattern on a backdrop or on any subject. When it is positioned in front of a light source, the cucoloris breaks up an evenly or flatly lit area into interesting pools of light and shadows. For example, this broken lighting effect can represent sunlight that has filtered down through tree branches. The cucoloris is made from wood or wire mesh. The *wood* cucoloris is opaque with open pattern areas. The *wire mesh* or celo cucoloris is more like a mesh scrim with open-patterned areas burned into it. The celo type is more durable due to the strength of its wire mesh material. It also creates a subtler pattern because of its wire mesh construction, which reduces the light output rather than completely blocking it. The closer a cucoloris is to the light source, the more diffused (softer) the resulting pattern will be on the subject. The closer a cucoloris is to the subject, the sharper (Harder) the shadow patterns will be.

The nickname for the cucoloris is a cuke, cookie; sometimes it may just be called a *gobo celo*. Always ask "*Wood* (or hard) *or celo* (or soft)?" material if called for.

Really confused now? (Welcome to the world of moviemaking. See, you're already learning how to interpret the movie language. Good for you.)

Both wood and celo cucolorises come in the following sizes:

18 in. × 24 in.
24 in. × 36 in.
4 ft. × 4 ft.

Note: A tree limb supported in a branch holder can (and will be) also be called a cucoloris or branchaloris.

Cup blocks

Cup blocks are made of wood and designed to be placed under wheeled objects, such as light stands or parallels, to prevent them from rolling (Figure 2.20). They are also used like mini apple boxes (e.g., to elevate a table, desk, or chair). The average size is 5-1/2 in. square and (usually) 1-1/2 in. thick, with a dished-out center (about 1/2 in. deep).

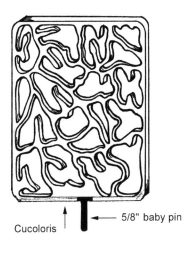

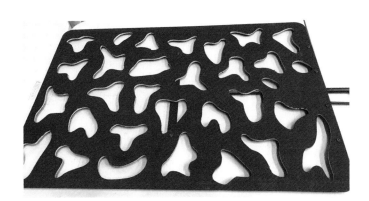

Cucoloris ↑ ← 5/8" baby pin

Figure 2.19a Cucoloris **Figure 2.19b** In action, notice shadows on wall

Figure 2.20 Cup blocks under wheels

Dots and fingers

Dots and fingers (mini gobos: block or reduce light) function along the same lines as scrims or flags – with one functional difference! Whereas scrims and nets are generally used to reshape a beam of light, dots and fingers are employed to alter or correct an "isolated," internal segment of light without affecting the overall pattern (Figure 2.21).

For example, suppose a man's bald head is giving off an unwanted highlight. A strategically placed dot would hold down that small portion of light hitting the bald spot without affecting the lighting for the remainder of the scene. Both dots and fingers have long handles to facilitate their placement and angle. They may be secured with grip heads or articulated arms (flex arms). Due to the thin wire constructions of the outer frame, no frame shadows are usually cast on the subject matter. Basically, dots and fingers are shaped much like mini nets and flags.

Dots

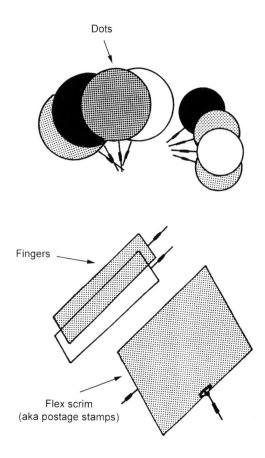

Fingers

Flex scrim
(aka postage stamps)

Figure 2.21 Fingers and dots

Dot sizes are 3 in., 6 in., and 10 in.
Finger sizes are 2 in. × 12 in. and 4 in. × 14 in.
Both dots and fingers are available in various sizes and materials:

Single
Double
Silk
Solid

Lavenders are usually standard in a set.

Note: *Remember that as you move the dot or finger closer to the light, the shadow will grow larger, but it will also become softer.*

Drop ceiling scissor clamp/cable holder

This is one of the greatest inventions you will ever find for working in an office with false, or drop, ceilings. As its name suggests, the drop ceiling mount is designed to scissor open and close over the conventional T-bar drop ceiling frames (Figure 2.22).

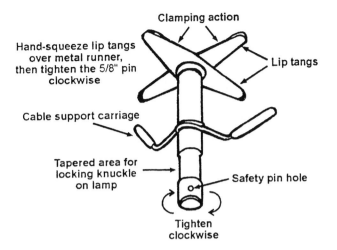

Figure 2.22 Drop ceiling scissor clamp/cable holder

The clamp or holder is fitted with a standard 5/8 in. pin. The drop ceiling cable holder works in conjunction with the scissor clamp to provide a neat, efficient way to run cable to the fixtures.

Note: *This mount is used for smaller lighting fixtures only, so care should be taken not to hang too much weight from any drop ceiling.* If you do work inside a drop ceiling, there are other ways to fly a larger lamp.

Drop-down, 45-degree angle

As the name "drop-down" implies (Figure 2.23), this tool is used in applications that require a reflector or lighting fixture to be positioned lower than the top of the combo stand with a 1-1/8 in. receiver. The 45-degree drop-down allows the unit to be mounted on an inverted (underslung/hung) plane. The angle allows the unit to be swung or tilted without interference from the stand. The mounting pin and receiver accommodate 1-1/8 in. equipment. *If a drop-down is NOT available, you can use a junior offset.*

Empty frames

Empty frames are great (Figure 2.24). You can cover them with whatever expendable material you may need, and they will hold it in place perfectly. The most common empty frame standard sizes are:

18 in. × 24 in.
24 in. × 36 in.
4 ft. × 4 ft.

Of course, if these frames are not large enough, build your own. Normally we use 1 in. × 3 in. lumber to build a larger frame – say, to make a 10 ft. × 10 ft. or a 6 ft. × 9 ft. odd size. When building your own uncovered frame out of wood, be sure to put a gusset (wood corner brace) in each corner to add strength to the frame and keep it from distorting (we call it pretzel or potato chipping) when moved. A smaller frame built out of wood can also have a baby plate attached to each side of it so it can be held in place by a C-stand. To fly (hang) a frame that you have built, drill a small hole in it (if time permits) to tie ropes through it. You can also tie ropes to the gussets if the gussets are securely fastened. To apply a gel

1-1/8" JR receiver

Figure 2.23 Drop-down, 45-degree angle

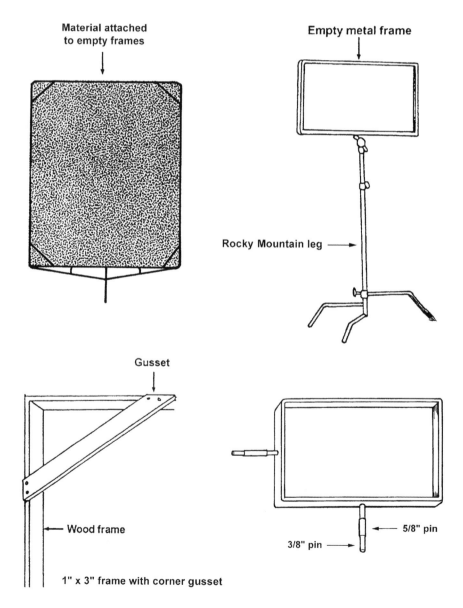

Material attached
to empty frames

Empty metal frame

Rocky Mountain leg

Gusset

Wood frame

1" x 3" frame with corner gusset

5/8" pin

3/8" pin

Figure 2.24a Empty frames

Figure 2.24b Notice black tape

to the frame, you can spray an adhesive or use automatic tape gun (ATG) tape, then just lay the gel on, and voilà, it's ready! If you're in a hurry to gel a frame, use four grip clips. Another thing to remember when you apply gel to a wood frame that you have built is always to use a tab of tape (1/2 in. × 1/2 in.) on the gel, then staple through the tape to the wood frame. This tab of tape will help keep the gel from tearing. (Without the tape, it is almost guaranteed that the gel will rip.)

Here is some advice that can help you identify a frame that someone has requested – for example, a "4 × 4 CTO" (CTO stands for "color temperature orange"). (Gel colors are very close – 1/8, 1/4, 1/2, full – and it can be difficult to tell the difference.) First, check the edge of the frame. Often, there will be a piece of tape attached by a pin that is marked to identify which gel is on the frame. If the frame has no such tape, pull out the frame and check for a Magic Marker description on the gel itself, usually in the corner. If there is no marking, check along the edge of the gel – the information will sometimes be printed along the entire edge of a new roll. If that fails, resort to a swatch book of gels. Hold the sample and the gelled frame up to a light source. After a few tries of making a match, you will get the hang of it. Always be sure to tell the boss of any problems you encounter.

A professional tip

For a gel on a frame, use Magic Markers to write the gel name and type in the corner; this will not show when a light is projected through it. (NICE TO KNOW)

A professional tip

If a gel has been put into a frame, placed in front of a light on an exterior location, and the wind starts blowing the gel back and forth in the frame, it may create noise problems. If it makes noise during a sound take (filming), there are ways to stop the noise. (1) Hold the gel by hand. (2) Use clear cellophane tape and tape an "X" over the gel. (3) Use a C-stand arm offset just enough to apply pressure on the gel in its center to hold the gel in place. This only works on a large light source, due to the shadow it might cast using a small light. (NICE TO KNOW)

A professional tip

Pre-tape empty frames with 1 in. cloth tape before applying ATG tape. This makes it easier to take off the old gel when you change to a different one. (NICE TO KNOW)

Flag box/scrim box

The scrim box is a box with dividers in it (Figure 2.25). The 18 in. × 24 in. flags fit perfectly in front, with just the handles exposed. This protects the scrim flags when not in use, such as during transportation to and from the job. The box has two handles, one on each side, and a detachable wheel frame with cantered wheels. The 24 in. × 36 in. flags and scrims fit in the rear slot.

Flags and cutters

This is where it may get a little thick. Flags and cutters are virtually the same thing. We just call out for them by size. *Flags and cutters are opaque instruments* designed to prevent light from reaching areas where light is not desired. (Figure 2.26). *They are also called gobos.* A gobo is defined in dictionaries as a strip of material used to block light.

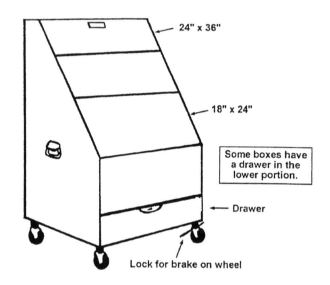

Figure 2.25 Flag box/scrim box

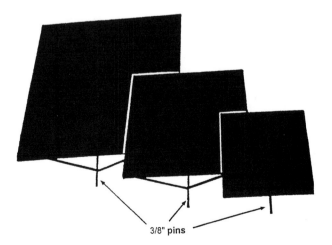

Figure 2.26a Flags and cutters

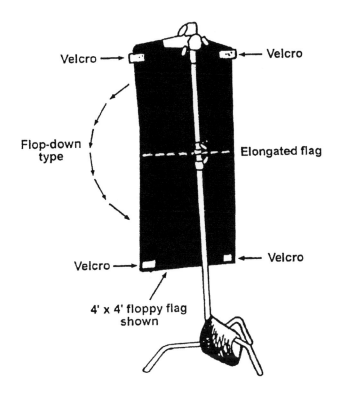

Figure 2.26b 4 × 4 flop with drop-down

A professional tip

Before setting a flag, first use your hand at the proper angle to make a shadow. It will save you time. (NICE TO KNOW)

A professional tip

The angle of a flag should match the angle of light. (STANDARD PRACTICES)

Cutters

The cutter is usually used for a larger lighting unit when you have to get farther away from a light or when light would leak or spill off the end if a smaller flag were used. Cutters usually come in various sizes, the most common being:

10 in. × 42 in.
2 in. × 36 in.
18 in. × 48 in.
24 in. × 60 in.
24 in. × 72 in.

A professional tip

The closer you get to the subject, the harder the shadow. Try this: hold your hand between a light and a wall, close to the wall. Notice how dark the shadow is on the wall; this is called a hard shadow. Now pull your hand back in the direction of the light and watch what happens to the shadow. It weakens or softens, becoming a soft shadow. (NICE TO KNOW)

A professional tip

Use a 1 in. × 3 in. × 4 ft. piece of lumber on floppies (flags) with grip clips, or use a 40 in. gobo (C-stand) head and arm to prevent the floppy part (the flop) from blowing in the wind. Clip one end of the flag with a grip clip, wrap the board or the arm on the opposite side of the center of the stand with the flag, then clip or use the head of the C-stand arm to bite the floppy part of the flag. This will prevent the flop from blowing up in the wind. When using the gobo head and arm, just open the plates on the head and sandwich the corner of the flop's edge in it. Do the same with the gobo arm plates as close to the other side. (STANDARD PRACTICES)

Flexarms

Flexarms (Figure 2.27) are also referred to as articulating arms. They are designed primarily to hold fingers, dots, and flex scrims. The joints of flexarms use a thumbscrew locking in order to support more weight. The flexarm terminates in a spring clamp at one end and a 1/4 in. diameter locking receiver at the other.

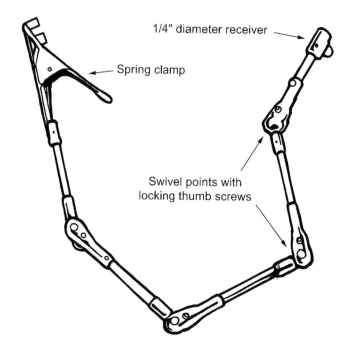

1/4" diameter receiver

Spring clamp

Swivel points with locking thumb screws

Figure 2.27 Flexarms

Furniture clamp

As the name implies, the furniture clamp (Figure 2.28) is similar to the type of clamps used by the furniture industry. It is also called a bar clamp. Furniture clamps are available in lengths of 6 in., 12 in., 18 in., 24 in., and 36 in. Furniture clamps are adjusted by moving a spring release over a serrated bar, which locks into any notch on the bar.

Fine adjustments of the clamp are made with a worm-screw handle. The furniture clamp usually works with a bar clamp adapter on it. When using a furniture clamp on any surface, always try to use two pieces of 1 in. × 3 in. cribbing. The reason for this is that when the clamp is tightened to the surface, the foot covers only a very small surface area.

If too much pressure or weight is applied too far out on the arm of the bar, the foot could punch a hole through a wall or dent the surface, leaving a mar or causing the light to shift or fall off. A couple of 1 in. × 3 in. cribbing pieces are thin enough not to take up too much room, but they will provide greater surface area for the pressure being applied, thus helping the clamp have a better grip on the surface. Another reason for using cribbing is a common grip concern: not to damage any area or structure on which this clamp is being rigged. If you take extra precautions and display consideration for someone else's belongings, it shows professionalism.

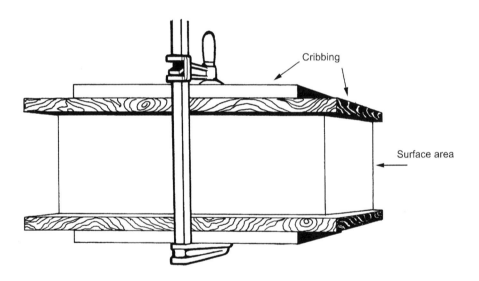

Figure 2.28a Furniture clamp in action

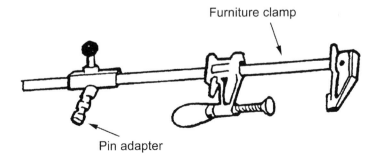

Figure 2.28b Furniture clamp/bar clamp

Note: *Never install a light on a clamp without a rope or wire safety.* Trust me on this. It will never be just "one quick shot," as grips are so often told. Just make it "one quick safety." Ever heard of an actor or actress getting hit by a falling lamp? (Not good on your résumé.)

Furniture pad

Furniture pads, also called sound blankets, are just moving blankets. They are heavy-duty quilts that are used for a multitude of applications (Figure 2.29). Sound technicians use furniture pads for acoustic deadening and isolation. Camera operators use them as a pad to sit or lie down on when shooting low angles. Grips use furniture pads to protect furniture, walls, floors, and the like.

Gaffer grip

The gaffer grip (Figure 2.30) is a multiuse device that is unique in that it comes with two 5/8 in. pins. One pin is on the handle and one is on the jaws. Adjustable jaw openings provide normal expanded mounting capabilities. Gaffer grips are normally used for quick-mounting small light fixtures

Figure 2.29a Furniture pad

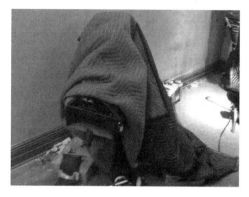

Figure 2.29b Furniture pad as safety cover for camera

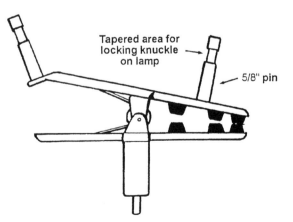

Tapered area for
locking knuckle
on lamp →

— 5/8" pin

Figure 2.30 Gaffer grip

to virtually anything, such as a door, pipe, furniture, or light stands. One of their many applications is as a means of securing foam core.

They are also called gator grips due to the style of the rubber teeth in the jaw.

Grid clamp

Baby grid clamps (Figure 2.31a) are designed to provide maximum hold. The baby grid clamp fits pipes 1-1/4 to 2-1/2 in. in diameter. When the bottom nut has been securely fastened, the grid clamp is virtually unmovable.

The clamp terminates in a 5/8 in. pin.

Junior grid clamps (Figure 2.31b) are the same as baby grid clamps, except that they terminate in a 1-1/8 in. receiver.

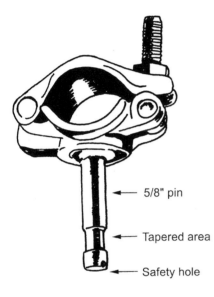

← 5/8" pin

← Tapered area

← Safety hole

Figure 2.31a Grid clamp with baby pin

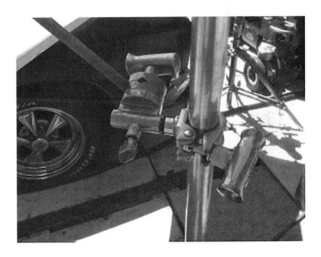

Figure 2.31b Grid clamp with baby pin and gobo head and arm

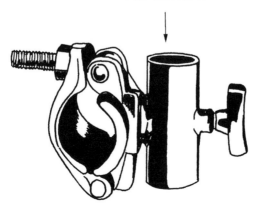

1-1/8" JR receiver

Figure 2.31c Grid clamp with Jr. receiver.

Grifflon

A grifflon is an extremely durable material made of three-ply, high-density rubber (Figure 2.32). It looks like cloth with webbing woven through it to prevent it from ripping. A grifflon takes a direct light and bounces it back onto the subject. If the sun were backlighting the subject, for example, it would bounce the sun back onto the subject's face. The most common sizes of grifflons are:

6 ft. × 6 ft.
8 ft. × 8 ft.
12 ft. × 12 ft.
20 ft. × 20 ft.

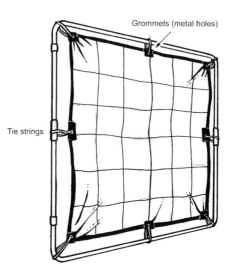

Figure 2.32a Grifflon on frame

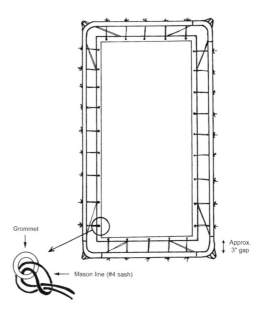

Figure 2.32b Grifflon with mason line tie-offs

A professional tip

If the grifflon should tear, a grifflon material tape is available specifically to repair it. Apply the tape, which is made of the same material as the grifflon, directly to the tear, and (voilà) the hole is fixed. The tape comes in white and black. It's about 4 in. wide.

A professional tip

A word of caution: an overhead kit, such as a 20 ft. × 20 ft., presents 400 square feet of surface area to the wind. This much sail can move a boat 15 knots or better, so don't underestimate the forces that are at play here. Grips have a joke: "Seems like every time you set up a 20 ft. × 20 ft. overhead kit, the wind will come up." So every time you set one up, make sure you have ropes on all four corners; usually 1/4 in. hemp is sufficient. You must tie down a 20 ft. × 20 ft. or a 12 ft. × 12 ft. when you fly it. Otherwise you may be flying to the next county to pick it up. (SAFETY)

A professional tip

All scrims, silks, grifflons, and muslins are usually made smaller than the frame. For example, for a 12 ft. × 12 ft. frame, the rag (silk, scrim, etc.) will measure approximately 11 ft. 6 in. × 11 ft. 6 in. This undersize allows for tightening the scrim or silk tightly into place by their drawstrings (also known as mason lines). (NICE TO KNOW)

A professional tip

Always put a minimum of four ropes on a 12 ft. × 12 ft. butterfly or larger frame. One rope on each corner, to tie off the frame when it's positioned overhead (horizontal) in place. Two ropes are used on the top corners when in the vertical position. (STANDARD PRACTICES)

Grip clip

"Grip clip" is the most common name for these devices (Figure 2.33). Other names that are used quite frequently are:

Hargrave #1, #2, #3, or #4
Handy clamp #1, #2, #3, or #4
Spring clamp #1, #2, #3, or #4
Pony clamp #1, #2, #3, or #4
Brinks and cotton #1, #2, #3, or #4
The number one is the smallest.

When a grip clip is called for, it is usually asked for by size. The number comes from the manufacturer (for example, Hargrave #1):

#1, smallest
#2, most common
#3, large (seen on houses being tented for fumigation)
#4, extremely large (hardly ever used).

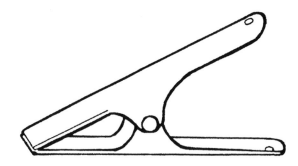

Figure 2.33a Grip clip

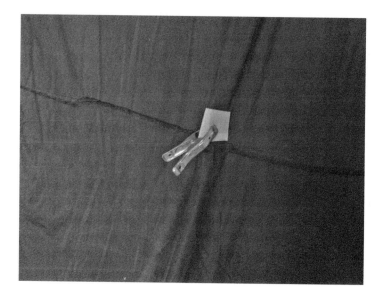

Figure 2.33b Grip clip with protective material in its jaws

Grip/electrical stage box

The grip/electrical stage box or grip box, as it is usually called, is nothing more than an extra-heavy-duty chest of drawers (Figure 2.34). It has a metal wheel frame that is detachable. This box is loaded with common hardware – from bolts, nuts, wire, and nails to power tools.

Grip helper

The grip helper is another special bracket (Figure 2.35). It allows a flag or scrim to fasten securely to a heavy-duty stand. The grip helper has a 1-1/8 in. pin on the bottom and a 1-1/8 in. receiver on the top. The pin drops into a 1-1/8 in. receiver on the stand. The light then slips into the top end of the receiver, remaining perfectly in the center. The arm extends from 3 ft. to 6 ft. and will rotate 360 degrees. It is fixed at a 45-degree down angle. The grip helper's other end has a 4-1/2 in. grip head mounted on it. A 40 in. single extension arm mounts into the 4-1/2 in. head. This extension arm has a 2-1/2 in. grip head on it that will hold the flag, frame, or net. This makes everything one unit.

Figure 2.34 Grip/electrical stage box

Figure 2.35 Grip saver/helper

Grounding rod/spike

Grounding rods or spikes (Figure 2.36) are used for electrical ground hookups or for securing guide wires or ropes. They are all steel rods (usually hardened). The spikes are about 2 to 3-1/2 ft. long. Their nicknames are:

Ford axle (at one time old automobile axles were used to make them).
Bull pr–ck (use your imagination).

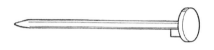

Figure 2.36a Grip saver/helper

Figure 2.36b In use

Hand truck

A picture is all you need to explain this tool (Figure 2.37). Sometimes called a stevedore.

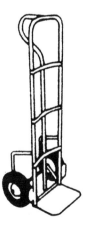

Figure 2.37 Hand truck

Ladder

The three basic types of ladders (Figure 2.38) are:

Ladders made of wood or fiberglass.
Ladders made of aluminum.
Rolling A-frame ladder, which has a center ladder that can be raised or lowered as needed.

Note: ***Never use an aluminum ladder when working with anything electrical***. This could be the fastest way to a short career. It can ground out and cause injury or death. And, remember, do not use the top step; get a taller ladder instead.

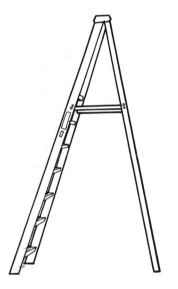

Figure 2.38a Ladder

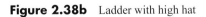

Figure 2.38b Ladder with high hat

A professional tip

Almost every ladder built today has a level or height that should not be exceeded. For example, a six-step or 6-foot ladder has five steps and a top platform, but this top platform is NOT A STEP. Nevertheless, people get careless and use it. Don't use the top step; get a taller ladder instead. (SAFETY)

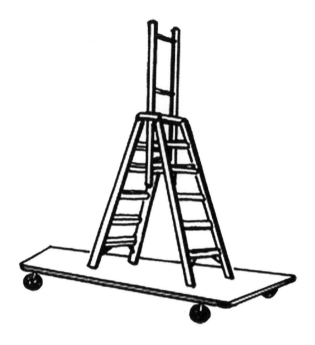

Figure 2.38c Rolling ladder

Lamppost system (by backstage equipment)

These lamppost systems (Figure 2.39) are excellent for any pre-rigs or last-minute changes. They are perfect for those swing sets (moving walls) that we squeeze into tight corners of our sets. They are held in place with just four screws.

Mafer clamp

The mafer clamp (Figure 2.40) is a great little clamp. It looks something like a C-clamp that has a removable 5/8 in. pin on it. The clamp has a rubber tip that will attach to most pipes and flat surfaces.

Matt pipe adapter baby

The matt pipe adapter (baby pin) (Figure 2.41) is a simple yet effective means of securing a light or grip equipment to a pipe or tubing. It terminates in a 5/8 in. pin.

Figure 2.39a Lamppost system (by backstage equipment) over wall with flag

Figure 2.39b Lamppost system (by backstage equipment) over wall

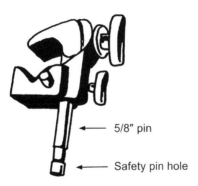

5/8" pin

Safety pin hole

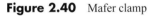

Figure 2.40 Mafer clamp

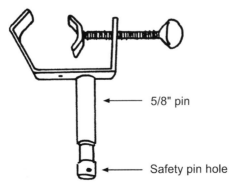

5/8" pin

Safety pin hole

Figure 2.41 Matt pipe adapter baby

Matt poles – polecats

Polecats (Figure 2.42) are adjustable poles that will support lightweight lighting and grip equipment. They can be used vertically or horizontally. A unique cam-action lock exerts pressure to securely wedge the suction-cup-affixed ends into place.

Note: *Only use a mafer clamp or a light-action clamp device on this tool.* The reason is that the walls of the tube are thin and designed to support only light equipment hanging from it.

Figure 2.42 Matt poles – polecats

Meat ax

The meat ax is a grip-arm-like accessory (Figure 2.43). The meat ax is designed to clamp onto the handrail of a studio overhead catwalk or any other suitable surface on which you can put a clamp. The long extension arm is adjustable to pivot in all directions around the clamp. The end of the arm is equipped with a gobo head. A small handle is affixed at the opposite end to facilitate adjustment and positioning. The meat ax comes with two clamp styles, one for the 2 in. × 4 in. handrail and the other for a pipe clamp.

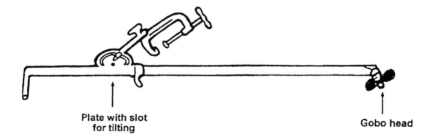

Plate with slot
for tilting

Gobo head

Figure 2.43a Meat ax

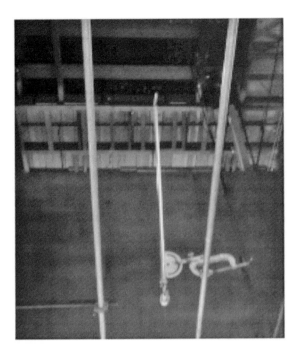

Figure 2.43b Meat ax (what it looks like)

Figure 2.43c Notice the PIPE FACE on the clamp

Miniboom

As the name implies, the miniboom is a miniature boom arm designed to support lighting fixtures (Figure 2.44). The arm is designed for situations in which a limited amount of extension is required. The unit is lightweight yet provides stability through the use of counterbalance weights.

Note, *If need be, you can use a C-stand and a branch holder in a high roller as a replacement.*

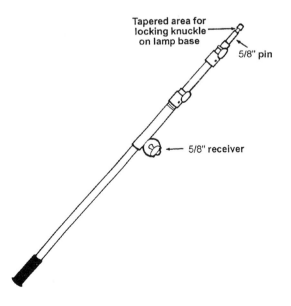

Figure 2.44 Miniboom

Muscle truck/cart

The muscle truck, as its name suggests, is a heavy-duty cart (Figure 2.45). It is used to transport sandbags, cable, or any heavy object that will fit in its well. Also known as a sandbag cart.

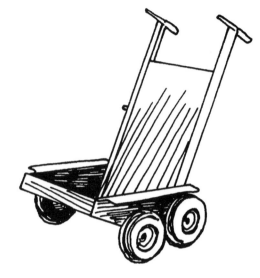

Figure 2.45a Muscle truck/cart

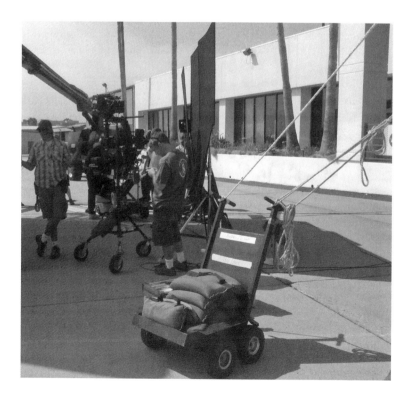

Figure 2.45b Muscle truck/cart in action

No-nail hanger/crowder

This bracket (Figure 2.46) easily fits over a 2 in. × 4 in. or 2 in. × 6 in. piece of wood. It will also fit over a door. It has a 1-1/8 in. receiver and will easily convert to a baby pin with a C-stand adapter pin.

Figure 2.46 No-nail hanger/crowder

Offset arms

An offset arm (Figure 2.47) offsets a light – for example, when you need to hide the stand outside the room and have only the light itself inside the room.

Offset arms are similar to sidearms. These are arms that have a receptacle that will fit on a stand that is 5/8 in. Most are a fixed length, but some have a sliding arm. This can almost double the length that it is offset from the base. Remember to sufficiently add baggage (ballast) to the stand's base. Also ensure you use the strongest telescoping riser to prevent bending.

A junior offset is the same thing as the baby, but with a 1-1/8 in. receptacle at one end and a 1-1/8 in. pin on the other.

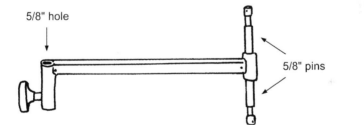

Figure 2.47a Offset arms with baby pin

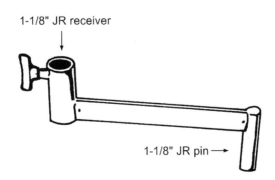

Figure 2.47b Offset arms with junior receiver

Parallels

Parallels, when totally assembled, are portable scaffolding designed for use as elevated platforms for camera or lighting equipment (Figure 2.48). All elements are constructed of lightweight steel tubing and are designed to fold for easy storage and transportation.

The upper foot platforms are two sections that may be removed to facilitate the hoisting or lowering of equipment. Parallels can also be supported on screw jacks for leveling on feet or wheels. You can stack one set of parallels on another.

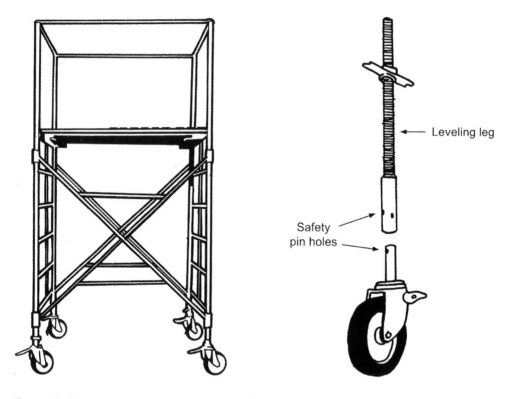

Figure 2.48a Parallels

Figure 2.48b Parallels screw jack leveling leg and wheel

A professional tip

I do not recommend stacking more than three sets of parallels (18 ft. high) when they are built on wheels. I'm not saying you can't do it, but it gives one a very shaky/loose feeling. You have to be mindful of your CG (center of gravity). You can build towers without wheels higher, but it is not recommended. If you must build towers higher than three sets, be sure you tie off the tower at every other level (using a four-point tie-off) and brace it as much as possible. Remember, be safe!

Pipe clamp, baby

Pipe clamps (baby) (Figure 2.49) are designed and strengthened to allow fixtures to hang on a pipe without the danger of slipping off the pipe while the clamp is loose. These are designed to hang from either theatrical or other heavy steel pipes. They are not recommended for use on lightweight or

thin-walled pipe or tubing, because as soon as you tighten up the bolt you will probably break right through a tube that is too thin. The lock-off bolt can be tightened to hold the pipe clamp in any desired position with ease. It terminates in a 5/8 in. baby pin.

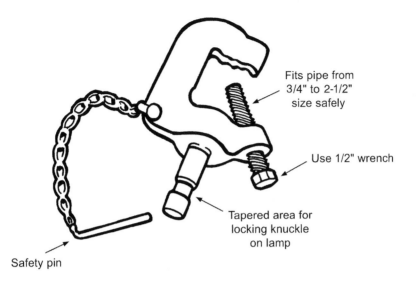

Fits pipe from 3/4" to 2-1/2" size safely

Use 1/2" wrench

Tapered area for locking knuckle on lamp

Safety pin

Figure 2.49 Pipe clamp, baby

Pipe clamp, junior

The junior pipe clamp (Figure 2.50) terminates in a 1-1/8 in. receptacle. You can also use a stand adapter pin (also known as a spud adapter) with a 5/8 in. pin on one end to transform a junior to a baby. The other end of the spud adapter has a 1-1/8 in. pin.

Figure 2.50 Pipe clamp, junior

Pony pipe clamp

The pony pipe clamp (Figure 2.51) is a heavy-duty clamp that has an adapter with a 5/8 in. pin attached to it. This is an ultra-heavy-duty type of furniture clamp. The clamp consists of a 1 in. outer diameter (OD) tube or pipe that can be changed in length as needed.

Poultry bracket (Matthews)

The poultry bracket (Figure 2.52) can be used on a tree, pole, or other curved items. It has a 1-1/8 in. junior receiver on the top of its arm, and on the bottom of its arm is a 5/8 in. baby pin.

Putty knife

The putty knife (Figure 2.53) is designed to place a 5/8 in. pin where it is nearly impossible to put any other mounting brackets. It is wedged into an area, such as a doorframe or windowsill.

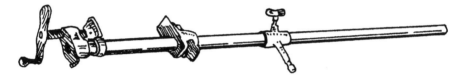

Figure 2.51 Pony pipe clamp

Figure 2.52 Poultry bracket (Matthews)

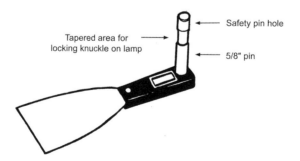

Tapered area for locking knuckle on lamp →

← Safety pin hole

← 5/8" pin

Figure 2.53 Putty knife

Reflector

A reflector (Figure 2.54) is designed to redirect or bounce natural or artificial light. The reflector has two sides to it: on one side, it is a very smooth surface. This is called the hard side. It gives you a very hard or bright light. It is identical to the practice of using a mirror in the sun to redirect light. *The hard side is sometimes called the lead side.*

The other side is called the soft side. The soft side of the board gives the subject a diffused pattern of light. A good comparison is a sheet of aluminum foil. When it is fresh from the roll, it is like a mirror, giving a hard side bounce. After crumpling and then uncoupling the foil, however, it reflects light less strongly and clearly; because of all the wrinkles in the foil, the light is not all bouncing in the same direction, so less light reaches the subject. At the present time, reflectors usually come in silver, but gold is very popular:

Gold boards are used a lot with African American actors and actresses because these boards give dark skin a nice hue.

Gold boards are also used on plants to give them a warmer/amber color, much like the color of the "magic hour" – the warm, golden yellow-orange color of a sunset.

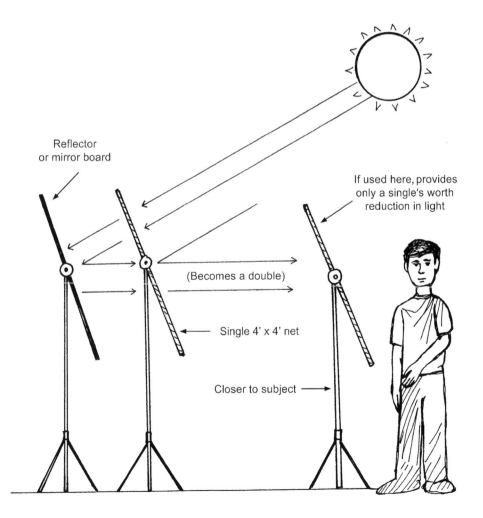

Figure 2.54a Reflector

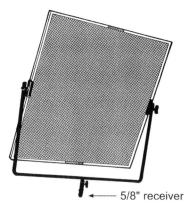

Figure 2.54b Reflector with 5/8 receiver

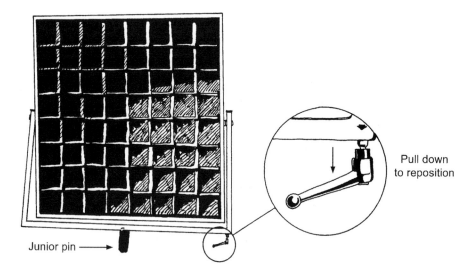

Figure 2.54c Reflector with junior receiver

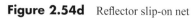

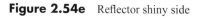

Figure 2.54d Reflector slip-on net **Figure 2.54e** Reflector shiny side

← Bungee straps

Figure 2.54f Reflector slip-on net straps on back

Figure 2.54g Reflector soft side in action

Reflector slip-ons (scrims)

Reflectors can also use a 42 in. × 42 in. slip-on single or double net (used to reduce light) that is held in place by means of an elastic strap (Figure 2.54).

Note: they can only be used on the hard/lead side.

If reflector slip-ons are used on the soft side, they will remove all the leaf that is lightly attached to the board. If a single- or double-width slip-on is required in front of a soft side, place the single or double net on an uncovered, closed-end, 4 ft. × 4 ft. empty frame, then put it in place after the sun has struck the board. The reflected light is reduced, as it passes through the slip-on only once. The reason it is done this way is that it is easier to control the reflected light and because the soft side is not damaged.

Sandbags

Sandbags are made from canvas or heavy vinyl bags filled with sand or shot (lead pellets) (Figure 2.55). The bags are placed on all light and grip stands once the stands have been set. They usually just lay over one leg, but they are sometimes hung by their strap-handle on a low knuckle on the stand. The bags come in several sizes. The most common are 15 lb. and 35 lb. Their nickname is silent grips because they will quietly hold a stand in place (unlike a grip). *The 35-lb. bags are often called ball busters.*

Scrims – grip

Scrims are also referred to as nets, which are nonelectrical dimmers. They provide a simple and versatile yet extremely controllable means of reducing light output without affecting color or temperature or generating electrical interference. They may be used to reduce the entire beam of light or just a portion of it to creatively control highlights and shadows. Open-end scrims are constructed of spring steel frames to provide constant tension on the net material. The open end facilitates feathering or blending of the edge of the light beam without causing a harsh visual line. Scrims come in three basic configurations – single, double, and lavender – as well as silk.

A professional tip

Don't stack large or small nets together; if they fall over, the pin might punch a hole through them. (STANDARD PRACTICES)

Single net

The single net will reduce about 30 percent of the light that shines through it. (About 1/2 of a camera stop.)

Figure 2.55a Sandbag

Figure 2.55b Lowering sandbags from roof

Its handle is usually painted white or green. On newer equipment, the outer edge of the net that connects to the frame has a white or green cloth covering for ease in identification. The single is one layer of material only. It looks like the material you might make a veil out of, but it has no design in it.

Double net

The double net will reduce the light shining through it by 50 percent. (About one full camera stop.) It is constructed almost exactly the same as the single net, but the major difference is that this one, as the name implies, has two layers of net material. The handle and outside cloth cover of the double net are red.

A professional tip

If a net is called for, remember: always bring what is called for in the net wanted plus the other scrim not called for (single and double). For example, if a single is wanted, bring it along with a double. It will save you many a return trip when the DP or gaffer sees the single in place. It may not be enough light reduced. Conversely, if a double is called for, too much light may be reduced, thus requiring a single. (NICE TO KNOW)

A professional tip

If too many nets are layered, they will broadcast a design on the subject. This is called a moray pattern. It is similar to looking through a screen door. (NICE TO KNOW)

Lavender net

This is a very delicate net that will reduce the light by only about 15 percent. The handle and edge of the cloth covering are painted blue or purple; hence the name.

A professional tip

To make a nice cover for a lavender net and protect the frailness of the material, I will usually cut a piece of show card, fold it in half, and make a sleeve. (NICE TO KNOW)

A professional tip

If you need to use a net, flag, or diffusion next to a window, you can sometimes just tape it to the window with paper tape. (NICE TO KNOW)

Silk

The silk net provides diffusion in addition to cutting (reducing) the light. It also softens the light source. The silk net has a gold handle and cloth edge. The actual extent of light reduction for scrims will vary according to the placement of the scrim relative to the light and the subject. Scrims come in various sizes, but the most common sizes called for are:

18 in. × 24 in.
24 in. × 36 in.
48 in. × 48 in.

Remember! *Always bring what is called for in the size wanted plus the other scrim not requested*; for example, if a single is wanted, bring a double along with it. It will save you many a return trip when the DP or gaffer sees the single in place and realizes that not enough light is being reduced. Conversely, if a double is called for, too much light may be reduced, thus requiring a single.

Scrims, butterfly kits

Okay, now let's discuss butterfly kits. We have both butterfly kits and overhead kits:

1. Butterfly kits are usually smaller in size (usually about 5 ft. × 5 ft. or 6 ft. × 6 ft.), and they can be supported by a single stand (although this is not a good practice).
2. *Overhead kits are larger*, about 12 ft. × 12 ft. or 20 ft. × 20 ft.
3. Butterfly and overhead frames are portable.
4. Both use lightweight tubes. They both can support any lighting control material, such as:
 a Silks (which diffuse light)
 b Nets (which reduce light)
 c Solid blacks (which cut light)
 d Grifflons (which reflect light)
5. Setup time is usually 5 to 10 minutes.
 Note: These textile materials are color coded for easy identification:
 • White, a single scrim
 • Red, a double scrim
 • Black, a black solid
 • Gold/yellow, a silk
 Each kit (butterfly or overhead) will usually include a
 • Frame
 • Single
 • Double
 • Silk
 • Solid
 • Grifflon (sometimes, but you'd better check when you order – never assume)

That makes up a butterfly kit. A grifflon is a separate unit. I will explain what each one does as we go along. Remember when I told you in the scrims section that the material is made out of a veil-like material? You have your single, which is one layer of material, and your double, which are basically two layers of the same material. Butterfly kits are the same as the scrims described earlier, only in larger sizes.

Silks

We use two types of "silk":

1. Taffeta
2. Chinese silk

The silk that we use most often is taffeta, which is not actually made of silk but is a silk-like material. It is more durable than real silk. The other is a Chinese silk, which is a very fine, actual silk.
 Note: Chinese silk is very expensive, and it rips or snags very easily, so we shy away from using it.
 Note: Always wrap a silk (Chinese or taffeta) into a ball. Never fold it. The reason for this is that the material may develop creases that will cast shadows on the subject. Also, always use a silk (if

possible) with the seams facing up or away from the subject. The seam may also cast a shadow on the subject if it is too close.

Scrims, flex

1. Flex scrims (Figure 2.56) are lightweight, smaller versions of regular scrims.
2. They are designed to be used in conjunction with articulating arms (flexarms).
3. Their usage is similar to that of fingers and dots.
4. Their size is usually 10 in. × 12 in.
5. They come as:
 a. Open-end singles
 b. Open-end doubles
 c. Open-end silks
 d. Closed end
6. They are used where a larger flag will not work.

Side arms

Side arms, which are adjustable in length, are designed to clamp onto a round surface 1 in. to 1-3/4 in. in diameter (Figure 2.57). They provide a mounting platform for lighting or grip equipment.

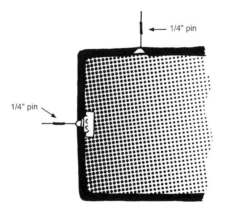

Figure 2.56 Scrims, flex

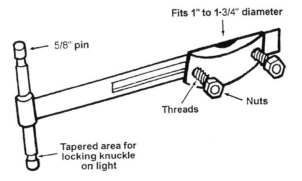

Figure 2.57 Side arms

Common applications include attaching them to lighting stands for low-angle placement. Another common use is hanging the arm from overhead pipe grids.

The baby side arm terminates in a double-ended 5/8 in. pin. The junior side arm has a 1-1/8 in. receiver.

Stair blocks

Stair blocks (Figure 2.58) are small wooden blocks attached together like a set of miniature steps, offering a variety of elevations. They are commonly used for elevating a table, couch, and other items. Each step is approximately 1-1/2 in. higher than the last, with approximately 4 in. between steps.

Stand adapter pin

The stand adapter pin (Figure 2.59) is a pin with a 1-1/8 in. base and a 5/8 in. pin on top.

This pin will go into a combo stand or high roller with a receptacle if an adapter is needed. *A nickname for the stand adapter pin is a spud.*

Stands

Okay, you have made it this far. Good for you! Now we are going to learn about stands. One stand is used the most by far (as you may have gathered by how often we have already mentioned it) – the C-stand.

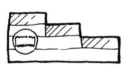

2" x 4" step blocks

Step blocks in stored position

Figure 2.58 Stair blocks

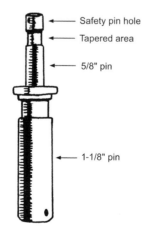

Safety pin hole

Tapered area

5/8" pin

1-1/8" pin

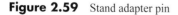

Figure 2.59 Stand adapter pin

A professional tip

Here is a normal rule of thumb when bagging a stand: 1 riser up equals 1 sandbag; 2 risers up equal 2 sandbags; and so on. (NICE TO KNOW)

C-stand

The C-stand (Figure 2.60), short for century stand, gets its name (legend has it) from how long it will take you to master using it. *It is also called a gobo stand or grip C-stand.*

The dictionary describes a gobo as an object used to block light from a subject, so it is only reasonable that a stand that holds a gobo is a gobo stand. The C-stand is considered to be the workhorse of the industry. The *century* or *gobo stand* is designed as a multipurpose support for flags, lighting fixtures, prop stands, and other items that must be held in place on the set. The legs are staggered in height, allowing them to fit in, around, and under furniture, props, and other lighting stands. A "sliding leg" (also called a Rocky Mountain) is available on some stands. This feature permits one leg to be raised so it can rest on an elevated surface, such as a stair, counter, sink top, and so on. The standard 40 in., double-raised stand can reach approximately 13 ft. 8 in. or so. A century stand weighs about 11 lb. All stands are constructed of durable lightweight alloys.

Each of the stand's risers is a tube inside a larger tube that will telescope about 38 in.

The C-stand is used with a head on it called a grip or gobo head. This bites onto a 40 in. tube or extension arm with another head on it (the gobo arm). The grip head sits on the century stand by means of a 5/8 in. diameter pin or rod, which, by the way, is the standard size for most lighting units under 2,000 watts.

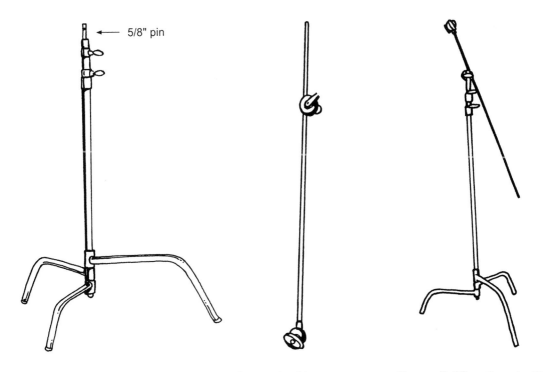

Figure 2.60a C-stand without a gobo/ C-stand head and arm

Figure 2.60b Gobo head and arm

Figure 2.60c C-stand with gobo/C-stand head and arm

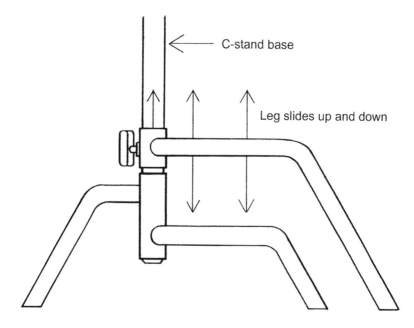

Figure 2.60d C-stand with location legs

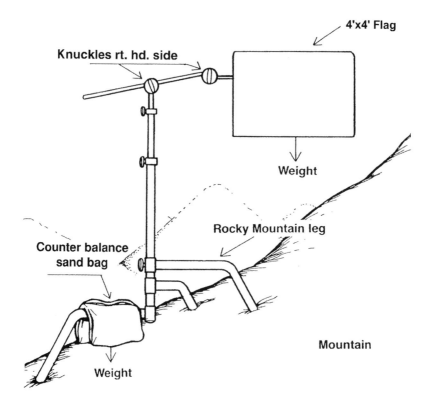

Figure 2.60e C-stand with location legs on a hill

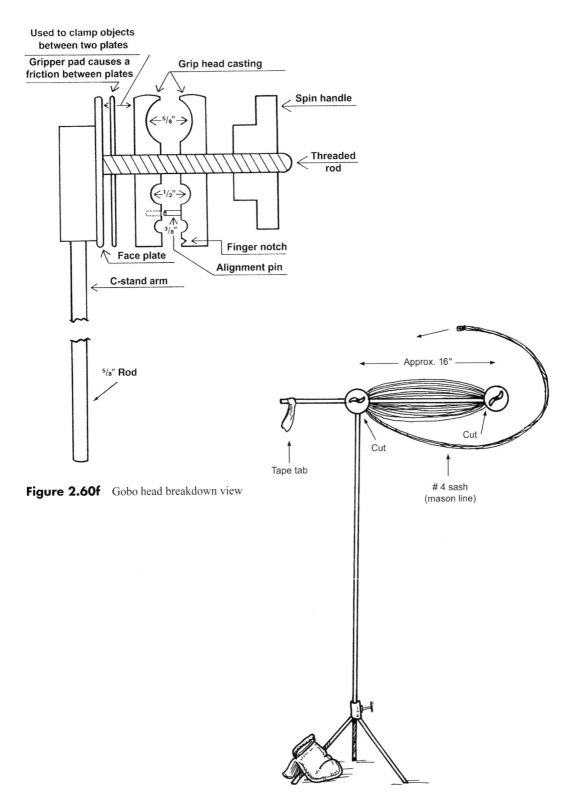

Used to clamp objects between two plates

Gripper pad causes a friction between plates

Grip head casting

Spin handle

$^5/_8''$

Threaded rod

$^1/_2''$

$^3/_8''$

Finger notch

Face plate

Alignment pin

C-stand arm

$^5/_8''$ **Rod**

Figure 2.60f Gobo head breakdown view

Approx. 16"

Tape tab

Cut

Cut

4 sash (mason line)

Figure 2.60g How to measure line to cut to equal lengths

C-stand operation

> ## A professional tip
>
> In wind, use the thickest risers possible. (NICE TO KNOW)

Most 2-1/2 in. grip heads and gobo heads are designed to receive 5/8 in., 1/2 in., or 3/8 in. round accessories. They will also accept an object of irregular shape – if not in the holes, then between the flat plates, as shown in Figure 2.60f. The head consists of a knob or knuckle, with outside and inside plates that butt up to a flat portion of the head. The holes of the plates are kept aligned by inserting an alignment pin between the outer and inner plates, which are attached to one plate, while the other plate has a hole for free floating. ***C-stands should always be used with the "head and arm" working knuckles on the right.*** The quickest way to show the rest of the crew that you are inexperienced is to forget this ***Golden Rule***. The reason the knuckles are on the right is that any time a flag (which is a weight) is put in the head, gravity will pull it downward. The knuckle or knob is tightened clockwise. The weight of the flag will cause the head to bite by pulling down (clockwise), causing a friction action and locking it in place. The C-stand should be placed with the heads working knuckles on the right. *The "RISER" knuckles on the stands base can be on any side.* The "Golden Rule" only pertains to the "Head and Arm!" *The "tallest" leg* of the C-stand *is commonly* placed in *a forward position* whenever possible. Albeit any leg placed in front, *under the weight*, will work. This will help support the weight of an object such as a flag and keep it from falling over forward. To help prevent the C-stand from falling over, a sandbag is placed on the ***rearmost*** leg to act as a counterbalance. By the way, just a side note: *always place a sandbag on a C-stand, whatever configuration it is in.* All you have to do is forget just once, and you've caused an accident. Okay, that wasn't so tough. As I said in the beginning of this book, I will tell you more about C-stands and how to use them after you remember what they look like. Now for the rest of the stands. They are used a lot, but not as much as this last monster.

> ## A professional tip
>
> Always try to place the bag on the leg opposite the weight. But if the weight is down the center, such as a light sitting on the middle of a stand, any leg will do. (STANDARD PRACTICES)
>
> ## A professional tip
>
> If you have to grab a head and arm off of a C-stand, always pull it from the back of the pile. (STANDARD PRACTICES)
>
> ## A professional tip
>
> When you hand off a C-stand to an awaiting hand, make sure you have grasped around the C-stand main post and the long gobo C-stand arm. If your fingers are wrapped only around the center post, they will get crushed as if they were in a nutcracker. (STANDARD PRACTICES)

Lowboy stand

A lowboy stand is nothing more than a combo/light stand – only lower (Figure 2.61). It can be used as an umbrella stand, but it was designed specifically for when a combo/light stand cannot be used due its height. The receiver is a 1-1/8 in. hole.

Figure 2.61 Lowboy stand

Reflector (combo/light) stand

Combo reflector stands (Figure 2.62) are considered to be the standard type for use with reflectors. The stand was originally designed for mobile or location production, back when studios were just beginning to get away from the back lot concept. The combo stand features a three-leg base with a

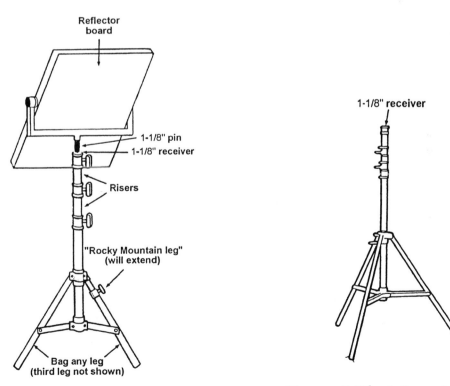

Figure 2.62a Reflector (combo/light) stand

Figure 2.62b Reflector (combo/light) stand with adapter

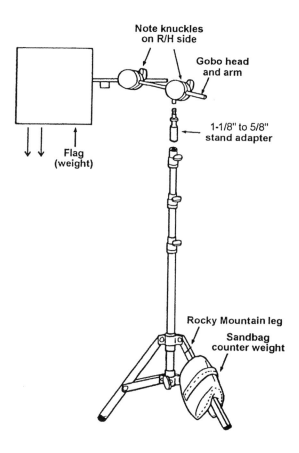

Figure 2.62c Reflector (combo/light) stand with adapter

folding brace in each leg. The stand is portable, yet it has enough heft to stand a moderate gust of wind blowing against the reflector surface. The name "combo" is short for "combination," referring to the fact that the stands are used to support a variety of exterior lighting fixtures. The combo/light stands are available with a Rocky Mountain leg (sometimes a sliding leg). One leg telescopes out of a tube inside a tube. The knob on this sliding leg is used to adjust the sliding leg into position to facilitate leveling on uneven terrain. The combo stand receptacle is 1-1/8 in. Note: You will find that most lights from 2,000 kW to 18,000 kW have a 1-1/8 in. pin.

Overhead (high roller) stand

Although "overhead stand" is the proper name, we can just call it a *high roller* (Figure 2.63).

There are several sizes of high rollers, ranging from junior to high to high high. Depending on what job you are doing, you will have to determine which stand you will need. These are wide-based units designed for extra stability. The legs slide up and down the center shaft to work in tighter environments. The high roller stands are primarily for exterior work or on stages where you need a beefy stand.

Some of the high roller stands have a grip head, which is a 4-1/2 in. head that is almost identical to the C-stand's 2-1/2 in. head.

Most new high roller stands have grip heads with a receptacle on the backside that will receive a 1-1/8 in. diameter pin.

Note: Another standard size to remember is 1-1/8 in.

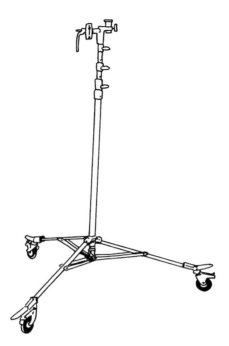

Figure 2.63a Overhead stand

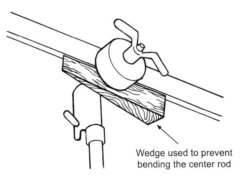

Wedge used to prevent
bending the center rod

Figure 2.63b With wedge to prevent bending of center threaded rod

A professional tip

Always unlock your high roller wheels before you fold the base up. This will allow the roller to fold correctly. (STANDARD PRACTICES)

Overhead stand usage

The overhead stand or high roller (Figure 2.64) is usually used to hold anything that has to go higher than a C-stand can hold it. An overhead stand is also stronger, with a larger gobo head (but it does not have a gobo arm). If need be, a gobo arm from a C-stand can be used by inserting it into the head of the overhead stand. The high roller tubes, called *risers* or *stems*, are larger in diameter than a

Figure 2.64a Overhead stand usage

Figure 2.64b Overhead stand tilted and tied

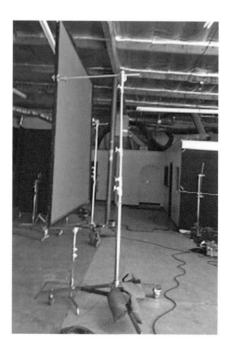

Figure 2.64c Overhead stand with gobo arm in action

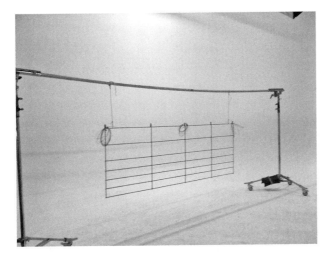

Figure 2.64d "GOAL POST"

C-stand; for this reason, they are not as apt to bend in a high-wind situation. It is a good practice not to raise the first riser above 18 in. If the high roller is stemmed (raised) completely up, the top riser might bend in a strong wind, due to the reduced diameter of the tube.

Note: Remember, people, it is only a tube, so use your common sense.

Stand extensions (riser)

The stand extension (Figure 2.65) will add extra height to various light and grip stands. The extension attaches directly to a 5/8 in. pin or a 1-1/8 in. receiver, depending on the style of stand. The extension comes in various lengths. If it is a 5/8 in. pin, it can be 3 in., 6 in., 9 in., or up to 18 in. long.

If it is a junior riser or junior stand extension, then it usually comes as a 36 in. rod that terminates in a 1-1/8 in. receiver. The last 6 in. should be painted red, indicating that the end is about to pop out or is near.

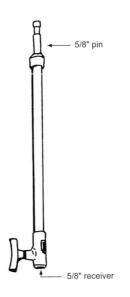

Figure 2.65 Stand extensions (riser)

A professional tip

A junior riser can sometimes be used in a high roller or mambo combo stand if the stand has a junior receiver on it. This means that you can make the stand taller. Make sure you bag it heavily. Also ensure you do not bend the risers. (NICE TO KNOW)

A professional tip

A stand extension pin can work in place of a short rod (norms pin). (NICE TO KNOW)

A professional tip

A lot of grips carry an aluminum rod or steel that is 5/8 in. in diameter and about one foot long (commonly referred to as "NORM" pins). Some grips have even drilled 1/8 in. diameter holes through the rod about 1/2 in. from the end for safety pins or bailing wire. These rods are great for hanging lights from a C-stand or gobo head. (NICE TO KNOW)

Studio overhead grip arm

A studio overhead grip arm (Figure 2.66) is an overhead C-clamp that terminates in a century-stand-like grip head with an extension arm. This unit can be clamped onto a pipe or a grid to hold flags, scrims, and other items.

Taco carts

The grip senior and grip junior (also known as *taco carts*) are made by Backstage Equipment. These grip carts are designed by Carrie Griffith, the owner of Backstage Equipment, and a key grip who knows just what grips need. The following carts (Figure 2.67) are used daily by several

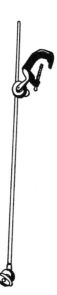

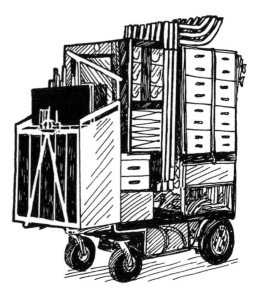

Figure 2.66 Studio overhead grip arm

Figure 2.67a The grip senior taco cart

Figure 2.67b Grip junior taco cart

Figure 2.67c Work cart with drawers

Figure 2.67d Work cart with apple boxes

Figure 2.67e C-stand cart

Figure 2.67f The grip senior in action

departments – grip, electrical, and props, just to name a few (remember that all the carts can be special-ordered to your design as well):

- Grip senior
- Grip junior
- Large grip cart (modern style)
- Small grip cart (modern style)
- Century stand cart

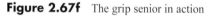

T-bone

The T-bone (Figure 2.68) provides rigid support for the low positioning of junior and senior lighting instruments. The T-bone may be nailed to the floor. (If it is not nailed, *always* bag it.)

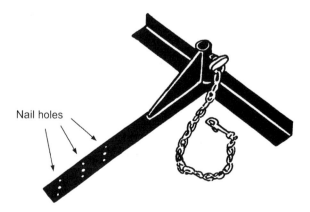

Nail holes

Figure 2.68 T-bone

Telescoping hanger-stirrup

Telescoping hangers (Figure 2.69) are designed for hanging lighting fixtures from overhead grid pipes, extending these fixtures well down into a set. The hangers can be adjusted for length and also permit pivoting around the vertical axis of the C-clamp. The single hangers have a maximum length of 3 ft., and the double hangers telescope from 3 ft. to 6 ft. The hangers end in a 1/2 in. × 16 pitch female thread, into which a stirrup or other accessories can be bolted.

Trapeze

As the name suggests, a trapeze (Figure 2.70) is designed to swing over a set where no overhead light is available or where the grid is too high. If you attach a chain to the center of the horseshoe, the trapeze can be dropped onto the set. You can also use a rope on a trapeze. The rings on either end receive ropes (tag lines) that are used to center the fixture.

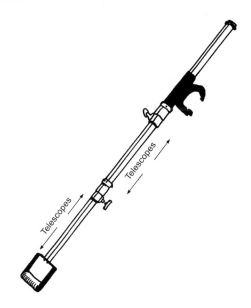

Figure 2.69 Telescoping hanger-stirrup

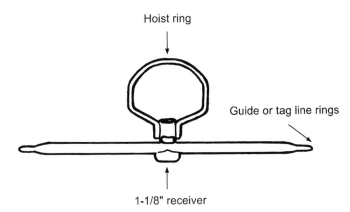

Figure 2.70a Trapeze

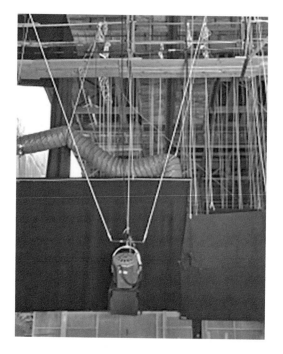

Figure 2.70b In use

Trombone

Trombones (Figure 2.71) are named for the way in which they bend or telescope. They are designed to hang from a set wall and to adjust to the width of the wall. A rubber ball on the telescoping shaft keeps the mount from marring the wall surface. The only difference between the baby and the junior trombone is the mounting device: a 5/8 in. pin or a 1-1/8 in. receiver, respectively.

Tube stretcher

Tube stretchers (Figure 2.72) are made out of pipe instead of wood.

Basically, they fit inside a wall spreader and do the same thing as a wall spreader (see the wall spreader section). I strongly suggest not exceeding a 16 ft. spread.

Tubing hanger

A tubing hanger (Figure 2.73) can be used to support overhead frames as well as other types of rigging. One end fits into a 4-1/2 in. grip head. The opposite end terminates in a clamp designed to hold pipe or tubing with a 1 in. to 2 in. outside diameter.

Turtle

The turtle base stand is perfect to mount a large lamp very low. The one pictured in Figure 2.74 is equipped with wheels. They also make them without wheels.

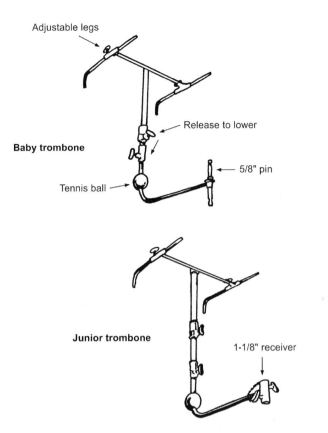

Adjustable legs

Release to lower

Baby trombone

5/8" pin

Tennis ball

Junior trombone

1-1/8" receiver

Figure 2.71 Trombone

Figure 2.72 Tube stretcher

Figure 2.73 Tubing hanger

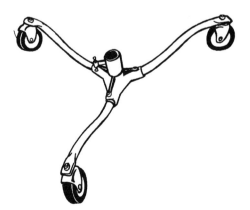

Figure 2.74 Turtle base stand

Umbrella

Okay, here's a tough one. The umbrella is nothing more than a large picnic umbrella (Figure 2.75). And who usually gets it? The director or at the very least, the cameraperson. (Remember, these are the guys and gals who called you.) (More films to be made after this job.)

Wall bracket (set)

The wall brackets is fitted with 1-1/8 in. receivers (Figure 2.76). The junior wall plate can be nailed in either a vertical or horizontal position. The set wall bracket provides an extremely stable base for mounting a fixture on top of a set wall.

Wall plate-junior

Junior wall plates (Figure 2.77) may also be called *set wall brackets*. They are similar in design to a baby plate. These products are fitted with a 1-1/8 in. receiver. The junior wall plate can be nailed in either a vertical or horizontal position. The set wall bracket provides an extremely stable base for mounting a fixture on top of a set, wall, and so on.

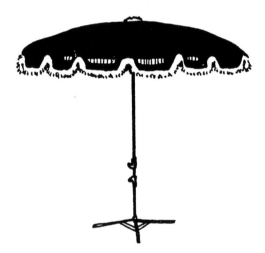

Figure 2.75 Umbrella

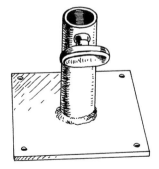

Figure 2.76 Wall bracket (set)

Figure 2.77 Junior wall plate

Wall sled

The wall sled (Figure 2.78) is a mounting device designed to support lighting equipment from a set wall without the necessity of nailing directly into the wall. The weight of the fixture exerts pressure to force the sled against the wall. The weight of the entire unit is supported by a chain or a rope that is secured to the top of the set. The baby wall sled is equipped with dual 5/8 in. pins. While the first pin is holding a lighting fixture, the other may be utilized to hold a grip arm or head. The junior and senior wall sled are the same in size. Both of them have 1-1/8 in. receptacles. Now, usually when we refer to "baby," we are talking about a 5/8 in. pin and when we refer to "junior" we are talking about 1-1/8 in.

Wall spreader

Wall spreaders (Figure 2.79) are used to suspend grip and lighting equipment wall-to-wall by inserting a precut 2 in. × 4 in. or 2 in. × 6 in. stick of lumber into the mounts, then wedging the complete unit between the walls. Supporting pressure is extended by a screw device. Caution must be taken in not applying too much pressure. It is also recommended that wall spreaders should be positioned in direct line with the wall studs.

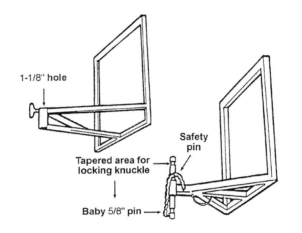

Figure 2.78 Wall sled

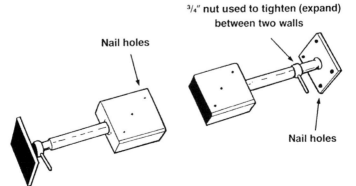

Figure 2.79 Wall spreader

Wedges

This is exactly what you think it is – a wedge (Figure 2.80). A wedge is usually 10 in. × 4 in. × 1/16 in. and tapers up to 1 in. thick. You will find it to be one of your most used pieces of equipment.

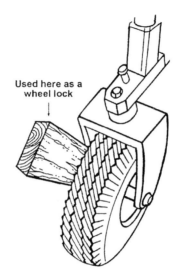

Figure 2.80 Wedges

A professional tip

Always mark damaged equipment with white tape. This is standard throughout the industry. (STANDARD PRACTICES)

3 Expendables

Automatic tape gun (ATG) tape (aka snot tape)

Automatic tape gun (ATG) tape is a clear, double-sided sticky tape. When you use this tape, it is best to use only a short strip of it, approximately 1 to 2 in. long. (It's like that old commercial – "a little dab'll do ya.") This stuff works great. Use it on wood or glass or for putting up gels, but remember that it can make a gel unusable if the sticky tape touches the wrong spot. Remove ATG tape from the old gel by simply pulling it off. Some tape will remain on the gel, but most of the tape will remain on the surface to which the gel was applied. To remove this remaining tape, use about a foot or so of gaffer tape. Stick it on the ATG double-face tape that was left behind, rub your finger on the back of the gaffer tape, and press firmly so it will stick to the ATG tape. Now simply pull the tab on the gaffer tape. When the gaffer tape is removed, the ATG tape should come with it. Actually, you will have to press the gaffer tape on the ATG tape several times to remove all the ATG tape. (Sort of like removing lint from your clothes with one of those adhesive roller brushes/tape rollers.) By the way, grips always try to clean up their mess. That's what the real pros do!

A professional tip

ATG tape is sometimes called snot tape. (NICE TO KNOW)

A professional tip

Note: I recommend that you have the production company rent/acquire a package of expendables (foam core, show cards, gels, and hardware) on an "as-used" basis. This way production will only pay for what has been used.

Baby powder

We sometimes use baby powder on a dolly track (steel and plywood) to prevent the wheels from squeaking when they're rolling along the track. I find it easier to apply it directly to the wheels as you have someone roll the dolly (less of a mess).

Bead board

Bead board comes in 4 ft. × 8 ft. sheets of foam that are about 3/4 to 1 in. thick (although it does come in thinner or thicker sheets as well.) It has a very porous surface that does not bounce all the light. It is used daily as a very soft redirected light source.

A professional tip

Bead board can be used to insulate a wall or door if you are having a sound recording problem. (NICE TO KNOW)

Black wrap

Black wrap is nothing more than aluminum foil with a heat-resistant, dull (matte finish) black coating on both sides. It has many uses. I sometimes use it as a heat shield to prevent a hot light from blistering wood or paint when a light has been set under or near it. Just tear off a sheet like you would any aluminum foil and place it between the lamp and a wall/or ceiling. It will act as a heat sink and somewhat of a heat reflector at the same time. Also it will cut light to prevent spill from the wall without bouncing back any light (as regular aluminum foil would). It can also be used on a flag's edge that may be too close to a light's beam. This will usually prevent the flag from burning.

A professional tip

Never form-fit black wrap foil to a light, because it will destroy the light. Apply black wrap to a light loosely. If the light is wrapped too tightly, the globe will heat up and burn out. (NICE TO KNOW)

Bobbinet

Bobbinet is the mesh, veil-like material that the film industry uses to make our scrims (single or double nets). We order it by the yard. We can also stretch it over a neon light to lower the light intensity a little. (Note: Neon lights cannot be fully dimmed electronically without going out.)

Butcher paper

Butcher paper is simply a heavy, plain brown paper; it comes in rolls of paper approximately 100 ft. × 3 ft. wide and is used to cover walks, floors, or painted surfaces.

Clothespins (C-47s)

The clothespins we use (also called C-47s) are wooden clothespins with metal springs. We use these to hold cut pieces of gels in place on the light doors or any other place where a clamp action is needed. I have been told that they have the nickname C-47 because the old major studios used to keep such clothespins in bin #C-47. Contrary to this, I noticed on an "old" bag of "Penley" clothespins, an item number/name: It read MODEL C-47. But who really knows for sure? Just know all their nicknames: *Bullets, C-47's, or Pins* and so on.

Drywall screws

Drywall screws are very sharp-pointed screws in different lengths that are used with battery-powered screw guns.

> ### A professional tip
>
> Slightly angle a drywall screw, about 5 degrees to 10 degrees off normal (90 degrees from level), when screwing it into a stick of 1 in. × 3 in. lumber. This helps prevent the lumber from cracking. (NICE TO KNOW)

Dulling spray

Dulling spray, as its name implies, will dull a surface such as chrome or a mirror, giving the surface a fogged look. It is often used to prevent reflections, such as a stage light bouncing off an object, or to mark or hide a camera's own reflection during filming. Next time you watch a movie, look at a mirror on a car or the contour of a car fender; chances are it will look like it has a morning dew settled on it (even if it is 97 degrees outside). Dulling spray wipes off with a clean cloth without leaving much more than a light wax-like surface residue. A warm, moist towel will usually remove all traces of dulling spray. If you run out of dulling spray and you need something, anything, to get rid of a "hard kick" (a reflection, usually from the sun or a lamp), you can be a genius, the hero of the hour, just by asking a makeup person for some hair spray. It does not work as well as dulling spray, but it works well enough to get the shot. A light coat or mist of Streaks 'n' Tips® will work, too.

Duvatyne

Duvatyne is a tough, canvas-like black cloth that has been saturated with a fire-retardant chemical at the factory. It is used to make the flags and cutters we use in the motion picture industry. We also carry a roll of Duvatyne when we go on location. The roll comes 48 in. wide by whatever length you order (it is usually sold by the yard). We use Duvatyne to black out a window and give the appearance of nightfall outside during a daytime shot. Sometimes we use Duvatyne as a shoulder pad or a scratch-proof cloth. It will be a very handy and often-used item in your inventory. By the way, it does not work as a spill wipe or a cleanup rag, due to its fire-retardant chemicals.

> ### A professional tip
>
> To make a Duvatyne poncho, peel off about 4 ft. to 5 ft., cut a hole approximately 18 in. from one end, and use as a large black bib for reflections of the people behind the camera. (NICE TO KNOW)

Foam core

Foam core comes in a 4 ft. × 8 ft. sheet. It is a thin (3/16 in., approximately) piece of foam laminated on both sides with a strong paper that has a glossy white finish. It is used to bounce (redirect) light from the source onto an object. Foam core comes in two colors:

White-on-white (white on both sides)
Black-on-white (black on one side and white on the other)

The dull black side is often used as a teaser, or cutter, of light.

Grip chain

Grip chain is what most grips in the industry use to secure (tie down) almost everything, ranging from a large light stand to a chain that has to stay in place. Grip chains are a must on all shoots. They are also called sash chains.

A professional tip

I highly recommend that you use a double-headed nail such as a #8 or #16 duplex when using grip chain (sash chain) to secure a stand on a parallel. The drywall screws that are now being used seem to have their heads pop or break off. I always use two nails at both ends of the chain. The first nail starts and secures the chain to the wood base. I place the second nail up the chain a couple of links, and drive it in to tighten any slack from the chain. (NICE TO KNOW)

Laminated glass

Laminated glass is used to protect the lens of a camera if you cannot get or afford Lexan (see the Lexan discussion that follows). The laminated glass we use is usually a 24 in. × 24 in. piece of glass attached to a sheet of 1/2 in. plywood with a square hole cut through it (approximately 20 in. × 20 in.). If you attach the glass with cribbing, you can cut the cost down and do pretty much the same job. *We prefer to use Lexan* because it is lighter and faster to work with, and this is a business where safety and speed go hand in hand.

Layout board

Layout board is a thin (approximately 1/16 in.) piece of cardboard that comes in 4 ft. × 8 ft. sheets. It is used to cover floors and surfaces to keep them from being marred.

Lexan

Lexan is clear plastic that we use in front of the camera to help protect the operator and camera from an explosion that is being filmed or from a gunshot near the camera. Lexan comes in 4 ft. × 8 ft. sheets of various thicknesses. I feel the safest when the Lexan is at least 1/2 in. thick. To cut Lexan, use a combination saw blade on a 7-1/4 in. circular saw. Use a carbide-tipped blade. Let the blade settle its way through the plastic; then make your normal cut through the plastic.

Penny nails (#8 and #16)

At about 2-1/2 in. long, #8 penny nails are smaller than #16 penny nails, which are about 3-1/2 in. long and have a little thicker shank and wider head. Both types of nails are common or duplex (double) head nails. (The word "penny" comes from the weight of the nail from days of yore.)

Plywood

Always use at least 3/4 in. A/C plywood. It is strong enough to support the weight of a dolly. The reason we use A/C is that the A side of the plywood is very smooth and acts as a good tracking surface.

The C side has knots or is rough, but that is okay. This side lies on the ground. Birch plywood that is 3/4 in. thick is ultra smooth and strong, but twice the price.

Pushpin

A pushpin is used a lot to put up gels on wooden window frames. Always put a small tab of tape on the gel where the pushpin is going to enter. This will prevent the gel from tearing where the pushpin has pierced it.

Sash cord #8

Sash cord #8 is a clothesline type of white cloth (not vinyl) cord that is used for many purposes. It is also called cotton cord.

Show card

The show card comes in 32 in. × 40 in. cards. Those that are dull black on one side and white on the other are most often used, although they come in a rainbow of colors. The show card is made of a cardboard-like material that is a little thicker than a cereal box, about 1/16 in. It is used to bounce (redirect) a small quantity of light. Show cards can easily be bent or curved to bounce light around both the side of an object and the front at the same time. One is sometimes laid in an actor's or actress's lap to create a fill light on their clothes or faces for a soft look. It is often also called an art card.

Silicone spray

Silicone spray is a dry type of lubricant. It is used where you cannot use an oil spray. I use it on steel dolly track in the dirt because dirt will not stick to the track as easily as it does with spray oil, but this is only my personal preference.

Spray glue

Spray glue is a strong aerosol glue. It is fast and works great wherever you need to glue something.

Spray oil

Spray oil is oil that is used to lubricate any moving part so that it will work properly. It also aids in preventing a squeak or noise during a sound take.

Staples

Staples are used like pushpins to install gels. It is faster and easier to staple up a gel, but it is more difficult to save the gel when you remove it.

> ## A professional tip
>
> When giving a staple gun to someone, always bring refills. If you don't, I promise you the stapler will run out every time. Shoot a long staple on an angle, which is the best way to get the staple back out. (NICE TO KNOW)

Stovepipe wire

Stovepipe wire is a black multipurpose wire that is sometimes called baling wire because it is the same as the wire used to bale hay.

Streaks 'n' Tips®

This is actually a spray-on hair dye that comes in a multitude of colors. The spray washes right out with soap and water. We use it in the industry to tone down a bright object such as a white picket fence that may look too white for the camera. We just spray it on, like a spray paint mist. When it settles on the fence, the mist dries almost on contact, causing the fence to take on the tone of the color spray used. This is sometimes called "aging the fence" so it will look more real, used, or older to the camera. We can also apply the product in the color gray, for example, to an actor's hair at the temples to age the actor. Remember, it washes off with soap and water.

Tapes

Use low-tack blue tape. It sticks great and is easy to remove without pulling the paint off. It comes in several widths. Most paint stores have it. It is sometimes called seven-day tape, because when it is peeled off after a week no sticky residue is left behind.

> ## A professional tip
>
> Remember! A lot of tapes will gather moisture, so remove it when you are finished with it. (NICE TO KNOW)

Camera tape

Camera tape is like gaffer or grip tape, except that it comes in 1 in. rolls. Usually we use black or white tape, although it comes in several colors. It had been used by the camera assistants to reseal film cans after they have been opened.

> ## A professional tip
>
> Tab your tape at the end of the roll so that it is ready to peel off easily. (NICE TO KNOW)

Double-faced tape

This tape comes in two forms. One type is a sponge-like foam about 1/8 in. thick with a sticky surface on both sides. The other is a thin cellophane-like material with a sticky surface on both sides

(sometimes called carpet tack tape). Double-faced tape of both types is used to tack something down, to hold it in place during and after a shot.

Gaffer or grip tape

Gaffer or grip tape is a cloth-like tape that is 2 in. wide. It looks like the air conditioning duct tape most of us have seen. It comes in various colors, although usually gray is used. It is handy wherever a strong tape is needed.

A professional tip

Put gaffer tape over the hard wheels of electric scissors lifts to prevent tire tracks on a painted surface. (NICE TO KNOW)

Paper tape

Paper tape usually comes in 1 in. and 2 in. widths, although you can order it wider. It is much like masking tape, although we order it in black. It has a matte finish, which means that the surface seen by the camera will just appear as a dull dark area. Stray light will not bounce off the tape unless it is aimed directly at it.

A professional tip

Always use paper tape on a painted wall or a surface where the paint or finish might pull off with a stronger tape such as gaffer/grip tape. (STANDARD PRACTICES)

A professional tip

Black photo tape is preferred over black masking tape for two reasons. The photo black tape will almost disappear on film due to its matte backing, whereas masking tape has a shiny back surface. Also, the glue on masking tape is white, and the glue on photo tape is black. Both are paper tapes. (NICE TO KNOW)

A professional tip

Photo black paper tape is preferred over black masking tape for two reasons. The photo black tape will almost disappear on film due to its matte backing, whereas the masking tape has a shiny back surface. Also, the glue on masking is white, and the glue on photo tape is black. (NICE TO KNOW)

Visqueen

Visqueen is plastic that comes in different thicknesses, widths, and lengths and in clear or black. We use .006 mil. × 20 ft. × 100 ft. rolls.

A professional tip

To create a rain hat for a camera, you can use a gel frame with a gel on it or visqueen or any other material that is safe for rain. (NICE TO KNOW)

4 Knots

Several types of knots can be tied, but in the film industry there are at least four knots that you will use on a daily basis:

1. Bowline
2. Clove hitch
3. Half hitch
4. Square knot

Each one of these knots is a must-know knot. Sure, it is great to know more types, but these are the most commonly used.

Bowline knot

This knot is used to hang anything that is a dead hang, or a straight pull-down. After you have read the instructions on how to tie this knot (Figure 4.1), practice it on several items. Learn to tie it with your eyes closed. Practice until it becomes second nature.

Note: Never walk away from a knot if you are unsure of it. Call for help or ask someone's advice to check whether it is correct. Your life may depend on it. I recommend you get a book on knots – an old Boy Scout manual gave me a good start.

Clove hitch knot

The clove hitch (Figure 4.2) is the *knot most commonly used* to tie off a dead hanging object. Always put a half hitch in your rope tail after you have secured the knot. This provides a little extra safety.

Half hitch knot

The half hitch knot is nothing more than an extra little safety tie in your locking knot. You use a half hitch every time you tie your shoes.

A professional's tip

A quick safety tie-off is to tie a half hitch in a #8 sash cord, then put a drywall screw with a large area washer on it through the center of the knot. Now screw the screw into the set's 1 in. × 3 in. lumber for a good bite, then tie off the lamp. (NICE TO KNOW)

1. The loop

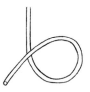

2. Slip end through loop
from bottom

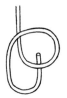

3. Wrap end around line

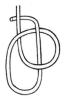

4. Slip end back down
through hole

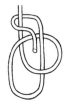

5. Pull end up

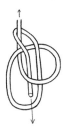

Pull down, tightening knot

Figure 4.1 How to tie a bowline

1. Lay rope over pipe; attach a weight to end to keep taut during practice

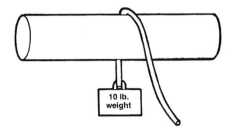

2. Wrap rope around pipe, then lay across the top of rope with weight

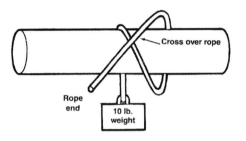

3. Lift the crossover rope and slide the rope end underneath the crossover rope

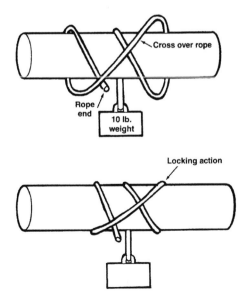

Figure 4.2 How to tie a clove hitch

Square knot

The square knot (Figure 4.3) is the knot used most often to tie up a bundle of cable. First, you wrap the excess of the long tie around the loop of cable; then you tie a square knot. This knot is a strong locking knot but is very easy to untie quickly. This knot is also commonly used to secure bundles of tubes together, such as a 12 × 12 frame tube.

1. Lay black lace over white lace

2. Start to tie a half hitch, wrapping the white lace around the black lace

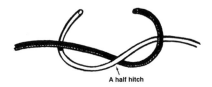

A half hitch

3. Now back loop the black lace around the white lace

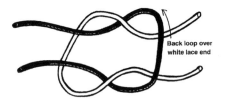

Back loop over
white lace end

4. Pull both black lace and white lace in opposite directions

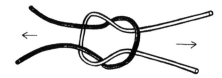

Figure 4.3 How to tie a square knot

5 *Basic tool descriptions*

Standard screwdriver (common or blade type)

A standard screwdriver, also known as a common or blade type, usually has a shank (shaft) ranging from 3 in. to about 12 in. long. Longer and shorter ones are available as well. The tip, which is also called the blade, has a wide face and a thin blade. Some screwdrivers have a thin face and a wide blade.

Phillips screwdriver

The most common Phillips screwdriver (Figure 5.1a) is a number two tip (a 30-degree tip). If you use a number one (which has a smaller tip but still a 30-degree angle) in place of the required number two, you will strip the screw head and eventually the screwdriver tip itself. Always be sure that the tip is correct and is completely and squarely set in the screw's head. This position is called normal or 90 degrees to the surface. The screw's head is horizontal, and the screwdriver shank is vertical. This position should prevent skipping or stripping out of the screw's head. If you hear or feel a chatter or grinding sound when using a hand or power driver, stop and reset the blade or tip to the normal (90 degrees) position, then proceed.

Reed and Prince screwdriver

The Reed and Prince screwdriver tool (Figure 5.1b) looks very much like a Phillips screwdriver except that the Reed and Prince tip has a sharp point (a 45-degree angle tip). In contrast, the Phillips screwdriver has a blunt or flat tip. Be sure that you have the correct tool on your tool belt (Phillips number two). It seems to me you will find very little use for the Reed and Prince – but I have one standing by in my hand-carry toolbox just in case.

Files

I use a four-in-one file (Figure 5.2), which is quite handy. Keep one in your tool box. The four types of files you should know about are:

1. Flat file (single cut), which is used for precise filing (see Figure 5.2B).
2. Flat double-cut or cross-file, which removes material faster than a single-cut file (see Figure 5.2C).
3. Round file (or rat tail; when the file is round and has a slight taper to the end opposite the handle, it is usually referred to as a rat tail file) (see Figure 5.2E).
4. Hand carriage rasp file (see Figure 5.2F).

Note: Never use a file without a handle if it is the type to need one.

When you are filing, do not rush. Smooth, slow strokes will give you a better finish. Slightly angle the file to the material when you file. Slow strokes give the cut material a chance to fall from the teeth.

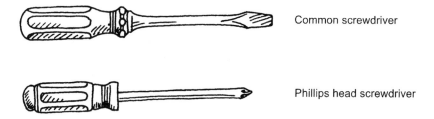

Common screwdriver

Phillips head screwdriver

Figure 5.1a Common screwdriver (top); Phillips screwdriver (bottom)

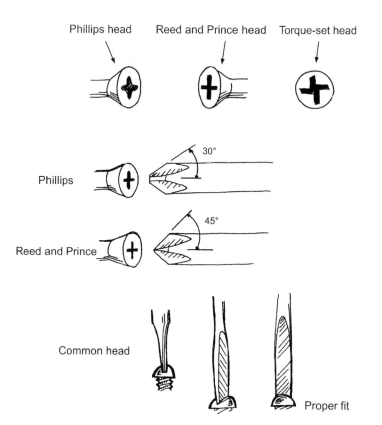

Phillips head

Reed and Prince head

Torque-set head

Phillips

30°

Reed and Prince

45°

Common head

Proper fit

Figure 5.1b Assorted screw heads/slots

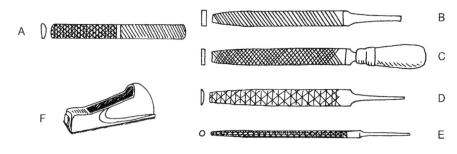

A

B

C

D

E

F

Figure 5.2 Assorted files

Hacksaw

There are several types of blades and lengths. I carry a compact handle style. On the blades, the teeth style is called the set. The teeth are bent out wider than the blade so as to cut and allow the blade not to bind. When you look at the blade, the set has a wavy look. The pitch of the hacksaw blade is also important to know about. The number of teeth per inch is usually indicated – for example, 18, which means 18 teeth per 1 inch of blade. The more teeth per inch makes for a smoother cut. Remember, when you are cutting steel, aluminum, or PVC, it is recommended that you cut at the rate of 32 to 40 strokes per minute. Do not try to cut like you have a date in 5 minutes. All that does is heat up the blade and jam up the teeth. A nice, slow, even cut will keep the blade somewhat cold and allow the cuttings to fall from the teeth. The hacksaw is used to cut metal and/or plastic. The hacksaw blade is usually 10 to 12 in. long. The blade will fit on the saw with its teeth (cutting surface) facing down, up, or sideways. The teeth of the blade, when installed properly, will face forward (away from the handle).

Lineman pliers

Lineman pliers (Figure 5.3) are great for heavy-duty cutting or bending or to grip an object. They are equipped with serrated jaws (teeth) as well as a cutting device for cutting light or thin metals or wire. They usually are about 9 in. long.

Torpedo level

Torpedo levels (Figure 5.4) are great levels. They are made from plastic or metal and fit easily into your tool belt. They are approximately 9 in. long.

Crosscut saw

The crosscut saw (Figure 5.5), or common all-purpose saw, is a must-have item. I carry a short version in my tool kit. Crosscut saws were designed to cut across the grain of wood. They come in

Figure 5.3 Lineman pliers

Figure 5.4 Torpedo level

Figure 5.5 Points and valleys per inch

different sizes, from 20 in. to 26 in. I recommend an eight-point saw, which has eight points (valleys) with seven teeth (points or peaks) per inch of the saw blade. The eight-point saw is used most often for rough framing. If you must have a cleaner (smoother) finish, step up to a 10-point saw and cut more slowly.

Circular saw and blades

There are several types of circular saw blades. I will only show you a few to get you started. The combination shown in Figure 5.6 is the blade that usually comes with the saw. I recommend that you also obtain a carbide-tipped blade; this blade will be the most useful.

Drill bits

When using a drill bit, always mark the material with a small dent or dimple. This will ensure that the drill bit does not walk (move) off the area to be drilled. If you are going to drill steel, drill slowly while applying pressure. This will actually cause the drill to work better because the bit will not heat up and dull the tip.

Note: *Always wear your safety goggles when drilling.*

When drilling aluminum, drill at a higher speed. Be sure that your drill bit is perpendicular to the surface. This position is called normal to the surface (90 degrees, or a right angle).

Matt knife

The matt knife or utility knife (Figure 5.7) is a tool you will use virtually every day. You will cut gels, filters, show card, and foam core with it.

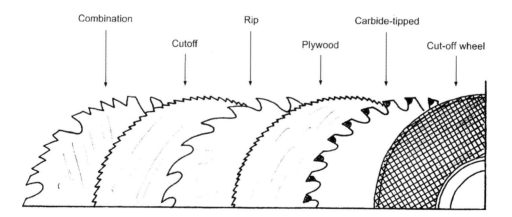

Figure 5.6 Assorted circular saw blades

Figure 5.7 Matt knife/utility knife

Tape measure

I recommend that you get yourself a good, strong 25 ft. to 30 ft. tape with a locking tab (Figure 5.8). Learn to read a tape properly. They are usually divided into sixteenths of an inch. You can get metric ones as well.

Reel tape measure

This type of tape measure comes in 50 ft. and 100 ft. lengths and longer. They are very handy for set work.

Claw hammer

The two basic types of claw hammer are the curved claw and the ripping claw or straight claw (Figure 5.9). The curved claw provides better leverage for pulling nails. I use a straight-claw hammer with a convex (bell-shaped) face on the hammerhead. It allows me to drive a nail flush with little or no marring. There is also a mesh or waffle-faced hammer, which is used mostly for driving large-headed nails during framing work. The mesh helps to keep the hammer from glancing off the nail head. Hammers come in many different head weights; pick one you can handle. I use a 16-oz. Estwing.

Personal tools

Here is what I think you should start with when building your tool belt. These are general recommendations and the minimum needed.

Locking top ⟶

Crank to rewind

Figure 5.8 Assorted tape measures

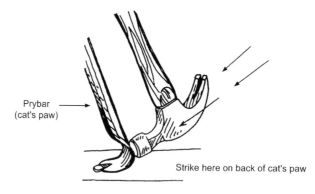

Prybar
(cat's paw)

Strike here on back of cat's paw

Figure 5.9 Claw hammer

Personal tool belt

- Your own personal headset for use with the walkie-talkies used on the set
- Padded suspenders, if you use them
- Pouch with several compartments
- Large, 90-degree ring hammer holder (makes it easy to remove and install your hammer when you're up on a ladder)
- Tape measure, 30 ft. long by 3/4 to 1 in. wide
- Gloves ("hand shoes")
- Hammer, 16 oz.
- 4-in-1 screwdriver
- Allen wrench set
- Pliers (rubber-insulated handles)
- Dikes (rubber handles)/side cutters/wire cutters
- Needle nose pliers (rubber handles)
- Miniature flashlight (2 in.)
- Black photo tape
- Clothespins (C-47s)
- Matt knife
- Torpedo level
- Bull's-eye level
- Nail and screw pouches (this does not mean you have to carry 5 pounds of each; carry about a dozen)
- #8 and #16 penny double-headed nails
- #8 drywall screws (1 in., 1-5/8 in., 2 in., 3 in.)
- Scissors (small pair)
- Mini-vise grips
- Leatherman knife.

Everyday basic tools for a grip's personal toolbox

I suggest that you carry the following tools in a hand-carried toolbox or tool (ditty) bag. This does not mean that you have to carry all of them on you at any given time – just make sure that you have these available near the set.

- (1) Hammer, claw type
- (5) Common screwdrivers, different sizes
- (1) Phillips head screwdrivers, different sizes

- (1) Reed and Prince screwdriver
- (1) Staple gun
- (1) Allen wrench set, 1/16 in. to 5/8 in. standard
- (1) Socket set, 3/8 in. drive, 1/4 in. up to 1 in.
- (1) Open-end box set, 1/4 in. to 1 in.; extra 3/8 in., 7/16 in., 1/2 in., and 9/16 in. open-end box – a box ratchet is very handy (note: the 9/16 in. wrench is the most used; have two)
- (1) Rubber-handled pliers/lineman pliers
- (1) Channel locks, rubber handle
- (1) Vise grip
- (1) 30 ft. tape measure
- (1) Torpedo level, 6 in.
- (1) Hacksaw
- (1) 4-in-1 file
- (2) Crescent wrenches (open to 1 in.)
- (1) Needle nose pliers, rubber handle
- (1) Matt knife
- (1) Flashlight
- Cam wedges
- Clothespins
- Push pins, box of 100
- Safety pins, 20
- Baling wire spool, 50 ft.
- Staples, spares
- #16 double-head nails
- #8 double-head nails
- Drywall screws, 1 in. and 1-5/8 in. to 2-1/2 in.
- Chalk, white or yellow
- Automatic tape gun (ATG)
- 3/8 in. drill bit (standard size 1/4 in. drill bit).

Power tools

These are the tools I carry in a milk crate that I bought:

- 7-1/4 in. circular saw, 110-volt A/C electric type (and a worm drive model for power cutting)
- Power screwdriver, battery operated
- Jigsaw, electric, any good one
- Drill with 1/2 in. chuck (reversible, electric, variable-trigger speed).

Useful items to also carry

- Compass with 360-degree plate – use to check direction of location.

Recommended personal gear

Clothing for sets

- Personal bag (always have your bag close by)
- Rain gear (you may be on a set that has a rain scene, or it may just rain on what was a sunny day)
- Change of clothes (you sometimes get filthy or wet)
- Ball cap or hat

- Two pairs of sunglasses (they break or get lost)
- Aspirin
- Toothbrush
- Battery-operated clock.

Clothing and items for location

Location gear is the same as set clothes but with more changes:

- Bathing suit (hotels have pools and spas)
- Plug-in clock with battery back up (always use two clocks – one electric and one battery or wind-up; I use the large number type so I do not have to wake fully up and strain to see my clock) *Note*: Never fully rely on a desk wake-up call. That's like certain death. You would not jump without a reserve chute, would you?
- All your hygiene needs
- Aspirin
- Two pairs of work shoes (rotate them daily – your feet sweat and get the shoes moist, and you don't want to get raw feet).

I always tell my grips to "plan for the worst and hope for the best." If you follow this advice, you won't be let down – I promise you!

I also carry an empty, soft-sided, zip-up duffel bag inside my travel bag. This way I have something to carry any presents home in. Trust me, you will say to yourself on many occasions, "Hey, I'll probably never be in Moscow again," or, "What are the chances of me ever coming back to Lawrence, Kansas?" When I was in Moscow, I bought several Russian army hats and several sets of nesting dolls. You will make good money, and you will spend good money.

Personal electronic equipment (a must)

It is essential to carry your own electronic equipment, particularly a statewide pager (if possible) with voice mail. If you only have a numerical pager, you usually get the number, call it back, and ask, "Did someone there page me?" If you are calling a large production office, the receptionist may not have been informed that a page was sent to you. You may miss a call that could have paid for a full year of voice-mail service. So, be smart and get a voice-mail pager.

Cell phone

A new era has arrived. If you don't answer the phone or quickly return a page, the calling party is under pressure to fill the slot with whomever else is available. This is true whether you are a newbie trying to break in or a regular trying to get more work. Once again, trust me on this. I have been on both sides of the fence. I have been told that production knows that, if I do not get back to them within 5 or 10 minutes after they have paged me, I am not in a place to call them back. That is a good reputation to have. I am a fanatic about returning a call quickly for work.

Once again, I promise you that, if your work is good, your attitude is great, and you return calls very quickly, you are projecting a sense of "ready, willing, and able." A future employer is very impressed by that. In a short time you will become known for your quick replies. Here is an illustration for you: suppose you look in a phone book for someone to replace a broken glass window, and the first company you call either does not answer the phone or you have to leave a message and they don't call you right back. I bet you then move right on down the list. It's human nature. I do not mean to sound preachy. I am just trying to get you your first job and propel you to the next and the next and the next.

6 *Filters and gels*

Fluorescent light filters

Standard cool-white or daylight fluorescent tubes offer a reasonable approximation of photographic daylight except for their excessive green content. Two separate techniques are available to deal with this situation: (1) balance all sources to the fluorescent, or (2) balance the fluorescent to the sources.

Tungsten conversion filters

Rosco Tungsten Conversion Filters convert incandescent 3,200 K sources to nominal daylight (aka 5,600 K). These filters offer a deep-dyed base for optical clarity and high-heat stability. They are about 100 sq. ft. (54 in. wide).

Rosco Product 3304 is applied to windows or daylight sources and 3306 is applied to 3,200 K sources to balance them to the fluorescent lights. Rosco Products 3308, 3313, 3314, 3310, and 3311 are applied to fluorescent lights to convert them to either 3,200 K or nominal daylight (aka 5,600 K). A roll of the material is generally a little over 100 sq. ft. (54 in. by 25 ft.), and the products are optically clear.

Neutral density filters

Rosco Sun Neutral Density Filters reduce the level of incident daylight. Two of the materials also convert daylight to a nominal 3,200 K. Except for RoscoScrim (54 in. wide), all roll materials are 100 sq. ft. (58 in. wide) and are optically clear.

Daylight conversion filters

Rosco Sun Daylight Conversion Filters are used when shooting in an interior at a 3,200 K balance. They are required at windows or other openings to convert incident daylight to an approximation of 3,200 K. Partial conversions are utilized where less than full correction (a cooler or bluer daylight appearance) is preferred. All roll materials are 100 sq. ft. (58 in. wide) and optically clear.

A professional's tips on the trade

A roll of gel is usually about 25 ft. long and about 4 ft. wide. This gives you enough gel to cover six 4 × 4 frames. (NICE TO KNOW)

7 *The rental house*

Let me give you a typical "load-in" day at a studio equipment rental supply house. First and foremost, "Thank God for rental houses." The owners have put a lot of time and money into setting them up. I know this because for eight years I owned one myself. Believe me when I say, it will turn a grown person's hair gray fast. No matter what size of rental company you go to, it probably will not have all the equipment that you need. You as a technician will sometimes have to plan for the equipment that the rental company does not have. You'll have to work with substitutions. You will have to work with what is available. Then, the other shoe drops. This is called the shortlist. Let me explain by giving you an everyday scenario.

Day 1

You arrive at the equipment rental yard on the first day to load in. This means you will be getting all the equipment pulled from their inventory. This equipment will be ("laced out") laid on the ground to be inspected, counted, and then loaded onto the truck later. Let's pretend you're going to begin a medium-sized feature film. You will probably get three to five working days to (prep) load the truck. You're excited, you're ready, and you're short! "What do you mean you don't have 12 Hi Hi rollers?," you ask. The rental company only has seven in stock. They may ask, "Will three low high and two high rollers do?" Quickly, you as the key grip will have to rethink your needs. Okay, let's say you have figured this out. You inspect the equipment as it is pulled, you have counted it out, and then you load it on the truck. You may have had to build shelves or rent prebuilt ones for the truck. Be prepared! Okay, here's the deal on the shortlist. When the truck rolls out of the rental yard to go to your location, you may have various pieces of the equipment that will be delivered to you over the course of your film. Sometimes these drops will entail a single drop load or four or five different loads, as needed. You might get reasons like, "We were out of stock and so is everyone else in the area." If the rental house has to substitute rent it from someplace far away, there may be a cost for shipping, which may become cost-prohibitive. If this piece of equipment is so essential, make sure you speak to the powers that be – the production manager, the producer, the rental house manager. Get it worked out! There is a saying: "If there are no issues, you will need no tissues," or so I've been told. Let me finish this by saying two words: "Can do." Here is the basic fix: "If you have all the money and time in the world, you can fix most problems." If you don't, work it out. Now let's get into some rigging of cameras on . . . well, everything!

8 Techniques for mounting the camera

Author note:

Local # 80 Key Grip "Brady Mc Elroy" drew all the following drawings for this chapter. He is a top Key Grip here in Hollywood who owns "BAM" Grip Inc.**http://bamgripinc.com**.

703 Pier Ave., Ste. B #191

Hermosa Beach, CA 90254

P: (661) 433-1668

F: (310) 375-7044

A camera can be mounted on aircraft, cars, motorcycles, Jet Skis, boats, parasails, and elsewhere, but you've got your work cut out for you. I will list a few things that are a must when mounting a camera. Remember that a camera and lens usually cost between $50,000 to $500,000 on the average. No oops, no do-overs allowed. If you want to be able to say, "I'll be back," do it right. (I know that I'm scaring you . . . Good!) Here are a few hints. There are many ways to rig a vehicle. First, if you can get most of the big chunks of equipment from Modern, American, Matthews, or Norm's Studio Equipment. (All near Hollywood, California.) You can either rent it or buy it. It will pay for itself over and over again – not only by the rental revenue, but also by the impression it leaves with directors of photography, directors, and producers if you excel in this area of gripping. You will look like a professional, and we all know what looks can do.

I use a combination of Modern and Speed-Rail® equipment. Seno Moussally (also known as "Yoda"), the owner of Modern, takes my designs, builds the rig exactly to my specifications, and usually enhances the design after he sees where I am going with it. All the other manufacturers mentioned have excellent equipment; I simply have developed a personal relationship with Seno. Eddie Phillips at Matthews is fantastic. He sold me my first grip equipment package. Norm Jr. at Norm's is a grip turned business executive who really knows the ins and outs, and Lance at American has always aimed to build a better mousetrap.

With reliable vendors, cellular telephones, and overnight delivery services, there is no reason not to get the right piece of equipment immediately. At Modern, Seno has a huge showroom of widgets, gadgets, tubes, sleeves, plates, and rigs already built. He really has "been there and rigged that." When I had four hours to rig a side-mounted camera on a brand new Mercedes, I drove the car to Modern, and Seno welded and fit what I needed on the spot. I drove back to the set, had a nice cup of coffee, and got the shots production needed. What I am trying to say is that I only act like a genius. *I use all the current Albert Einsteins of the film industry* to further my projects. I can't do it all, but I know who can, and I just gave you their names. Learn from the masters.

Here is a trick I use when I mount clamps on motorcycle frames. I apply 2 in. paper tape to the area where I will apply the starter clamp. Then I put gaffer tape over the paper tape. The paper tape is easier to peel off the painted frame than gaffer tape is. After you have wrapped the gaffer

tape two to three times around the frame, cut out a piece of rubber mat and wrap it only once around the frame, then attach the metal clamp. This system should hold the clamp in place without scraping or marring the tube of the motorcycle frame. Whenever you mount a camera on a motorcycle, try to get three or four starter points on each mount. This gives it stability, and when you are asked to adjust the rig angle of the camera, your work will be expedited. Trust me on this; no mount is rigged in stone. Film is moving art. Changes to camera angles are often made. Be prepared for those changes.

At first it may seem like it takes a little longer to get started, but I promise you it will pay off for you. It's called planning ahead. They say advice is worth what it cost you; you paid for the advice in this book, so use it. This book is about my making you one of the best, safest, and fastest mounting riggers out there.

A car, truck, boat, or other vehicle may have to have a camera mounted on it. This is where expertise and imagination come together. You may be called on to mount a camera on a bicycle, airplane, train, or even a Jet Ski. (Believe me, a Jet Ski can be fitted with a camera.) There are several types of mounts, but there are no specific mounts for specific applications. This is where you step in as a grip. You will have to use the basic mounts available and design your own. It seems tough at first, but if you are someone who likes to build things you will enjoy this. I have provided illustrations of mounts I have made with any materials at hand (Figure 8.1).

Use the list of materials to get a basic idea of what you will need to design and rig your own mounts. You can use wood, metal, plastic, or anything else that works safely. Observe one of the Golden Rules: there are ten ways to do the same job, and usually they all work.

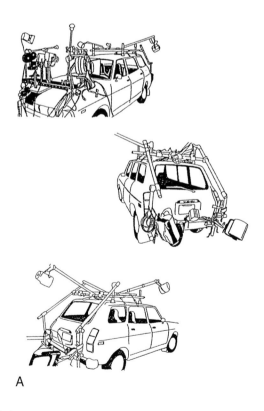

A

Figure 8.1a Speed-Rail rig on car

B

Figure 8.1b Adjustable leveling leg on hood mount

C

Figure 8.1c Gobo head and arm (C-stand head and arm) used as a menace arm to rig a small light

Speed-Rail® tubing and fittings

I prefer Speed-Rail® tubing and fittings. They can be assembled quickly, they are strong, and your rig will look like a professional designed it. You can add or subtract tubing by loosening two setscrews. The standard-size tubing I have used most is 1-1/4 in. (1.68 in. OD; or 3.2 mm with a 4.27 mm OD), although larger tubing can be used.

A pro trick of the trade for mounting a camera on a car or any vehicle is to find out whether the vehicle has been strip painted. Strip painting is temporary paint that peels off after you are finished with the vehicle. Strip painting sometimes is needed to match or change the color of a car for a certain scene. The car is then changed back to the original color for a matching scene, days or even weeks later. Your job as a grip is to ensure that the camera is mounted securely and safely without ruining the paint or damaging the car. Installing a camera on a mount you have safely and securely rigged on a vehicle usually is accomplished with one bolt – a 3/8 in. × 16 pitch bolt. This bolt cannot be too tight or you will bend or pull the thread out of the $100,000 camera. If the bolt is too loose, the camera may move, ruining the shot and possibly your career (Figures 8.2, 8.3, and 8.4). Screw the bolt into the base of the camera until it bottoms, mark the remaining threads with a marking pen or tape, back out the bolt, and measure the amount of threaded portion of the bolt that went into the camera body.

Another pro trick of the trade is to know that usually about 1/4 in. to 1/2 in. of thread can be inserted into the camera base.

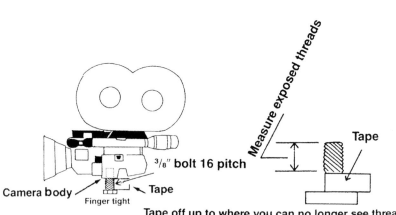

Figure 8.2 Tape method

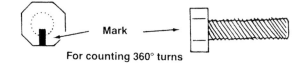

Figure 8.3 Marker methods

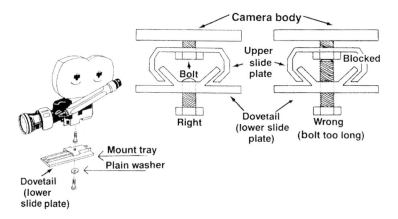

Figure 8.4 Dovetail method

If you cannot mark the threaded portion of the bolt that is sticking out, mark the head of the bolt and count how many completed 360-degree counterclockwise revolutions or fractions thereof it takes to back out the bolt. Record this information to use later when you are mounting the camera for your shot. Never insert the bolt too deeply, but do not use too few of the threads, either. My suggestion is to know how deep the bolt can and will go into the camera body, measure the thickness of the plate or mounting surface, and add this length and the thickness of a flat washer to the length of the bolt. I use a washer (usually flat) because when you tighten the bolt to the base, the bolt grinds (galls) its way into the metal and produces a locking action. These mounts usually are expensive and usually are rented from a rental house. You do not want to ruin an expensive mount when an inexpensive washer can take the beating instead. It shows you are a professional. If too much bolt enters the base of the

camera, the camera will jam or short circuit. You must work with someone who has experience before you start mounting cameras. A dovetail plate is a slide plate for the base of a camera (Figure 8.4). There are other types of quick releases as well. I only use a dovetail to illustrate. Most camera plates allow quick mounting and dismounting of a camera. Continued: insert a bolt through the mount plate base to the dovetail (slide plate) to ensure that the thread of the bolt does not exceed the height of the wings or lip of the dovetail plate. If the threads are too high, the camera will not slide on the plate. This should tell you that something is wrong. You should not have any problems if you use this plate. If there is no dovetail (slide plate) to use, you must mount the camera body directly with a bolt, as described earlier.

Power grip or super grip (mounting technique)

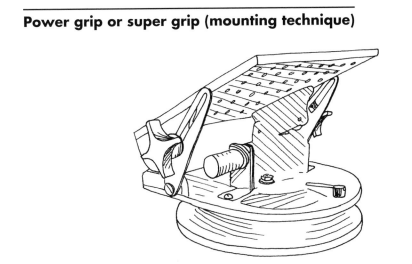

Figure 8.5 Adjustable plate on super grip

Camera clamp

Fastened with a screwdriver for greater holding power, a 16 mm clamp is specially designed for a lightweight film or television camera. A 35 mm camera clamp is a heavy-duty camera clamp. The clamps have a steel core and are cadmium plated and electro painted (Figure 8.6).

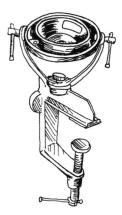

Figure 8.6 Camera clamp

Figure 8.7 Ball level head

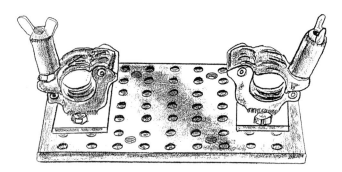

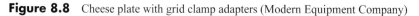

Figure 8.8 Cheese plate with grid clamp adapters (Modern Equipment Company)

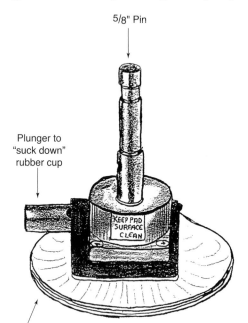

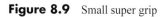

Figure 8.9 Small super grip

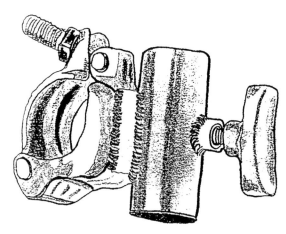

Figure 8.10 Junior grid clamp 1-1/8 in. receiver (Modern Equipment Company)

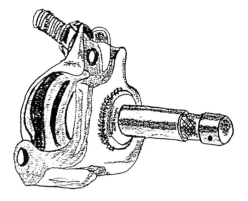

Figure 8.11 Baby grid clamp 5/8 in. pin (Modern Equipment Company)

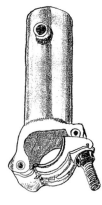

Figure 8.12 Speed-Rail® to grid clamp adapter (Modern Equipment Company)

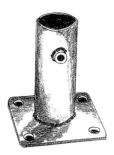

Figure 8.13 Speed-Rail® flange plate (Modern Equipment Company)

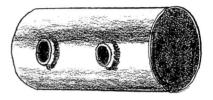
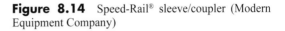

Figure 8.14 Speed-Rail® sleeve/coupler (Modern Equipment Company)

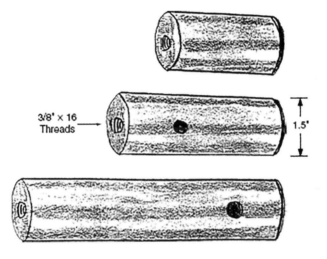

3/8' × 16 Threads

1.5'

Figure 8.15 Starter plugs (smooth) for Speed-Rail® 1-1/2 in. (Modern Equipment Company)

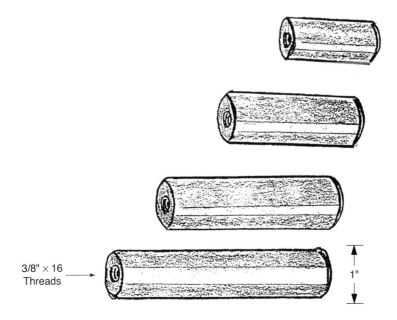

3/8" × 16 Threads

1"

Figure 8.16 Starter plugs (smooth) for Speed-Rail® 1 in. (Modern Equipment Company)

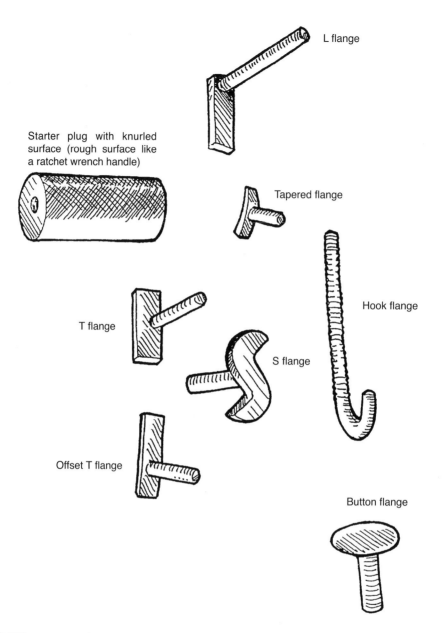

L flange

Starter plug with knurled surface (rough surface like a ratchet wrench handle)

Tapered flange

Hook flange

T flange

S flange

Offset T flange

Button flange

Figure 8.17 Speed-Rail® starter plug flanges for auto frames (3/8 in. × 16 pitch thread) (Modern Equipment Company)

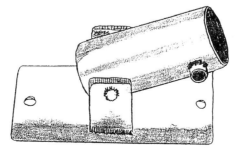

Figure 8.18 Speed-Rail® swivel flange (Modern Equipment Company)

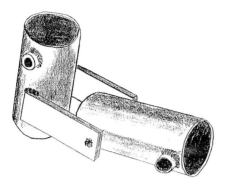

Figure 8.19 Speed-Rail® double coupler swivel (Modern Equipment Company)

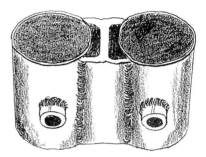

Figure 8.20 Speed-Rail® double coupler (Modern Equipment Company)

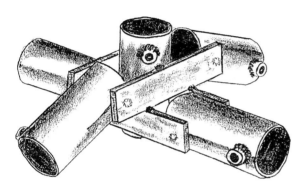

Figure 8.21 Four-way swivel coupler for Speed-Rail® (Modern Equipment Company)

Figure 8.22 No nail hanger

Figure 8.23 Baby 5/8 in. to junior 1-1/8 in. pin adapter 90% 5/8 in. angle pin (Modern Equipment Company)

Figure 8.24 Baby pin 5/8 in. to spade adapter (Modern Equipment Company)

Figure 8.25 Four-way baby pin 5/8 in. offset pin and receiver (Modern Equipment Company)

Figure 8.26 Four-way star offset pin 5/8 in. pin and receiver (Modern Equipment Company)

Figure 8.27 Three-way baby pin 5/8 in. pin and receiver (Modern Equipment Company)

Figure 8.28 Junior receiver 1-1/8 in. to baby pin 5/8 in. (Modern Equipment Company)

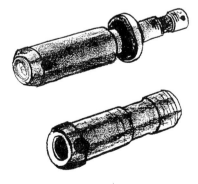

Figure 8.29 Baby pin to baby pin adapter 5/8 in. receiver (Modern Equipment Company)

Figure 8.30 Junior pin 1-1/8 in. to baby pin 5/8 in. receiver/adapter (Modern Equipment Company)

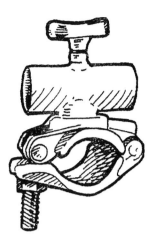

Figure 8.31 Junior grip clamp

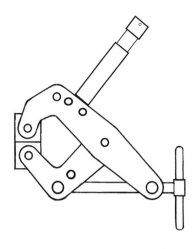

Figure 8.32 Speed clamp (Timco Company)

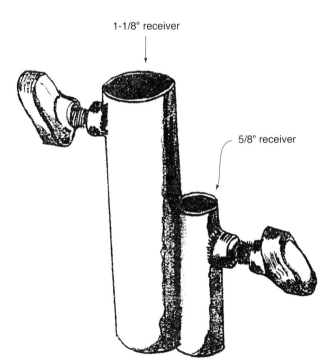

Figure 8.33 Junior 1-1/8 in. receiver to baby pin 5/8 in. receiver (Modern Equipment Company)

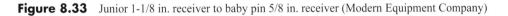

Mini-slider SR-71 dolly (mounting technique)

The mini-slider dolly requires no assembly. Figures 8.34 and 8.35 illustrate two different types. It is a skate-wheel dolly that glides securely within black anodized aluminum channel beams. Wheel tension can be adjusted to control slider flow. A locking brake allows rigid camera positioning. Beam end clamps have 1-1/4 in. Speed-Rail® flanges mounted to facilitate rigging (the Speed-Rail®, elbows, and tees are not included). The package includes one set of 4 ft. (1.2 m) beams; optional 8 ft. (2.4 m)

Figure 8.34 Boxed slider with Mitchell mount

beams also are available. A longer channel beam can be used. The mini-slider dolly comes with a Mitchell plate on 4 in. (10 cm) riser stands. The Mitchell plate can be secured to the dolly base for lower mounting of a fluid head or secured to the underside of the dolly base for use with a remote or Weaver Steadman head.

Slider

www.theslider.com

- Ultra-smooth linear bearing movement
- Quick and easy setup with no assembly required
- Carrying case
- Many models: 2 ft., 3 ft., up to 60 ft.
- Use with any camera movement from 0 to 6 in.
- Use with any Mitchell detail head.

Mounting suggestions

- Two apple boxes as a sliding high hat
- Any camera dolly to make adjustments
- Any camera dolly to make camera moves without a track
- Tripod to make camera moves
- Speed-Rail® pipe for a sliding car mount
- Process trailer to make moves without a dolly track
- Car to make moves on the interior of a car
- Undersling on a crane arm to make the crane arm more versatile
- Condor to make camera moves wherever the condor takes you
- Camera car to add a new dimension to camera car moves.

I have used this piece of equipment on many car shoots, and the camera operators have been very pleased with the shots they have gotten. Don't limit your shots to car shoots, though.

Figure 8.35 Slider with Mitchell plate

Truss system

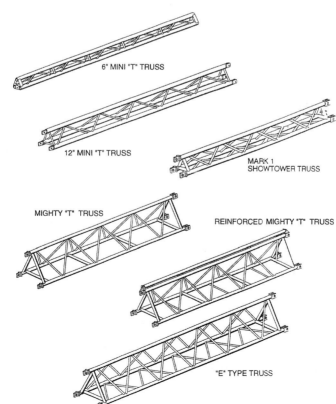

Figure 8.36a Assorted show rig truss systems

PATENT PENDING
Designed and Manufactured by
SGPS,Inc.

• Use it for framing translights, painted backings and green screens.

• Mini T is a low profile truss that has been designed as a lighter weight, stiffer alternative to steel water pipe and irrigation pipe.

•6" Mini-"T' weighs 62 lbs. per 20 ft. section A 20 ft. piece of 1 1/2" schedule 40 black water pipe weighs 54.5 lbs. Three times the rigidity for almost the same weight.

• Our framing corners are designed so the single pipe is on the inside for easy tensioning of soft goods in the frame.

• A 20 ft. section is easily carried by one person.

• Hang curtains and masking on less points.

Chords are made using 1 1/4" Speed Rail

Unit Weight
• 20 ft 60 lbs.

Securely bolts together using Grade 8 Hardened Bolts

Figure 8.36b Mini truss

SAFE WORKING LOAD 1000 lbs UNIFORMLY DISTRIBUTED OVER 40 ft SPAN.

GREAT FOR BACKINGS AND BLUE SCREENS

12" FROM CENTER TO CENTER OF MAIN CHORDS

LIGHTWEIGHT ALL-ALUMINUM CONSTRUCTION AVAILABLE IN 4 ft, 5 ft, 8 ft,10 ft, 14 ft & 20 ft SECTIONS.

ISOMETRIC VIEW OF 10 ft SECTION

TOP CHORD 1.5" SCH. 40 PIPE

BOTTOM CHORDS 1.5" SCH. 40 PIPE FITS ALL SCAFFOLD CLAMPS

ALL BRACING WITH 1" SCH. 40 PIPE

Unit Weight
• 4 ft 15 lbs.
• 8 ft 30 lbs.
•10 ft 40 lbs.
•16 ft 70 lbs.
•20 ft 80 lbs.

Figure 8.36c 12 in. mini "T" truss

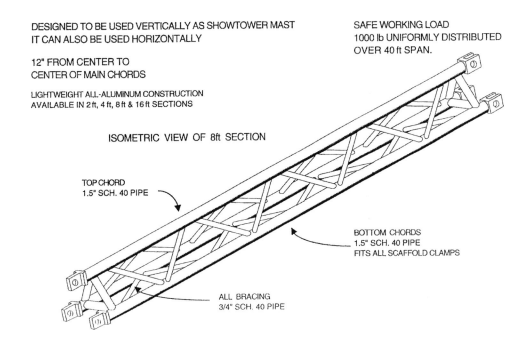

DESIGNED TO BE USED VERTICALLY AS SHOWTOWER MAST
IT CAN ALSO BE USED HORIZONTALLY

SAFE WORKING LOAD
1000 lb UNIFORMLY DISTRIBUTED
OVER 40 ft SPAN.

12" FROM CENTER TO
CENTER OF MAIN CHORDS

LIGHTWEIGHT ALL-ALUMINUM CONSTRUCTION
AVAILABLE IN 2 ft, 4 ft, 8 ft & 16 ft SECTIONS

ISOMETRIC VIEW OF 8ft SECTION

TOP CHORD
1.5" SCH. 40 PIPE

BOTTOM CHORDS
1.5" SCH. 40 PIPE
FITS ALL SCAFFOLD CLAMPS

ALL BRACING
3/4" SCH. 40 PIPE

Figure 8.36d Mark 1 show tower truss

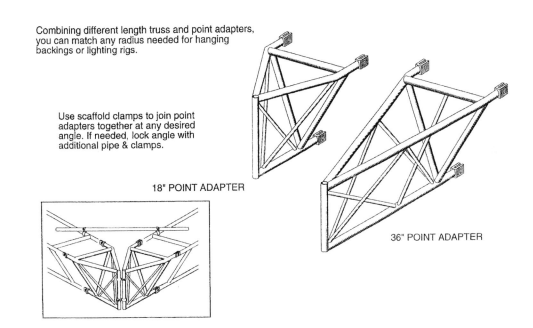

Combining different length truss and point adapters,
you can match any radius needed for hanging
backings or lighting rigs.

Use scaffold clamps to join point
adapters together at any desired
angle. If needed, lock angle with
additional pipe & clamps.

18" POINT ADAPTER

36" POINT ADAPTER

Figure 8.36e Pointed adapters

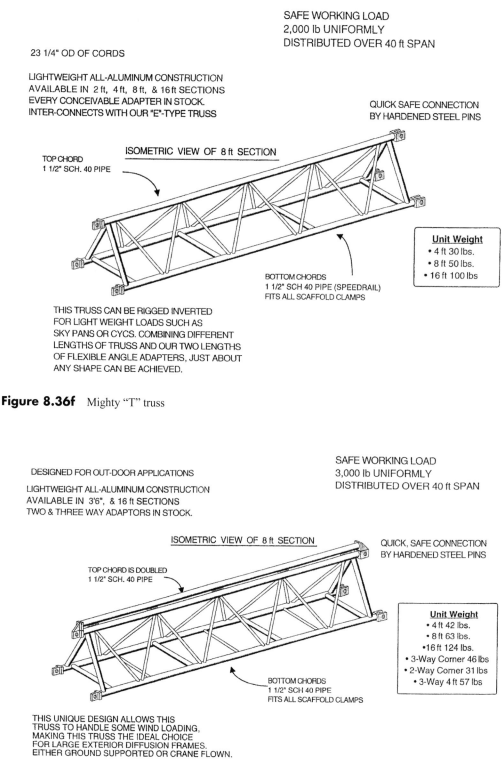

SAFE WORKING LOAD
2,000 lb UNIFORMLY
DISTRIBUTED OVER 40 ft SPAN

23 1/4" OD OF CORDS

LIGHTWEIGHT ALL-ALUMINUM CONSTRUCTION
AVAILABLE IN 2 ft, 4 ft, 8 ft, & 16 ft SECTIONS
EVERY CONCEIVABLE ADAPTER IN STOCK.
INTER-CONNECTS WITH OUR "E"-TYPE TRUSS

QUICK SAFE CONNECTION
BY HARDENED STEEL PINS

ISOMETRIC VIEW OF 8 ft SECTION

TOP CHORD
1 1/2" SCH. 40 PIPE

Unit Weight
• 4 ft 30 lbs.
• 8 ft 50 lbs.
• 16 ft 100 lbs

BOTTOM CHORDS
1 1/2" SCH 40 PIPE (SPEEDRAIL)
FITS ALL SCAFFOLD CLAMPS

THIS TRUSS CAN BE RIGGED INVERTED
FOR LIGHT WEIGHT LOADS SUCH AS
SKY PANS OR CYCS. COMBINING DIFFERENT
LENGTHS OF TRUSS AND OUR TWO LENGTHS
OF FLEXIBLE ANGLE ADAPTERS, JUST ABOUT
ANY SHAPE CAN BE ACHIEVED.

Figure 8.36f Mighty "T" truss

DESIGNED FOR OUT-DOOR APPLICATIONS

LIGHTWEIGHT ALL-ALUMINUM CONSTRUCTION
AVAILABLE IN 3'6", & 16 ft SECTIONS
TWO & THREE WAY ADAPTORS IN STOCK.

SAFE WORKING LOAD
3,000 lb UNIFORMLY
DISTRIBUTED OVER 40 ft SPAN

ISOMETRIC VIEW OF 8 ft SECTION

QUICK, SAFE CONNECTION
BY HARDENED STEEL PINS

TOP CHORD IS DOUBLED
1 1/2" SCH. 40 PIPE

Unit Weight
• 4 ft 42 lbs.
• 8 ft 63 lbs.
• 16 ft 124 lbs.
• 3-Way Corner 46 lbs
• 2-Way Corner 31 lbs
• 3-Way 4 ft 57 lbs

BOTTOM CHORDS
1 1/2" SCH 40 PIPE
FITS ALL SCAFFOLD CLAMPS

THIS UNIQUE DESIGN ALLOWS THIS
TRUSS TO HANDLE SOME WIND LOADING,
MAKING THIS TRUSS THE IDEAL CHOICE
FOR LARGE EXTERIOR DIFFUSION FRAMES.
EITHER GROUND SUPPORTED OR CRANE FLOWN.

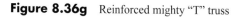

Figure 8.36g Reinforced mighty "T" truss

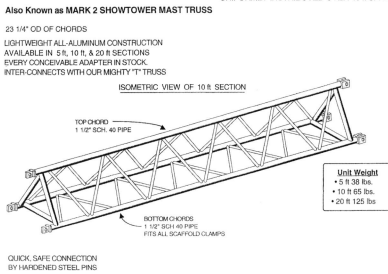

SAFE WORKING LOAD 2,000 lbs
UNIFORMLY DISTRIBUTED OVER 40 ft SPAN

Also Known as MARK 2 SHOWTOWER MAST TRUSS

23 1/4" OD OF CHORDS

LIGHTWEIGHT ALL-ALUMINUM CONSTRUCTION
AVAILABLE IN 5 ft, 10 ft, & 20 ft SECTIONS
EVERY CONCEIVABLE ADAPTER IN STOCK.
INTER-CONNECTS WITH OUR MIGHTY "T" TRUSS

ISOMETRIC VIEW OF 10 ft SECTION

TOP CHORD
1 1/2" SCH. 40 PIPE

Unit Weight
• 5 ft 38 lbs.
• 10 ft 65 lbs.
• 20 ft 125 lbs

BOTTOM CHORDS
1 1/2" SCH 40 PIPE
FITS ALL SCAFFOLD CLAMPS

QUICK, SAFE CONNECTION
BY HARDENED STEEL PINS

Figure 8.36h Also known as Mark 2 show tower mass truss

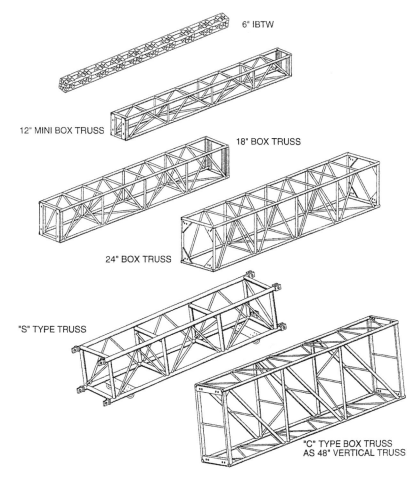

6" IBTW

12" MINI BOX TRUSS

18" BOX TRUSS

24" BOX TRUSS

"S" TYPE TRUSS

"C" TYPE BOX TRUSS
AS 48" VERTICAL TRUSS

Figure 8.36i Assorted box truss

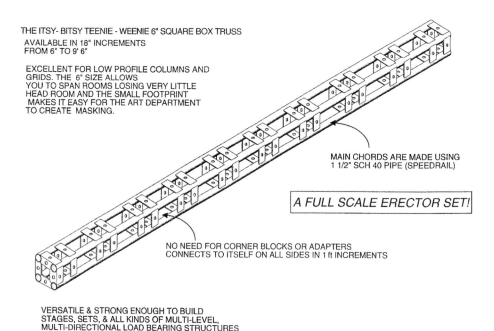

THE ITSY- BITSY TEENIE - WEENIE 6" SQUARE BOX TRUSS

AVAILABLE IN 18" INCREMENTS
FROM 6" TO 9' 6"

EXCELLENT FOR LOW PROFILE COLUMNS AND
GRIDS. THE 6" SIZE ALLOWS
YOU TO SPAN ROOMS LOSING VERY LITTLE
HEAD ROOM AND THE SMALL FOOTPRINT
MAKES IT EASY FOR THE ART DEPARTMENT
TO CREATE MASKING.

MAIN CHORDS ARE MADE USING
1 1/2" SCH 40 PIPE (SPEEDRAIL)

A FULL SCALE ERECTOR SET!

NO NEED FOR CORNER BLOCKS OR ADAPTERS
CONNECTS TO ITSELF ON ALL SIDES IN 1 ft INCREMENTS

VERSATILE & STRONG ENOUGH TO BUILD
STAGES, SETS, & ALL KINDS OF MULTI-LEVEL,
MULTI-DIRECTIONAL LOAD BEARING STRUCTURES

Figure 8.36j 6 in. IBTW

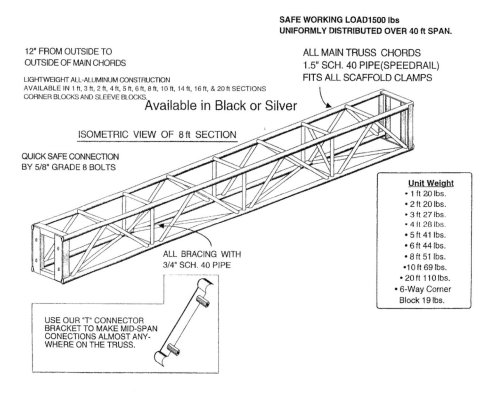

SAFE WORKING LOAD 1500 lbs
UNIFORMLY DISTRIBUTED OVER 40 ft SPAN.

12" FROM OUTSIDE TO
OUTSIDE OF MAIN CHORDS

ALL MAIN TRUSS CHORDS
1.5" SCH. 40 PIPE (SPEEDRAIL)
FITS ALL SCAFFOLD CLAMPS

LIGHTWEIGHT ALL-ALUMINUM CONSTRUCTION
AVAILABLE IN 1 ft, 3 ft, 2 ft, 4 ft, 5 ft, 6 ft, 8 ft, 10 ft, 14 ft, 16 ft, & 20 ft SECTIONS
CORNER BLOCKS AND SLEEVE BLOCKS.

Available in Black or Silver

ISOMETRIC VIEW OF 8 ft SECTION

QUICK SAFE CONNECTION
BY 5/8" GRADE 8 BOLTS

Unit Weight
• 1 ft 20 lbs.
• 2 ft 20 lbs.
• 3 ft 27 lbs.
• 4 ft 28 lbs.
• 5 ft 41 lbs.
• 6 ft 44 lbs.
• 8 ft 51 lbs.
• 10 ft 69 lbs.
• 20 ft 110 lbs.
• 6-Way Corner Block 19 lbs.

ALL BRACING WITH
3/4" SCH. 40 PIPE

USE OUR "T" CONNECTOR
BRACKET TO MAKE MID-SPAN
CONECTIONS ALMOST ANY-
WHERE ON THE TRUSS.

Figure 8.36k 12 in. mini box truss

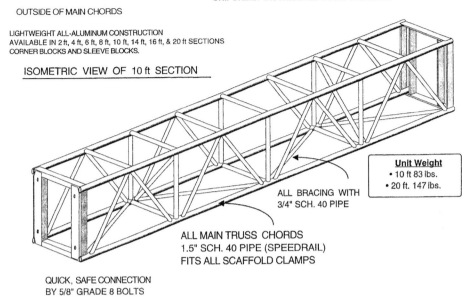

SAFE WORKING LOAD 2000 lbs
UNIFORMLY DISTRIBUTED OVER 40 ft SPAN.

OUTSIDE OF MAIN CHORDS

LIGHTWEIGHT ALL-ALUMINUM CONSTRUCTION
AVAILABLE IN 2 ft, 4 ft, 6 ft, 8 ft, 10 ft, 14 ft, 16 ft, & 20 ft SECTIONS
CORNER BLOCKS AND SLEEVE BLOCKS.

ISOMETRIC VIEW OF 10 ft SECTION

Unit Weight
• 10 ft 83 lbs.
• 20 ft. 147 lbs.

ALL BRACING WITH
3/4" SCH. 40 PIPE

ALL MAIN TRUSS CHORDS
1.5" SCH. 40 PIPE (SPEEDRAIL)
FITS ALL SCAFFOLD CLAMPS

QUICK, SAFE CONNECTION
BY 5/8" GRADE 8 BOLTS

Figure 8.36l 18 in. box truss

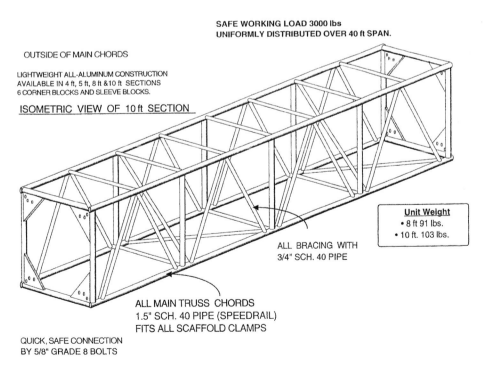

SAFE WORKING LOAD 3000 lbs
UNIFORMLY DISTRIBUTED OVER 40 ft SPAN.

OUTSIDE OF MAIN CHORDS

LIGHTWEIGHT ALL-ALUMINUM CONSTRUCTION
AVAILABLE IN 4 ft, 5 ft, 8 ft & 10 ft SECTIONS
6 CORNER BLOCKS AND SLEEVE BLOCKS.

ISOMETRIC VIEW OF 10 ft SECTION

Unit Weight
• 8 ft 91 lbs.
• 10 ft. 103 lbs.

ALL BRACING WITH
3/4" SCH. 40 PIPE

ALL MAIN TRUSS CHORDS
1.5" SCH. 40 PIPE (SPEEDRAIL)
FITS ALL SCAFFOLD CLAMPS

QUICK, SAFE CONNECTION
BY 5/8" GRADE 8 BOLTS

Figure 8.36m 24 in. box truss

SAFE WORKING LOAD **4,000 lb** UNIFORMLY
DISTRIBUTED OVER **40 ft SPAN**

26" HIGH BY 22.1/2" WIDE

LIGHTWEIGHT ALL-ALUMINUM CONSTRUCTION,
YET BUILT FOR VERY HEAVY LOADS
1 TON & 1/2 TON MOTORS CAN BE MOUNTED INTERNALLY.
AVAILABLE IN 4 ft, & 8 ft SECTIONS
STANDARD ANGLE ADAPTERS AND CORNER BLOCKS IN STOCK.

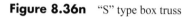

ISOMETRIC VIEW OF 8 ft SECTION

QUICK, SAFE CONNECTION
BY HARDENED STEEL PINS

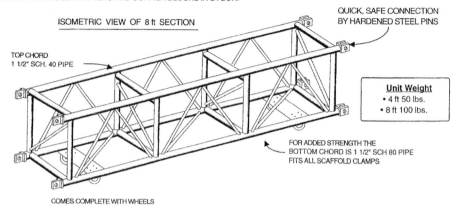

TOP CHORD
1 1/2" SCH. 40 PIPE

Unit Weight
• 4 ft 50 lbs.
• 8 ft 100 lbs.

FOR ADDED STRENGTH THE
BOTTOM CHORD IS 1 1/2" SCH 80 PIPE
FITS ALL SCAFFOLD CLAMPS

COMES COMPLETE WITH WHEELS

Figure 8.36n "S" type box truss

48 in HIGH BY 18 in WIDE
LIGHTWEIGHT, HIGH STRENGTH
ALUMINUM CONSTRUCTION

WHEN USED IN A VERTICAL ORIENTATION
THIS TRUSS IS CAPABLE OF SPANNING **80 ft**,
WITH A SAFE WORKING LOAD OF **2000 lbs**
UNIFORMLY DISTRIBUTED.

AVAILABLE IN 20 ft, 10 ft, 4 ft, & 2 ft SECTIONS

ISOMETRIC VIEW OF 10 ft SECTION

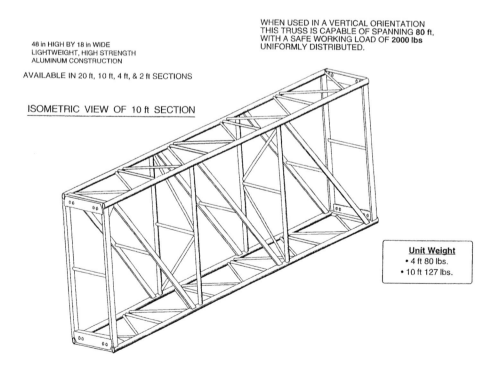

Unit Weight
• 4 ft 80 lbs.
• 10 ft 127 lbs.

Figure 8.36o "C" type box truss as 48 in. vertical truss

18 in BY 48 in LIGHTWEIGHT HIGH STRENGTH
ALUMINUM CONSTRUCTION

AVAILABLE IN 20 ft, 10 ft, 4 ft, & 2 ft SECTIONS

ISOMETRIC VIEW OF 10 ft SECTION

WHEN USED IN A HORIZONTAL ORIENTATION
THIS TRUSS IS CAPABLE OF SPANNING **40 ft**,
WITH A SAFE WORKING LOAD OF
2000 lbs UNIFORMLY DISTRIBUTED.

Unit Weight
• 4 ft 80 lbs.
• 10 ft 127 lbs.

QUICK, SAFE CONNECTION
BY 5/8" GRADE 8 BOLTS

THIS TRUSS IS IDEAL FOR HANGING OF LIGHTING
OR SET PIECES THAT REQUIRE SOME SEPARATION,
ON THE SAME TRUSS.

USED IN ITS 48"in VERTICAL POSITION,
IT'S CAPABLE OF SPANNING **80ft**,
WITH A SAFE WORKING LOAD OF
4000 lbs UNIFORMLY DISTRIBUTED.

Figure 8.36p Isometric view

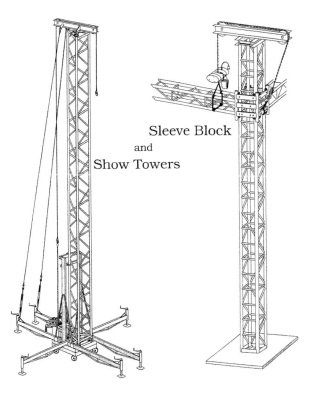

Sleeve Block
and
Show Towers

Figure 8.36q Show tower and sleeve blocks

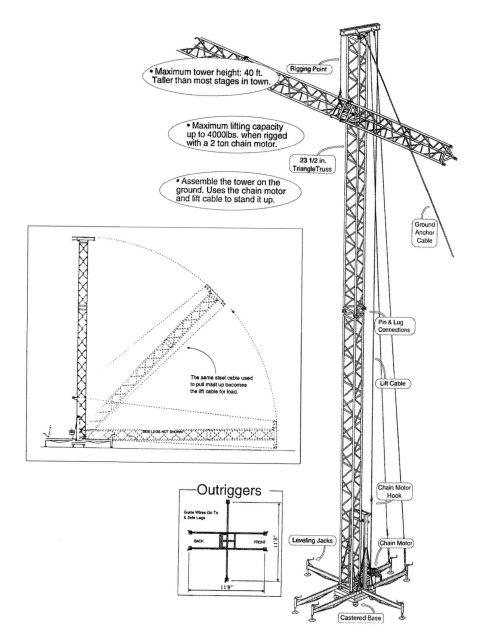

Figure 8.36r With outriggers

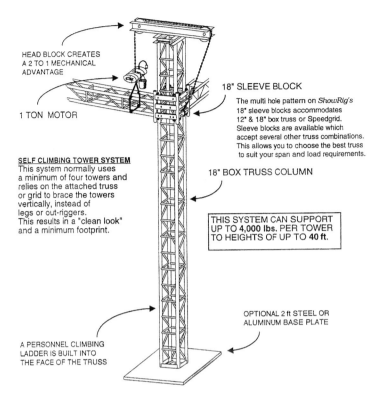

HEAD BLOCK CREATES
A 2 TO 1 MECHANICAL
ADVANTAGE

1 TON MOTOR

SELF CLIMBING TOWER SYSTEM
This system normally uses
a minimum of four towers and
relies on the attached truss
or grid to brace the towers
vertically, instead of
legs or out-riggers.
This results in a "clean look"
and a minimum footprint.

A PERSONNEL CLIMBING
LADDER IS BUILT INTO
THE FACE OF THE TRUSS

18" SLEEVE BLOCK
The multi hole pattern on *ShowRig's*
18" sleeve blocks accommodates
12" & 18" box truss or Speedgrid.
Sleeve blocks are available which
accept several other truss combinations.
This allows you to choose the best truss
to suit your span and load requirements.

18" BOX TRUSS COLUMN

THIS SYSTEM CAN SUPPORT
UP TO **4,000 lbs.** PER TOWER
TO HEIGHTS OF UP TO **40 ft.**

OPTIONAL 2 ft STEEL OR
ALUMINUM BASE PLATE

Figure 8.36s Self-climbing system

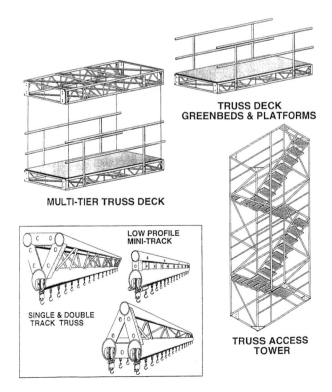

**TRUSS DECK
GREENBEDS & PLATFORMS**

MULTI-TIER TRUSS DECK

**LOW PROFILE
MINI-TRACK**

**SINGLE & DOUBLE
TRACK TRUSS**

**TRUSS ACCESS
TOWER**

Figure 8.36t Deck, railing, and track systems

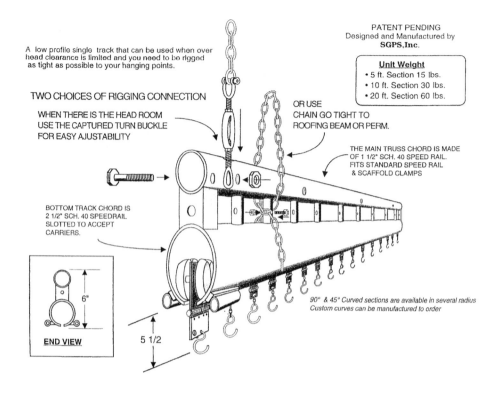

A low profile single track that can be used when over head clearance is limited and you need to be rigged as tight as possible to your hanging points.

PATENT PENDING
Designed and Manufactured by
SGPS,Inc.

Unit Weight
• 5 ft. Section 15 lbs.
• 10 ft. Section 30 lbs.
• 20 ft. Section 60 lbs.

TWO CHOICES OF RIGGING CONNECTION

WHEN THERE IS THE HEAD ROOM
USE THE CAPTURED TURN BUCKLE
FOR EASY AJUSTABILITY

OR USE
CHAIN GO TIGHT TO
ROOFING BEAM OR PERM.

THE MAIN TRUSS CHORD IS MADE
OF 1 1/2" SCH. 40 SPEED RAIL.
FITS STANDARD SPEED RAIL
& SCAFFOLD CLAMPS

BOTTOM TRACK CHORD IS
2 1/2" SCH. 40 SPEEDRAIL
SLOTTED TO ACCEPT
CARRIERS.

90° & 45° Curved sections are available in several radius
Custom curves can be manufactured to order

6"

END VIEW

5 1/2

Figure 8.36u Track system

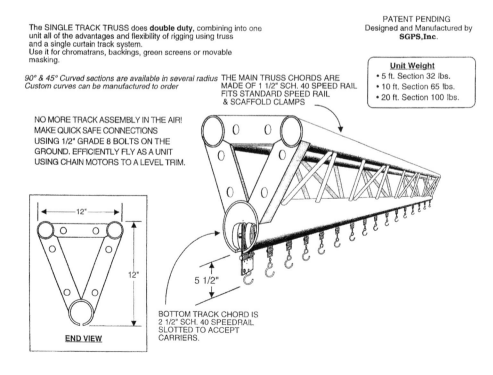

The SINGLE TRACK TRUSS does **double duty**, combining into one unit all of the advantages and flexibility of rigging using truss and a single curtain track system.
Use it for chromatrans, backings, green screens or movable masking.

PATENT PENDING
Designed and Manufactured by
SGPS,Inc.

90° & 45° Curved sections are available in several radius Custom curves can be manufactured to order

THE MAIN TRUSS CHORDS ARE
MADE OF 1 1/2" SCH. 40 SPEED RAIL
FITS STANDARD SPEED RAIL
& SCAFFOLD CLAMPS

Unit Weight
• 5 ft. Section 32 lbs.
• 10 ft. Section 65 lbs.
• 20 ft. Section 100 lbs.

NO MORE TRACK ASSEMBLY IN THE AIR!
MAKE QUICK SAFE CONNECTIONS
USING 1/2" GRADE 8 BOLTS ON THE
GROUND. EFFICIENTLY FLY AS A UNIT
USING CHAIN MOTORS TO A LEVEL TRIM.

12"

12"

5 1/2"

BOTTOM TRACK CHORD IS
2 1/2" SCH. 40 SPEEDRAIL
SLOTTED TO ACCEPT
CARRIERS.

END VIEW

Figure 8.36v Single truss track

The Double Truss Track does **double duty**, combining into one unit all of the advantages and flexibility of rigging using truss and the convenience of a double curtain track system.
Use it for day and night chromatrans, backings, green screens or movable masking.

90° Curved sections are available in several radius Custom curves can be manufactured to order

NO MORE TRACK ASSEMBLY IN THE AIR!
MAKE QUICK SAFE CONNECTIONS
USING 1/2" GRADE 8 BOLTS ON THE
GROUND. EFFICIENTLY FLY AS A UNIT
USING CHAIN MOTORS TO A LEVEL TRIM.

PATENT PENDING
Designed and Manufactured by
SGPS,Inc.

THE MAIN TRUSS CHORD IS MADE
OF 1 1/2" SCH. 40 SPEED RAIL.
FITS STANDARD SPEED RAIL
& SCAFFOLD CLAMPS

Unit Weight
• 5 ft. Section 35 lbs.
• 10 ft. Section 70 lbs.
• 20 ft. Section 110 lbs.

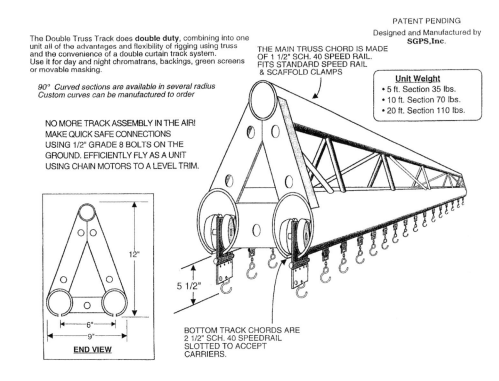

END VIEW

12"
6"
9"
5 1/2"

BOTTOM TRACK CHORDS ARE
2 1/2" SCH. 40 SPEEDRAIL
SLOTTED TO ACCEPT
CARRIERS.

Figure 8.36w Double truss track

A safe and cost effective full featured greenbed system for places that "studio" beds don't work. This system can be rigged or ground supported in any warehouse or aircraft hanger.

THIS SYSTEM COMBINES THE STRUCTURAL STRENGTH OF AN ALUMINUM TRUSSING SYSTEM WITH A CONVENTIONAL GREENBED STYLE DECK SO YOU CAN SPAN THE DISTANCES BETWEEN THE BUILDINGS'S STRUCTURAL BEAMS.

LIGHT WEIGHT, HIGH STRENGTH ALUMINUM CONSTRUCTION
ALLOWS FOR EASY ACCESS AND GREATER DECK CAPACITY
WITHOUT EXCEEDING THE LOAD LIMITS OF THE BUILDING

Unit Weight
• 4' x 4' Deck 90 lbs.
• 4' x 10' Deck 223 lbs.

DECKS ARE AVAILABLE IN 2 FT, 3 FT & 4 FT WIDE VERSIONS.
VARIOUS LENGTHS ALONG WITH
CORNER SECTIONS & "T" CONNECTIONS,
ACCOMMODATES YOUR EXACT LAYOUT REQUIREMENTS

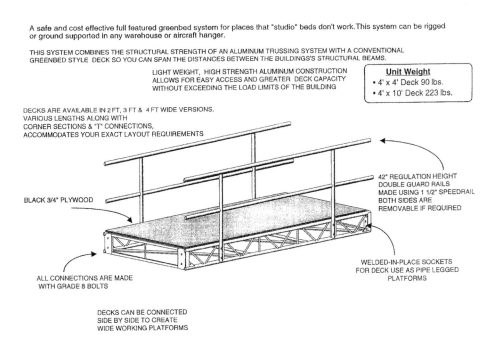

BLACK 3/4" PLYWOOD

42" REGULATION HEIGHT
DOUBLE GUARD RAILS
MADE USING 1 1/2" SPEEDRAIL
BOTH SIDES ARE
REMOVABLE IF REQUIRED

ALL CONNECTIONS ARE MADE
WITH GRADE 8 BOLTS

WELDED-IN-PLACE SOCKETS
FOR DECK USE AS PIPE LEGGED
PLATFORMS

DECKS CAN BE CONNECTED
SIDE BY SIDE TO CREATE
WIDE WORKING PLATFORMS

Figure 8.36x Studio beds

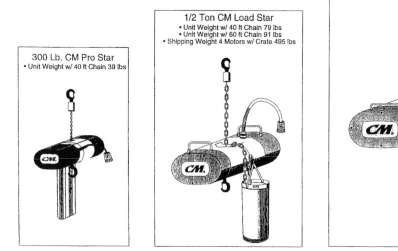

300 Lb. CM Pro Star
• Unit Weight w/ 40 ft Chain 39 lbs

1/2 Ton CM Load Star
• Unit Weight w/ 40 ft Chain 79 lbs
• Unit Weight w/ 60 ft Chain 91 lbs
• Shipping Weight 4 Motors w/ Crate 495 lbs

1 Ton CM Load Star
• Unit Weight w/ 60 ft Chain 147 lbs
• Shipping Weight 2 Motors w/ Case 421 lbs

Figure 8.36y Assorted chain motors

This Power Distribution and control unit can control from 1 to 6 motors. Each motor circuit can be controlled separately. Because the PD is compact and light weight it can be mounted on the truss, easily hauled up into the perms or left on the floor taking up very little space.

The power connection is on the back panel. Power cable comes with each PD. For the power tie-in we can provide bare ends, sister lugs, or tweko connectors. Additionally on the back panel is a power output allowing for the use of "jumpers" to feed other PDs, eliminating the need for multiple power tie-ins.

Power Requirement:	
For use with 1/2 ton motors	30 amps 208v/3 phase
For use with 1 ton motors	60 amps 208v/3 phase

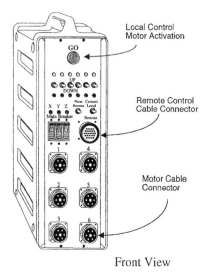

Local Control Motor Activation

Remote Control Cable Connector

Motor Cable Connector

Front View

6-Way Hand Held Remote

Figure 8.36z Distribution system

9 *Cables, slings, and hardware*

When picking cable for a project, I usually use aircraft-rated cable. It is strong and flexible and works nicely for most jobs. Seven by nineteen (see later discussion) usually seems to work best. Use the fixture that allows you to accomplish the job safely. If you do not have a great deal of experience with cable, contact VER Sales in Burbank, California. They are as close to experts as anyone can be. I did a car spot for a Japanese manufacturer with a hot young actor. My crew had to fly a 60 ft. by 80 ft. frame with silk on it. We used aircraft cable locks, span sets, and a 70-ton crane with a spreader beam on it to distribute the weight. I tell this story because years ago, when I first started keying, my budget was for rope, not cable. As my jobs grew, I had to ask a lot of folks for a lot of advice. For this particular job, I went to VER Sales and explained that I really did not have a lot of experience, told them what the shot entailed, and asked them to help me decide what equipment I needed. Do not try to be a know-it-all. Plenty of folks are willing and available to help.

Following is a list of different types of hardware. This is only a glimpse of the equipment, cables, and attaching hardware that I have used over a period of years. The facts and figures sometimes change, and the charts are only for reference. Contact the various manufacturers and vendors before you head into the unknown. I really can't emphasize that enough. This book contains a few examples to get you started; devise what you think you need, map it out, and then call a local merchant or the manufacturer.

Miniature cable

Miniature cable line is perfect for special effects and mechanical designs that require sharp bends and confined space situations (Figure 9.1):

- 1×7 – One center wire with six wires laid around the center; more flexible than 1×3; used for push-pull applications and for conductive needs with low flexibility.
- 7×7 – Most standard cable construction; six 1×7 outside strands cabled around a 1×7 center; very flexible, good cycle life, and breaking strength.
- 1×19 – Twelve wires laid around a 1×7 center; more flexible than 1×7 in push-pull and conductive applications; almost as high breaking strength as 1×7 with same diameter.
- 7×19 – Most flexible standard construction for cable; six 1×19 strands around a 1×19 center; lower breaking strength, more expensive than 7×7; long cycle life.

Wire rope

Wire rope consists of three basic components. These components vary in complexity and configuration to produce ropes for specific purposes or characteristics. The three basic components of a standard wire rope design are (1) wires that form the strand, (2) multi-wire strands laid in a helix around a core, and (3) the core.

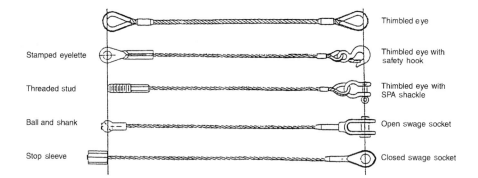

Stamped eyelette

Threaded stud

Ball and shank

Stop sleeve

Thimbled eye

Thimbled eye with safety hook

Thimbled eye with SPA shackle

Open swage socket

Closed swage socket

Figure 9.1a Miniature cable

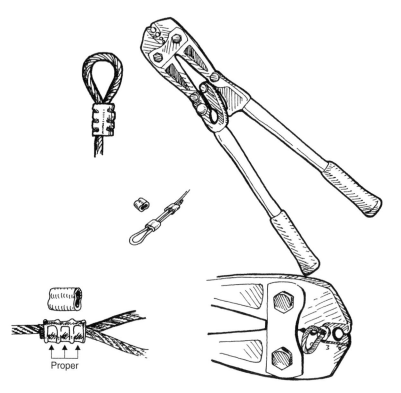

Proper

Figure 9.1b Nico press and sleeve

Wires

Wire for rope is made in several materials and types, including steel, iron, stainless steel, Monel metal, and bronze. By far the most widely used material is high carbon steel, which is available in a variety of grades, each of which has properties related to the basic curve for steel rope wire. Wire rope manufacturers select the wire type that is most appropriate for the requirements of the finished product.

Steel

The strength of steel wire is appropriate to the particular grade of the wire rope in which the wires are used. Grades of wire rope are referred to as traction steel (TS), improved plow steel (MPS),

plow steel (PS), improved steel (IPS), and extra – improved plow steel (EIP). These names originated at the earliest stages of development of wire rope and have been retained as references to the strength of a particular size and grade of rope. The plow steel strength curve forms the basis for calculating the strength of all steel rope wires. The tensile strength (measured in pounds per square inch, or psi) of any grade of steel wire is not constant. It varies with diameter and is highest in the smallest wires. The most common finish for steel wire is bright or non-coated. Steel wire also may be galvanized, which means it is coated with zinc. Drawn galvanized wire has the same strength as bright wire, but wire galvanized at a required finished size usually is 10 percent lower in strength. In certain applications, tinned wire is used, but tin does not provide the sacrificial protection for steel that zinc does. Different coatings are available for other applications.

Iron

Iron wire is actually drawn from low-carbon steel and has a fairly limited use except in older elevator installations. When iron is used for other than elevator applications, it is most often galvanized.

Stainless steel

Stainless steel ropes are made of American Iron and Steel Institute (AISI) types 302/304, 316, and 305 (listed in order of frequency of use). Contrary to general belief, hard-drawn stainless steel type 302/304 is magnetic. Type 316 is less magnetic, and type 305 has a permeability low enough to qualify as nonmagnetic.

Monel metal

Monel metal is steel that contains 68 percent nickel. Monel metal wire usually is type 400 and conforms to federal specification QQ-N-281.

Bronze

Bronze wire usually is type A phosphor bronze (Composite Design and Analysis Code [CDA] 510), although other bronzes can be specified.

Strands

Strands are made up of two or more wires laid in one of many specific geometric arrangements or in combinations of steel wires and other materials such as natural or synthetic fibers. A strand can be composed of any number of wires, and a rope can have any number of strands.

Core

The core is the foundation of a wire rope. It is made of materials that support the strands under normal bending and loading conditions. Core materials include fibers (hard vegetable and synthetic) or steel. A steel core consists of a strand or an independent wire rope.

Spreader beams

Load spreaders are used when loads to be lifted on a single hoist must be picked up and supported at two or more suspension points. Load spreaders can be furnished in a large number of practical designs to suit any lifting or handling condition (Figure 9.2).

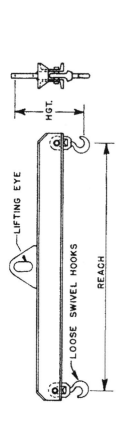

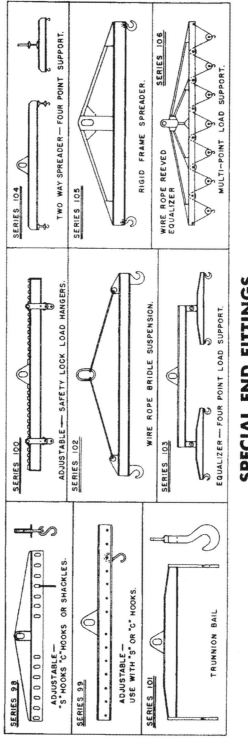

Figure 9.2 Spreader beams

Sling types

Various types of slings are shown in Figure 9.3. First I'll tell you of a way to measure your load when using a sling.

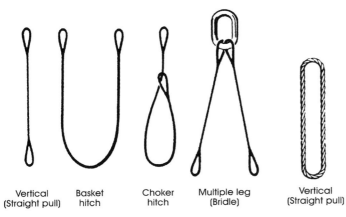

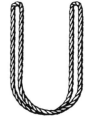

| Vertical (Straight pull) | Basket hitch | Choker hitch | Multiple leg (Bridle) | Vertical (Straight pull) | Choker hitch | Basket hitch |

Figure 9.3a Sling types

Figure 9.3b Additional sling types

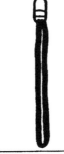

Choker **Vertical** **Basket**

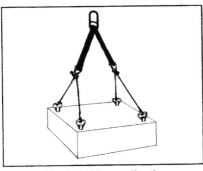

Single–bridle application **Mutiple–bridle application**

Figure 9.3c Correct versus incorrect applications

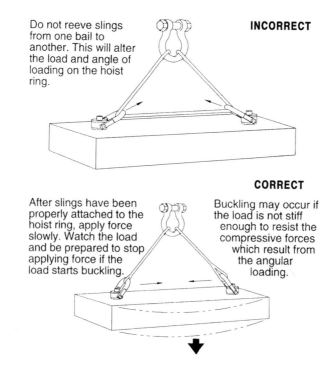

Do not reeve slings from one bail to another. This will alter the load and angle of loading on the hoist ring.

INCORRECT

CORRECT

After slings have been properly attached to the hoist ring, apply force slowly. Watch the load and be prepared to stop applying force if the load starts buckling.

Buckling may occur if the load is not stiff enough to resist the compressive forces which result from the angular loading.

Figure 9.3d Correct applications

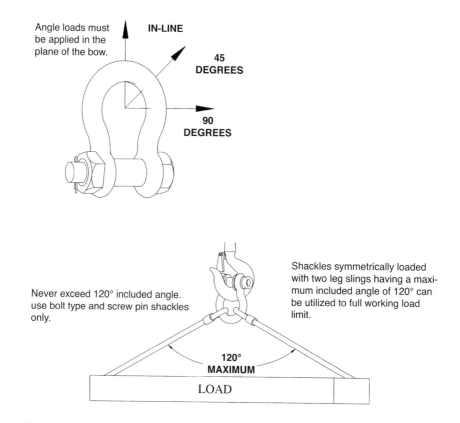

Angle loads must be applied in the plane of the bow.

IN-LINE

45 **DEGREES**

90 **DEGREES**

Never exceed 120° included angle. use bolt type and screw pin shackles only.

Shackles symmetrically loaded with two leg slings having a maximum included angle of 120° can be utilized to full working load limit.

120° **MAXIMUM**

LOAD

Figure 9.3e Correct applications

Dynafor MWX miniweigher

The grip hoist Dynafor MWX Miniweigher is a method of check-weighing and load measurement. The Dynafor MWX Miniweigher relies on microprocessor-based electronics and offers new standard functions and systems. Features of the Dynafor MWX Miniweigher include (Figure 9.4) it is operated via three push-button controls: (1) on-off, (2) 100 percent tare with return to total load applied, and (3) peak hold to show the maximum load applied. The choice of unit measurement – kilograms, tons, pounds, short tons, daN, or kN – is displayed on the LCD. An overload indicator helps prevent overloading the equipment and systems. The unit is set at automatic zero when switched on. It has an output connection to handheld display and controls, to a personal computer, or to an interface for processing or printing the information.

Glossary of cables and slings

* Alloy steel chain – The only chain recommended for overhead lifting.
* Angle of lift – Angle between the horizontal surface of the load and the lift chain, measured in degrees; should never be less than 30 degrees.
* Elongation – The effect on the chain of severe overload or exposure to shock load.
* Grade 30 – Proof coil chain; a general utility chain of low-carbon steel used for many everyday applications. Grade 30 is not to be used for lifting or hoisting applications.
* Grade 40 – High test chain; a higher carbon steel chain that is considerably stronger than grade 30, meaning that a lighter chain can often do similar work. Grade 40 is not to be used for lifting or hoisting applications.
* Grade 70 – Transport tie-down or binding chain; a high-strength, lightweight boron manganese steel chain designed for load-binding applications. Grade 70 is not to be used for lifting or hoisting applications.
* Grade 80 – High-strength alloy chain with a high strength-to-weight ratio. Grade 80 is used predominantly for lifting and hoisting applications. Grade 80 is the only chain recommended for lifting and hoisting.

Figure 9.4 Dynafor MWX Miniweigher

Staging systems

Ferrellels

The features of the Ferrellel™ system are a scissors lift and a variable height feature that allows the deck to change height in seconds with no loose legs (Figure 9.5). The operator reaches under each end, squeezes the lock-pin lever, and raises or lowers the deck to 16, 24, 32, or 40 in. Quick-lock extrusions connect decks together quickly with no bolts or screws. One end can be locked higher than the other to produce a ramp. Strong and solid. Ferrellels are engineered to support 160 pounds of live load per square foot. The understructure is all aluminum with no welded joints. The enclosed base provides exceptional stability and distributes weight over a large footprint. I have used Ferrellels since I first learned of their existence. They are the Swiss Army knife of tables, platforms, and portable stages. A Ferrellel is super quick to assemble and relatively inexpensive if you consider the time, material, and personnel it takes to build a riser or stage from scratch. Use Ferrellels – you will look like a million-dollar technician. It's the top gun for fast location work.

Steel deck

The combination of features in Steel deck® (Figure 9.6), as with all systems, represents a compromise between the properties we want a unit to possess – strength, ease of use, portability, versatility – and what is possible in light of such constraints as materials and cost.

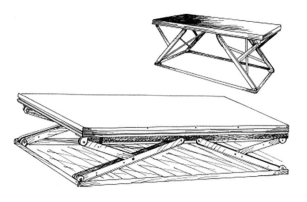

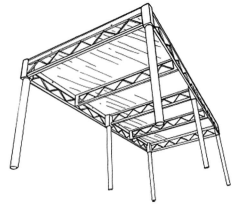

Figure 9.5 Ferrellels

Figure 9.6 Steel deck

10 Lifts

Condors and cherry-pickers

We are shooting on a rooftop, 30 feet up. We need to have a moonlight system to fly high above as well as an eye-level shooting platform. What do we need to accomplish these tasks? What are the factors to consider?

1. Where is the building?
2. What is the ground access?
3. Are there high-tension wires overhead?
4. What size moon (how big a light) do we need?
5. Will a person have to ride the basket? At what angle?
6. Does it have to be a four-wheel-drive unit?
7. Are we on a hill?
8. Can I use the outriggers?
9. Is the ground level?

These are a few, but not all, of the factors you have to think about and ask questions about. Here are a few more:

1. What size shooting crew do we need?
2. Will there be any light on the shooting basket, and will it require an electrician?
3. Are we shooting level, below level, or as an above look-down?
4. Does the camera crew know how to work the lift?

These are not dumb questions; they must be answered before you do anything. Do not assume anything.

First let's talk about a condor. This is a company name that has come to be synonymous with the name of the device it manufactures. Condors are also called cherry-pickers or high lifts, among other names. A cherry-picker or condor usually has two-wheel drive unless you ask for four-wheel drive. It is white or brightly colored and bears the name of the rental company, which would be fantastic if we were shooting a spot for that company. I usually request a cherry-picker with an arm painted flat black, which reduces reflection problems. If you do not remember to order an arm that is painted black and a problem arises, you can always use a long piece of Duvetyn cloth. This was a common way to black out an arm before manufacturers began painting the arms black. My advice is always to order a black arm. Sometimes day shoots end up as night shoots, and a lift with a black arm almost disappears at night.

Most cherry-pickers or condors have an elliptical tail travel. This means the lift is very slender when it is lined up straight with the base. When you rotate the base section, the tail extends past the sides of the wheelbase. Sometimes this blocks access. If necessary, a condor model that has zero tail swing is available. This means that nothing extends past the wheelbase. Use this type of condor in a tight area. I do not always call for this type because they are not readily available with longer arms.

Some cherry-pickers have an articulating arm. These are terrific pieces of equipment and take up less room than conventional devices. As with all pieces of equipment, however, there is a price to pay,

157

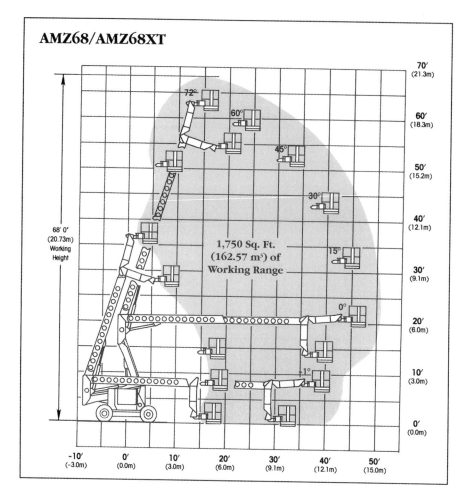

Figure 10.1 Condor/cherry picker

usually in terms of lift capacity. The angle and the length of an arm determine the weight capacity and use of the arm. Look over the charts. Call and ask or even go and see for yourself.

Cherry-pickers and condors come with a wide base or a narrow base. If I have the room, I usually ask for a wide base for stability. Don't get me wrong – they are all very stable, but a wide base usually gives me and other crew members (who do not normally ride these things) a greater sense of confidence. All other things being equal, I generally opt for the wider base. Figure 10.1 provides an example of the many boom arms/cherry-pickers/condors/lifts that are out there. The model, shape, and size of crane required might be different in each area you are filming. Know what is available and how to use it. Use the right tool for the job. Don't guess or try to make do.

Scissors lifts

Scissors lifts frighten me. I have used narrow ones to go high. They are safe, but this old guy does not like them. Scissors lifts come in narrow and wide models with and without outriggers (Figure 10.2). I prefer outriggers, but sometimes you just cannot use that type. Scissors lifts can be fueled by gasoline or propane, and even electric models are available. You certainly would not want to use a gas engine

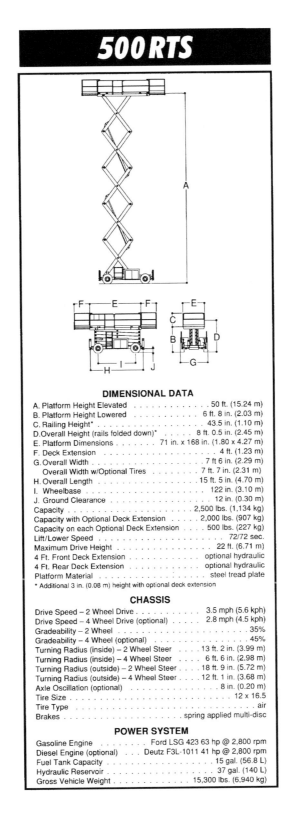

500 RTS

DIMENSIONAL DATA

A. Platform Height Elevated 50 ft. (15.24 m)
B. Platform Height Lowered 6 ft. 8 in. (2.03 m)
C. Railing Height* 43.5 in. (1.10 m)
D. Overall Height (rails folded down)* 8 ft. 0.5 in. (2.45 m)
E. Platform Dimensions 71 in. x 168 in. (1.80 x 4.27 m)
F. Deck Extension 4 ft. (1.23 m)
G. Overall Width 7 ft 6 in. (2.29 m)
 Overall Width w/Optional Tires 7 ft. 7 in. (2.31 m)
H. Overall Length 15 ft. 5 in. (4.70 m)
I. Wheelbase 122 in. (3.10 m)
J. Ground Clearance 12 in. (0.30 m)
Capacity 2,500 lbs. (1,134 kg)
Capacity with Optional Deck Extension 2,000 lbs. (907 kg)
Capacity on each Optional Deck Extension 500 lbs. (227 kg)
Lift/Lower Speed 72/72 sec.
Maximum Drive Height 22 ft. (6.71 m)
4 Ft. Front Deck Extension optional hydraulic
4 Ft. Rear Deck Extension optional hydraulic
Platform Material steel tread plate
* Additional 3 in. (0.08 m) height with optional deck extension

CHASSIS

Drive Speed – 2 Wheel Drive 3.5 mph (5.6 kph)
Drive Speed – 4 Wheel Drive (optional) 2.8 mph (4.5 kph)
Gradeability – 2 Wheel 35%
Gradeability – 4 Wheel (optional) 45%
Turning Radius (inside) – 2 Wheel Steer 13 ft. 2 in. (3.99 m)
Turning Radius (inside) – 4 Wheel Steer 6 ft. 6 in. (2.98 m)
Turning Radius (outside) – 2 Wheel Steer 18 ft. 9 in. (5.72 m)
Turning Radius (outside) – 4 Wheel Steer 12 ft. 1 in. (3.68 m)
Axle Oscillation (optional) 8 in. (0.20 m)
Tire Size . 12 x 16.5
Tire Type . air
Brakes spring applied multi-disc

POWER SYSTEM

Gasoline Engine Ford LSG 423 63 hp @ 2,800 rpm
Diesel Engine (optional) . . . Deutz F3L-1011 41 hp @ 2,800 rpm
Fuel Tank Capacity 15 gal. (56.8 L)
Hydraulic Reservoir 37 gal. (140 L)
Gross Vehicle Weight 15,300 lbs. (6,940 kg)

Figure 10.2 Scissors lifts

lift on a small-enclosed stage. Some lifts have a platform that extends on one end; these are helpful for maneuvering over obstacles. When ordering a scissors lift, be as specific as you can be. Consider as many factors as you can to determine the proper piece of equipment. Do not use, move, or operate any piece of equipment until you are fully trained and fully confident that you can operate it safely.

Suppliers

When you use any lift, determine the physical weight of the unit fully loaded with people, material, and equipment; and then decide whether you need to put double sheets of 3/4 in. (1.9 cm) plywood under each wheel to distribute the weight over a larger area. I always order at least eight sheets of plywood for a condor or cherry-picker shoot. Here's why. Say we start shooting at 7:00 a.m. on a city street. Around noon, the asphalt softens, and the wheels of the cherry-picker will slowly settle into the softened asphalt and leave large ruts behind if you do not use double-sheet plywood. Trust me on this. This is not to say that the plywood will not leave a ridge too, but it indicates that you have planned ahead as well as you can. As with any piece of equipment, call the supplier with any questions you might have. Suppliers are very knowledgeable about their equipment. They do not want anyone to get hurt, either. Do not try to figure it out on your own. Ask questions.

Mike's note: Too large costs extra money; too small costs time and money. The dispatcher asks necessary questions about the details of what you need to avoid extra costs and to ensure that you have the proper size crane.

Additional equipment

The pieces of equipment shown in Figure 10.3 are helpful (and are now required by Local 80 Hollywood grips) and necessary for work with lifts, cherry-pickers, or booms. Check with local unions and studios to determine which harness is required for your particular piece of equipment.

Figure 10.3a Body harness

Figure 10.3b Body harness fall protection strap and body harness tie-in strap

Beam tie-off sling

Tie-off eye

Figure 10.3c I-beam end with hole

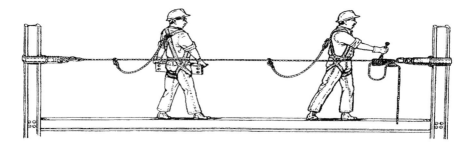

Figure 10.3d Men in harness attached with safety harness tie-in strap

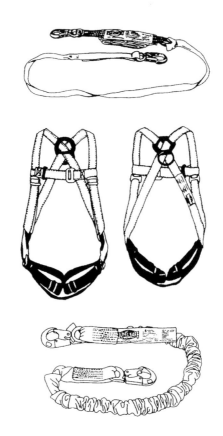

Figure 10.3e Safety harness and tie-in strap

11 Cranes, jibs, arms, dollies, and heads

This chapter provides descriptions of and specifications for the cranes, jibs, and arms used in the industry. Cranes, jibs, and arms can be set lower or higher, depending on which base, dolly, tripod, or other crane they are being used with.

Some of these cranes, jibs, and arms may look short, but they may be the type that have kits or extensions to lengthen their reach or to change from remote operation to carrying a cameraperson or assistant. The manufacturers' specs shown in their brochures indicate their recommended dollies, bases, or tripods. Please call the manufacturer or supplier if you have any questions about a crane, jib, or arm.

Remember: read the manufacturer's specifications carefully!
Caution: take the following precautions:

- Do not operate any of these cranes, jibs, or arms without first being instructed on the proper operation of each unit.
- Remember that the reach (length of arm) past the pivot point determines the actual height (plus base height and risers, if any).
- See the manufacturer's instructions for full details on each piece of equipment.
- The rigs (cranes, jibs, or arms) shown in this book are not all meant to support personnel, unless there is a note to the contrary.
- Call the manufacturer of the arm or jib if the weight of the camera is an issue.

A professional tip

Before taking or building a crane onto a stage floor, check and see if the stage is elevated. Sometimes you have to lay Titan track (large planks of wood that can hold the weight of the huge crane). (STANDARD PRACTICES)

Cranes and communication systems

When you get a mobile crane, jib, or arm that will keep you some distance from the camera operator (for example, the camera operator is on a Titan crane or a Lenny arm with a remote), I highly recommend that you ask production to rent you a communication system so that you can hear the operator's requests. Any good sound department will set up a one-way system for you. The operator will have an open microphone and transmitter that will probably be an omnidirectional microphone. The operator will request movement in whichever direction is desired. He or she can speak in a normal voice, even as soft as a whisper during a sound take. You and the other grips will have the receiver system (headsets) on so that the grip operating the crane or arm knows what is requested. I use a system that a mixer (sound person) designed for my jobs.

I provide this information because if you cannot get the perfect piece of equipment to do the job right, you might as well use two tin cans and a string.

Huge note: The sizes and weights are ever changing on cranes, jibs, arms, and dollies. The reference listed must be checked before you rely solely on it. Be smart! Check out the equipment with the manufacturer first. I don't want anyone hurt or killed, and I don't want to be sued! This is on you – am I clear?

The following cranes are listed from short to long arm length:

Seno's Over/Under Jib Arm (Figure 11.1)

Lens height: 2 ft./up from the base (depending on what this unit is mounted on)
Arm capacity: 100 lb.

Figure 11.1 Seno's Over/Under Jib Arm

Trovato Jr. (Figure 11.2)

Lens height: 4 ft./up (depending on what this unit is mounted on)
Arm capacity: 100 lb.

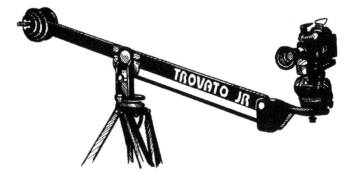

Figure 11.2 Trovato Jr.

Trovato Tote Jib (Figures 11.3–11.6)

Lens height: 4 ft./up (depending on what this unit is mounted on)
Arm capacity: 100 lb.

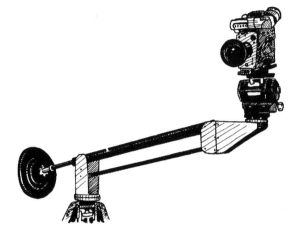

Figure 11.3 Trovato Jr./Tote

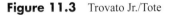
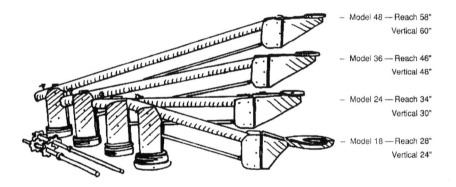

- Model 48 — Reach 58"
 Vertical 60"

- Model 36 — Reach 46"
 Vertical 48"

- Model 24 — Reach 34"
 Vertical 30"

- Model 18 — Reach 28"
 Vertical 24"

Figure 11.4 Trovato Tote jib

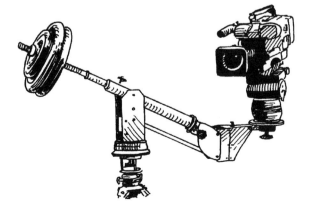

Figure 11.5 Model 36, 48, 60, 72

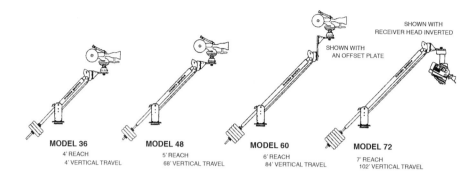

MODEL 36
4' REACH
4' VERTICAL TRAVEL

MODEL 48
5' REACH
68' VERTICAL TRAVEL

MODEL 60
6' REACH
84' VERTICAL TRAVEL

MODEL 72
7' REACH
102' VERTICAL TRAVEL

SHOWN WITH
RECEIVER HEAD INVERTED

SHOWN WITH
AN OFFSET PLATE

Figure 11.6 Trovato

Euro-Jib (Figure 11.7)

Lens height: 4 ft./up (depending on what this unit is mounted on)
Arm capacity: 77 lb.

Liberty Range Jib (Figure 11.8)

Lens height: 5 ft./8 in./up (depending on what this unit is mounted on)
Arm capacity: 99 lb.

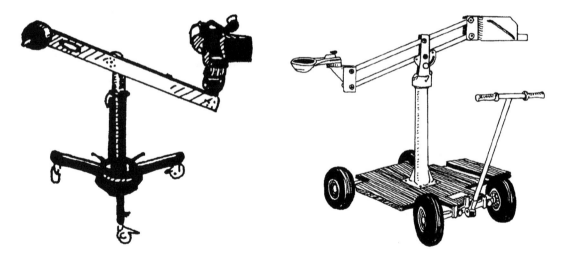

Figure 11.7 Euro-Jib

Figure 11.8 Liberty Range Jib on doorway dolly

Egripment Mini-Jib/Arms Model 124 (Figure 11.9)

Lens height: 5 ft./8 in./up from the base (depending on what this unit is mounted on)
Arm capacity: 99 lb.

Porta Jib (Figure 11.10)

Lens height: 6 ft./up (depending on what this unit is mounted on)
Arm capacity: 90 lb.

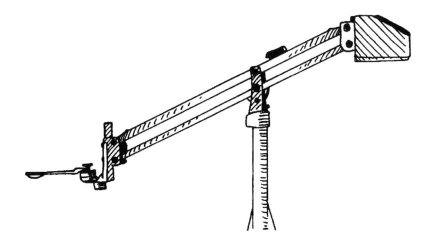

Figure 11.9 Egripment Mini-Jib/Arms Model 124

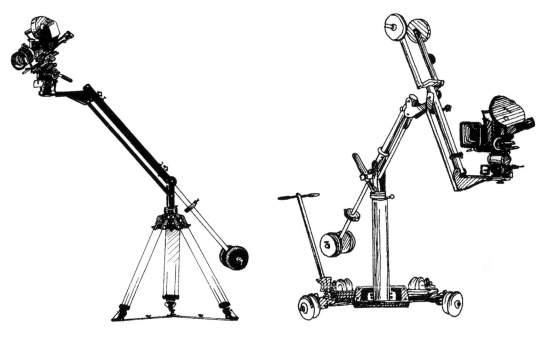

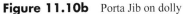

Figure 11.10a Porta Jib on sticks **Figure 11.10b** Porta Jib on dolly

Mini-Jib Liberty (Figure 11.11)

Lens height: 5 ft./8 in./up (depending on what this unit is mounted on)
Arm capacity: 99 lb.

Weaver-Steadman Five-Axis Fluid Crane (Figure 11.12)

Lens height: 6 ft./up (depending on what this unit is mounted on)
Arm capacity: 90 lb.

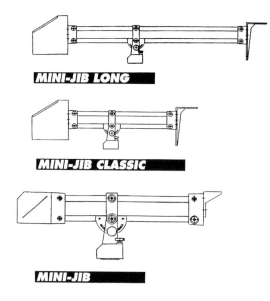
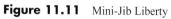

Figure 11.11 Mini-Jib Liberty

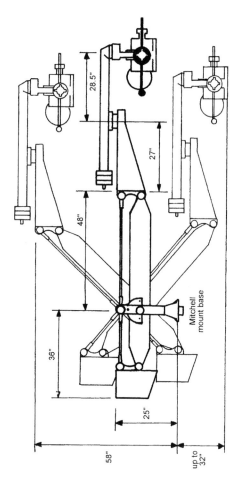

Figure 11.12 Weaver-Steadman Five-Axis Fluid Crane

JF Crossarm (Figures 11.13 and 11.14)
Arm capacity: 100 lb.

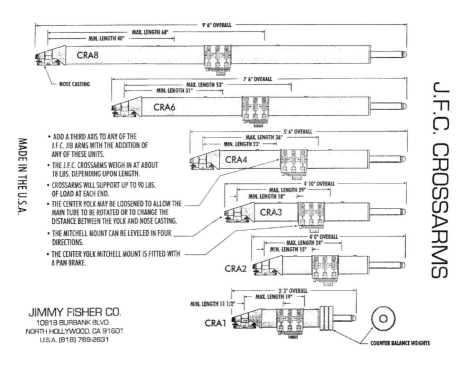

- ADD A THIRD AXIS TO ANY OF THE J.F.C. JIB ARMS WITH THE ADDITION OF ANY OF THESE UNITS.
- THE J.F.C. CROSSARMS WEIGH IN AT ABOUT 18 LBS. DEPENDING UPON LENGTH.
- CROSSARMS WILL SUPPORT UP TO 90 LBS. OF LOAD AT EACH END.
- THE CENTER YOLK MAY BE LOOSENED TO ALLOW THE MAIN TUBE TO BE ROTATED OR TO CHANGE THE DISTANCE BETWEEN THE YOLK AND NOSE CASTING.
- THE MITCHELL MOUNT CAN BE LEVELED IN FOUR DIRECTIONS.
- THE CENTER YOLK MITCHELL MOUNT IS FITTED WITH A PAN BRAKE.

JIMMY FISHER CO.
10918 BURBANK BLVD.
NORTH HOLLYWOOD, CA 91601
U.S.A. (818) 769-2631

Figure 11.13 JF Crossarm

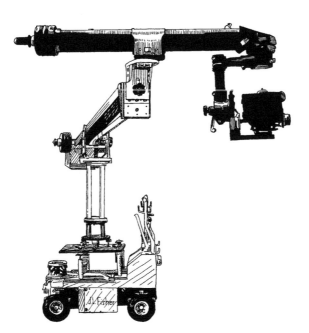

Figure 11.14 JF Crossarm on dolly

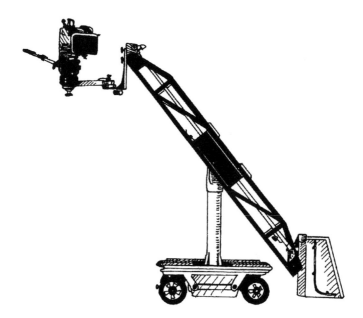

Figure 11.15a Maxi-Jib/Super Maxi-Jib on dolly

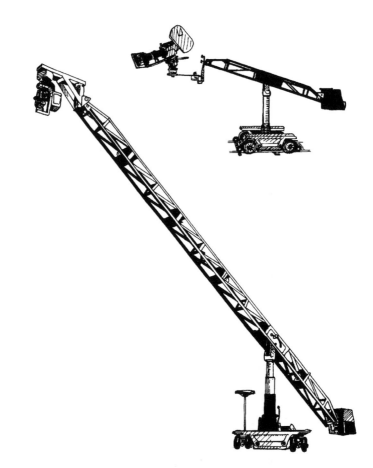

Figure 11.15b Maxi-Jib/Super Maxi-Jib – extended

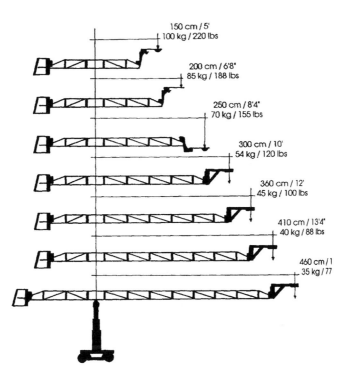

150 cm / 5'
100 kg / 220 lbs

200 cm / 6'8"
85 kg / 188 lbs

250 cm / 8'4"
70 kg / 155 lbs

300 cm / 10'
54 kg / 120 lbs

360 cm / 12'
45 kg / 100 lbs

410 cm / 13'4"
40 kg / 88 lbs

460 cm / 1
35 kg / 77

Figure 11.15c Assorted versions of the Maxi-Jib/Super Maxi-Jib

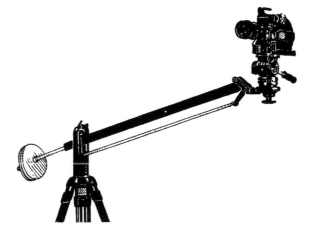

Figure 11.16 Seven Jib on sticks

Maxi-Jib/Super Maxi-Jib (Figure 11.15)

Lens height: 16 ft./8 in./up (depending on what this unit is mounted on)
Arm capacity: 77 lb.

Note: Remember that the heights given are a maximum, but the crane may be used in several shorter configurations. Check the manufacturer's specifications.

Seven Jib (Figure 11.16)

Lens height: 6 ft./4 in./up (depending on what this unit is mounted on)
Arm capacity: 45 lb.

Spotting the post

The post on all jibs, cranes, and arms is the pivot point, the balance point, the place where the arm will teeter-totter and spin. Let's say, for example, that the camera has to start 10 ft. in the air. The camera has to arm down to 4 ft. high above the ground. Now it has to float across to left for about 20 ft. The lens will land like a floating, falling feather in an extreme close-up face-to-face with the actor.

Here are some questions:

Where do you put the pivot point?
How long an arm do you need?
Is the crane manned? Does it have one, two, or three people riding on it?
What is the weight of the crane?
Will the ground support the base of the crane?
What is the terrain that the base will sit on?

Let's say that you have only a 22 ft. Lenny arm. The arm is nonrideable and only works with a remote head. You're on a flat asphalt parking lot.

Here's a trick to do. Grab yourself a piece of long rope and tie a knot at one end. The knot will represent the post. Now stretch the rope, keeping the rope tight from the vertical post to the position where the camera lens will start. Cut off any excess rope. Have one person hold the end that would represent the camera. Have the other person holding the postposition move to a point that could act as a pivot point. Just guesstimate. Now move the camera end to the second position, keeping the rope tight. When the second position is found, move the post end of the rope to a position to plant your post. Do this a couple times until the rope swings freely from one to two without going slack. It is a good practice to have a little wiggle room for adjustments of the pivot point.

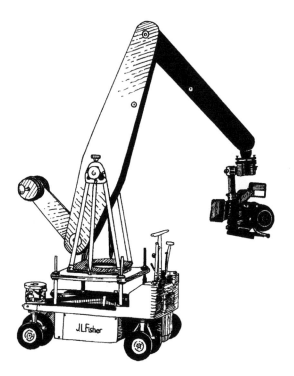

Figure 11.17 ZG Arm (Model 6–200)

ZG Arm (Model 6–200) (Figure 11.17)

Lens height: 7 ft./up (depending on what this unit is mounted on)
Arm capacity: 200 lb.

ZG Arm (Model 8–130, Ken Hill MFG) (Figure 11.18)

Lens height: 12 ft./up (depending on what this unit is mounted on)
Arm capacity: 130 lb.

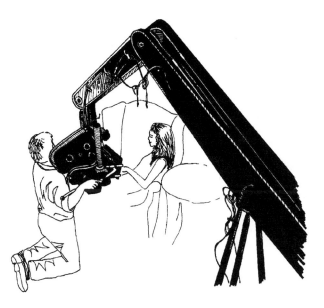

Figure 11.18 ZG Arm (Model 8–130)

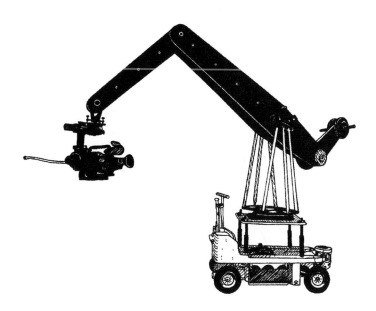

Figure 11.19 ZG Arm (Model 11–100)

ZG Arm (Model 11–100, Ken Hill MFG) (Figure 11.19)

Lens height: 14 ft./up (depending on what this unit is mounted on)
Note: Training and demo reels are available; call K. Hill Manufacturing.

Javelin Crane Arm (Figure 11.20)

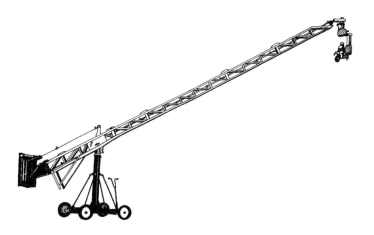

Figure 11.20a Javelin Crane Arm

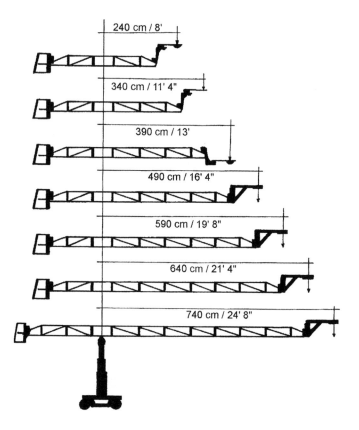

Figure 11.20b Javelin Crane Arm assorted lengths

Lens height: 29 ft./4 in. up (depending on what this unit is mounted on)

Arm capacity: 220 lb.

Note: This crane can be assembled in seven different lengths and variations.

Piccolo Crane (Figure 11.21)

Lens height: 14 ft./up (depending on what this unit is mounted on)

Arm capacity: 145 lb.

Note: This crane will work on straight or curved track, supplied by the equipment manufacturer. It has its own integral track wheels.

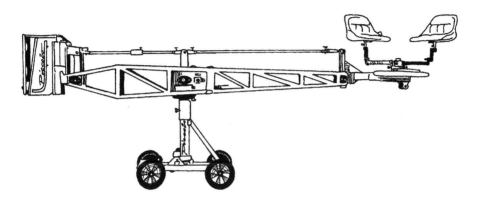

Figure 11.21 Piccolo Crane

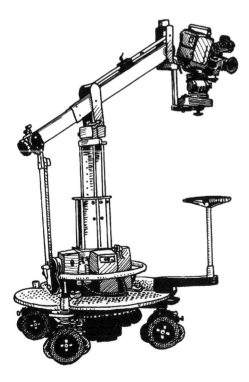

Figure 11.22a Lightweight Jib

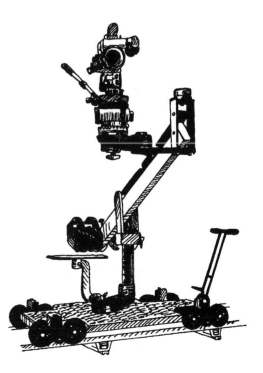

Figure 11.22b Lightweight Jib on track

Lightweight Jib (Figure 11.22)

Lens height: 8 ft./8 in. up (depending on what this unit is mounted on)
Arm capacity: 65 lb.

Jimmy Jib (Junior to Giant) (Figure 11.23)

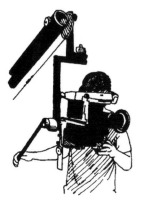

Figure 11.23a Jimmy Jib (Junior to Giant) on sticks

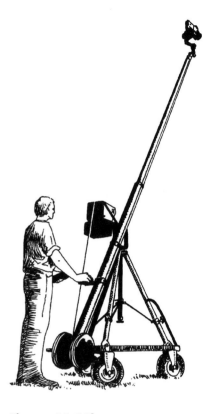

Figure 11.23b Jimmy Jib (Junior to Giant) on base

Figure 11.23c Jimmy Jib (Junior to Giant) on arm

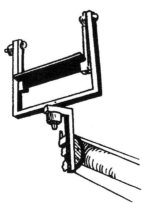

Figure 11.23d Jimmy Jib head (Junior to Giant)

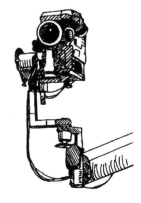

Figure 11.23e Jimmy Jib (Junior to Giant) single arm head

Figure 11.23f Jimmy Jib (Junior to Giant) with monitor

Lens height: 9 ft./30 ft./up from the base (depending on what this unit is mounted on)
Arm capacity: 70 lb.
Note: This jib can be adjusted to seven different configurations with some additional accessories.

Fisher Jib/Arm (Model 20) (Figure 11.24)

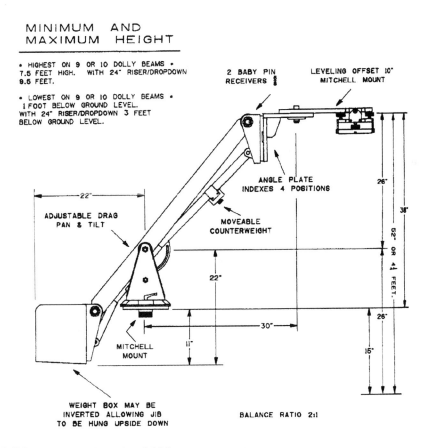

Figure 11.24a Fisher Jib/Arm (Model 20)

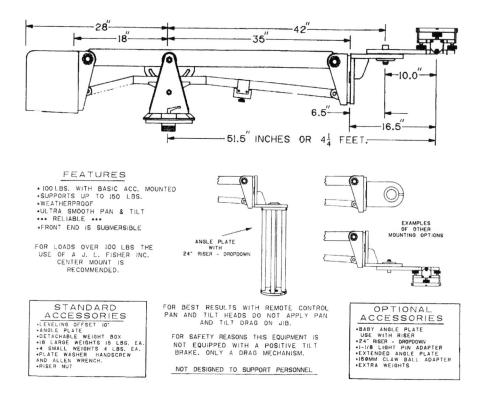

FEATURES

• 100 LBS. WITH BASIC ACC. MOUNTED
• SUPPORTS UP TO 150 LBS.
• WEATHERPROOF
• ULTRA SMOOTH PAN & TILT
••• RELIABLE •••
• FRONT END IS SUBMERSIBLE

FOR LOADS OVER 100 LBS THE
USE OF A J. L. FISHER INC.
CENTER MOUNT IS
RECOMMENDED.

ANGLE PLATE
WITH
24" RISER - DROPDOWN

EXAMPLES
OF OTHER
MOUNTING OPTIONS

STANDARD ACCESSORIES
• LEVELING OFFSET 10"
• ANGLE PLATE
• DETACHABLE WEIGHT BOX
• 18 LARGE WEIGHTS 15 LBS. EA.
• 4 SMALL WEIGHTS 4 LBS. EA.
• PLATE WASHER HANDSCREW
 AND ALLEN WRENCH.
• RISER NUT

FOR BEST RESULTS WITH REMOTE CONTROL
PAN AND TILT HEADS DO NOT APPLY PAN
AND TILT DRAG ON JIB.

FOR SAFETY REASONS THIS EQUIPMENT IS
NOT EQUIPPED WITH A POSITIVE TILT
BRAKE. ONLY A DRAG MECHANISM.

NOT DESIGNED TO SUPPORT PERSONNEL

OPTIONAL ACCESSORIES
• BABY ANGLE PLATE
 USE WITH RISER
• 24" RISER - DROPDOWN
• 1-1/8 LIGHT PIN ADAPTER
• EXTENDED ANGLE PLATE
• 150MM CLAW BALL ADAPTER
• EXTRA WEIGHTS

Figure 11.24b Fisher Jib/Arm (Model 20) specifications

Figure 11.24c Fisher Jib/Arm (Model 20) on dolly

Lens height: 9 ft./5 in. up (depending on what this unit is mounted on)
Arm capacity: 210 lb.
Note: These heights or depths can be achieved only with the use of a 24 in. riser.

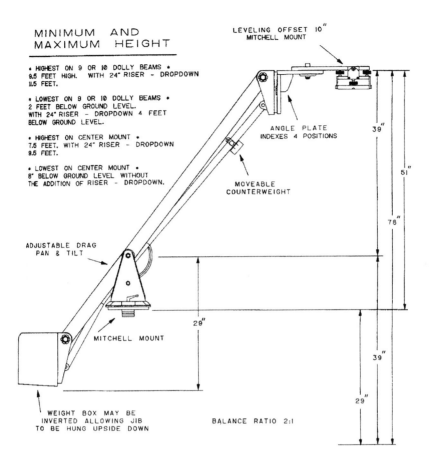

Figure 11.25a Fisher Jib/Arm (Model 21)

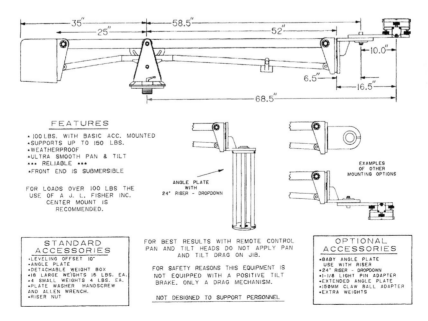

Figure 11.25b Fisher Jib/Arm (Model 21) specifications

Figure 11.25c Fisher Jib/Arm (Model 21) on dolly

Fisher Jib/Arm (Model 21) (Figure 11.25)

Lens height: 11 ft./5 in. up (depending on what this unit is mounted on)
Arm capacity: 210 lb.
Note: These heights or depths can be achieved only with the use of a 24 in. riser.

Fisher Jib/Arm (Model 22) (Figure 11.26)

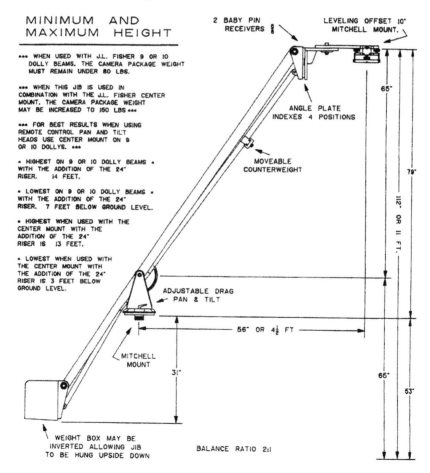

Figure 11.26a Fisher Jib/Arm (Model 22)

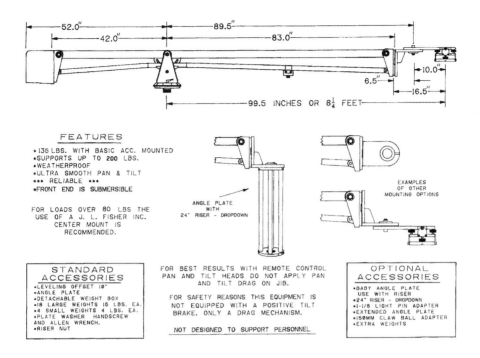

Figure 11.26b Fisher Jib/Arm (Model 22) specifications

Figure 11.26c Fisher Jib/Arm (Model 22) on dolly

Lens height: 13 ft./up (depending on what this unit is mounted on)
Arm capacity: 150 lb.
Note: These heights or depths can be achieved only with the use of a 24 in. riser.

Chapman Crane Arm (Figure 11.27)

Lens height: 9 ft./6 in. up (depending on what this unit is mounted on)
Arm capacity: 600 lb.

Figure 11.27a Chapman Crane Arm on Titan

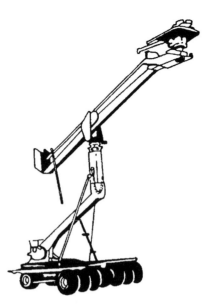

Figure 11.27b Chapman Crane Arm on Olympian

Figure 11.27c Chapman Crane Arm on dolly

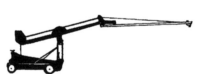

Figure 11.27d Chapman Crane Arm on mobile base

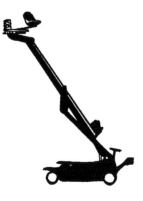

Figure 11.27e Chapman Crane Arm on sidewinder

Figure 11.27f Chapman Crane Arm with snorkel lens

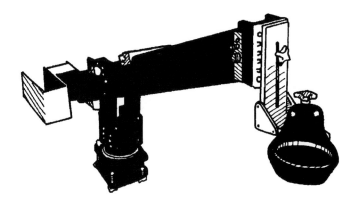

Figure 11.28a Aerocrane Jib/Arm

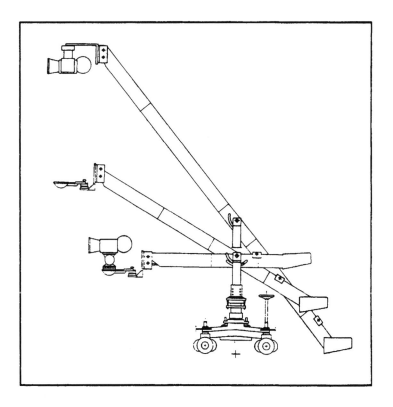

Figure 11.28b Aerocrane Jib/Arm on dolly

Aerocrane Jib/Arm (Figure 11.28)

Lens height: 9 ft./6 in. up (depending on what this unit is mounted on)
Arm capacity: 75 lb.

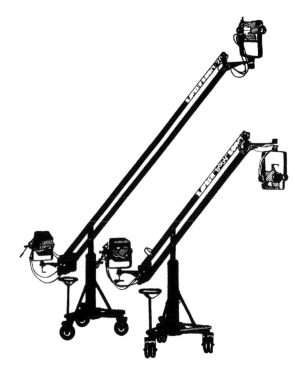

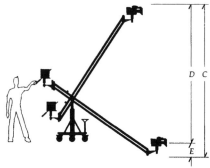

Figure 11.29a　Barber Baby Boom on rolling base

Figure 11.29b　Barber Baby Boom specifications

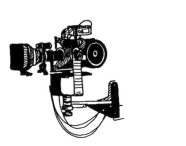

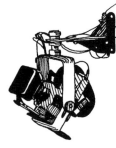

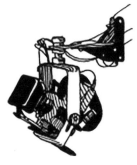

Figure 11.29c　Barber Baby Boom top slung head

Figure 11.29d　Barber Baby Boom under slung head

Barber Baby Boom (Figure 11.29)

Lens height: 10 ft./up (depending on what this unit is mounted on)
Arm capacity: 75 lb.

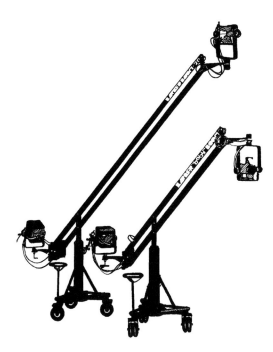

Figure 11.30a Barber Boom 20 on rolling base

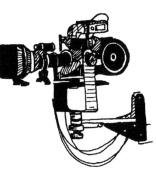

Figure 11.30b Barber Boom 20 top slung head

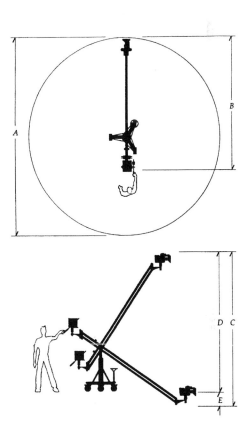

Figure 11.30c Barber Boom 20 under slung head

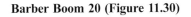

Figure 11.30d Barber Baby Boom specifications

Barber Boom 20 (Figure 11.30)

Lens height: 20 ft./up (depending on what this unit is mounted on)
Arm capacity: 50 lb.

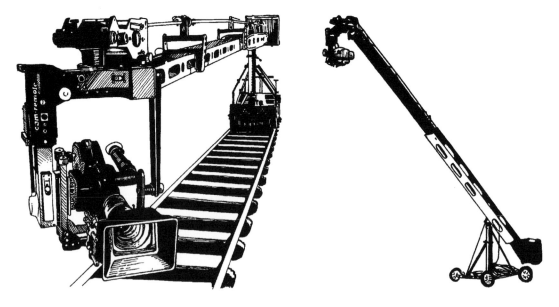

Figure 11.31a MC-88 Crane on track

Figure 11.31b MC-88 Crane on a base

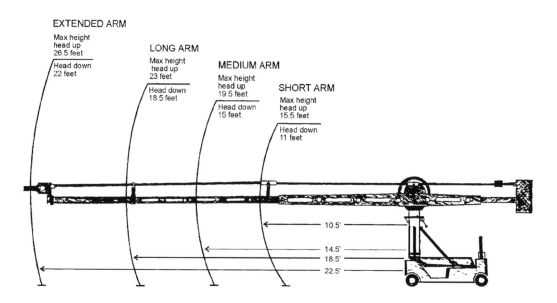

EXTENDED ARM
Max height
head up
26.5 feet

Head down
22 feet

LONG ARM
Max height
head up
23 feet

Head down
18.5 feet

MEDIUM ARM
Max height
head up
19.5 feet

Head down
15 feet

SHORT ARM
Max height
head up
15.5 feet

Head down
11 feet

10.5'
14.5'
18.5'
22.5'

Figure 11.31c MC-88 Crane specifications

MC-88 Crane (Figure 11.31)

Lens height: 24 ft./up (depending on what this unit is mounted on)
Arm capacity: 105 lb.

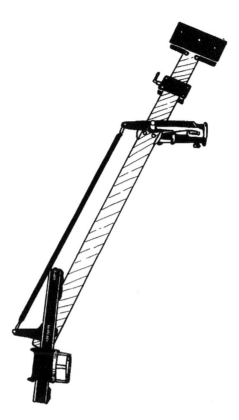

Figure 11.32a Straight Shoot'R (PDM Mfg. Co.)

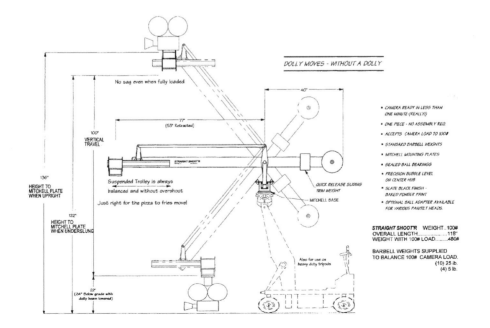

Figure 11.32b Straight Shoot'R (PDM Mfg. Co.) specifications

Straight Shoot'R (PDM Mfg. Co.) (Figure 11.32)

Lens height: 9 ft./2 in. up (depending on what this unit is mounted on)
Arm capacity: 110 lb.

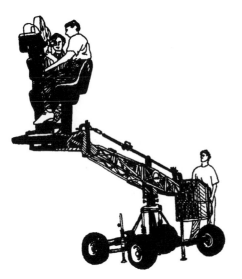

Figure 11.33a Pegasus Crane (Standard and Super) with crew

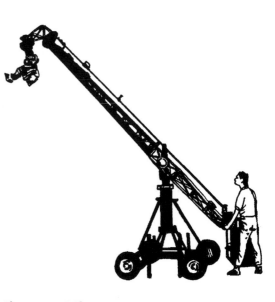

Figure 11.33b Pegasus Crane (Standard and Super) remote

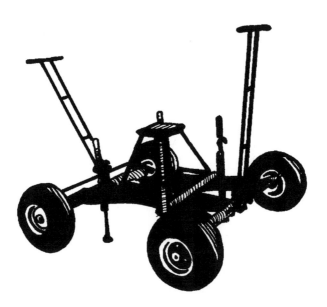

Figure 11.33c Pegasus Crane (Standard and Super) base

The Panther Pegasus Crane...

... is the answer for grips, DP's and camera operators who want that little bit more from a crane.

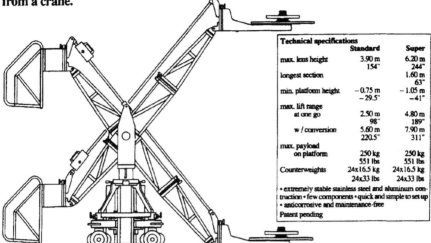

Technical specifications		
	Standard	**Super**
max. lens height	3.90 m	6.20 m
	154"	244"
longest section		1.60 m
		63"
min. platform height	−0.75 m	−1.05 m
	−29.5"	−41"
max. lift range		
at one go	2.50 m	4.80 m
	98"	189"
w / conversion	5.60 m	7.90 m
	220.5"	311"
max. payload		
on platform	250 kg	250 kg
	551 lbs	551 lbs
Counterweights	24x16.5 kg	24x16.5 kg
	24x33 lbs	24x33 lbs

• extremely stable stainless steel and aluminum construction • few components • quick and simple to set up • anticorrosive and maintenance-free
Patent pending

Panther Pegasus Crane standard version

The use of high-quality materials and art of contruction plus design, guarantee the utmost in stability and **safety.**

The **uncomplicated** change-over to different sized set-ups is achieved through few and simple-to-use **accessories.**

Panther Pegasus Crane in extended version

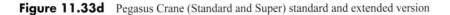

Figure 11.33d Pegasus Crane (Standard and Super) standard and extended version

Pegasus Crane (Standard and Super) (Figure 11.33)

Lens height: 12 ft./8 in. up (depending on what this unit is mounted on)
Arm capacity: 110 lb.

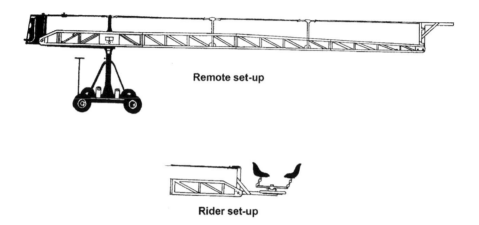

Remote set-up

Rider set-up

Figure 11.34a V.I.P. Four-in-One Crane

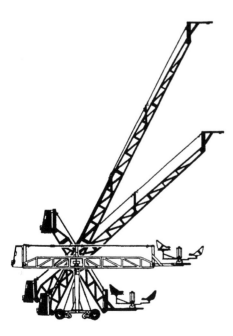

Figure 11.34b V.I.P. Four-in-One Crane
with operator's variations

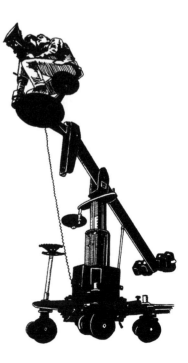

Figure 11.35 Super Jib with operator

V.I.P. Four-in-One Crane (Figure 11.34)

Lens height: 13 ft./up (depending on what this unit is mounted on)
Arm capacity: 110 lb.

Super Jib (Figure 11.35)

Lens height: 13 ft./7 in. up (depending on what this unit is mounted on)
Arm capacity: 331 lb.

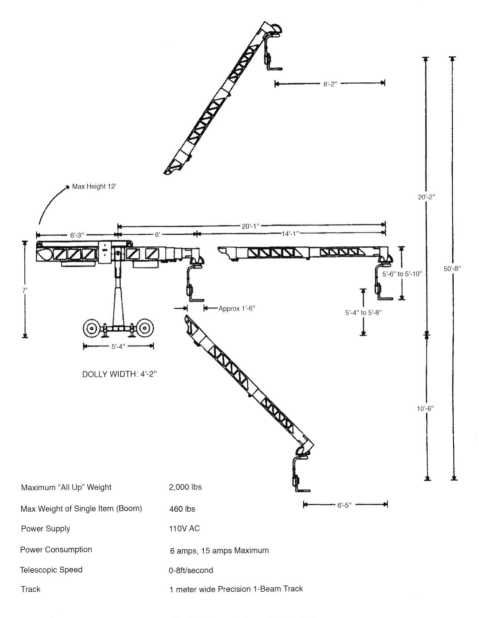

Maximum "All Up" Weight	2,000 lbs
Max Weight of Single Item (Boom)	460 lbs
Power Supply	110V AC
Power Consumption	6 amps, 15 amps Maximum
Telescopic Speed	0-8ft/second
Track	1 meter wide Precision 1-Beam Track

TECHNOCRANE SPECIFICATIONS Revised January 1997

Figure 11.36a Technocrane specifications

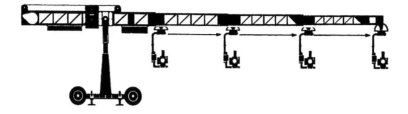

Figure 11.36b Technocrane example of telescoping

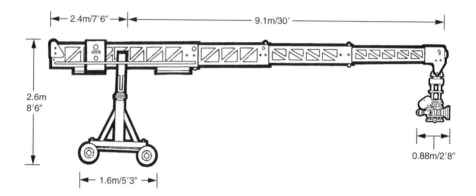

Figure 11.37 Super Technocrane

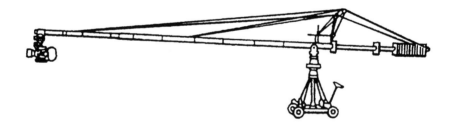

Figure 11.38 Louma crane

Technocrane (Figure 11.36)

> Lens height: 20 ft./2 in. up (depending on what this unit is mounted on)
> Arm capacity: 80 lb.
> **Highlights**: Technocrane can telescope during a shot, from a reach of 6 to 20 ft., at up to
> 8 ft. per second. The crane can be mounted on top of Technocrane's truck, allowing a
> higher reach.

Super Technocrane (Figure 11.37)

> Lens height: 30 ft./up (depending on what this unit is mounted on)
> Arm capacity: 80 lb.

Louma (Figure 11.38)

Lens height: 27 ft./up (depending on what this unit is mounted on)
Arm capacity: 74 lb.

Note: Louma can also be used on the Titan and Super Nova cranes. The crane's attaching base
(to dolly or crane) is a Mitchell mount base.

Enlouva II Crane (Figure 11.39)

Lens height: 24 ft./up (depending on what this unit is mounted on)
Arm capacity: 140 lb.

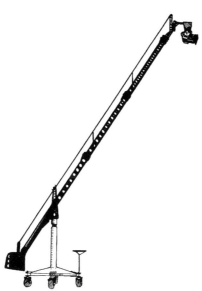

Figure 11.39 Enlouva II Crane

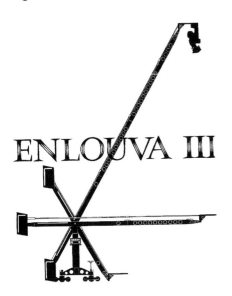

Figure 11.40a Enlouva IIIA Crane

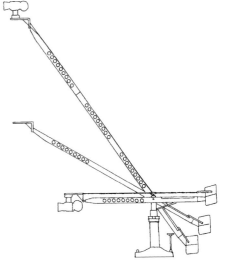

Figure 11.40b IIIA Crane extensions

Enlouva IIIA Crane (Figure 11.40)

Lens height: 25 ft./up (depending on what this unit is mounted on)
Arm capacity: 140 lb.
Note: Above measurements are based on a dolly column height of 48 in.

Cam-Mate Crane/Jib/Arm (Figure 11.41)

Lens height: 28 ft./6 in. up (depending on what this unit is mounted on)
Arm capacity: 550 lb.

The Crane (Mathews Studio Equipment) (Figure 11.42)

Lens height: 25 ft./up (depending on what this unit is mounted on)
Arm capacity: 80 lb.
Note: This crane is designed to support personnel!

Giraffe Crane (Filmair) (Figure 11.43)

Lens height: 30 ft./up (depending on what this unit is mounted on)
Arm capacity: 175 lb.
Note: This crane is designed to support personnel!

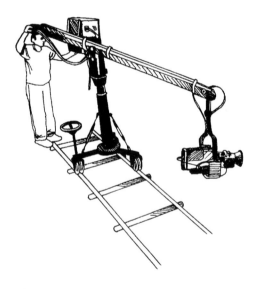

Figure 11.41a Cam-Mate Crane/Jib/Arm on track

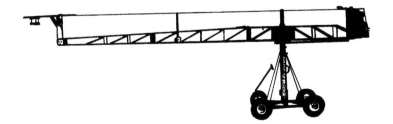

Figure 11.41b Cam-Mate Crane/Jib/Arm on base

Figure 11.42a The Crane (Mathews Studio Equipment)

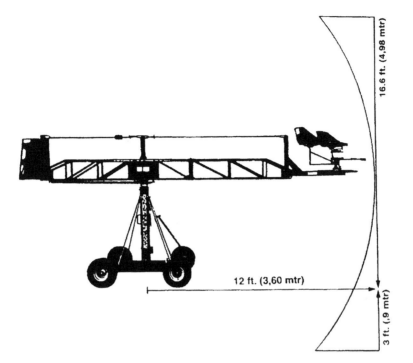

Figure 11.42b The Crane (Mathews Studio Equipment) specifications

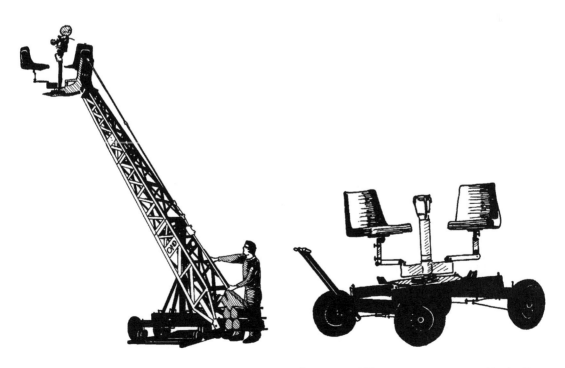

Figure 11.43a Giraffe Crane (Filmair) on track **Figure 11.43b** Giraffe Crane (Filmair) wheelbase

Swiss Crane (Figure 11.44)

Lens height: 32 ft./up (depending on what this unit is mounted on)
Arm capacity: 155 lb.

The Akela Crane (Jr. and Sr.) (Figure 11.45)

Lens height: 32 ft./up (depending on what this unit is mounted on)
Arm capacity: 225 lb.

Motorized cranes

The Chapman Company is my top choice for motorized cranes. In my humble opinion, you will never find a safer or better-engineered crane in the industry. Be safe, be smart, and call for a Chapman motorized crane. It is an Academy Award winner. Note: it is advised that the user of Chapman/Leonard equipment check with the manufacturer for the latest updates on all equipment. Leave nothing to chance. Be smart. Check first.

A professional's tips on the trade

A good safety practice when letting a camera operator off a riding crane is to lock the brakes, put an arm on the chains, step on the arm, have another grip take the place of the camera operator, then reduce the lead or mercury for counterbalance. (NICE TO KNOW)

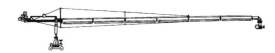

Figure 11.44a Swiss Crane

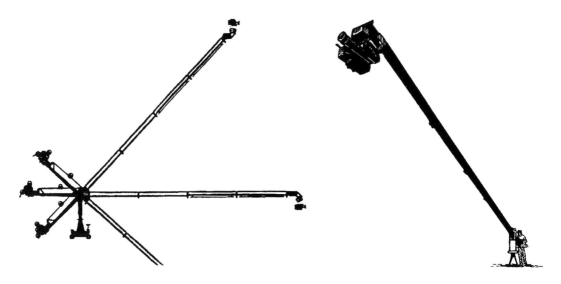

Figure 11.44b Swiss Crane in various positions on dolly **Figure 11.44c** Swiss Crane on rolling base

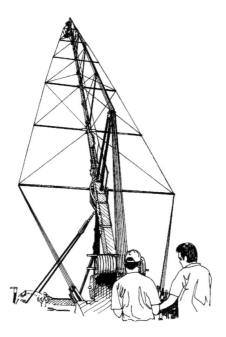

Figure 11.45a The Akela Crane (Jr. and Sr.)

SPECIFICATIONS

ARM REACH	LENS HEIGHT UNDERSLUNG	OVERALL ARM LENGTH	MAX. NOSE LOAD (INCLUDES REMOTE HEAD & CAMERA PKG.)
32'	32'	41'	225 lbs.
39'	39'	48'	200 lbs.
46'	46'	55'	175 lbs.
53'	53'	62'	150 lbs.

Weight (w/chassis & weights) . . .3000 lbs.
Dolly Dimension6' x 6'
Pedestal Height9'

Pedestal to rear9'
Steerable Dolly (Conventional)1
Operator (provided)1

*The Akela Jr. is lightweight and can be broken down into highly portable elements enabling assembly in the remotest of locations.

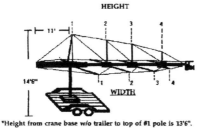

*Height from crane base w/o trailer to top of #1 pole is 13'6".
*Optimum working space required is 17' back from the Pedestal.

Figure 11.45b The Akela Crane (Jr. and Sr.) specifications

SPECIFICATIONS (Akela Sr.)

ARM REACH	LENS HEIGHT UNDERSLUNG	OVERALL ARM LENGTH	MAX. NOSE LOAD (includes remote head & camera pkg.)
71'6"	68'	83'	200 lbs.
58'6"	55'	70'	250 lbs.
45'6"	44'	57'	300 lbs.

Weight (w/ Main Chassis & weights) 7000 lbs.
Chassis w/Steering 10'6" x 12'2"
Pedestal Pivot Point Height 10'
Overall Crane Height 15'

Weight (w/Portable Chassis & weights) 5000 lbs.
Chassis without Steering 8' x 10'
Pedestal to Rear 12'
Operator (Provided) 2
Setup Time .. 3 hrs.
Strike Time 2 hrs.

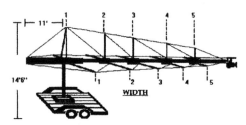

HEIGHT

WIDTH

*Height from crane base w/o trailer to top of #1 pole is 13'6".
*Optimum working space required is 17' back from the Pedestal.

Figure 11.45c The Akela Crane (Jr. and Sr.) specifications

SPECIFICATIONS

ARM REACH	LENS HEIGHT UNDERSLUNG	OVERALL ARM LENGTH	MAX. NOSE LOAD (INCLUDES REMOTE HEAD & CAMERA PKG.)
85'	79'	94'	100 lbs.

MAX. CAMERA WEIGHT............................45 lbs.

Weight (w/Main Chassis & weights)8000 lbs.
Chassis w/Steering10'6" x 12'2"
Pedestal Pivot Point Height10'
Overall Crane Height15'

Weight (w/Portable Chassis & weights) . .6000 lbs.
Chassis w/out Steering8' x 10'
Pedestal to Rear12'
Operator (provided)2

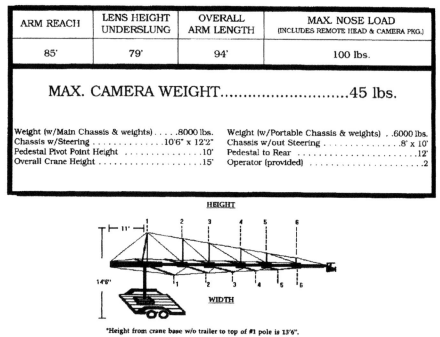

HEIGHT

WIDTH

*Height from crane base w/o trailer to top of #1 pole is 13'6".
*Optimum working space required is 17' back from the Pedestal.

Figure 11.45d The Akela Crane (Jr. and Sr.) specifications

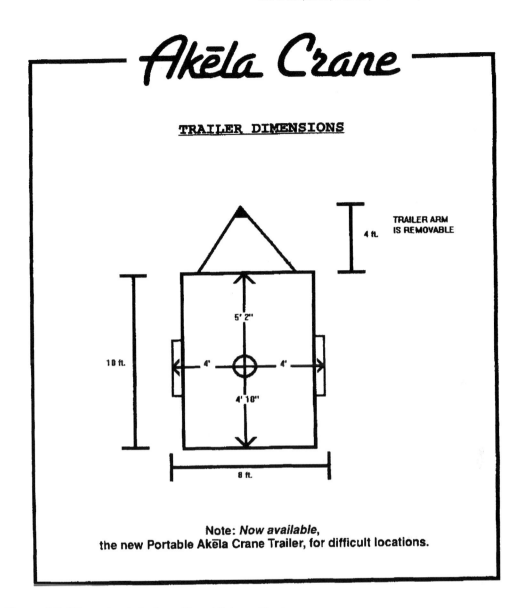

Figure 11.45e The Akela Crane (Jr. and Sr.) specifications

Super nova

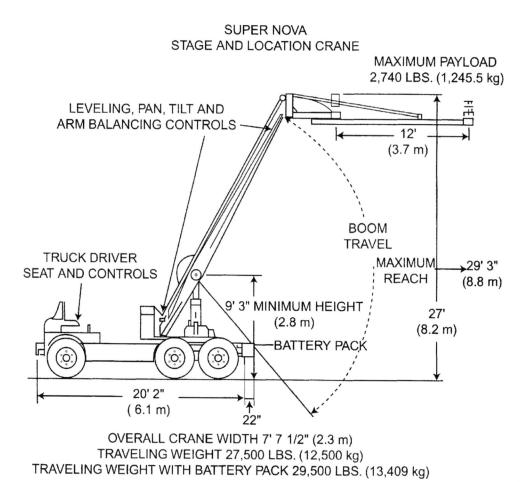

SUPER NOVA
STAGE AND LOCATION CRANE

MAXIMUM PAYLOAD
2,740 LBS. (1,245.5 kg)

LEVELING, PAN, TILT AND
ARM BALANCING CONTROLS

12'
(3.7 m)

BOOM
TRAVEL

TRUCK DRIVER
SEAT AND CONTROLS

MAXIMUM
REACH

29' 3"
(8.8 m)

9' 3" MINIMUM HEIGHT
(2.8 m)

27'
(8.2 m)

BATTERY PACK

20' 2"
(6.1 m)

22"

OVERALL CRANE WIDTH 7' 7 1/2" (2.3 m)
TRAVELING WEIGHT 27,500 LBS. (12,500 kg)
TRAVELING WEIGHT WITH BATTERY PACK 29,500 LBS. (13,409 kg)

MOBILE CRANE ACCESSORIES

4' Hydraulic Riser - (Mobile Crane & Western Dolly)
Telescoping Arm Adapter - Mobile Crane
Super Nova Sideboard - (Set of 2)
Mobile Crane Long Sliding Tow Bar
Steel Leveling Head - Mobile Crane
Vehicle Tow Dolly - Mobile Crane
12" Camera Riser (Steel) - Mobile Crane
Mobile Crane Ramp / Riser
6' Camera Extension - Mobile Crane
12' Camera Extension - Mobile Crane
10' Camera Riser - Mobile Crane
Super Casper Mobile Crane Extension

2 Camera Plate - Mobile Crane, Steel
2 Cam. Plate Setup Package - Mobile Crane, Steel
3' Drop Down - Mobile Crane
6' Drop Down - Mobile Crane
10' Drop Down - Mobile Crane
Nitrogen Bottle & Regulator - Mobile Crane
180° Remote Camera Platform - Mobile Crane
Lead Bucket Extension - Mobile Crane
360° Remote Camera Platform - Mobile Crane
Nose Platform - SteadiCam Platform
Titan Track - 20' Single Piece
Super Nova Battery Pack

Figure 11.46 Super nova

Lens Height (with 12" Riser, Turret and Camera)	27 ft.	8.2 m
Base Mount Height	23 ft. 6 in.	7.2 m
Reach beyond Chassis to Lens	17 ft. 3 in.	5.5 m
Reach beyond Chassis with Extension	29 ft. 3 in.	8.8 m
Vertical Travel of Boom above Ground	23 ft.	7 m
Vertical Travel of Boom below Ground	3 ft. 7 in.	1.1 m
Chassis Width	7 ft. 7 1/2 in.	2.3 m
Chassis Length	20 ft. 2 in.	6.1 m
Chassis Length w/ Battery Pack	22 ft.	6.7 m
Minimum Chassis Height	9 ft. 3 in.	2.8 m
Fully Extended Boom Length	30 ft. 11 in.	9.4 m
Maximum Length of Boom and Chassis w/ Battery Pack	39 ft. 2 in.	11.9 m
Clearance Height for Man and Camera with Arm Level and Post down	11 ft.	3.4 m
Crane Traveling Weight	27,500 lbs.	12,500 kg
Crane Traveling Weight with Battery Pack	29,500 lbs.	13,409 kg
Arm Balancing Ratio	2.5 : 1	
Tread	6 ft. 4 in.	1.9 m
Wheel Base (Outside Wheels)	13 ft. 10 1/2 in.	4.2 m
Ground Clearance with Arm Level (Post up)	8 ft. 5 in.	2.6 m
Maximum Speed on Level Ground with Battery Power (ft./sec.)	8 ft. 8 in./sec.	2.6 m/sec.
Minimum Turn Radius to Extremity of Chassis	23 ft. 3 in.	7 m
*Maximum Payload (with Bucket Extension)	2,740 lbs.	1,245.5 kg

OTHER SUPER NOVA FEATURES

- Remote Controlled Power Steering for Rear Wheels
- Heavy Duty Braking Applied to All 6 Wheels
- Pans 360°
- Electric Powered for Silence
- Smooth, Automatic Leveling in Less Than 10 Seconds
- Hand or Foot / Geared or Belt Driven Camera Turrets
- Qualified Driver Dispatched with Every Order
- Battery Pack System for Remote Power to Cameras
- Battery Pack System for Remote Lighting Power for up to 12k HMI's

- Cruises at 50 mph
- Gasoline Engine for Highway Travel
- Defies Most Terrain
- Crab Steering Capabilities
- 6-Wheel Steering and 6-Wheel Drive
- Battery Powered Arm Brakes
- Push Button Balancing

*Payload Includes All Items (i.e. Man, Camera, Platform, Turret, Crane Arm, etc.) on Base Mount.

Figure 11.46 *(Continued)* Super nova

Titan II

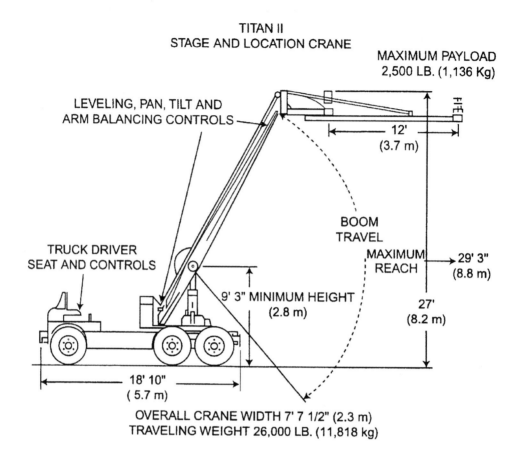

TITAN II
STAGE AND LOCATION CRANE

MAXIMUM PAYLOAD
2,500 LB. (1,136 Kg)

LEVELING, PAN, TILT AND
ARM BALANCING CONTROLS

12'
(3.7 m)

BOOM
TRAVEL

MAXIMUM
REACH

29' 3"
(8.8 m)

TRUCK DRIVER
SEAT AND CONTROLS

9' 3" MINIMUM HEIGHT
(2.8 m)

27'
(8.2 m)

18' 10"
(5.7 m)

OVERALL CRANE WIDTH 7' 7 1/2" (2.3 m)
TRAVELING WEIGHT 26,000 LB. (11,818 kg)

MOBILE CRANE ACCESSORIES

4' Hydraulic Riser - (Mobile Crane & Western Dolly)
Telescoping Arm Adapter - Mobile Crane
Super Nova Sideboard - (Set of 2)
Mobile Crane Long Sliding Tow Bar
Steel Leveling Head - Mobile Crane
12" Camera Riser (Steel) - Mobile Crane
Mobile Crane Ramp / Riser
6' Camera Extension - Mobile Crane
12' Camera Extension - Mobile Crane
10' Camera Riser - Mobile Crane
Super Casper Mobile Crane Extension

2 Camera Plate - Mobile Crane, Steel
2 Cam. Plate Setup Package - Mobile Crane, Steel
3' Drop Down - Mobile Crane
6' Drop Down - Mobile Crane
10' Drop Down - Mobile Crane
Nitrogen Bottle & Regulator - Mobile Crane
180° Remote Camera Platform - Mobile Crane
Lead Bucket Extension - Mobile Crane
360° Remote Camera Platform - Mobile Crane
Nose Platform - SteadiCam Platform
Titan Track - 20' Single Piece

Figure 11.47 Titan II

SPECIFICATIONS

Lens Height (with 12" Riser, Turret and Camera)	27 ft.	8.2 m
Base Mount Height	23 ft. 6in.	7.2 m
Reach beyond Chassis to Lens	17 ft. 3 in.	5.5 m
Reach beyond Chassis with Extension	29 ft. 3 in.	8.8 m
Vertical Travel of Boom above Ground	23 ft.	7 m
Vertical Travel of Boom below Ground	3 ft. 7 in.	1.1 m
Chassis Width	7 ft. 71/2 in.	2.3 m
Chassis Length	20 ft. 2 in.	6.1 m
Minimum Chassis Height	9 ft. 3 in.	2.8 m
Fully Extended Boom Length	30 ft. 11 in.	9.4 m
Maximum Length of Boom and Chassis	37 ft. 4 in.	11.4 m
Clearance Height for Man and Camera with Arm Level and Post Down	11 ft.	3.4 m
Crane Traveling Weight	26,000 lbs.	11,818 kg
Arm Balancing Ratio	2.5 : 1	
Gross Weight with 600 lb. Nose Load	26,600 lbs.	12,091 kg
Tread	6 ft. 4 in.	1.9 m
Wheel Base (Outside Wheels)	13 ft. 10 1/2 in.	4.2 m
Ground Clearance with Arm Level (Post up)	8 ft. 5 in.	2.6 m
Maximum Speed on Level Ground with Battery Power (ft./sec.)	8.8 ft/sec.	2.6 m/sec.
Outside Turn Radius of Chassis	23 ft. 3 in.	7 m
*Maximum Payload (with Bucket Extension)	2,500 lbs.	1,136.3 kg

OTHER TITAN II / NOVA FEATURES

- Remote Controlled Power Steering for Rear Wheels
- Heavy Duty Braking Applied to All 6 Wheels
- Battery Powered Hydraulic Arm Brakes
- Gasoline Engine and Electric Motor
- Hydraulic Leveling in Less Than 10 Seconds
- Hand or Foot Operated Camera Turrets
- Qualified Driver Sent with Every Order

- Cruises at 50 mph
- 6-Wheel Steering and 6-Wheel Drive
- Defies Most Terrain
- Partial Crabbing Ability
- Push Button Balancing
- Silent Operation
- Swings 360°

*Payload Includes All Items (i.e. Man, Camera, Platform, Turret, Crane Arm, etc.) on Base Mount.

*It is advised that the user of Chapman/Leonard equipment check with the manufacturer for the latest updates on *all* equipment.

Figure 11.47 *(Continued)* Titan II

Apollo

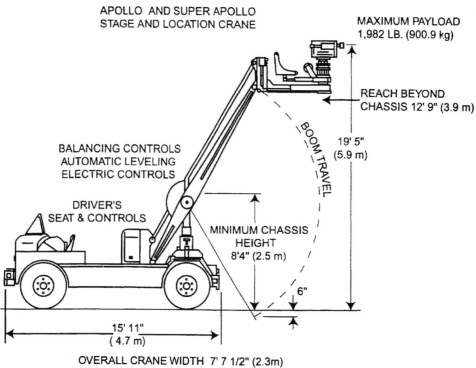

APOLLO AND SUPER APOLLO
STAGE AND LOCATION CRANE

MAXIMUM PAYLOAD
1,982 LB. (900.9 kg)

REACH BEYOND
CHASSIS 12' 9" (3.9 m)

19' 5"
(5.9 m)

BOOM TRAVEL

BALANCING CONTROLS
AUTOMATIC LEVELING
ELECTRIC CONTROLS

DRIVER'S
SEAT & CONTROLS

MINIMUM CHASSIS
HEIGHT
8'4" (2.5 m)

6"

15' 11"
(4.7 m)

OVERALL CRANE WIDTH 7' 7 1/2" (2.3m)
UNIT TRAVEL WEIGHT 17,500 LB. (7,955 kg)

MOBILE CRANE ACCESSORIES

4' Hydraulic Riser - (Mobile Crane & Western Dolly)
Telescoping Arm Adapter - Mobile Crane
Super Nova Sideboard - (Set of 2)
Mobile Crane Long Sliding Tow Bar
Steel Leveling Head - Mobile Crane
Vehicle Tow Dolly - Apollo Crane
12" Camera Riser (Steel) - Mobile Crane
Mobile Crane Ramp / Riser
6' Camera Extension - Mobile Crane
12' Camera Extension - Mobile Crane
10' Camera Riser - Mobile Crane

Super Casper Mobile Crane Extension
2 Camera Plate - Mobile Crane, Steel
2 Cam. Plate Setup Package - Mobile Crane, Steel
3' Drop Down - Mobile Crane
6' Drop Down - Mobile Crane
10' Drop Down - Mobile Crane
Nitrogen Bottle & Regulator - Mobile Crane
180° Remote Camera Platform - Mobile Crane
Lead Bucket Extension - Mobile Crane
360° Remote Camera Platform - Mobile Crane
Nose Platform - SteadiCam Platform

Figure 11.48 Apollo

SPECIFICATIONS

Lens Height (with 12 " Riser, Turret and Camera)	19 ft. 5 in.	5.9 m
Base Mount Height	15 ft. 11 in.	4.9 m
Reach beyond Chassis to Lens	12 ft. 9 in.	3.9 m
Reach beyond Chassis with Extension	18 ft. 9 in.	5.7 m
Vertical Travel of Boom above Ground	15 ft. 5 in.	4.7 m
Vertical Travel of Boom below Ground	10 1/2 in.	27 cm
Chassis Width	7 ft. 7 1/2 in.	2.3 m
Chassis Length	15 ft. 11 in.	4.7 m
Minimum Chassis Height	8 ft. 4 in.	2.5 m
Fully Extended Boom Length	23 ft.	7 m
Maximum Length of Boom and Chassis	29 ft. 4 in.	8.9 m
Clearance Height for Man and Camera w/ Arm Level and Post down	10 ft. 1 in.	3 m
Crane Traveling Weight	17,500 lbs.	7,955 kg
Arm Balancing Ratio	1.9 : 1	
Tread	6 ft. 4 in.	1.9 m
Wheel Base	10 ft. 6 1/2 in.	3.2 m
Ground Clearance w/ Arm Level (Post Up)	7 ft.	2.1 m
Maximum Speed on Level Ground with Battery Power (ft./sec.)	11.2 ft./ sec.	3.4 m/ sec
Minimum Turn Radius to Extremity of Chassis	21 ft. 2 in.	6.5 m
*Maximum Payload	1,982 lbs.	900.9 kg

OTHER APOLLO FEATURES

- Remote Controlled Power Steering for Rear Wheels
- Heavy Duty Braking Applied to All 4 Wheels
- Battery Powered Hydraulic Arm Brakes
- Gasoline Engine and Electric Motor
- Hydraulic Leveling in Less Than 5 Seconds
- Hand or Foot Operated Camera Turrets
- Qualified Driver Sent with Every Order
- Super Apollo Comes with a Built-In Generator to Recharge

- Cruises at 50 mph
- 4-Wheel Steering and 4-Wheel Drive
- Defies Most Terrain
- Partial Crabbing Ability
- Swings 360 Degrees
- Battery Powered Arm Brakes
- Push Button Balancing

Batteries while in Remote Locations

*Payload Includes All Items (i.e. Man, Camera, Platform, Turret, Crane Arm, etc.) on Base Mount.

*It is advised that the user of Chapman/Leonard equipment check with the manufacturer for the latest updates on *all* equipment.

Figure 11.48 *(Continued)* Apollo

Zeus

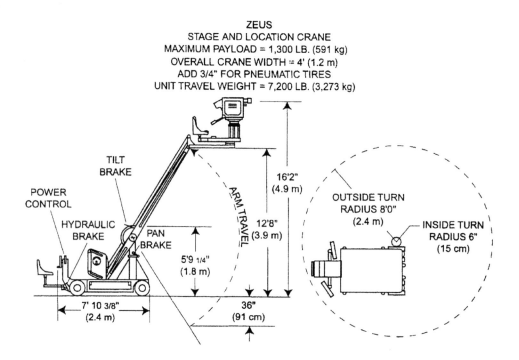

ZEUS
STAGE AND LOCATION CRANE
MAXIMUM PAYLOAD = 1,300 LB. (591 kg)
OVERALL CRANE WIDTH = 4' (1.2 m)
ADD 3/4" FOR PNEUMATIC TIRES
UNIT TRAVEL WEIGHT = 7,200 LB. (3,273 kg)

STAGE CRANE ACCESSORIES

Aluminum Leveling Head - Stage Crane
6" Camera Riser - Crane
12" Camera Riser - Crane
3' Camera Riser - Crane
3' Camera Extension - Stage Crane
8' Camera Extension (Remote Use - Stage Crane Only)
10' Camera Extension (Remote Use - Stage Crane Only)
3' Camera Drop Down - Crane
Bucket Seat
Kidney Seat
4" Seat Arm - Stage Crane
6" Seat Arm - Stage Crane
12" Seat Arm - Stage Crane
19" Seat Arm - Stage Crane
3" Seat Riser - Stage Crane
6" Seat Riser - Stage Crane
12" Seat Riser - Stage Crane
Film (Hand-Operated) Turret - Geared

Film (Hand-Operated) Turret - Belted
Electric, Video / Film Turret
TV (Foot-Operated) Turret
Free Head Turret
Offset Turret
Hydraulic Jack & Handle
Stage Crane Tires (2nd Set) - Pneumatic
Stage Crane Tires (2nd Set) - Solid
Stage Crane Track (10' Section)
¼ Lead Weight
½ Lead Weight
Lead Weight
Stage Crane Slide Weight (8 lbs.)
Stage Crane Slide Weight (16 lbs.)
Lead Bucket Extension
Zeus Sideboard
Circular Platform w/ Rails - 48"
Circular Platform w/ Rails - 72"
Crane Steadicam Platform Adapter Package

Figure 11.49 Zeus

SPECIFICATIONS

Lens Height (Turret)	14 ft.	4.3 m
Lens Height (Platform)	16 ft.	4.9 m
Base Mount Height	10 ft. 6 in.	3.2 m
*Maximum Payload (Turret)	600 lbs.	273 kg
*Maximum Payload for Front of the Arm (Platform)	600 lbs.	273 kg
*Maximum Payload for Back of the Arm (Platform)	600 lbs.	273 kg
Maximum Horizontal Reach (to Lens without Extension)	9 ft. 6 in.	2.9 m
Chassis Length	7 ft. 3 in.	2.2 m
Maximum Chassis Width	6 ft. 2 1/2 in.	1.9 m
Minimum Chassis Width	34 1/2 in.	88 cm
Center to Center Wheel Width for Track (Solid Wheel Setup)	31 3/8 in.	80 cm
Center to Center Wheel Width (Single Knobby Pneumatic Setup)	45 1/2 in.	1.2 m
Center to Center Width (Double Knobby Pneumatic Setup)	65 in.	1.7 m
Maximum Chassis Width (Knobby Pneumatic Wheel Setup)	6 ft. 2 1/2 in.	1.9 m
Minimum Chassis Height	5 ft. 3 1/4 in.	1.6 m
Normal Operating Weight Less Payload*	5,200 lbs.	2,364 kg

OTHER ATB II FEATURES

- **Remote Actuator to Control Arm Independently** from the Camera Platform or Crane Operator Seat
- Built-In Charging System Operates on 110v or 220v
- Electric Powered for Smooth, Silent Operation in Forward and Reverse Modes
- Up to 12' of Vertical Boom Travel from Ground Level to Maximum Height
- Tires Come in Your Choice of Knobby, Pneumatic or Solid Track Wheels
- Selection of Turrets, Risers and Extensions, Aluminum Track Available upon Request
- 36 volt System Will Give Exceptional Performance and Acceleration along Sport Sidelines
- Comes with 48" Platform, Sideboards, Monitor Platform and Padding
- 360 Degree Arm Swing
- Versatility for Use with Film (Hand Operated) or TV (Foot Operated) Turrets
- Rocker Suspension
- Hydraulic Chassis and Parking Brake

*Payload Includes All Items (i.e. Man, Camera, Platform, Turret, Crane Arm, etc.) on Base Mount.

*It is advised that the user of Chapman/Leonard equipment check with the manufacturer for the latest updates on *all* equipment.

Figure 11.49 *(Continued)* Zeus

Electra II/Nike

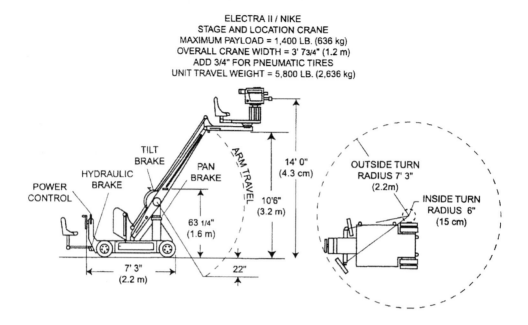

ELECTRA II / NIKE
STAGE AND LOCATION CRANE
MAXIMUM PAYLOAD = 1,400 LB. (636 kg)
OVERALL CRANE WIDTH = 3' 7¾" (1.2 m)
ADD 3/4" FOR PNEUMATIC TIRES
UNIT TRAVEL WEIGHT = 5,800 LB. (2,636 kg)

STAGE CRANE ACCESSORIES

Aluminum Leveling Head - Stage Crane
6" Camera Riser - Crane
12" Camera Riser - Crane
3' Camera Riser - Crane
3' Camera Extension - Stage Crane
8' Camera Extension (Remote Use - Stage Crane Only)
10' Camera Extension (Remote Use - Stage Crane Only)
3' Camera Drop Down - Crane
Bucket Seat
Kidney Seat
4" Seat Arm - Stage Crane
6" Seat Arm - Stage Crane
12" Seat Arm - Stage Crane
19" Seat Arm - Stage Crane
3" Seat Riser - Stage Crane
6" Seat Riser - Stage Crane
12" Seat Riser - Stage Crane
Film (Hand-Operated) Turret - Geared

Film (Hand-Operated) Turret - Belted
Electric, Video / Film Turret
TV (Foot-Operated) Turret
Free Head Turret
Offset Turret
Hydraulic Jack & Handle
Stage Crane Tires (2nd Set) - Pneumatic
Stage Crane Tires (2nd Set) - Solid
Stage Crane Track (10' Section)
¼ Lead Weight
½ Lead Weight
Lead Weight
Stage Crane Slide Weight (8 lbs.)
Stage Crane Slide Weight (16 lbs.)
Lead Bucket Extension
Zeus Sideboard
Circular Platform w/ Rails - 48"
Circular Platform w/ Rails - 72"
Crane Steadicam Platform Adapter Package

Figure 11.50 Electra II/Nike

SPECIFICATIONS

Lens Height (with 12 in. Riser)	14 ft.	4.3 m
Base Mount Height	10 ft. 6 in.	3.2 m
Reach beyond Chassis to Lens	9 ft. 6 in.	2.9 m
*Maximum Payload	1,400 lbs.	636 kg
Vertical Travel of Boom above Ground	10 ft.	3 m
Vertical Travel of Boom below Ground	2 ft.	60 cm
Chassis Width	3 ft. 8 in.	1.1 m
Outside dimensions w/ Pneumatic Tires	3 ft. 9 1/2 in.	1.2 m
Chassis Length	7 ft. 3 in.	2.2 m
Minimum Chassis Height	5 ft. 3 1/2 in.	1.6 m
Fully Extended Boom Length	15 ft. 9 in.	4.8 m
Maximum Length of Boom and Chassis	16 ft. 9 in.	5.1 m
Clearance Height for Man and Camera w/ Arm Level	8 ft.	2.4 m
Crane Weight w/Turret	4,000 lbs.	1,818 kg
Arm Balancing Ratio	2 : 1	
Tread	39 7/8 in.	1 m
Wheel Base	5 ft. 1/2 in.	1.5 m
Ground Clearance w/ Arm Level	4 ft. 1 in.	1.2 m
Maximum Speed on Level Ground	9.8 ft. / sec.	2.5 m / sec.
Outside Turn Radius	6 ft. 3 in.	1.9 m
Normal Operating Weight Less Payload *	5,200 lbs.	2,364 kg

OTHER ELECTRA II / NIKE FEATURES

- Operates on 6 Tires (4 Front, 2 Rear)
- Solid or Pneumatic Tires Available
- On a Full Charge, Batteries Allow 24 Hours Use
- Charger Tapers off as Batteries Are Energized
- Battery Charge Pre-Set for either 110v or 220v
- Friction Brakes for Pan and Tilt Movement
- Selection of Turrets, Risers, Extensions and Aluminum Track
- Electric Powered for Smooth, Silent Operation in Forward / Reverse Modes

- Rocker Suspension
- Turnaround Front Wheels
- All Steel Construction
- Hydraulic Chassis / Parking Brake
- 360 Degree Arm Swing

*Payload Includes All Items (i.e. Man, Camera, Platform, Turret, Crane Arm, etc.) on Base Mount.

*It is advised that the user of Chapman/Leonard equipment check with the manufacturer for the latest updates on *all* equipment.

Figure 11.50 *(Continued)* Electra II/Nike

ATB II sport package

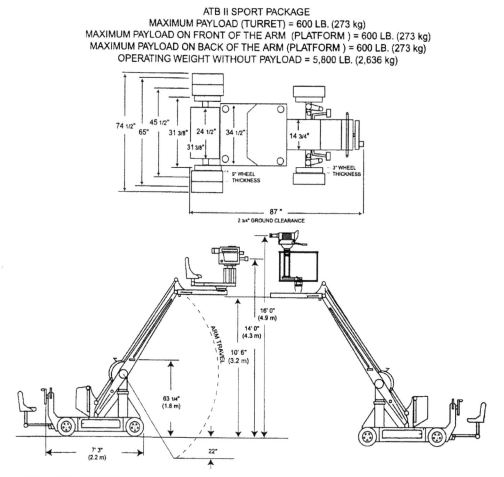

ATB ACCESSORIES

CS / ATB 7" Riser
ATB Knobby Pneumatic Tires - (Set of 6)
ATB Solid Tires - (Set of 6)
ATB Sand Pneumatic Tires - (Set of 6)
ATB Golf Pneumatic Tires - (Set of 6)
ATB Stage Pneumatic Tires - (Set of 6)
ATB Front Mounted Low Deck
Sport ATB Dual Platform Setup
Aluminum Leveling Head - Stage Crane
6" Camera Riser - Crane
12" Camera Riser - Crane
Bucket Seat
Kidney Seat
4" Seat Arm - Stage Crane
6" Seat Arm - Stage Crane
12" Seat Arm - Stage Crane
19" Seat Arm - Stage Crane

3" Seat Riser - Stage Crane
6" Seat Riser - Stage Crane
12" Seat Riser - Stage Crane
Film (Hand-Operated) Turret - Geared
Film (Hand-Operated) Turret - Belted
TV (Foot-Operated) Turret
Free Head Turret
Offset Turret
Stage Crane Tires (2nd Set) - Pneumatic
Stage Crane Tires (2nd Set) - Solid
Stage Crane Track (10' Section)
¼ Lead Weight
½ Lead Weight
Lead Weight
Stage Crane Slide Weight (8 lbs.)
Stage Crane Slide Weight (16 lbs.)
Circular Platform w/ Rails - 48"
Crane Steadicam Platform Adapter Package

Figure 11.51 ATB II sport package

SPECIFICATIONS

Lens Height (Turret)	14 ft.	4.3 m
Lens Height (Platform)	16 ft.	4.9 m
Base Mount Height	10 ft. 6 in.	3.2 m
*Maximum Payload (Turret)	600 lbs.	273 kg
*Maximum Payload for Front of the Arm (Platform)	600 lbs.	273 kg
*Maximum Payload for Back of the Arm (Platform)	600 lbs.	273 kg
Maximum Horizontal Reach (to Lens without Extension)	9 ft. 6 in.	2.9 m
Chassis Length	7 ft. 3 in.	2.2 m
Maximum Chassis Width	6 ft. 2 1/2 in.	1.9 m
Minimum Chassis Width	34 1/2 in.	88 cm
Center to Center Wheel Width for Track (Solid Wheel Setup)	31 3/8 in.	80 cm
Center to Center Wheel Width (Single Knobby Pneumatic Setup)	45 1/2 in.	1.2 m
Center to Center Width (Double Knobby Pneumatic Setup)	65 in.	1.7 m
Maximum Chassis Width (Knobby Pneumatic Wheel Setup)	6 ft. 2 1/2 in.	1.9 m
Minimum Chassis Height	5 ft. 3 1/4 in.	1.6 m
Normal Operating Weight Less Payload*	5,200 lbs.	2,364 kg

OTHER ATB II FEATURES

- **Remote Actuator to Control Arm Independently** from the Camera Platform or Crane Operator Seat
- Built-In Charging System Operates on 110v or 220v
- Electric Powered for Smooth, Silent Operation in Forward and Reverse Modes
- Up to 12' of Vertical Boom Travel from Ground Level to Maximum Height
- Tires Come in Your Choice of Knobby, Pneumatic or Solid Track Wheels
- Selection of Turrets, Risers and Extensions, Aluminum Track Available upon Request
- 36 volt System Will Give Exceptional Performance and Acceleration along Sport Sidelines
- Comes with 48" Platform, Sideboards, Monitor Platform and Padding
- 360 Degree Arm Swing
- Versatility for Use with Film (Hand Operated) or TV (Foot Operated) Turrets
- Rocker Suspension
- Hydraulic Chassis and Parking Brake

*Payload Includes All Items (i.e. Man, Camera, Platform, Turret, Crane Arm, etc.) on Base Mount.

*It is advised that the user of Chapman/Leonard equipment check with the manufacturer for the latest updates on *all* equipment.

Figure 11.51 *(Continued)* ATB II sport package

Olympian

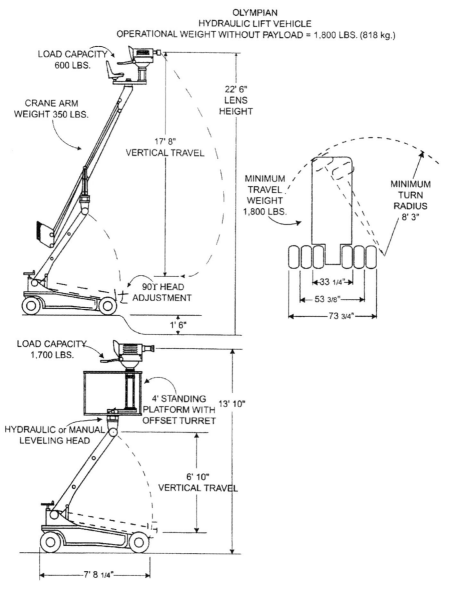

OLYMPIAN ACCESSORIES
6" Mitchell Riser
Olympian Hydraulic Leveling Head
Olympian Track (10' Section)
Olympian 2' Camera Riser
Circular Platform w/ Rails - 48"
Circular Platform w/ Rails - 72"
Olympian Platform Monitor Bracket

6' Adjustable (Olympian) Crane Arm
6' (Olympian) Crane Arm
Olympian Balloon Tires - (Set of 8)
Olympian Solid Tires - (Set of 6)
Olympian Long Sideboard
Olympian Short Sideboard
Olympian II Camera Offset Plate
10' Fiberglass Ramp - Rated for 3,000 lbs.

Figure 11.52 Olympian

Lens Height (with Standard Film, TV, or Platform Setup)	13 ft. 10 in.	4.2 m
Lens Height (with Crane Arm Setup)	22 ft. 6 in.	6.9 m
Minimum Lens Height (with Crane Arm Setup, below Ground Level)	1 ft. 6 in.	46 cm
Reach beyond Chassis (with Film Setup)	9 ft.	23 cm
Reach beyond Chassis (with TV Setup)	1 ft. 4 in.	41 cm
Reach beyond Chassis (with Crane Arm (Film) Setup)	10 ft. 9 in.	3.3 m
Reach beyond Chassis (with Crane Arm (TV) Setup)	8 ft. 7 in.	2.6 m
*Maximum Payload	1,700 lbs.	798 kg
Vertical Travel (Standard Setup)	6 ft. 10 in.	2.1 m
Boom Travel (Crane Arm Setup)	17 ft. 8 in.	5.4 m
Chassis Single Wheel Width (Standard Setup Only)	2 ft. 9 1/4 in.	85 cm
Chassis Dual Wheel Width (Standard Setup Only)	4 ft. 5 3/8 in.	1.4 m
Chassis Triple Wheel Width	6 ft. 1 3/4 in.	1.9 m
Chassis Length	7 ft. 8 1/4 in.	2.3 m
Minimum Turn Radius	8 ft. 3 in.	2.5 m
Maximum Speed (with Full Charge)	18 mph	30 kph
Normal Operating Weight Less Payload*	1,800 lbs.	818 kg

OTHER OLYMPIAN FEATURES

- Two Motor Drive Enabling Speeds up to 18 mph
- Special Rear Steering Design with 20:1 Ratio
- Video Platform, Video or Film Turret Available
- Chassis Allows Removable Padded Barrier
- Large Balloon Tires (4psi to 30psi), for Movement in Sand
- Hydraulic Lift for Smooth, One-Man Operation
- Streamline Profile Does Not Interfere with Audience View
- Great for Football (or Other Sports) Sideline Coverage
- Complete Football Safety Package (Includes: Padding, Wheel Skirts, Cable Draggers)

- Rigid Single Beam Lift
- Flexibility in Camera Operator Setup
- Ability to Carry Crane Arm
- Hydraulic Leveling Accessory
- Detachable Sideboards
- Variable Camera Head Mount
- Ability To Be Used on or off Track
- Narrow Chassis w/ Variable Tire Widths

*Payload Includes All Items (i.e. Man, Camera, Platform, Turret, Crane Arm, etc.) on Base Mount.

*It is advised that the user of Chapman/Leonard equipment check with the manufacturer for the latest updates on *all* equipment.

Figure 11.52 *(Continued)* Olympian

Olympian II hydraulic lift vehicle

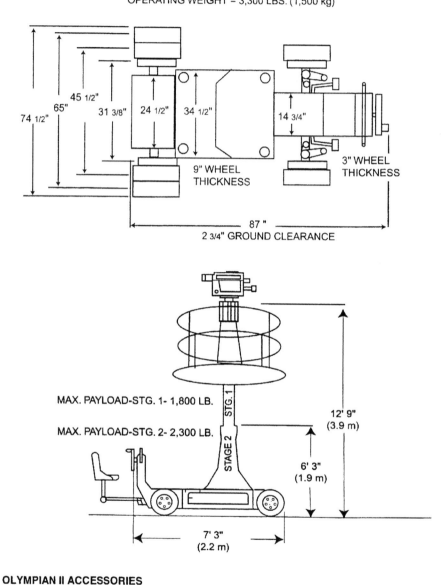

OLYMPIAN II HYDRAULIC LIFT VEHICLE
MAXIMUM RATED PAYLOAD = 1,800 LBS. (818 kg)
OPERATING WEIGHT = 3,300 LBS. (1,500 kg)

45 1/2"
65"
74 1/2"
31 3/8"
24 1/2"
34 1/2"
14 3/4"

9" WHEEL THICKNESS

3" WHEEL THICKNESS

87 "
2 3/4" GROUND CLEARANCE

MAX. PAYLOAD-STG. 1- 1,800 LB.

MAX. PAYLOAD-STG. 2- 2,300 LB.

STG. 1

STAGE 2

12' 9"
(3.9 m)

6' 3"
(1.9 m)

7' 3"
(2.2 m)

OLYMPIAN II ACCESSORIES
6" Mitchell Riser
Olympian 2' Camera Riser
Olympian Platform Monitor Bracket
Olympian II Camera Offset Plate
ATB Knobby Pneumatic Tires - (Set of 6)
Bucket Seat
Kidney Seat

Figure 11.53 Olympian II hydraulic lift vehicle

SPECIFICATIONS

Maximum Camera Mount Height	12 ft. 9 in.	3.9 m
Minimum Camera Mount Height	6 ft. 3 in.	1.9 m
*Maximum Payload - Stage 1	2,300 lbs.	1,045.4 kg
*Maximum Payload - Stage 2	1,800 lbs.	818.1 kg
Vertical Travel	6 ft. 6 in.	2 m
Minimum Ground Clearance	2 3/4 in.	7 cm
Chassis Deck Height	16 in.	41 cm
Maximum Chassis Length without Seat or Platform	7 ft. 3 in.	2.2 m
Maximum Chassis Width	6 ft. 2 1/2 in.	1.9 m
Minimum Chassis Width	34 1/2 in.	88 cm
Platform Diameter	72 in.	1.8 m
Platform Rail Height	3 ft. 1 in.	94 cm
Center to Center Wheel Width for Track (Solid Wheel Setup)	31 3/8 in.	80 cm
Center to Center Wheel Width (Single Knobby Pneumatic Setup)	45 1/2 in.	1.2 m
Center to Center Wheel Width (Double Knobby Pneumatic Setup)	65 in.	1.7 m
Wheel Base	5 ft. 1 1/2 in.	1.6 m
Speed	13 ft./sec.	4 m/sec.
Normal Operating Weight Less Payload*	3,300 lbs.	1,500 kg

OTHER OLYMPIAN II FEATURES

- Drive System Enables Speed of 13 ft./sec.
- Great for Football (or Other Sports) Sideline Coverage
- Streamline Profile Does Not Interfere with Audience View
- Relocated Hydraulic System Gives Driver Better Access
- Platform Mounts on Column for Easy Transportation
- Package Reduces to 2 ft. 10 1/2 in. for Transportation
- Complete Football Safety Package (Includes: Padding, Wheel Skirts, Cable Draggers)
- Electric Powered for Smooth Operation in Forward and Reverse Modes
- Over 6' of Vertical Camera Travel
- Built-In Battery Charger (110v/220v)
- Wraparound Platform Rail (38 in.)
- Silent Operation for Sound Stages
- Hydraulic Chassis and Parking Brake

*Payload Includes All Items (i.e. Man, Camera, Platform, Turret, Crane Arm, etc.) on Base Mount.

*It is advised that the user of Chapman/Leonard equipment check with the manufacturer for the latest updates on *all* equipment.

Figure 11.53 *(Continued)* Olympian II hydraulic lift vehicle

12 Cranes mounted on wheeled bases

In the following pages, you will find images and diagrams of a selection of different cranes mounted on wheeled bases. A summary of the cranes shown, including some specifications for each, is below.

A professional tip

During installation of a remote head on a jib arm or a crane arm in an underslung position, I have found it easier to loosen all four leveling bolts on the head, which allows the leveling head to move freely with its four-way tilting action. Set the remote head on the ground (or deck) with the threaded portion upward, if the head permits this position. With the arm balance out, lower it to the threaded end of the remote, then gently slide the receiver hole over the threads of the remote, making sure not to damage the threads. Align the key way (slotted area), then install the winged/gland nut on the threads and rough level it in place. Add weight to the bucket end of the jib or crane to rebalance the pivot point of the arm. Raise the arm to a working height. (Usually a six-step ladder under the arm will do nicely for judging the right height.) Now install the camera and safety. Rebalance the arm for the camera weight. (NICE TO KNOW) (CRANES)

Felix (Figures 12.1–12.4)

Lens height: 9 ft./up from the base (depending on what this unit is mounted on)
Arm capacity: 484 lb.

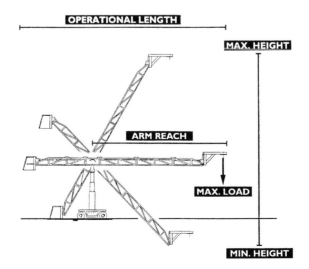

Figure 12.1 Felix

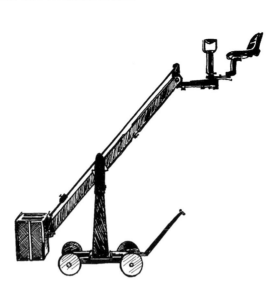

Figure 12.2 Felix

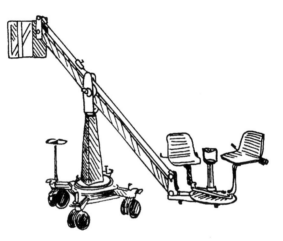

Figure 12.3 Felix

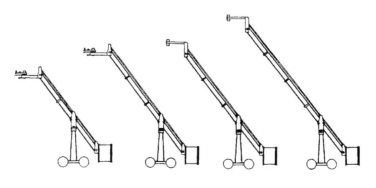

FELIX

Figure 12.4 Felix

Piccolo (Figure 12.5)

Lens height: 9 ft./5 in./up (depending on what this unit is mounted on)
Arm capacity: 550 lb.

Mini Skyking (Figure 12.6)

Lens height: 11 ft./6 in./up (depending on what this unit is mounted on)
Arm capacity: 550 lb.

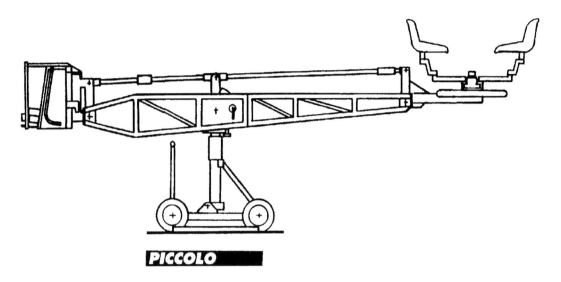

Figure 12.5 Piccolo

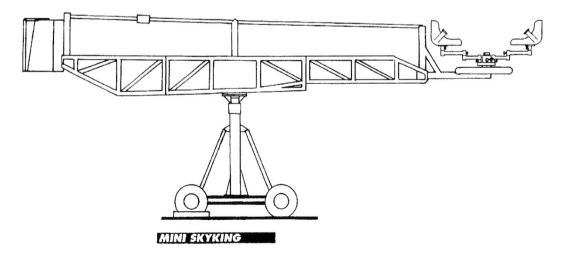

Figure 12.6 Mini Skyking

Tulip (Figure 12.7)

Lens height: 12 ft./1 in./up (depending on what this unit is mounted on)
Arms capacity: 550 lb.

Super Maxi-Jib (Figure 12.8)

Lens height: 15 ft./4 in./up (depending on what this unit is mounted on)
Arms capacity: 77 lb.

Strada (Figure 12.9)

Lens height: 85 ft./up (depending on what this unit is mounted on)
Arms capacity: 100 lb.

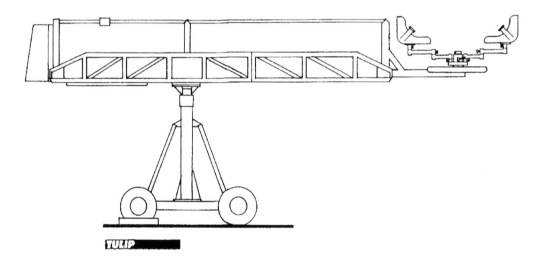

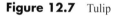

Figure 12.7 Tulip

Figure 12.8 Super Maxi-Jib

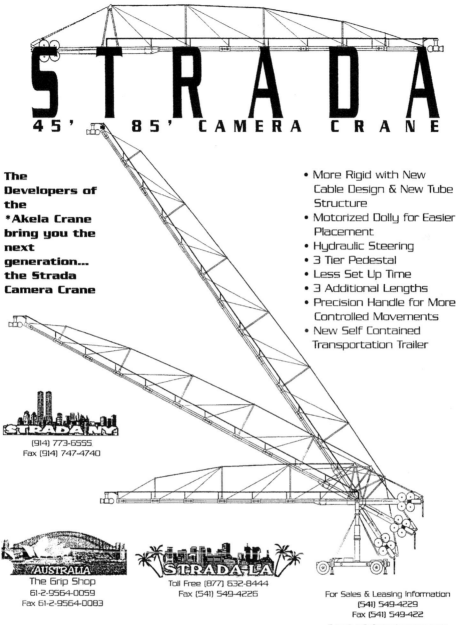

Figure 12.9 Strada

13 *Lenny arms*

The Chapman/Lenard Company in North Hollywood builds the Lenny arm.
The Lenny arms include:

1. Lenny Mini
2. Lenny Arm Plus
3. Lenny Arm II
4. Lenny Arm II Plus
5. Lenny Arm III

Examples of Lenny
CABLE SYSTEM

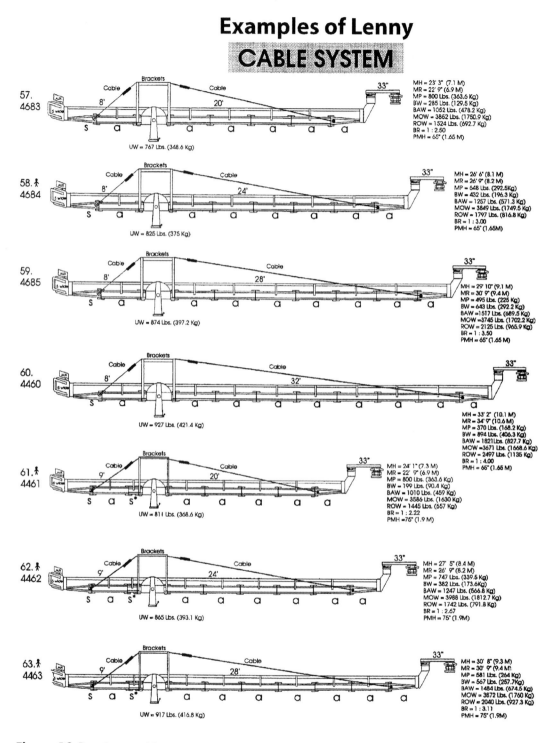

Figure 13.1a Lenny cable system

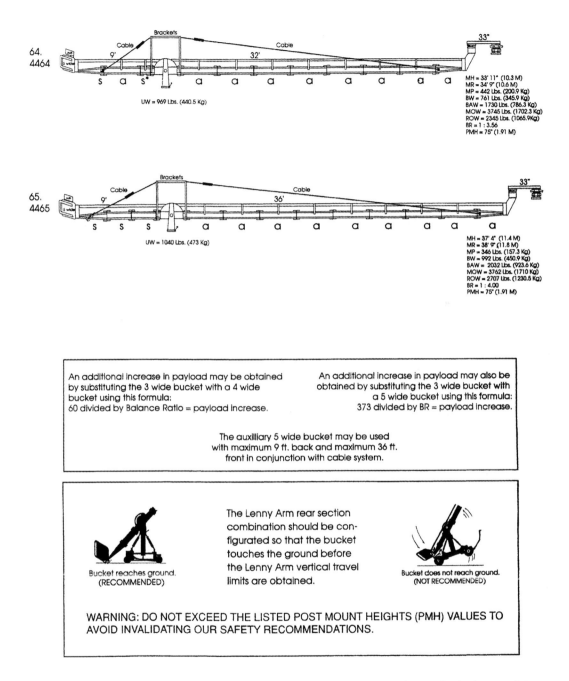

64.
4464

Brackets

Cable

9' 32' Cable

33"

UW = 969 Lbs. (440.5 Kg)

MH = 33' 11" (10.3 M)
MR = 34' 9" (10.6 M)
MP = 442 Lbs. (200.9 Kg)
BW = 761 Lbs. (345.9 Kg)
BAW = 1730 Lbs. (786.3 Kg)
MOW = 3745 Lbs. (1702.3 Kg)
ROW = 2345 Lbs. (1065.9Kg)
BR = 1 : 3.56
PMH = 75" (1.91 M)

65.
4465

Brackets

Cable

9' 36' Cable

33"

UW = 1040 Lbs. (473 Kg)

MH = 37' 4" (11.4 M)
MR = 38' 9" (11.8 M)
MP = 346 Lbs. (157.3 Kg)
BW = 992 Lbs. (450.9 Kg)
BAW = 2032 Lbs. (923.6 Kg)
MOW = 3762 Lbs. (1710 Kg)
ROW = 2707 Lbs. (1230.5 Kg)
BR = 1 : 4.00
PMH = 75" (1.91 M)

An additional increase in payload may be obtained by substituting the 3 wide bucket with a 4 wide bucket using this formula:
60 divided by Balance Ratio = payload increase.

An additional increase in payload may also be obtained by substituting the 3 wide bucket with a 5 wide bucket using this formula:
373 divided by BR = payload increase.

The auxiliary 5 wide bucket may be used with maximum 9 ft. back and maximum 36 ft. front in conjunction with cable system.

Bucket reaches ground.
(RECOMMENDED)

The Lenny Arm rear section combination should be configurated so that the bucket touches the ground before the Lenny Arm vertical travel limits are obtained.

Bucket does not reach ground.
(NOT RECOMMENDED)

WARNING: DO NOT EXCEED THE LISTED POST MOUNT HEIGHTS (PMH) VALUES TO AVOID INVALIDATING OUR SAFETY RECOMMENDATIONS.

*It is advised that the user of Chapman/Leonard equipment check with the manufacturer for the latest updates on *all* equipment.

Figure 13.1b Lenny cable system

Lenny Arm II Plus® Mounting Choices

The Lenny Arm II Plus can be mounted on these Chapman/Leonard products:

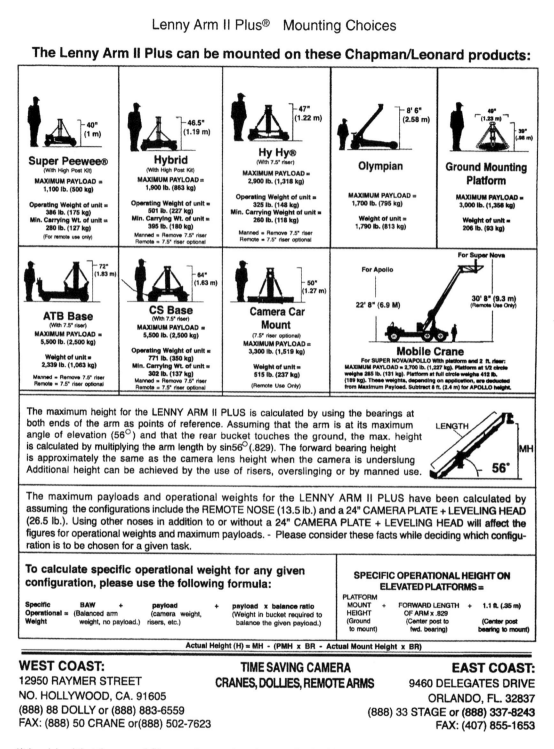

The maximum height for the LENNY ARM II PLUS is calculated by using the bearings at both ends of the arm as points of reference. Assuming that the arm is at its maximum angle of elevation (56°) and that the rear bucket touches the ground, the max. height is calculated by multiplying the arm length by sin56° (.829). The forward bearing height is approximately the same as the camera lens height when the camera is underslung Additional height can be achieved by the use of risers, overslinging or by manned use.

The maximum payloads and operational weights for the LENNY ARM II PLUS have been calculated by assuming the configurations include the REMOTE NOSE (13.5 lb.) and a 24" CAMERA PLATE + LEVELING HEAD (26.5 lb.). Using other noses in addition to or without a 24" CAMERA PLATE + LEVELING HEAD will affect the figures for operational weights and maximum payloads. - Please consider these facts while deciding which configuration is to be chosen for a given task.

To calculate specific operational weight for any given configuration, please use the following formula:

Specific Operational Weight = BAW (Balanced arm weight, no payload.) + payload (camera weight, risers, etc.) + payload x balance ratio (Weight in bucket required to balance the given payload.)

SPECIFIC OPERATIONAL HEIGHT ON ELEVATED PLATFORMS =

PLATFORM MOUNT HEIGHT (Ground to mount) + FORWARD LENGTH OF ARM x .829 (Center post to fwd. bearing) + 1.1 ft. (.35 m) (Center post bearing to mount)

Actual Height (H) = MH - (PMH x BR - Actual Mount Height x BR)

WEST COAST:
12950 RAYMER STREET
NO. HOLLYWOOD, CA. 91605
(888) 88 DOLLY or (888) 883-6559
FAX: (888) 50 CRANE or(888) 502-7623

TIME SAVING CAMERA CRANES, DOLLIES, REMOTE ARMS

EAST COAST:
9460 DELEGATES DRIVE
ORLANDO, FL. 32837
(888) 33 STAGE or (888) 337-8243
FAX: (407) 855-1653

*It is advised that the user of Chapman/Leonard equipment check with the manufacturer for the latest updates on *all* equipment.

Figure 13.2 Lenny Arm II Plus mounting systems

Lenny Arm® III Mounting Options

The Lenny Arm III can be mounted on these Chapman/Leonard products:

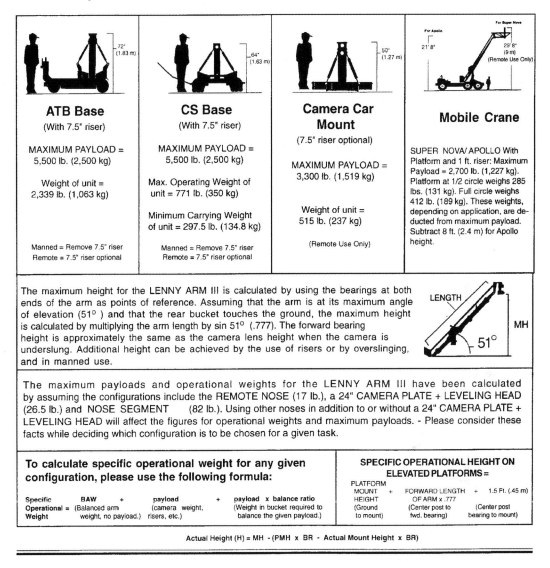

ATB Base	CS Base	Camera Car Mount	Mobile Crane
(With 7.5" riser)	(With 7.5" riser)	(7.5" riser optional)	

ATB Base

MAXIMUM PAYLOAD = 5,500 lb. (2,500 kg)

Weight of unit = 2,339 lb. (1,063 kg)

Manned = Remove 7.5" riser
Remote = 7.5" riser optional

CS Base

MAXIMUM PAYLOAD = 5,500 lb. (2,500 kg)

Max. Operating Weight of unit = 771 lb. (350 kg)

Minimum Carrying Weight of unit = 297.5 lb. (134.8 kg)

Manned = Remove 7.5" riser
Remote = 7.5" riser optional

Camera Car Mount

MAXIMUM PAYLOAD = 3,300 lb. (1,519 kg)

Weight of unit = 515 lb. (237 kg)

(Remote Use Only)

Mobile Crane

SUPER NOVA/ APOLLO With Platform and 1 ft. riser: Maximum Payload = 2,700 lb. (1,227 kg). Platform at 1/2 circle weighs 285 lbs. (131 kg). Full circle weighs 412 lb. (189 kg). These weights, depending on application, are deducted from maximum payload. Subtract 8 ft. (2.4 m) for Apollo height.

The maximum height for the LENNY ARM III is calculated by using the bearings at both ends of the arm as points of reference. Assuming that the arm is at its maximum angle of elevation (51°) and that the rear bucket touches the ground, the maximum height is calculated by multiplying the arm length by sin 51° (.777). The forward bearing height is approximately the same as the camera lens height when the camera is underslung. Additional height can be achieved by the use of risers or by overslinging, and in manned use.

The maximum payloads and operational weights for the LENNY ARM III have been calculated by assuming the configurations include the REMOTE NOSE (17 lb.), a 24" CAMERA PLATE + LEVELING HEAD (26.5 lb.) and NOSE SEGMENT (82 lb.). Using other noses in addition to or without a 24" CAMERA PLATE + LEVELING HEAD will affect the figures for operational weights and maximum payloads. - Please consider these facts while deciding which configuration is to be chosen for a given task.

To calculate specific operational weight for any given configuration, please use the following formula:

Specific Operational = Weight	BAW (Balanced arm weight, no payload.)	+	payload (camera weight, risers, etc.)	+	payload x balance ratio (Weight in bucket required to balance the given payload.)

SPECIFIC OPERATIONAL HEIGHT ON ELEVATED PLATFORMS =

PLATFORM MOUNT HEIGHT (Ground to mount)	+	FORWARD LENGTH OF ARM x .777 (Center post to fwd. bearing)	+	1.5 Ft. (.45 m) (Center post bearing to mount)

Actual Height (H) = MH - (PMH x BR - Actual Mount Height x BR)

WARNING: Never exceed the maximum payload values for any configuration. Chapman/Leonard Studio Equipment, Inc. will **NOT** guarantee the safety or performance of any alterations to the depicted arm configurations.

Figure 13.3 Lenny Arm III mounting options

Lenny Arm® III Configurations

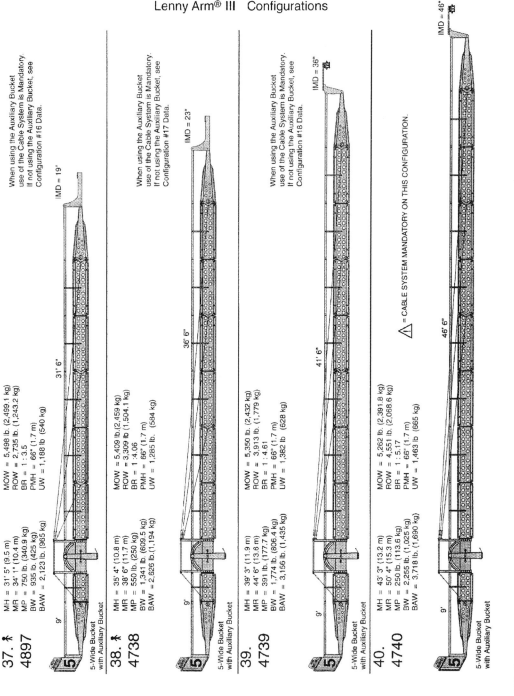

37. ⚹
4897

MH = 31' 5" (9.5 m)
MR = 34' 1" (10.4 m)
MP = 750 lb. (340.9 kg)
BW = 935 lb. (425 kg)
BAW = 2,123 lb. (965 kg)

MOW = 5,498 lb. (2,499.1 kg)
ROW = 2,735 lb. (1,243.2 kg)
BR = 1 : 3.5
PMH = 66" (1.7 m)
UW = 1,188 lb (540 kg)

When using the Auxiliary Bucket use of the Cable System is Mandatory. If not using the Auxiliary Bucket, see Configuration #16 Data.

5-Wide Bucket with Auxiliary Bucket

38. ⚹
4738

MH = 35' 4" (10.8 m)
MR = 38' 6" (11.7 m)
MP = 550 lb. (250 kg)
BW = 1,341 lb. (609.5 kg)
BAW = 2,626 lb.(1,194 kg)

MOW = 5,409 lb.(2,459 kg)
ROW = 3,309 lb (1,504.1 kg)
BR = 1 :4.06
PMH = 66" (1.7 m)
UW = 1,285 lb. (584 kg)

When using the Auxiliary Bucket use of the Cable System is Mandatory. If not using the Auxiliary Bucket, see Configuration #17 Data.

5-Wide Bucket with Auxiliary Bucket

39.
4739

MH = 39' 3" (11.9 m)
MR = 44' 6" (13.6 m)
MP = 391 lb. (177.7 kg)
BW = 1,774 lb. (806.4 kg)
BAW = 3,156 lb. (1,435 kg)

MOW = 5,350 lb. (2,432 kg)
ROW = 3,913 lb. (1,779 kg)
BR = 1 :4.61
PMH = 66" (1.7 m)
UW = 1,382 lb (628 kg)

When using the Auxiliary Bucket use of the Cable System is Mandatory. If not using the Auxiliary Bucket, see Configuration #18 Data.

5-Wide Bucket with Auxiliary Bucket

40.
4740

MH = 43' 3" (13.2 m)
MR = 50' 4" (15.3 m)
MP = 250 lb. (113.6 kg)
BW = 2,255 lb. (1,025 kg)
BAW = 3,718 lb. (1,690 kg)

MOW = 5,262 lb. (2,391.8 kg)
ROW = 4,551 lb. (2,068.6 kg)
BR = 1 : 5.17
PMH = 66" (1.7 m)
UW = 1,463 lb (665 kg)

⚠ = CABLE SYSTEM MANDATORY ON THIS CONFIGURATION.

5-Wide Bucket with Auxiliary Bucket

IMD = 19"
IMD = 23"
IMD = 36"
IMD = 46"

31' 6"
36' 6"
41' 6"
46' 6"

Figure 13.4a Lenny Arm III configurations

Lenny Arm® III Configurations

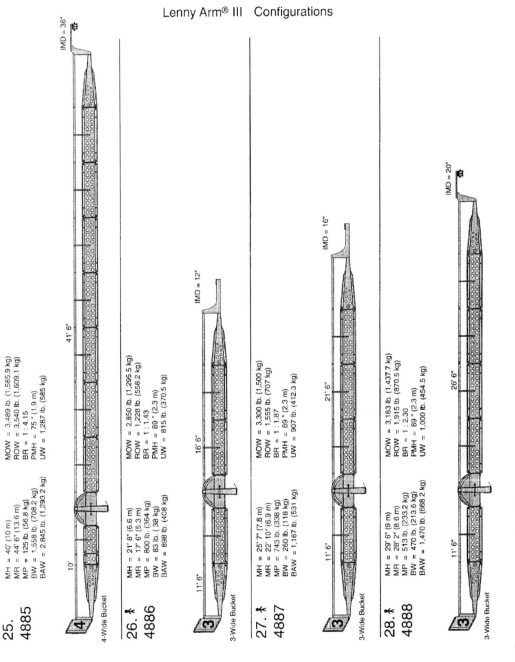

25.
4885

MH = 40' (10 m)
MR = 44' 6' (13.6 m)
MP = 125 lb. (56.8 kg)
BW = 1,558 lb. (708.2 kg)
BAW = 2,845 lb. (1,293.2 kg)

MOW = 3,489 lb. (1,585.9 kg)
ROW = 3,540 lb. (1,609.1 kg)
BR = 1 : 4.15
PMH = 75 " (1.9 m)
UW = 1,287 lb. (585 kg)

4-Wide Bucket

26.
4886

MH = 21' 8' (6.6 m)
MR = 17' 6' (5.3 m)
MP = 800 lb. (364 kg)
BW = 83 lb. (38 kg)
BAW = 898 lb. (408 kg)

MOW = 2,850 lb. (1,295.5 kg)
ROW = 1,228 lb. (558.2 kg)
BR = 1 : 1.43
PMH = 89 " (2.3 m)
UW = 815 lb. (370.5 kg)

3-Wide Bucket

27.
4887

MH = 25' 7' (7.8 m)
MR = 22' 10' (6.9 m)
MP = 743 lb. (338 kg)
BW = 260 lb. (118 kg)
BAW = 1,167 lb. (531 kg)

MOW = 3,300 lb. (1,500 kg)
ROW = 1,555 lb. (707 kg)
BR = 1 : 1.87
PMH = 89 " (2.3 m)
UW = 907 lb. (412.3 kg)

3-Wide Bucket

28.
4888

MH = 29' 6" (9 m)
MR = 28' 2' (8.6 m)
MP = 513 lb. (233.2 kg)
BW = 470 lb. (213.6 kg)
BAW = 1,470 lb. (668.2 kg)

MOW = 3,163 lb. (1,437.7 kg)
ROW = 1,915 lb. (870.5 kg)
BR = 1 : 2.30
PMH = 89 " (2.3 m)
UW = 1,000 lb. (454.5 kg)

3-Wide Bucket

Figure 13.4b Lenny Arm III configurations

14 Cablecams

General information

Cable cam can be suspended above any terrain, including mountains, forests, rivers, water-falls, lakes, playing fields, roadways, stadiums, city streets, off-road terrain, and skiing courses (Figure 14.1). Cable cam is not temperature or moisture sensitive and runs smoothly in a wide range of conditions. Setup and breakdown of the system usually takes 1 or 2 days, depending on the location. Running spans of up to 2,000 ft. (600 m) are readily achievable with the standard 60 ft. (18 m) towers. Longer spans are possible with higher attachment points, such as larger towers, cranes, or the tops of buildings or stadiums. Dollies can boom up or down during a shot to match a landscape or to ascend or descend in relation to obstacles in the path of the dollies. This is accomplished by means of paying in or paying out high-line cable on or off a hydraulic winch. The dolly is 2 ft. (0.6 m.) wide, which allows rigging through tight areas, such as between trees, through windows and doorways, and under lighting grids and scoreboards. The remote dolly can be safely flown close to pyrotechnical effects. Note: cable cam now uses remote camera operation for greater safety. Check with Cable cam before you decide on which system to use. They are fantastic and will help you design the safest way to get your shot.

Cable cam motion control system

The movement of the dolly and camera is programmed to repeat itself during each take. The computer can memorize dolly height, speed acceleration, deceleration, and direction. The computer can also memorize camera pan, tilt, roll, speed and aperture, zoom, and focus. The system can be set up to simultaneously trigger synchronized special effects sequences. These features eliminate the variables a filmmaker faces when combining camera tracking, stunt action, and pyrotechnical effects.

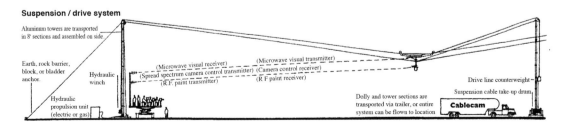

Figure 14.1a Cable cam over large area

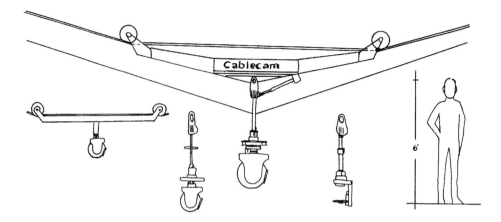

Figure 14.1b Cable cam head

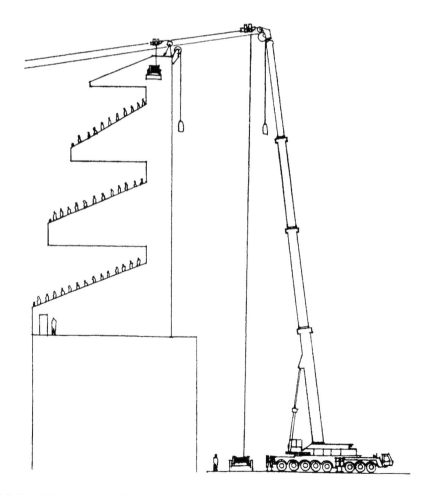

Figure 14.1c Cable cam at stadium

15 Dollies

The dollies described in this section are only a few of the types available (Figure 15.1). I believe that the examples chosen are the best the industry has to offer. Each dolly has its own characteristics, but all of the dollies do one basic thing: they are a mobile platform for the camera. This invention has saved the grip and camera department many hours of pain due to carrying a tripod with a camera on it. As you look through the charts and specifications for each dolly, decide for yourself which dolly is best suited for the job you are about to do.

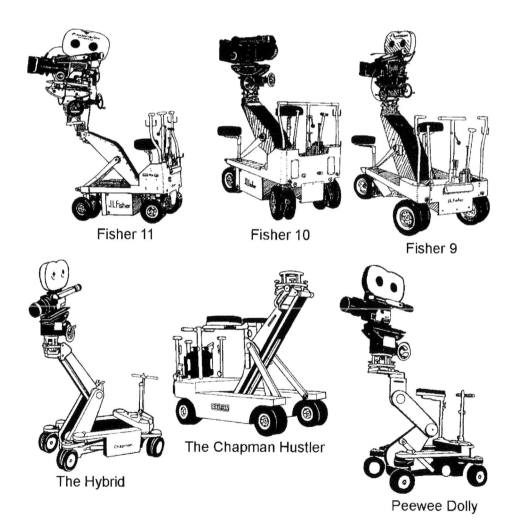

Fisher 11

Fisher 10

Fisher 9

The Hybrid

The Chapman Hustler

Peewee Dolly

Figure 15.1 Assorted dollies

Doorway dolly

As the name suggests, the doorway dolly (Figure 15.2) was designed to be an inexpensive camera dolly that is narrow enough to fit through most standard doorways. Over the years doorway dollies have been used not only for this purpose but also as efficient equipment transporters for camera cases, lighting fixtures, cable, and other pieces of equipment. Pneumatic tires are standard on the doorway dolly, but the dolly can also be fitted with track wheels for use on straight dolly track. Steering is accomplished by using a pull handle (like a wagon). Recently a new steering feature has been added that allows the operator to steer from onboard the dolly. This is accomplished by inserting the pull handle through the push bar at the front of the dolly. A recent addition available for the push bar is an angled fitting that allows the bar to tilt down 34 degrees for more clearance between the dolly and the dolly operator. The basic construction is a wooden platform attached to a steel tubing frame. The platform is fitted with a recessed camera tie-down area, and it is carpeted for a nonslip, low-maintenance surface. For extra-low-angle shots, the dolly can be inverted, thereby positioning the platform closer to the ground. This dolly also includes the ability to extend the rear wheels outward in order to provide greater operating stability.

Western dolly

A western dolly (Figure 15.3) is somewhat similar in design to the doorway dolly, but the western is much larger and is capable of transporting a heavier load. Its larger wheels offer a smoother, steadier ride than the smaller dollies. The western can be fitted with flotation track wheels and (unlike the doorway) can be operated on curved track. Applications for the western dolly include use as a camera dolly, equipment transporter, or low platform behind a camera car. For operator convenience, the push bar can be tilted down 34 degrees using a tilt adapter. The bar can also be side-mounted for close shots. When the western dolly is used inverted, the platform clearance is raised

Push bar
tilts 34°

Figure 15.2 Doorway dolly

Figure 15.3 Western dolly

for use over rough terrain. Two recent additions to the western dolly include a turret assembly and pop-off wheels. The turret assembly allows for the mounting of two seats and a complete camera configuration supported by a Mitchell base. This is the standard mounting base for most cameras. It is flat with a key slot. The pop-off wheels allow for the quick removal of the dolly wheels for easy storage. The axle is incorporated into the wheel assembly to prevent the axle from becoming separated from the wheel upon removal.

Tube dolly

A tube dolly (Figure 15.4) is a specialized dolly originally designed to ride on sections of straight standard dolly track or tubing. The tube dolly was created to serve as a tracking platform for the older conventional-type crab dollies, which were not capable of being adapted for track use; the crab dolly would be physically loaded onto the tube dolly. The rear carriage of the tube dolly is adjustable back

Figure 15.4 Tube dolly

and forth to compensate for differing wheel lengths of crab dollies. Another application of the adjustable rear carriage is to serve as an outrigger platform for lighting or sound when the camera is riding on the main platform.

Fisher #11 crab dolly
Features

- Three-way steering system: crab, conventional, and round
- 80 to 240 volts AC or DC
- Multi-position level head
- Rotary knob or up-down lever
- Camera battery compartment
- Self-contained track system.

Standard accessories

- Two seats
- Two front boards (elephant ears or pork chops)
- Two high-side boards (31-1/2 in. [79 cm] long)
- Two low-side boards (11 in. [28 cm] long)
- One battery rack
- Two push posts
- Two carry handles (nickname: can openers)
- One knee bumper
- One power cord
- Front pins.

Figure 15.5a Fisher #11 crab dolly with gear head and camera

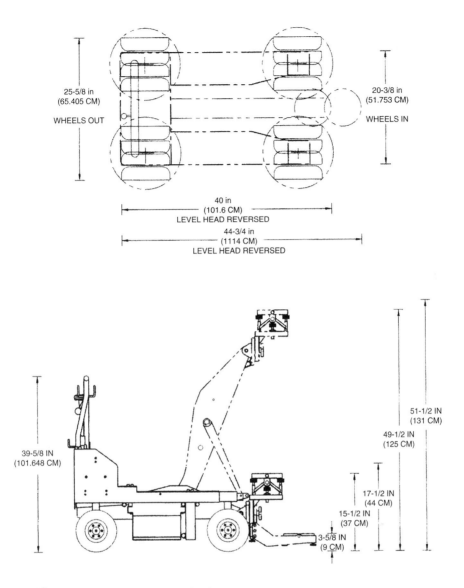

Figure 15.5b Fisher #11 crab dolly specifications

Optional accessories

- Straight (square) track: 20 ft., 16 ft., 10 ft., 8 ft., 4 ft., 3 ft., or 2 ft.
- Curved track: 10 ft. diameter, 20 ft. diameter, 30 ft. diameter, or 70 ft. diameter
- Rotating offsets (four models to choose from)
- Low-level heads (two- or four-way level-type models)
- 45-degree seat offset
- 90-degree seat offset
- Seat riser
- Rotating seats
- Camera offsets: 10 in. or 24 in. (nickname: Ubangi)
- Universal adapter (converts a Mitchell base into a Ball base)
- Camera risers: 3 in., 6 in., or 12 in.

- 90-degree camera angle plate
- Round track adapter wheel set (boogie wheels)
- Diving boards (42 in. [107 cm] long)
- Lamp adapter
- Front board bridge
- Front track platform (low board with roller wheels)
- Ice skates
- Center mount kit (for large jib arms)
- Soft wheels (used as a softening effect).

Fisher #10 crab dolly
Standard accessories

- Two seats
- Two front boards (elephant ears or pork chops)
- Two high-side boards (36 in. long)
- Two low-side boards (20-1/2 in. long)
- One battery rack
- Two push posts
- Two carry handles (nickname: can openers)
- One knee bumper
- One power cord
- Front pins.

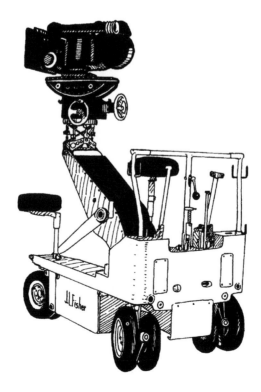

Figure 15.6a Fisher #10 crab dolly

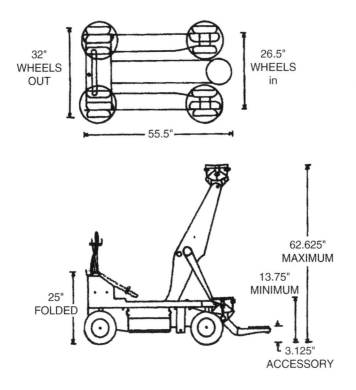

32"
WHEELS
OUT

26.5"
WHEELS
in

55.5"

62.625"
MAXIMUM

13.75"
MINIMUM

25"
FOLDED

3.125"
ACCESSORY

Figure 15.6b Fisher #10 crab dolly with gear head

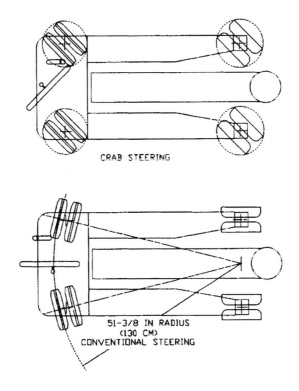

CRAB STEERING

51-3/8 IN RADIUS
(130 CM)
CONVENTIONAL STEERING

Figure 15.6c Fisher #10 crab dolly specifications

Optional accessories

- Straight (square) track: 20 ft., 16 ft., 10 ft., 8 ft., 4 ft., 3 ft., or 2 ft.
- Curved track: 10 ft. diameter, 20 ft. diameter, 30 ft. diameter, or 70 ft. diameter
- Rotating offsets (four models to choose from)
- Low-level heads (two-or four-way level-type models)
- 45-degree seat offset
- 90-degree seat offset
- Seat riser
- Rotating seat
- Beam step standing platform
- Camera offsets: 10 in. or 24 in. (nickname: Ubangi)
- Universal adapter (converts a Mitchell base into a ball base)
- Camera risers: 3 in., 6 in., or 12 in.
- 90-degree camera angle plate
- Round track adapter wheel set (boogie wheels)
- Diving boards (48 in. long)
- Lamp adapter
- Front track platform (low board with roller wheels)
- Front porch (high board that hooks on front of the dolly)
- Ice skates
- Center mount kit (for large jib arms)
- Soft wheels (used as a softening effect)
- Monitor rack
- Cue board.

Fisher #9 crab dolly

Features

- Three-way steering system: crab, conventional, and steering
- 80 to 240 volts AC or DC.

Standard accessories

- High (36 in.) and low (20-1/2 in. [52 cm]) side boards
- Interchangeable front boards
- Adjustable seats
- Push posts
- Carry handles
- Power cord
- Front pins
- Battery rack
- Kneeboard.

Optional accessories

- 3 in., 6 in., and 12 in. risers
- 10 in. and 24 in. camera offsets
- Fisher rotating (nickname: Ubangi)
- 90-degree angle plates

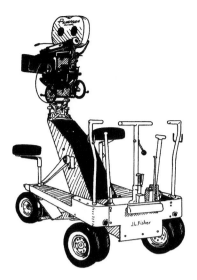

Figure 15.7 Fisher crab dolly

- Pan/tilt adapters
- Monitor rack
- Low-level head
- Seat offset
- Seat risers
- Seat platform
- Extended high sideboards
- Track trucks (for Fisher, Matthews, Elemack, and Dexter straight tracks)
- Straight track (round or square)
- Track ramps
- Shipping case.

See Figures 15.8 through 15.48.

Fisher Camera Dolly Accessories

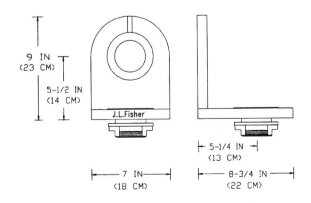

Figure 15.8 Fisher crab dolly 90-degree plate

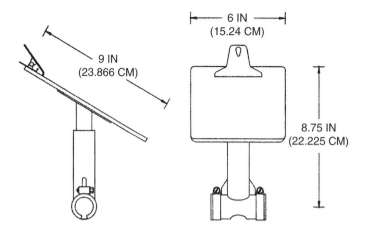

Figure 15.9 Fisher crab dolly cue clip board

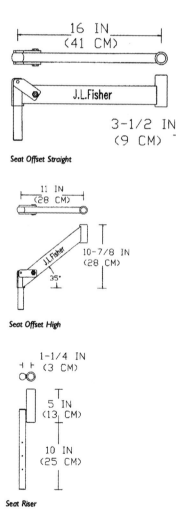

Figure 15.10 Fisher crab dolly seat offset, 45% seat offset, seat riser

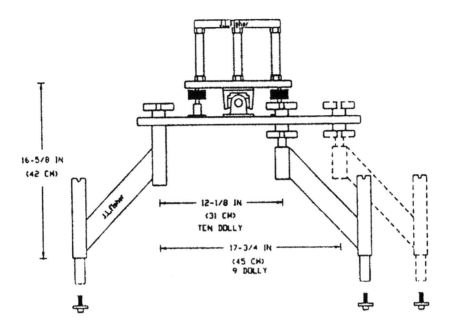

Figure 15.11 Fisher crab dolly center mount kit

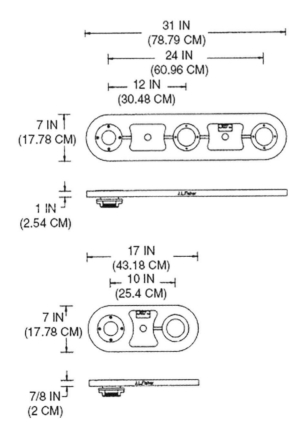

Figure 15.12 Fisher crab dolly offsets

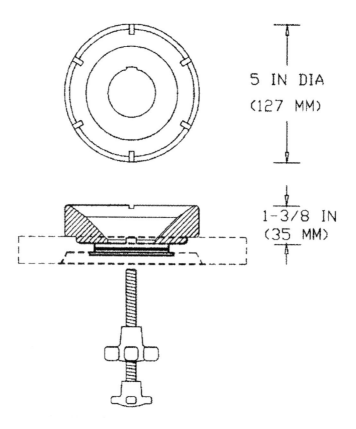

Figure 15.13 Fisher crab dolly ball mount adapter

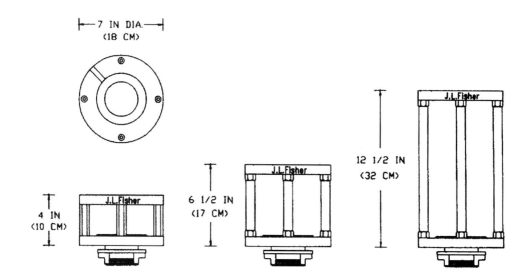

Figure 15.14 Risers

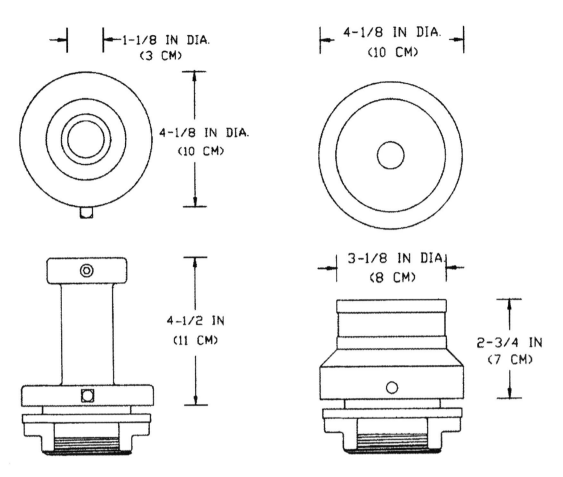

Figure 15.15 Adapter for light mount kit

Figure 15.16 Adapter for Euro riser

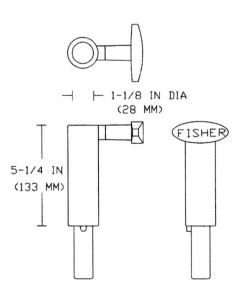

Figure 15.17 Adapter kit for lamp

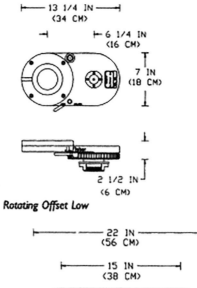

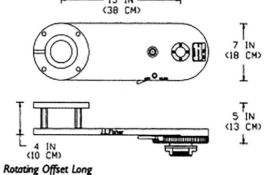

Figure 15.18 Rotating offset

Figure 15.19 Monitor rack

Figure 15.20 Scooter rolling front boards

Figure 15.21 Side boards

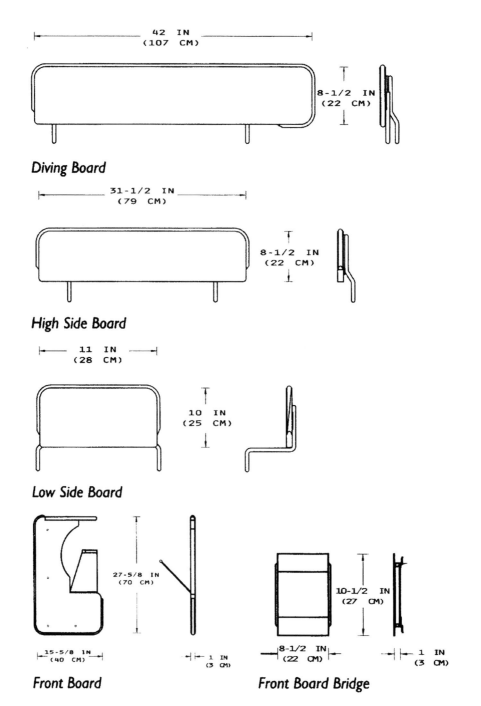

Figure 15.22 Front boards

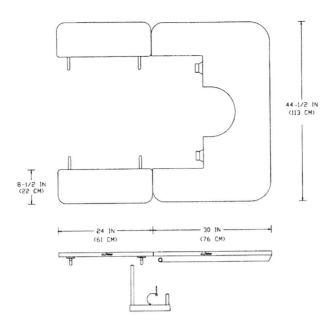

Figure 15.23 Low front porch

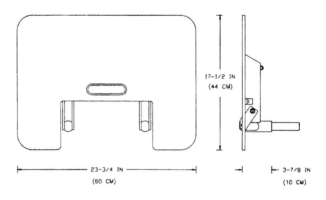

Model 9 Dolly Platform

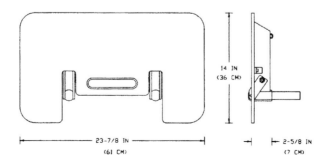

Model Ten Dolly Platform

Figure 15.24 Beam step riser

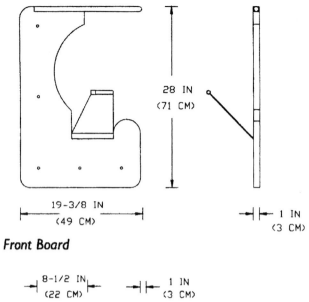

28 IN
(71 CM)

1 IN
(3 CM)

19-3/8 IN
(49 CM)

Front Board

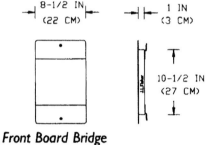

8-1/2 IN
(22 CM)

1 IN
(3 CM)

10-1/2 IN
(27 CM)

Front Board Bridge

Figure 15.25 Front board bridges

48 IN
(122 CM)

24 IN
(61 CM)

5 IN
(13 CM)

24-1/2 IN
(62 CM)

Front Track Platform

Figure 15.26 Front track platforms

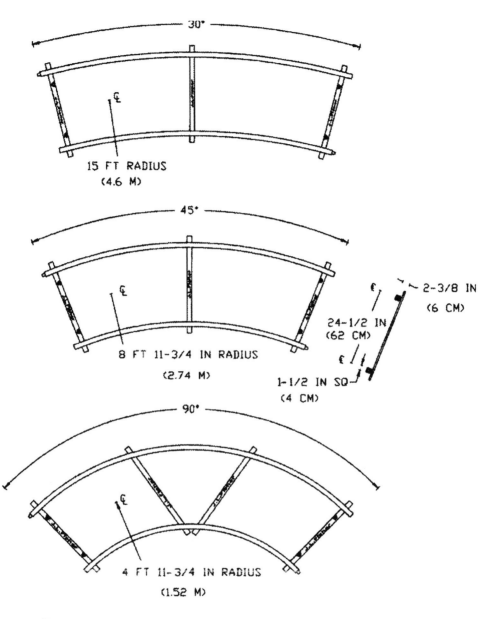

Figure 15.27 Curved track

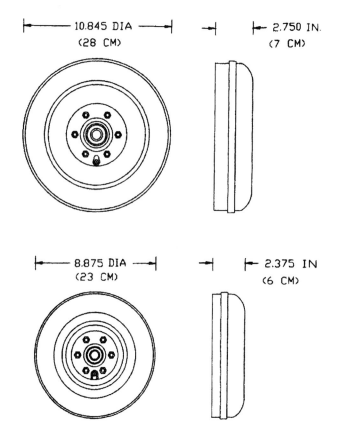

Figure 15.28 Pneumatic wheels

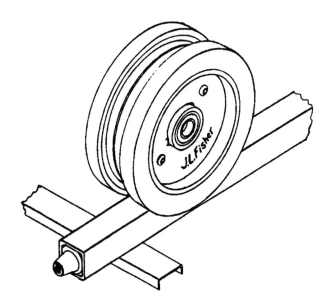

Figure 15.29 Square tube track wheels

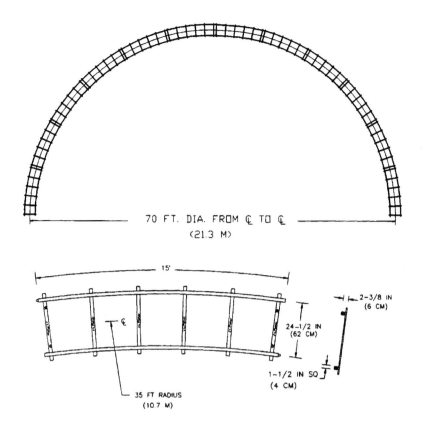

70 FT. DIA. FROM ℄ TO ℄
(21.3 M)

15'

2-3/8 IN
(6 CM)

24-1/2 IN
(62 CM)

℄

1-1/2 IN SQ
(4 CM)

35 FT RADIUS
(10.7 M)

Figure 15.30 Seventy-foot large curved track

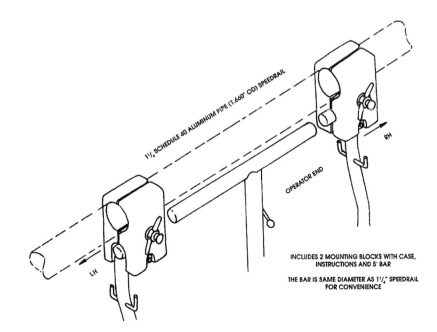

1¼ SCHEDULE 40 ALUMINUM PIPE (1.660" OD) SPEEDRAIL

RH

OPERATOR END

LH

INCLUDES 2 MOUNTING BLOCKS WITH CASE,
INSTRUCTIONS AND 5' BAR

THE BAR IS SAME DIAMETER AS 1¼" SPEEDRAIL
FOR CONVENIENCE

Figure 15.31 Push bar

Shotmaker Blue Goes Above and Beyond You Know Who.

SPECIFICATIONS

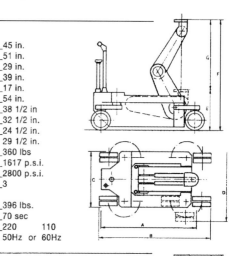

Minimum length (A)	45 in.
Maximum length (B)	51 in.
Minimum width (C)	29 in.
Maximum width (D)	39 in.
Minimum height (E)	17 in.
Maximum height (F)	54 in.
Arm travel (G)	38 1/2 in
Minimum turn radius	32 1/2 in.
Usable track gauge	24 1/2 in.
	29 1/2 in.
Lifting capacity (recommended)	360 lbs
Minimum working pressure	1617 p.s.i.
Maximum working pressure	2800 p.s.i.
Maximum arm lifts	3
(with accumulator fully charged)	
Weight (without accessories)	396 lbs.
Charge time in Electronic Mode	70 sec
Power Supply	220 110
	50Hz or 60Hz

SPECIFICATIONS

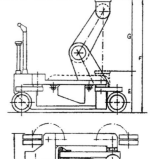

Minimum length (A)	35 1/2 in.
Maximum length (B)	49 in.
Minimum width (C)	22 in.
Maximum width (D)	35 1/2 in.
Minimum height (E)	15 1/2 in.
Maximum height (F)	51 in.
Arm travel (G)	35 1/2 in
Minimum turn radius	35 in.
Usable track gauge	24 1/2 in.
Lifting capacity for camera head	100 lbs
Lifting capacity for hoisting arm	300 lbs
Minimum working pressure	890 p.s.i.
Maximum working pressure	2900 p.s.i.
Maximum arm lifts	3
(with accumulator fully charged)	
Weight (without accessories)	320 lbs.
Charge time in Electronic Mode	45 sec
Power Supply	50Hz or 60Hz

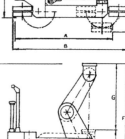

SPECIFICATIONS

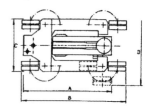

Minimum length (A)	34 in.
Maximum length (B)	44 in.
Minimum width (C)	22 in.
Maximum width (D)	35 in.
Minimum height (E)	17 in.
Maximum height (F)	46 1/2 in.
Arm travel (G)	29 1/2 in
Minimum turn radius	24 1/2 in.
Usable track gauge	17 in.
	24 1/2 in.
	29 1/2 in.
Lifting capacity (recommended)	132 lbs
Minimum working pressure	855 p.s.i.
Maximum working pressure	1854 p.s.i.
Maximum arm lifts	4
(with accumulator fully charged)	
Weight (without accessories)	270 lbs.
Charge time in Electronic Mode	70 sec
Power Supply	220 110
	50Hz or 60Hz

Figure 15.32 Shotmaker = Eagle, Hawk, Falcon dollies

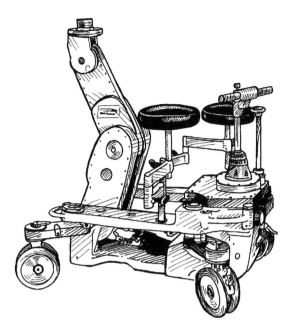

Figure 15.33 Eagle dolly

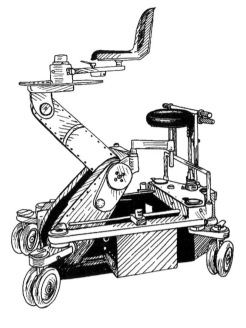

Figure 15.34 Hawk dolly

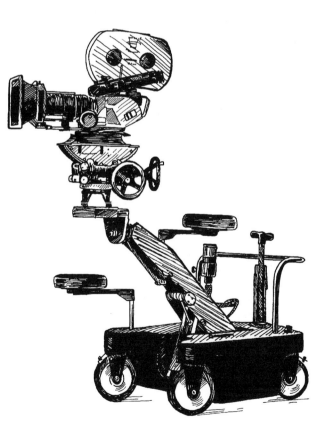

Figure 15.35a Falcon dolly

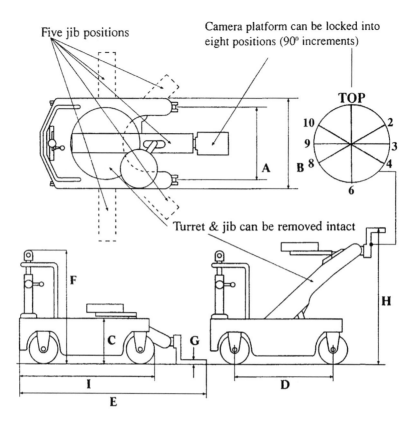

A	Wheel track centers	24¹/₂"	622.3mm
B	Overall width Mk II	27"	686.0mm
C	Chassis height	15"	381.0mm
D	Wheel centers	33"	838.2mm
E	Overall length	65"	1651.0mm
F	Height to steering handle	22"	952.5mm
G	Minimum nose mount height	2"	50.8mm
H	Jib height without camera and head	49"	1245.0mm
I	Chassis length	47"	1193.8mm
J	Reach off the side	23"	584.0mm
	Chassis weight	182lbs	82.5kg
	Turret weight	198lbs	89.9kg

Figure 15.35b Frazer dolly specifications

Figure 15.36 Straight track (round)

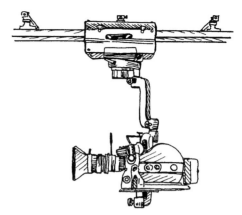

Figure 15.37 Filou track system

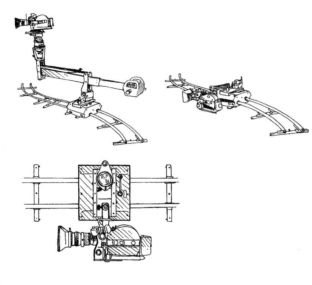

Figure 15.38 Filou camera system

Figure 15.39 Track connectors

Figure 15.40 Portable wheels

Figure 15.41 Pipe track connectors

Figure 15.42 Starter track

Figure 15.43 Wheelchair dolly

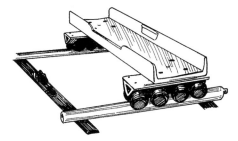

Figure 15.44 Channel wheels

ACTION DOLLY WIDTH ADJUSTMENTS:

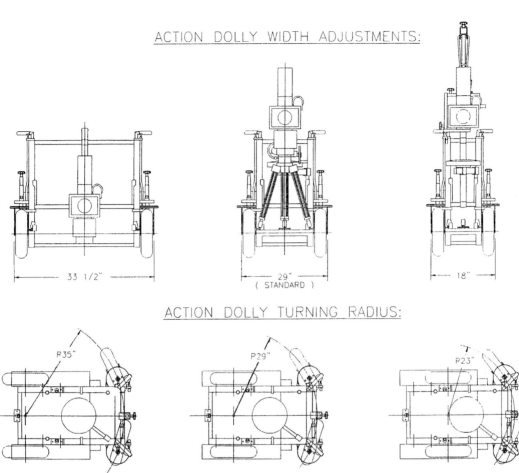

ACTION DOLLY TURNING RADIUS:

Figure 15.45 Action dolly

ACTION DOLLY CAMERA OPTIONS:

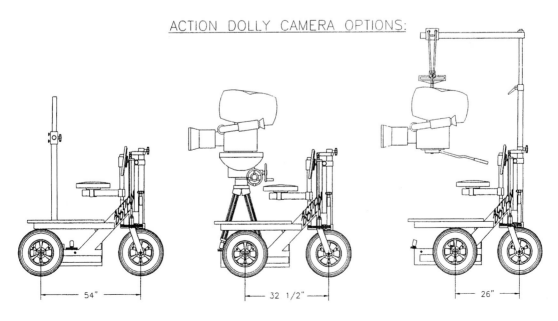

Figure 15.46 Action dolly specifications

Figure 15.47 Bazooka

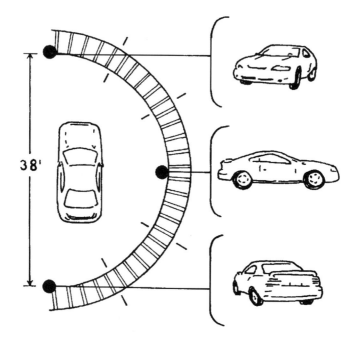

Figure 15.48 Seventy-foot track

Chapman Pedolly

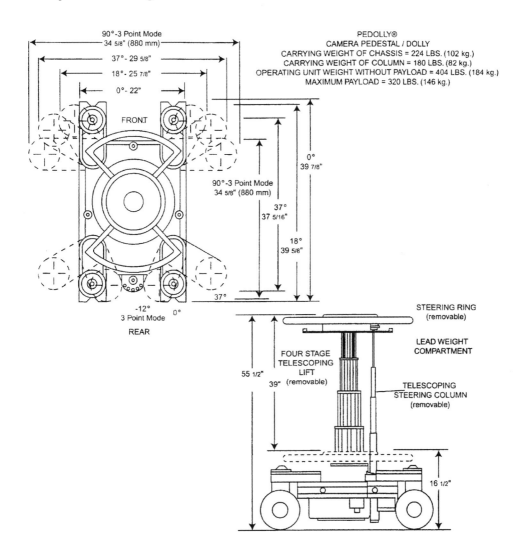

PEDOLLY ACCESSORIES
Pedolly Wood Crate (Shipping & Storage)
Pedolly 7" Seat Offset
Pedolly Full Support Seat w/Back
Pedolly Steering Attachment
Pedolly Push Bar
Pedolly Battery Tray
Pedolly Adjustable Battery Tray - (3 Pieces)
Pedolly Precision Seat Offset
Pedolly Soft Tires - (Set of 8)
Pedolly Electronic Shifter
Pedolly Push Bar Offset
Pedolly Sideboards - (Set of 3)

Pedolly Sideboard Extension - (Set of 6)
Pedolly Weather Cover
Pedestal Mitchell Adapter - 3"
Pedestal Mitchell Adapter - 6"
Pedestal Mini Monitor Bracket
Pedestal 18" Column Riser
Pedestal Center Post Insert
Pedestal Column Star Base
Pedestal Pressure Regulator & Hose
Pedestal Nitrogen Bottle-Large
Pedestal Nitrogen Bottle Kit
Pedestal Small Steering Ring
Pedestal 4 Bolt 6" Riser

Figure 15.49 Chapman Pedolly

SPECIFICATIONS

Minimum Camera Mount Height	16 1/2 in.	42 cm
Maximum Camera Mount Height	55 1/2 in.	1.4 m
Vertical Travel	39 in.	99 cm
*Payload Range	20 - 320 lbs.	9 - 145 kg
**Maximum Payload with Center Post Insert	1,100 lbs.	500 kg
Number of Stages in Column	4	
Steering Ring Diameter	28 in.	71 cm
Column Diameter (when Removed)	16 5/8 in.	42 cm
Column Charging Pressure	70 - 385 psi	
Chassis Width - Legs at 0 Degree Position	22 in.	56 cm
Chassis Width - Legs at 18 Degree Position	25 7/8 in.	66 cm
Chassis Width - Legs at 37 Degree Position (Track Position)	29 5/8 in.	75 cm
Chassis Width - Legs at 90 Degree Position (3 Point Mode)	34 5/8 in.	880 mm
Minimum Chassis Width	22 in.	56 cm
Minimum Chassis Length	33 5/16 in.	85 cm
Minimum Turning Radius	27 1/2 in.	70 cm
Carrying Weight of Chassis	224 lbs.	102 kg
Carrying Weight of Column	180 lbs.	82 kg
Total Weight	404 lbs.	184 kg
Operational Weight of Unit w/ Center Post Insert (w/o Payload)	305 lbs.	139 kg

OTHER PEDOLLY FEATURES

- Longer Tilt Line
- Open Access To Wheels for Maintenance
- Lock Column at Any Height (Cam Lock)
- Special Tire Compound Reduces Squeaking
- Can Be Used Indoors and Outdoors
- PEDOLLY Has Wheel Brakes
- Easily Replaced Steering Column
- Split Chassis Is Adjustable for Different Loads
- Split Chassis - with Dampened 3 Point Suspension and 4 Wheeled Stability
- Electronic Shifting of Steering
- Removable Lift Columns
- Securable to Floors or Platforms
- Can Be Used on Standard Track
- Interchangeable Hard or Soft Tires
- Virtually Silent Operation
- Changeable Leg Positions
- Easily Adjusted Cable Guards
- 22 Inch Steering Ring Available
- Seating Capability

*Payload Includes All Items (i.e. Man, Camera, Platform, Turret, Crane Arm, etc.) on Column.

**Payload Includes All Items (i.e. Man, Camera, Platform, Turret, Crane Arm, etc.) on Base Mount.

*It is advised that the user of Chapman/Leonard equipment check with the manufacturer for the latest updates on *all* equipment.

Figure 15.49 *(Continued)* Chapman Pedolly

Chapman Peewee

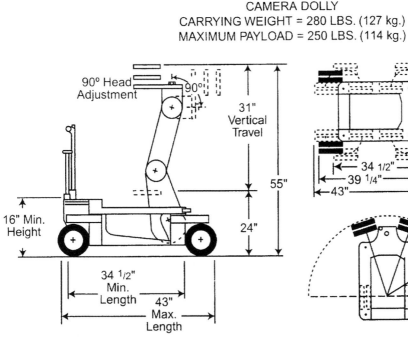

PEEWEE®
CAMERA DOLLY
CARRYING WEIGHT = 280 LBS. (127 kg.)
MAXIMUM PAYLOAD = 250 LBS. (114 kg.)

PEEWEE ACCESSORIES

PeeWee Grip Pouch
PeeWee Front Board
PeeWee Narrow Sideboard
PeeWee Wide Sideboard
PeeWee Standing Board
PeeWee Drop Down Sideboard
PeeWee Battery Box
PeeWee Levon Tracking Bar (Narrow)
PeeWee Tracking Bar (Wide)
PeeWee Rader Walk-Around Package
PeeWee Excalibur Case - (Set of 2)
PeeWee Soft Tires - (Set of 8)
PeeWee Pneumatic Tires - (Set of 8)
PeeWee Lifting Bars - (Set of 2)
PeeWee Square Track Tires - (Set of 8)
PeeWee Accessory Cart
PeeWee Heating System
3" Camera Riser - Mitchell 100
6" Camera Riser - Mitchell 100
12" Camera Riser - Mitchell 100
18" Camera Riser - Mitchell 100
24" Camera Riser - Mitchell 100
38" Camera Riser - Mitchell 100
3" Mitchell Riser with 24" Offset
Dolly Rain House
Open 4" Mitchell 4-Way Leveling Head

12" Mitchell Riser with 12" Offset
16" Camera Extension / 2 Cam Plate
24" Camera Extension / 2 Cam Plate
36" Camera Extension / 2 Cam Plate
Dolly Seat Pocket Light Adapter - 1 1/8"
3" Mitchell/Mitchell Male Adapter
3" Mitchell/Mitchell Female Adapter
3' Variable Extension - Panther
Euro / Mitchell Swing Head
Dolly Swivel Seat with Back Rest (Long Post)
Dolly Swivel Seat with Back Rest (Short Post)
Dolly Swivel Seat
Dolly Seat Complete
12" Dolly Seat Riser
Seat Offset Arm Short Post
Camera Swing Head & Case
Euro Camera Swing Head & Case
EVA (Electronic Valve Actuator)
Vibration Isolator & Case
Speed Rail Push Bar Adapter - (Set of 2)
Box of Wedges (FLORIDA ONLY)
Box of Shims (FLORIDA ONLY)
Box of Cribbing (FLORIDA ONLY)
Tire Holder - Short
Tire Holder - Tall
Underslung Seat Offset Arm

Figure 15.50 Chapman Peewee

SPECIFICATIONS

Maximum Camera Mount Height (without Risers)	55 in.	1.4 m
Maximum Camera Mount Height (with Standard 12" Riser)	67 in.	1.7 m
Minimum Camera Mount Height (without Riser)	24 in.	61 cm
Minimum Camera Mount Height with PeeWee 90 Degree Plate	3 in.	8 cm
Vertical Travel	31 in.	79 cm
*Maximum Payload	250 lbs.	114 kg
**Maximum Payload with High Post Kit	1,100 lbs.	500 kg
Maximum Boom Lifts (Fully Charged)	4 Lifts	
Chassis Maximum Length (Wheels Fully Extended)	43 in.	109 cm
Chassis Minimum Length (Wheels Fully Retracted)	34 1/2 in.	88 cm
Minimum Chassis Height for Transportation	16 in.	41 cm
Chassis Width - Legs at 0° Position	20 in.	51 cm
Chassis Width - Legs at 17° Position (Pneumatic Tire Position)	23 1/2 in.	60 cm
Chassis Width - Legs at 45° Position	28 1/2 in.	71 cm
Chassis Width - Legs at 90° Position (Sideways or Scissor Track Position)	32 in.	81 cm
Steering Post Height	35 in.	89 cm
Minimum Turn Radius	24 in.	61 cm
Minimum Door Width PeeWee Can Be Carried Through	16 in.	41 cm
Carrying Weight	280 lbs.	127 kg
Standard Operational Weight	329 lbs.	150 kg
Operational Weight w/ High Post Kit (w/o Payload)	386 lbs.	178 kg

OTHER PEEWEE FEATURES

- PEEWEE Incorporates Brakes on Rear Wheels
- Variable Chassis Leg Adjustment Cam-Lock Chassis
- Hardened Stainless Steel Bushings
- Compact and Lightweight for Travel and Storage

- Vertical Arm Travel
- Planetary Gear-Driven Arm
- Rear Controlled Steering
- Corrected Steering Geometry

*Payload Includes All Items (i.e. Man, Camera, Platform, Turret, Crane Arm, etc.) on Arm.
**Payload Includes All Items (i.e. Man, Camera, Platform, Turret, Crane Arm, etc.) on Base Mount.

*It is advised that the user of Chapman/Leonard equipment check with the manufacturer for the latest updates on *all* equipment.

Figure 15.50 *(Continued)* Chapman Peewee

Chapman Super Peewee IV

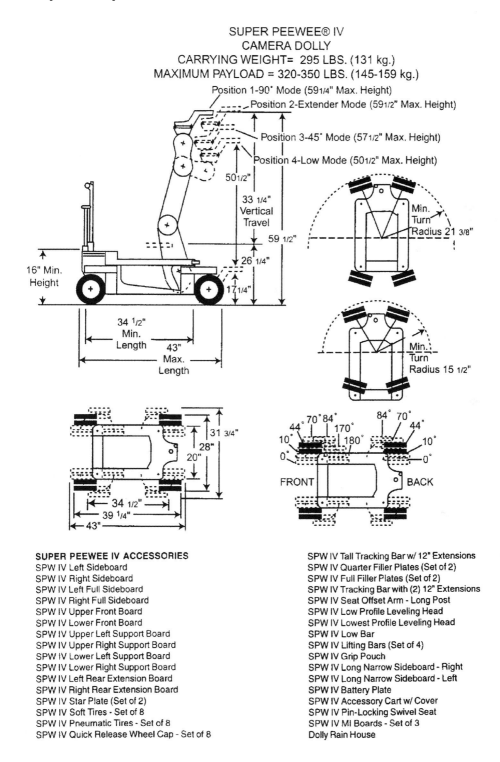

SUPER PEEWEE® IV
CAMERA DOLLY
CARRYING WEIGHT= 295 LBS. (131 kg.)
MAXIMUM PAYLOAD = 320-350 LBS. (145-159 kg.)

Position 1-90° Mode (591/4" Max. Height)
Position 2-Extender Mode (591/2" Max. Height)
Position 3-45° Mode (571/2" Max. Height)
Position 4-Low Mode (501/2" Max. Height)

501/2"
33 1/4" Vertical Travel
59 1/2"
26 1/4"
17 1/4"

16" Min. Height

34 1/2" Min. Length
43" Max. Length

Min. Turn Radius 21 3/8"

Min. Turn Radius 15 1/2"

31 3/4"
28"
20"
34 1/2"
39 1/4"
43"

70° 84° 84° 70°
44° 170° 44°
10° 180° 10°
0° 0°
FRONT BACK

SUPER PEEWEE IV ACCESSORIES
SPW IV Left Sideboard
SPW IV Right Sideboard
SPW IV Left Full Sideboard
SPW IV Right Full Sideboard
SPW IV Upper Front Board
SPW IV Lower Front Board
SPW IV Upper Left Support Board
SPW IV Upper Right Support Board
SPW IV Lower Left Support Board
SPW IV Lower Right Support Board
SPW IV Left Rear Extension Board
SPW IV Right Rear Extension Board
SPW IV Star Plate (Set of 2)
SPW IV Soft Tires - Set of 8
SPW IV Pneumatic Tires - Set of 8
SPW IV Quick Release Wheel Cap - Set of 8

SPW IV Tall Tracking Bar w/ 12" Extensions
SPW IV Quarter Filler Plates (Set of 2)
SPW IV Full Filler Plates (Set of 2)
SPW IV Tracking Bar with (2) 12" Extensions
SPW IV Seat Offset Arm - Long Post
SPW IV Low Profile Leveling Head
SPW IV Lowest Profile Leveling Head
SPW IV Low Bar
SPW IV Lifting Bars (Set of 4)
SPW IV Grip Pouch
SPW IV Long Narrow Sideboard - Right
SPW IV Long Narrow Sideboard - Left
SPW IV Battery Plate
SPW IV Accessory Cart w/ Cover
SPW IV Pin-Locking Swivel Seat
SPW IV MI Boards - Set of 3
Dolly Rain House

Figure 15.51 Chapman Super Peewee IV specifications

SPECIFICATIONS

Maximum Camera Mount Height (Position 1-90º Mode)	59 1/2 in.	1.5 m
Minimum Camera Mount Height (Position 1-90º Mode)	26 1/4 in.	67 cm
Vertical Boom Travel (Position 1-90º Mode)	33 1/4 in.	85 cm
Maximum Camera Mount Height (Position 2-Extender Mode)	59 1/2 in.	1.5 m
Minimum Camera Mount Height (Position 2-Extender Mode)	18 1/4 in.	46 cm
Vertical Boom Travel (Position 2-Extender Mode)	41 1/4 in.	1 m
Maximum Camera Mount Height (Position 3- 45º Mode)	57 1/2 in.	1.5 m
Minimum Camera Mount Height (Position 3- 45º Mode)	24 1/4 in.	62 cm
Vertical Boom Travel (Position 3- 45º Mode)	33 1/4 in.	85 cm
Maximum Camera Mount Height (Position 4-Low Mode)	50 1/2 in.	1.3 m
Minimum Camera Mount Height (Position 4-Low Mode)	17 1/4 in.	44 cm
Vertical Boom Travel (Position 4-Low Mode)	33 1/4 in.	85 cm
Minimum Camera Mount Height (Low Bar Setup w/ Lowest 4-Way Leveling Head)	4 in.	10 cm
Maximum Camera Mount Height (Low Bar Setup w/ Lowest 4-Way Leveling Head)	37 1/4 in.	95 cm
NOTE: LOWEST SETUP 1 1/2" REFER TO SPW IV USERS GUIDE		
Chassis Width - All Legs at 0º (Use in Tight Quarters)	20 in.	51 cm
Chassis Width - All Legs at 10º (Pneumatic or 880 mm Track Position)	25 in.	64 cm
Chassis Width - All Legs at 44º (Track Position)	28 in.	71 cm
Chassis Width - All Legs at 70º (Tread and Wheel Base are Equal -'S' Position)	31 in.	79 cm
Chassis Width - All Legs at 84º (Sideways or Scissor Track Position)	31 3/4 in.	81 cm
Chassis Width - Front Legs at 84º/Rear at 0º (3 Point Solid Tire Position)	31 3/4 in.	81 cm
Chassis Width - Front Legs at 84º/Rear at 10º (3 Point Pneumatic Tire Position)	31 3/4 in.	81 cm
Chassis Width - Front Legs at 180º/Rear at 0º (Compact Solid Tire Position)	20 in.	51 cm
Chassis Width - Front Legs at 170º/Rear at 10º (Compact Pneumatic Tire Position)	25 in.	64 cm
Steering Post Height	38 in.	97 cm
Minimum Chassis Length	34 1/2 in.	88 cm
Maximum Chassis Length	43 in.	109 cm
*Maximum Payload with Accumulator Charge at 2,400psi	320 lbs.	145 kg
*Maximum Payload with Accumulator Charge at 2,600psi	350 lbs,	159 kg
**Maximum Payload with High Post Kit	1,100 lbs.	500 kg
Maximum Number of Lifts on a Single Charge	5 Lifts	
Accumulator Charging Time (Empty to Full)	60 sec.	
Carrying Weight	295 lbs.	131 kg
Operational Weight w/ High Post Kit (w/o Payload)	391 lbs.	178 kg

*Payload Includes All Items (i.e. Man, Camera, Platform, Turret, Crane Arm, etc.) on Arm.
**Payload Includes All Items (i.e. Man, Camera, Platform, Turret, Crane Arm, etc.) on Base Mount.

Figure 15.51 *(Continued)* Chapman Super Peewee IV specifications

OTHER SUPER PEEWEE IV FEATURES (CONTINUED)

- Revolutionary new three mode transmission featuring conventional, crab and round steering that can be shifted while the dolly is moving or stationary, without the dolly operator's hands leaving the steering handle. This transmission has the ability to be adjusted to provide perfect steering geometry when re-configuring the chassis to its various leg positions. No other transmission has been able to do this.
- The Super PeeWee® IV now provides for much less maintenance.
 - (a) The need for air bleeding has been eliminated.
 - (b) Corrosion resistance has been dramatically improved.
 - (c) All exposed working joints have been sealed.
 - (d) Far greater precision greatly reduces the need for adjustments. All adjustments, if required by operator's specific desires, can be done externally without removing bolted covers or lids.
 - (e) Steering chain adjustments have been virtually eliminated, dramatically reducing maintenance time.
 - (f) Larger hydraulic capacity requires less recharging.
 - (g) Greater strength reduces the possibility of damage.
 - (h) Modular design of steering transmission and shifting linkage facilitates quick and easy replacements.

Above: New convenient location of Universal Stop Valve controls.

- New arm design provides greater operator clearance, while assuring greater rigidity, smoothness, speed and added vertical travel. This new trim arm design also allows for lower camera setups when the camera is located above the chassis. All edges and corners are rounded to provide for greater operator comfort.
- New valve concept gives the operator much improved control, providing for greater speed with added precision.
- Stop valve now requires no tools to make adjustments. Accessibility is now directly in front of the dolly operator, providing for quick and easy adjustments.
- Improved Universal Head performance is now achieved. Added arm precision, a control cylinder and a middle rib, provides major gains in safety and rigidity.
- Improved arm performance is exhibited with five full strokes of the arm on a single charge, while still achieving added vertical travel. The rigidity has been dramatically increased. The profile has been streamlined, providing added clearance for lower lens levels when operating over the chassis. This new design also adds to operator comfort. The new internal drive mechanism is smoother and maintenance free.
- Improved valve design provides for smoother, faster and quieter arm control. The dolly operator control has been significantly improved.
- The Super PeeWee® IV has a new sideboard system. Feedback from thousands of users and our own survey has led to this new design that provides complete walk-a-round ability at both the high and low levels.
- The Super PeeWee® IV now comes with built-in heat control for the hydraulic system to maintain a minimum hydraulic oil temperature of 70º F, thus providing constant performance even in the coldest environment.
- Leg positions have been improved to enhance performance by providing:
 - (a) **0º** position for **narrowest configuration with standard tires.**
 - (b) **10º** position for **narrowest configuration with pneumatic tires** OR for **side mounting the dolly on 880mm track.**
 - (c) **44º** position for **standard 24½" track** alignment and **general all-around use.**
 - (d) **84º** position for **maximum lateral stability** or for **side mounting dolly on 24½" track.**
 - (e) **Front legs at 84º, rear legs at 0º.** This is the **three point contact position** for standard tires which is great for outdoor use on rough terrain.
 - (f) **70º** position where Tread and Wheel Base are Equal, called the **S position.**

Figure 15.51 *(Continued)* Chapman Super Peewee IV specifications

Chapman Hustler

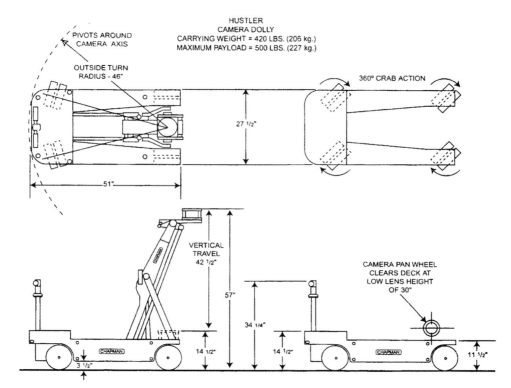

HUSTLER ACCESSORIES

Drop Down / Z Plate	3" Mitchell Riser with 24" Offset
Hustler Steering Extension	12" Mitchell Riser with 12" Offset
Hustler Mitchell 4-Way Leveling Head	16" Camera Extension / 2 Cam Plate
Hustler Grip Pouch	24" Camera Extension / 2 Cam Plate
Hustler Short Sideboard Pin	36" Camera Extension / 2 Cam Plate
Hustler Medium Sideboard Pin	Dolly Seat Pocket Light Adapter - 1 1/8"
Hustler High Level Front Board	3" Mitchell/Mitchell Male Adapter
Hustler Front Board	3" Mitchell/Mitchell Female Adapter
Hustler Standing Board	3' Variable Extension - Panther
Hustler Narrow Sideboard	Euro / Mitchell Swing Head
Hustler Wide Sideboard	Dolly Swivel Seat with Back Rest
Hustler Grease Gun	Dolly Swivel Seat
Hustler Large Grease Gun	Dolly Seat Complete
Hustler Push Bar - (Set of 2)	12" Dolly Seat Riser
Hustler AR Battery Tray	Seat Offset Arm Short Post
Hustler Extended Push Bar (Set of 2)	Camera Swing Head & Case
Hustler Track Wheel Attachment & Ramps	Euro Camera Swing Head & Case
Hustler Steadicam Z Plate	EVA (Electronic Valve Actuator)
Hustler III Steadicam Platform Package	Vibration Isolator & Case
Hustler Heating System (Advanced Notice Required)	Speed Rail Push Bar Adapter - (Set of 2)
3" Camera Riser - Mitchell 100	Box of Wedges (FLORIDA ONLY)
6" Camera Riser - Mitchell 100	Box of Shims (FLORIDA ONLY)
12" Camera Riser - Mitchell 100	Box of Cribbing (FLORIDA ONLY)
18" Camera Riser - Mitchell 100	Tire Holder - Short
24" Camera Riser - Mitchell 100	Tire Holder - Tall
38" Camera Riser - Mitchell 100	Underslung Seat Offset Arm
Open 4" Mitchell 4-Way Leveling Head	Dolly Rain House

Figure 15.52 Chapman Hustler specifications

SPECIFICATIONS

Camera Mount Height (without Risers)	57 in.	1.4 m
Camera Mount Height (with Standard 12" Riser)	69 in.	1.8 m
Minimum Camera Mount Height (without Risers)	14 1/2 in.	37 cm
Minimum Camera Mount Height (with Standard 12" Riser)	26 1/2 in.	67 cm
Vertical Travel	42 1/2 in.	1.1 m
*Maximum Payload	500 lbs.	227 kg
Maximum Boom Lifts (Fully Charged)	6 Lifts	
Chassis Length	51 in.	1.3 m
Chassis Width	27 1/2 in.	70 cm
Steering Post Height	34 1/4 in.	87 cm
Front Deck Height	11 1/4 in.	29 cm
Rear Deck Height	14 1/2 in.	37 cm
Minimum Turn Radius	46 in.	1.2 m
Accumulator Charging Time (110 A.C. and D.C.)	under 60 sec.	
Accumulator Charging Time (Hand Pump)	2 min.	
	420 lbs.	191 kg
Carrying Weight	454 lbs.	206 kg
Standard Operational Weight (w/o Payload)		

HUSTLER FEATURES

- Hustler Camera Dolly Incorporates a Hydraulic Lift
- Hustler Has Both Crab and Conventional Steering
- Hustler Dolly Works on Straight or Curved Tubular
 Track with the Hustler Track Wheel Attachments
- Hustler II Incorporates a Hand Brake System
- Many Accessories Available
- Sealed Hydraulic System

*Payload Includes All Items (i.e. Man, Camera, Platform, Turret, Crane Arm, etc.) on Arm.

*It is advised that the user of Chapman/Leonard equipment check with the manufacturer for the latest updates on *all* equipment.

Figure 15.52 *(Continued)* Chapman Hustler specifications

Chapman Hustler II

HUSTLER II
CAMERA DOLLY
CARRYING WEIGHT = 420 LBS. (206 kg.)
MAXIMUM PAYLOAD = 500 LBS. (227 kg.)

PIVOTS AROUND
CAMERA AXIS

OUTSIDE TURN
RADIUS - 46"

360° CRAB ACTION

27 1/2"

51"

VERTICAL
TRAVEL
42 1/2"

CAMERA PAN WHEEL
CLEARS DECK AT
LOW LENS HEIGHT
OF 30"

57"

37 1/2"

14 1/2"

14 1/2"

11 1/2"

3 1/2"

HUSTLER ACCESSORIES

Drop Down / Z Plate
Hustler Steering Extension
Hustler Mitchell 4-Way Leveling Head
Hustler Grip Pouch
Hustler Short Sideboard Pin
Hustler Medium Sideboard Pin
Hustler High Level Front Board
Hustler Front Board
Hustler Standing Board
Hustler Narrow Sideboard
Hustler Wide Sideboard
Hustler Grease Gun
Hustler Large Grease Gun
Hustler Push Bar - (Set of 2)
Hustler AR Battery Tray
Hustler Extended Push Bar (Set of 2)
Hustler Track Wheel Attachment & Ramps
Hustler Steadicam Z Plate
Hustler III Steadicam Platform Package
Hustler Heating System (Advanced Notice Required)
3" Camera Riser - Mitchell 100
6" Camera Riser - Mitchell 100
12" Camera Riser - Mitchell 100
18" Camera Riser - Mitchell 100
24" Camera Riser - Mitchell 100
38" Camera Riser - Mitchell 100
Open 4" Mitchell 4-Way Leveling Head

3" Mitchell Riser with 24" Offset
12" Mitchell Riser with 12" Offset
16" Camera Extension / 2 Cam Plate
24" Camera Extension / 2 Cam Plate
36" Camera Extension / 2 Cam Plate
Dolly Seat Pocket Light Adapter - 1 1/8"
3" Mitchell/Mitchell Male Adapter
3" Mitchell/Mitchell Female Adapter
3' Variable Extension - Panther
Euro / Mitchell Swing Head
Dolly Swivel Seat with Back Rest
Dolly Swivel Seat
Dolly Seat Complete
12" Dolly Seat Riser
Seat Offset Arm Short Post
Camera Swing Head & Case
Euro Camera Swing Head & Case
EVA (Electronic Valve Actuator)
Vibration Isolator & Case
Speed Rail Push Bar Adapter - (Set of 2)
Box of Wedges (FLORIDA ONLY)
Box of Shims (FLORIDA ONLY)
Box of Cribbing (FLORIDA ONLY)
Tire Holder - Short
Tire Holder - Tall
Underslung Seat Offset Arm
Dolly Rain House

Figure 15.53 Chapman Hustler II specifications

SPECIFICATIONS

Camera Mount Height (without Risers)	57 in.	1.4 m
Camera Mount Height (with Standard 12" Riser)	69 in.	1.8 m
Minimum Camera Mount Height (without Risers)	14 1/2 in.	37 cm
Minimum Camera Mount Height (with Standard 12" Riser)	26 1/2 in.	67 cm
Vertical Travel	42 1/2 in.	1.1 m
*Maximum Payload	500 lbs.	227 kg
Maximum Boom Lifts (Fully Charged)	6 Lifts	
Chassis Length	51 in.	1.3 m
Chassis Width	27 1/2 in.	70 cm
Steering Post Height	37 1/2 in.	95 cm
Front Deck Height	11 1/4 in.	29 cm
Rear Deck Height	14 1/2 in.	37 cm
Minimum Turn Radius	46 in.	1.2 m
Accumulator Charging Time (110 A.C. and D.C.)	under 60 sec.	
Accumulator Charging Time (Hand Pump)	2 min.	
Carrying Weight	420 lbs.	191 kg
Standard Operational Weight (w/o Payload)	454 lbs.	206 kg

OTHER HUSTLER II FEATURES

- Hustler II Is Nickel Plated for Easy Maintenance
- Hustler II Incorporates the Universal Stop Valve System
- Hustler II Incorporates a Built-In Track Wheel System
- Hustler II Incorporates a Hand Brake System
- Many Accessories Available
- Operates in Both Crab and Conventional Steering
- **Optional AR Battery Tray Accessory**

- Extended Steering Column
- Hustler II Has Improved **Faster** Arm
- Swift Brake and Valve Controls
- Works on Standard Tubular Track
- Sealed Hydraulic System

*Payload Includes All Items (i.e. Man, Camera, Platform, Turret, Crane Arm, etc.) on Arm.

*It is advised that the user of Chapman/Leonard equipment check with the manufacturer for the latest updates on *all* equipment.

Figure 15.53 *(Continued)* Chapman Hustler II specifications

Chapman Hustler III

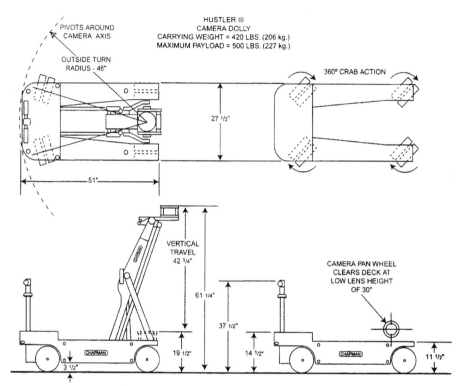

HUSTLER ACCESSORIES

Drop Down / Z Plate
Hustler Steering Extension
Hustler Mitchell 4-Way Leveling Head
Hustler Grip Pouch
Hustler Short Sideboard Pin
Hustler Medium Sideboard Pin
Hustler High Level Front Board
Hustler Front Board
Hustler Standing Board
Hustler Narrow Sideboard
Hustler Wide Sideboard
Hustler Grease Gun
Hustler Large Grease Gun
Hustler Push Bar - (Set of 2)
Hustler AR Battery Tray
Hustler Extended Push Bar (Set of 2)
Hustler Track Wheel Attachment & Ramps
Hustler Steadicam Z Plate
Hustler III Steadicam Platform Package
Hustler Heating System (Advanced Notice Required)
3" Camera Riser - Mitchell 100
6" Camera Riser - Mitchell 100
12" Camera Riser - Mitchell 100
18" Camera Riser - Mitchell 100
24" Camera Riser - Mitchell 100
38" Camera Riser - Mitchell 100
Open 4" Mitchell 4-Way Leveling Head

3" Mitchell Riser with 24" Offset
12" Mitchell Riser with 12" Offset
16" Camera Extension / 2 Cam Plate
24" Camera Extension / 2 Cam Plate
36" Camera Extension / 2 Cam Plate
Dolly Seat Pocket Light Adapter - 1 1/8"
3" Mitchell/Mitchell Male Adapter
3" Mitchell/Mitchell Female Adapter
3' Variable Extension - Panther
Euro / Mitchell Swing Head
Dolly Swivel Seat with Back Rest
Dolly Swivel Seat
Dolly Seat Complete
12" Dolly Seat Riser
Seat Offset Arm Short Post
Camera Swing Head & Case
Euro Camera Swing Head & Case
EVA (Electronic Valve Actuator)
Vibration Isolator & Case
Speed Rail Push Bar Adapter - (Set of 2)
Box of Wedges (FLORIDA ONLY)
Box of Shims (FLORIDA ONLY)
Box of Cribbing (FLORIDA ONLY)
Tire Holder - Short
Tire Holder - Tall
Underslung Seat Offset Arm
Dolly Rain House

Figure 15.54 Chapman Hustler III specifications

SPECIFICATIONS

Camera Mount Height (without Risers)	61 1/4 in.	1.6 m
Camera Mount Height (with Standard 12" Riser)	73 1/4 in.	1.9 m
Minimum Camera Mount Height (without Risers)	19 1/2 in.	50 cm
Minimum Camera Mount Height (with Standard 12" Riser)	31 1/2 in.	80 cm
Minimum Camera Mount Height with Standard 90º Plate	3 1/2 in.	9 cm
Vertical Travel	42 1/4 in.	1.1 m
*Maximum Payload	500 lbs.	227 kg
Maximum Boom Lifts (Fully Charged)	6 Lifts	
Chassis Length	51 in.	1.3 m
Chassis Width	27 1/2 in.	70 cm
Steering Post Height	37 1/2 in.	95 cm
Front Deck Height	11 1/4 in.	29 cm
Rear Deck Height	14 1/2 in.	37 cm
Minimum Turn Radius	46 in.	1.2 m
Accumulator Charging Time (110 A.C. and D.C.)	under 60 sec.	
Accumulator Charging Time (Hand Pump)	2 min.	
Carrying Weight	420 lbs.	191 kg
Standard Operational Weight (w/o Payload)	454 lbs.	206 kg

OTHER HUSTLER III FEATURES

- Hustler III Is Nickel Plated for Easy Maintenance
- Hustler III Incorporates the Universal Stop Valve System
- Hustler III's Newly Designed King Pin System Allows for Fluid Movement on Straight or Curved Tubular Track
- Operates in Both Crab and Conventional Steering
- **Optional Universal Head Mount** for Convenient, Quick Placement of the Camera

- Extended Steering Column
- Hustler III Has Improved Faster Arm
- Hustler III has a Hand Brake System
- Swift Brake and Valve Controls
- Many Accessories Available
- Sealed Hydraulic System

*Payload Includes All Items (i.e. Man, Camera, Platform, Turret, Crane Arm, etc.) on Arm.

*It is advised that the user of Chapman/Leonard equipment check with the manufacturer for the latest updates on *all* equipment.

Figure 15.54 *(Continued)* Chapman Hustler III specifications

Chapman Hybrid

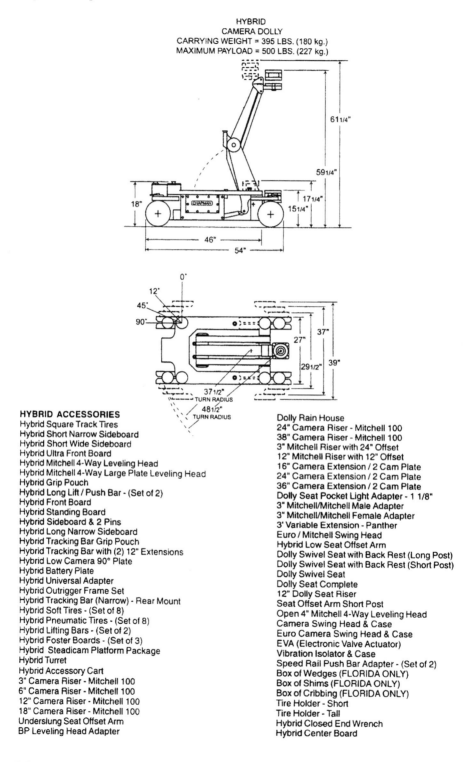

HYBRID
CAMERA DOLLY
CARRYING WEIGHT = 395 LBS. (180 kg.)
MAXIMUM PAYLOAD = 500 LBS. (227 kg.)

HYBRID ACCESSORIES

Hybrid Square Track Tires
Hybrid Short Narrow Sideboard
Hybrid Short Wide Sideboard
Hybrid Ultra Front Board
Hybrid Mitchell 4-Way Leveling Head
Hybrid Mitchell 4-Way Large Plate Leveling Head
Hybrid Grip Pouch
Hybrid Long Lift / Push Bar - (Set of 2)
Hybrid Front Board
Hybrid Standing Board
Hybrid Sideboard & 2 Pins
Hybrid Long Narrow Sideboard
Hybrid Tracking Bar Grip Pouch
Hybrid Tracking Bar with (2) 12" Extensions
Hybrid Low Camera 90° Plate
Hybrid Battery Plate
Hybrid Universal Adapter
Hybrid Outrigger Frame Set
Hybrid Tracking Bar (Narrow) - Rear Mount
Hybrid Soft Tires - (Set of 8)
Hybrid Pneumatic Tires - (Set of 8)
Hybrid Lifting Bars - (Set of 2)
Hybrid Foster Boards - (Set of 3)
Hybrid Steadicam Platform Package
Hybrid Turret
Hybrid Accessory Cart
3" Camera Riser - Mitchell 100
6" Camera Riser - Mitchell 100
12" Camera Riser - Mitchell 100
18" Camera Riser - Mitchell 100
Underslung Seat Offset Arm
BP Leveling Head Adapter

Dolly Rain House
24" Camera Riser - Mitchell 100
38" Camera Riser - Mitchell 100
3" Mitchell Riser with 24" Offset
12" Mitchell Riser with 12" Offset
16" Camera Extension / 2 Cam Plate
24" Camera Extension / 2 Cam Plate
36" Camera Extension / 2 Cam Plate
Dolly Seat Pocket Light Adapter - 1 1/8"
3" Mitchell/Mitchell Male Adapter
3" Mitchell/Mitchell Female Adapter
3' Variable Extension - Panther
Euro / Mitchell Swing Head
Hybrid Low Seat Offset Arm
Dolly Swivel Seat with Back Rest (Long Post)
Dolly Swivel Seat with Back Rest (Short Post)
Dolly Swivel Seat
Dolly Seat Complete
12" Dolly Seat Riser
Seat Offset Arm Short Post
Open 4" Mitchell 4-Way Leveling Head
Camera Swing Head & Case
Euro Camera Swing Head & Case
EVA (Electronic Valve Actuator)
Vibration Isolator & Case
Speed Rail Push Bar Adapter - (Set of 2)
Box of Wedges (FLORIDA ONLY)
Box of Shims (FLORIDA ONLY)
Box of Cribbing (FLORIDA ONLY)
Tire Holder - Short
Tire Holder - Tall
Hybrid Closed End Wrench
Hybrid Center Board

Figure 15.55 Chapman Hybrid specifications

Maximum Camera Mount Height (with Standard 12" Riser)	73 in.	1.9 m
Maximum Camera Mount Height (without Risers)	61 1/4 in.	1.6 m
Minimum Camera Mount Height	15 1/4 in.	39 cm
Minimum Camera Mount Height with Hybrid Low Camera 90 Degree Plate	1 in.	3 cm
Vertical Travel	44 in.	1.1 m
*Maximum Payload	500 lbs.	227 kg
**Maximum Payload with High Post Kit	1,900 lbs.	863 kg
Maximum Boom Lifts (Fully Charged)	5 Lifts	
Chassis Maximum Length (Wheels Fully Extended)	54 in.	1.4 m
Chassis Minimum Length (Wheels Fully Retracted)	46 in.	1.2 m
Minimum Chassis Height for Transportation	18 in.	46 cm
Chassis Variable Widths - Legs in	27 in.	69 cm
Chassis Variable Widths - Legs at 12 Degree Track Position	29 1/2 in.	75 cm
Chassis Variable Widths - Legs at 45 Degrees	37 in.	89 cm
Chassis Variable Widths - Legs at 90 Degrees	39 in.	99 cm
Steering Post Height	36 in.	91 cm
Minimum Turn Radius	37 1/2 in.	95 cm
Accumulator Charging Time (110 A.C. and D.C.)	under 60 sec.	
Accumulator Charging Time (Hand Pump)	2 1/2 min.	
Minimum Door Width Hybrid Can Be Carried Through	18 in.	46 cm
Carrying Weight	395 lbs.	180 kg
Standard Operational Weight (w/o Payload)	463 lbs.	210 kg
Hybrid w/ High Post Kit Operational Weight (w/o Payload)	501 lbs.	227 kg

OTHER HYBRID II FEATURES

- The Hybrid II Incorporates the Universal Stop Valve System
- The Hybrid II Is Nickel Plated for Less Maintenance
- Works on Both Straight or Curved Track
- Interchangeable Soft, Hard or Pneumatic Tires for Different Terrain
- Hybrid II Incorporates Brakes on Rear Wheels

- Cam-Lock Chassis Legs
- Enclosed King Pin System
- Variable Camera Head
- Variable Chassis Legs
- Compact and Lightweight

*Payload Includes All Items (i.e. Man, Camera, Platform, Turret, Crane Arm, etc.) on Arm.
**Payload Includes All Items (i.e. Man, Camera, Platform, Turret, Crane Arm, etc.) on Base Mount.

*It is advised that the user of Chapman/Leonard equipment check with the manufacturer for the latest updates on *all* equipment.

Figure 15.55 *(Continued)* Chapman Hybrid specifications

Chapman Hybrid II

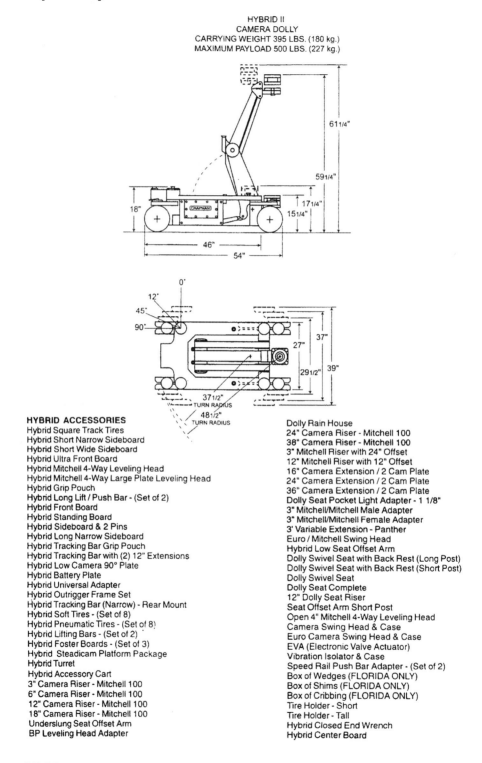

HYBRID ACCESSORIES
Hybrid Square Track Tires
Hybrid Short Narrow Sideboard
Hybrid Short Wide Sideboard
Hybrid Ultra Front Board
Hybrid Mitchell 4-Way Leveling Head
Hybrid Mitchell 4-Way Large Plate Leveling Head
Hybrid Grip Pouch
Hybrid Long Lift / Push Bar - (Set of 2)
Hybrid Front Board
Hybrid Standing Board
Hybrid Sideboard & 2 Pins
Hybrid Long Narrow Sideboard
Hybrid Tracking Bar Grip Pouch
Hybrid Tracking Bar with (2) 12" Extensions
Hybrid Low Camera 90° Plate
Hybrid Battery Plate
Hybrid Universal Adapter
Hybrid Outrigger Frame Set
Hybrid Tracking Bar (Narrow) - Rear Mount
Hybrid Soft Tires - (Set of 8)
Hybrid Pneumatic Tires - (Set of 8)
Hybrid Lifting Bars - (Set of 2)
Hybrid Foster Boards - (Set of 3)
Hybrid Steadicam Platform Package
Hybrid Turret
Hybrid Accessory Cart
3" Camera Riser - Mitchell 100
6" Camera Riser - Mitchell 100
12" Camera Riser - Mitchell 100
18" Camera Riser - Mitchell 100
Underslung Seat Offset Arm
BP Leveling Head Adapter

Dolly Rain House
24" Camera Riser - Mitchell 100
38" Camera Riser - Mitchell 100
3" Mitchell Riser with 24" Offset
12" Mitchell Riser with 12" Offset
16" Camera Extension / 2 Cam Plate
24" Camera Extension / 2 Cam Plate
36" Camera Extension / 2 Cam Plate
Dolly Seat Pocket Light Adapter - 1 1/8"
3" Mitchell/Mitchell Male Adapter
3" Mitchell/Mitchell Female Adapter
3' Variable Extension - Panther
Euro / Mitchell Swing Head
Hybrid Low Seat Offset Arm
Dolly Swivel Seat with Back Rest (Long Post)
Dolly Swivel Seat with Back Rest (Short Post)
Dolly Swivel Seat
Dolly Seat Complete
12" Dolly Seat Riser
Seat Offset Arm Short Post
Open 4" Mitchell 4-Way Leveling Head
Camera Swing Head & Case
Euro Camera Swing Head & Case
EVA (Electronic Valve Actuator)
Vibration Isolator & Case
Speed Rail Push Bar Adapter - (Set of 2)
Box of Wedges (FLORIDA ONLY)
Box of Shims (FLORIDA ONLY)
Box of Cribbing (FLORIDA ONLY)
Tire Holder - Short
Tire Holder - Tall
Hybrid Closed End Wrench
Hybrid Center Board

Figure 15.56 Chapman Hybrid II specifications

SPECIFICATIONS

Maximum Camera Mount Height (with Standard 12" Riser)	73 in.	1.9 m
Maximum Camera Mount Height (without Risers)	61 1/4 in.	1.6 m
Minimum Camera Mount Height	15 1/4 in.	39 cm
Minimum Camera Mount Height with Hybrid Low Camera 90 Degree Plate	1 in.	3 cm
Vertical Travel	44 in.	1.1 m
*Maximum Payload	500 lbs.	227 kg
**Maximum Payload with High Post Kit	1,900 lbs.	863 kg
Maximum Boom Lifts (Fully Charged)	5 Lifts	
Chassis Maximum Length (Wheels Fully Extended)	54 in.	1.4 m
Chassis Minimum Length (Wheels Fully Retracted)	46 in.	1.2 m
Minimum Chassis Height for Transportation	18 in.	46 cm
Chassis Variable Widths - Legs in	27 in.	69 cm
Chassis Variable Widths - Legs at 12 Degree Track Position	29 1/2 in.	75 cm
Chassis Variable Widths - Legs at 45 Degrees	37 in.	89 cm
Chassis Variable Widths - Legs at 90 Degrees	39 in.	99 cm
Steering Post Height	36 in.	91 cm
Minimum Turn Radius	37 1/2 in.	95 cm
Accumulator Charging Time (110 A.C. and D.C.)	under 60 sec.	
Accumulator Charging Time (Hand Pump)	2 1/2 min.	
Minimum Door Width Hybrid Can Be Carried Through	18 in.	46 cm
Carrying Weight	395 lbs.	180 kg
Standard Operational Weight (w/o Payload)	463 lbs.	210 kg
Hybrid w/ High Post Kit Operational Weight (w/o Payload)	501 lbs.	227 kg

OTHER HYBRID II FEATURES

- The Hybrid II Incorporates the Universal Stop Valve System
- The Hybrid II Is Nickel Plated for Less Maintenance
- Works on Both Straight or Curved Track
- Interchangeable Soft, Hard or Pneumatic Tires for Different Terrain
- Hybrid II Incorporates Brakes on Rear Wheels

- Cam-Lock Chassis Legs
- Enclosed King Pin System
- Variable Camera Head
- Variable Chassis Legs
- Compact and Lightweight

*Payload Includes All Items (i.e. Man, Camera, Platform, Turret, Crane Arm, etc.) on Arm.
**Payload Includes All Items (i.e. Man, Camera, Platform, Turret, Crane Arm, etc.) on Base Mount.

*It is advised that the user of Chapman/Leonard equipment check with the manufacturer for the latest updates on *all* equipment.

Figure 15.56 *(Continued)* Chapman Hybrid II specifications

Chapman Hybrid III

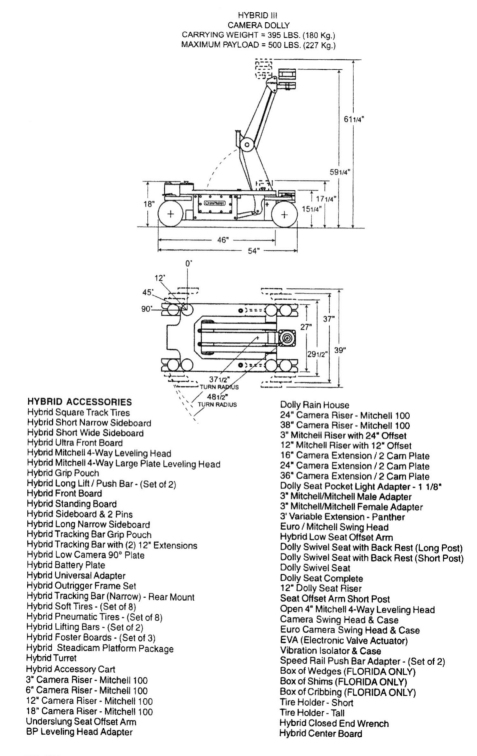

HYBRID III
CAMERA DOLLY
CARRYING WEIGHT = 395 LBS. (180 Kg.)
MAXIMUM PAYLOAD = 500 LBS. (227 Kg.)

HYBRID ACCESSORIES

Hybrid Square Track Tires
Hybrid Short Narrow Sideboard
Hybrid Short Wide Sideboard
Hybrid Ultra Front Board
Hybrid Mitchell 4-Way Leveling Head
Hybrid Mitchell 4-Way Large Plate Leveling Head
Hybrid Grip Pouch
Hybrid Long Lift / Push Bar - (Set of 2)
Hybrid Front Board
Hybrid Standing Board
Hybrid Sideboard & 2 Pins
Hybrid Long Narrow Sideboard
Hybrid Tracking Bar Grip Pouch
Hybrid Tracking Bar with (2) 12" Extensions
Hybrid Low Camera 90° Plate
Hybrid Battery Plate
Hybrid Universal Adapter
Hybrid Outrigger Frame Set
Hybrid Tracking Bar (Narrow) - Rear Mount
Hybrid Soft Tires - (Set of 8)
Hybrid Pneumatic Tires - (Set of 8)
Hybrid Lifting Bars - (Set of 2)
Hybrid Foster Boards - (Set of 3)
Hybrid Steadicam Platform Package
Hybrid Turret
Hybrid Accessory Cart
3" Camera Riser - Mitchell 100
6" Camera Riser - Mitchell 100
12" Camera Riser - Mitchell 100
18" Camera Riser - Mitchell 100
Underslung Seat Offset Arm
BP Leveling Head Adapter

Dolly Rain House
24" Camera Riser - Mitchell 100
38" Camera Riser - Mitchell 100
3" Mitchell Riser with 24" Offset
12" Mitchell Riser with 12" Offset
16" Camera Extension / 2 Cam Plate
24" Camera Extension / 2 Cam Plate
36" Camera Extension / 2 Cam Plate
Dolly Seat Pocket Light Adapter - 1 1/8"
3" Mitchell/Mitchell Male Adapter
3" Mitchell/Mitchell Female Adapter
3' Variable Extension - Panther
Euro / Mitchell Swing Head
Hybrid Low Seat Offset Arm
Dolly Swivel Seat with Back Rest (Long Post)
Dolly Swivel Seat with Back Rest (Short Post)
Dolly Swivel Seat
Dolly Seat Complete
12" Dolly Seat Riser
Seat Offset Arm Short Post
Open 4" Mitchell 4-Way Leveling Head
Camera Swing Head & Case
Euro Camera Swing Head & Case
EVA (Electronic Valve Actuator)
Vibration Isolator & Case
Speed Rail Push Bar Adapter - (Set of 2)
Box of Wedges (FLORIDA ONLY)
Box of Shims (FLORIDA ONLY)
Box of Cribbing (FLORIDA ONLY)
Tire Holder - Short
Tire Holder - Tall
Hybrid Closed End Wrench
Hybrid Center Board

Figure 15.57 Chapman Hybrid III specifications

SPECIFICATIONS

Maximum Camera Mount Height (with Standard 12" Riser)	73 in.	1.9 m
Maximum Camera Mount Height (without Risers)	61 1/4 in.	1.6 m
Minimum Camera Mount Height	15 1/4 in.	39 cm
Minimum Camera Mount Height with Hybrid Low Camera 90 Degree Plate	1 in.	3 cm
Vertical Travel	44 in.	1.1 m
*Maximum Payload	500 lbs.	227 kg
**Maximum Payload with High Post Kit	1,900 lbs.	863 kg
Maximum Boom Lifts (Fully Charged)	5 Lifts	
Chassis Maximum Length (Wheels Fully Extended)	54 in.	1.4 m
Chassis Minimum Length (Wheels Fully Retracted)	46 in.	1.2 m
Minimum Chassis Height for Transportation	18 in.	46 cm
Chassis Variable Widths - Legs in	27 in.	69 cm
Chassis Variable Widths - Legs at 12 Degree Track Position	29 1/2 in.	75 cm
Chassis Variable Widths - Legs at 45 Degrees	37 in.	89 cm
Chassis Variable Widths - Legs at 90 Degrees	39 in.	99 cm
Steering Post Height	36 in.	91 cm
Minimum Turn Radius	37 1/2 in.	95 cm
Accumulator Charging Time (110 A.C. and D.C.)	under 60 sec.	
Accumulator Charging Time (Hand Pump)	2 1/2 min.	
Minimum Door Width Hybrid Can Be Carried Through	18 in.	46 cm
Carrying Weight	395 lbs.	180 kg
Standard Operational Weight (w/o Payload)	463 lbs.	210 kg
Hybrid w/ High Post Kit Operational Weight (w/o Payload)	501 lbs.	227 kg

OTHER HYBRID III FEATURES

- Hybrid III Incorporates the Universal Stop Valve System
- Hybrid III has a Built-in Automatic Hydraulic Oil Heating System
- Interchangeable Soft, Hard or Pneumatic Tires for Different Terrain
- Works on Both Straight or Curved Track
- Hybrid III Is Nickel Plated
- Hybrid III Incorporates Brakes on Rear Wheels

- Cam-Lock Chassis Legs
- Compact and Lightweight
- Enclosed King Pin System
- Variable Camera Head Mount
- Variable Chassis Legs

*Payload Includes All Items (i.e. Man, Camera, Platform, Turret, Crane Arm, etc.) on Arm.

**Payload Includes All Items (i.e. Man, Camera, Platform, Turret, Crane Arm, etc.) on Base Mount.

*It is advised that the user of Chapman/Leonard equipment check with the manufacturer for the latest updates on *all* equipment.

Figure 15.57 *(Continued)* Chapman Hybrid III specifications

Chapman Sidewinder

Figure 15.58 Sidewinder specifications

SPECIFICATIONS

Lens Height (Turret and Camera)	9 ft.	2.7 m
Base Mount Height	5 ft. 6 in.	1.7 m
Vertical Travel	5 ft.	1.5 m
Minimum Lens Height (Extension Setup) with Gear Head and Leveling Device	22 in.	56 cm
Minimum Lens Height (without Gear Head) Adapter Available	12 in.	30 cm
Maximum Lens Height with Sidewinder Setup (Leveling Head Only)	7 ft. 6 in.	2.3 m
Low Lens Height with Same Setup	30 in.	76 cm
*Maximum Payload	900 lbs.	409 kg
Maximum Horizontal Reach (with Extension)	38 in.	97 cm
Chassis Length	64 in.	1.6 m
Minimum Chassis Height	41 in.	1 m
Chassis Width (with Special or Pneumatic Tires)	38 3/4 in.	98 cm
Tread	26 in.	66 cm
Wheel Base	42 in.	1.1 m
Normal Operating Weight	1,450 lbs.	659 kg

OTHER SIDEWINDER FEATURES

- Operates on 8 Wheels (Power Delivered to 4)
- Dual Rocker Suspension (8 Wheels to 3 Point Suspension)
- Operates in Both Crab and Conventional Steering
- Selection of Turrets, Risers, Extensions and Aluminum Track
- On a Full Charge, Batteries Allow 24 Hours Use
- Built-In Battery Charger (110v/220v)
- Hydraulic Floor Locks
- Dual Steering Control
- Automatic Valve Control
- Silent Operation

*Payload Includes All Items (i.e. Man, Camera, Platform, Turret, Crane Arm, etc.) on Base Mount.

*It is advised that the user of Chapman/Leonard equipment check with the manufacturer for the latest updates on *all* equipment.

Figure 15.58 *(Continued)* Sidewinder specifications

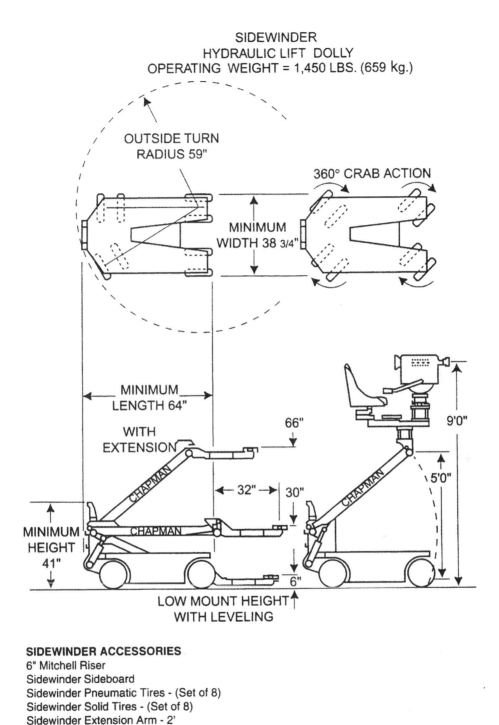

SIDEWINDER
HYDRAULIC LIFT DOLLY
OPERATING WEIGHT = 1,450 LBS. (659 kg.)

OUTSIDE TURN
RADIUS 59"

360° CRAB ACTION

MINIMUM
WIDTH 38 3/4"

MINIMUM
LENGTH 64"

WITH
EXTENSION

66"

9'0"

5'0"

32"

30"

MINIMUM
HEIGHT
41"

6"

LOW MOUNT HEIGHT
WITH LEVELING

SIDEWINDER ACCESSORIES
6" Mitchell Riser
Sidewinder Sideboard
Sidewinder Pneumatic Tires - (Set of 8)
Sidewinder Solid Tires - (Set of 8)
Sidewinder Extension Arm - 2'
Rear 14" Seat Arm w/Seat - Sidewinder
Sidewinder Standing Board

*It is advised that the user of Chapman/Leonard equipment check with the manufacturer for the latest updates on *all* equipment.

Figure 15.58 *(Continued)* Sidewinder specifications

16 Precision Cadillac Track and Chapman Lencin

Precision Cadillac Track is a variety of crane and dolly track; see Figure 16.1 for specifications and more information.

Specifications	Folding Length	
	Feet	Meters
3' Straight	5'1"	1.5
5' Straight	7'2"	2.1
8' Straight	10'2"	3.0
10' Straight	12'2"	3.7
12' Straight	14'2"	4.3
30 Curve	6'6"	1.98
2-5' Sections =		
20' Dia. Circlei		
	Track Width	
	Feet	Meters
With Standard Sleepers	24½"	0.6
With Expandable Sleepers		
1st Position	24½"	0.6
2nd Position	28"	0.7
3rd Position	34½"	0.8

Figure 16.1 Precision Cadillac Track

The Lencin is a camera pedestal from Chapman/Leonard Studio Equipment. See Figure 16.2a for a diagram and list of accessories; see Figure 16.2b for specifications and features.

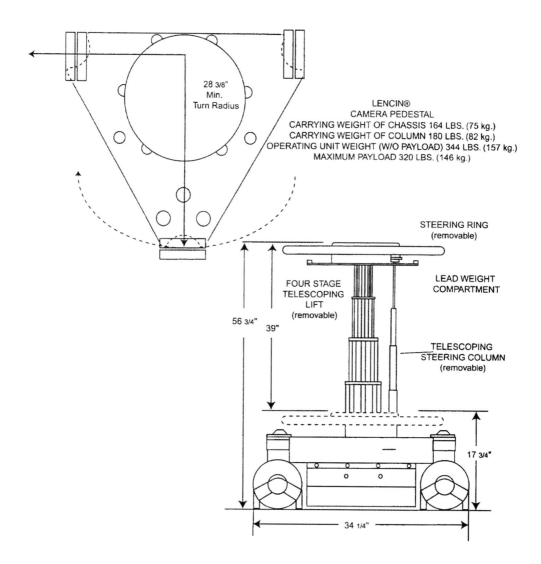

LENCIN ACCESSORIES
Lencin Seat Offset with Wheel
Lencin Wood Crate (Shipping & Storage)
Lencin Soft Tires - (Set of 6)
Lencin Battery Tray
Lencin Weather Cover
Pedestal Mitchell Adapter - 3"
Pedestal Mitchell Adapter - 6"
Pedestal Nitrogen Bottle-Large

Pedestal Mini Monitor Bracket
Pedestal 18" Column Riser
Pedestal Center Post Insert
Pedestal Column Star Base
Pedestal Pressure Regulator & Hose
Pedestal Nitrogen Bottle
Pedestal Small Steering Ring
Pedestal 4 Bolt 6" Riser
Pedestal Nitrogen Bottle Kit

Figure 16.2a Lencin accessories

SPECIFICATIONS

Minimum Camera Mount Height	17 3/4 in.	45 cm
Maximum Camera Mount Height	56 3/4 in.	1.4 m
Vertical Travel	39 in.	1 m
*Payload Range	20-320 lbs.	9 - 146 kg
**Maximum Payload with Center Post Insert	1,100 lbs.	500 kg
Steering Ring Diameter	30 in.	76 cm
Number of Stages in Column	4	
Carrying Weight of Chassis	164 lbs.	75 kg
Carrying Weight of Column	180 lbs.	82 kg
Total Weight	344 lbs.	157 kg
Operational Weight of Unit w/ Center Post Insert (w/o Payload)	245 lbs.	111 kg
Minimum Chassis Width	34 1/4 in.	87 cm
Minimum Turning Radius	28 3/8 in.	72 cm
Column Diameter (when Removed)	16 5/8 in.	42 cm
Chassis Minimum Height (without Column)	14 1/2 in.	37 cm
Column Minimum Height (when Removed)	16 1/2 in.	42 cm

OTHER LENCIN FEATURES

- Open Access to Wheels for Maintenance
- Lock Column at Any Height (Optional Cam Lock)
- Special Performance Enhancing Tire Compound
- Can Be Used Indoors and Outdoors
- Track Ready, for Use on Straight Track Only
- Incorporates Both Crab and Conventional Steering
- Low Maintenance
- 22 Inch Steering Ring Available

- Removable Column
- Securable to Floors or Platforms
- Interchangeable Wheels-Hard or Soft
- Easily Adjusted Cable Guards
- Easily Replaced Steering Column
- Virtually Silent Operation
- LENCIN Has A Wheel Brake

*Payload Includes All Items (i.e. Man, Camera, Platform, Turret, Crane Arm, etc.) on Column.

**Payload Includes All Items (i.e. Man, Camera, Platform, Turret, Crane Arm, etc.) on Base Mount.

*It is advised that the user of Chapman/Leonard equipment check with the manufacturer for the latest updates on *all* equipment.

Figure 16.2b Lencin specifications and features

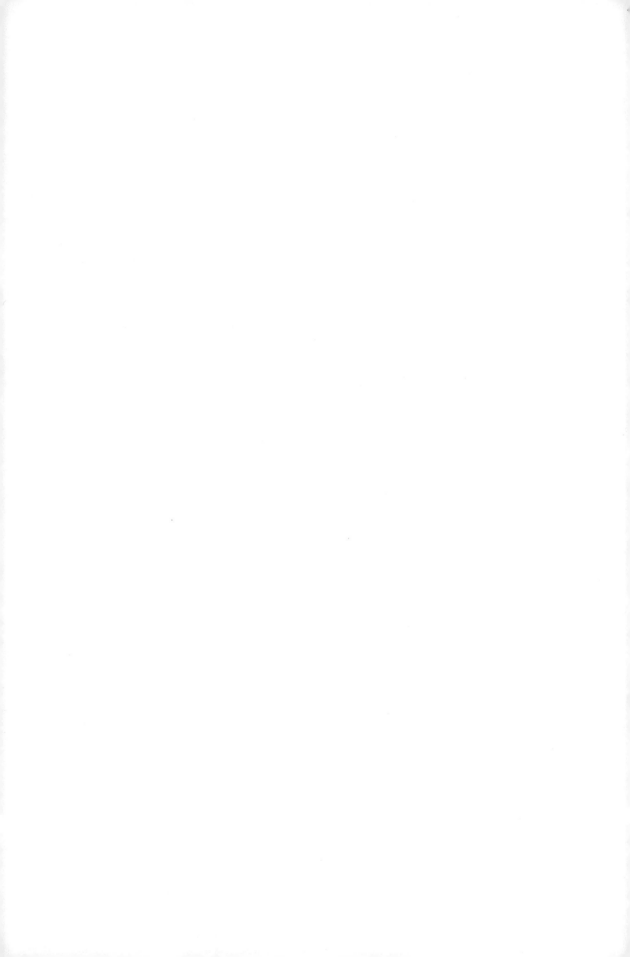

17 *Fluid and remote heads*

Fluid heads in cameras give hands-on control. They are designed with springs and lubricants that give the camera operator a pan-and-tilt movement. They usually have adjustment levers or collars that can restrict or lessen the friction of each head – sort of like an adjustable power steering unit. Each operator will prefer a certain "feel" that enhances his or her movement of the camera. There are several designs out there in the film world; I will show you some of what I see used daily.

Remote heads are electronic heads that attach to cranes, dollies, or rigs. They are fast becoming preferred over having a person riding a crane and operating the camera. They have control wheels, a joystick, or even a fluid-type head with sensors on it to operate the remotely controlled head. They are sometimes located up to 100 ft. from the operator. On a set, I am often asked what remote heads I want to use because the production personnel want to place an order to hold a particular piece of equipment. I give them my standard answer: "I'll tell you as soon as I talk to the DP and find out what camera they are using and how high a crane or jib is supposed to be." The weight of each camera is usually not the main factor but is one of several factors. Another factor is the length (or how high the camera is supposed to go). The longer the arm of a crane, the less weight can be put on the receiving end. You have to know the weight of the remote head and the weight of the camera. Always use your worst-case scenario (e.g., the heaviest the remote might be is if it's rigged with extensions; the heaviest the camera will be is with a zoom and the largest – usually a 1,000 ft. – magazine). Plan for the worst and then design for the best.

Some cranes may take a lot of weight, but they must have added cable strength. This is wonderful for safety, but it makes the crane wider, which could be a problem in a tight spot. You may not get the desired movement on the crane shot. The remote head may be the type that can be reduced in overall size; by using certain remotes, you can squeeze down the size (adjust the unit to a smaller size) for use on a shot. For example, if you want a high shot on a set that drops as the actor approaches a door, opens it, and walks in, then the remote head you use could actually enter an adjoining living room window and go inside with the actor.

So now you can see why there is no one easy answer to the question of which remote heads should be used. First, you have to know what shots are desired. After you have planned out the shot, you now have to find out what equipment is available. Sometimes shots may have to be reconsidered because of the unavailability of equipment or funds. I have worked with production companies when, through no fault of their own, equipment suddenly does not show up, and then they are told: "Oh, by the way, we do not have that in stock." As the grip in this situation, you have to ensure that the substituted equipment will work and is safe.

Flight head (remote)

FLIGHT HEAD w/ AUTO-ROBOT CRANE
(Four Axis Gyrostabilized System)

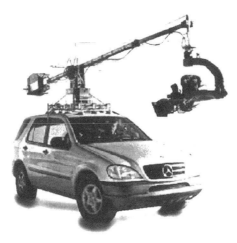

SPECIFICATIONS (Flight Head and Auto-Robot Crane - Item # 6020)

Unit Weight	580 lb.	263.6 kg
(Max. Configuration with Arri 453 camera and 70 mm Zoom Lens FIZ Wireless Control and Two Batteries)		
Shipping Weight for Complete System	1500 lb.	681.8 kg
Maximum Payload for Auto-Robot Crane	120 lb.	54.5 kg
Maximum Speed Approved for Base Vehicle	65 mph	100 kph
Angular Speed of Boom Control	25 deg./sec.	
Power (10 hour job w/ 216 Gel Batteries)	30 v, 7 A DC	
Setup Time	Approximately 1-2 Hours	

OTHER FLIGHT HEAD / AUTO-ROBOT FEATURES

- The Flight Head Can Be Mounted on Lenny Arms, Dollies, Super Nova & Apollo Mobile Cranes, or Any Standard Mitchell Mount.
- The Flight Head Can Be Mounted on the Auto-Robot Crane or Shock Absorber System. This Setup Can Also Be Mounted on Cars, Boats and Cranes.
- The Flight Head Offers Automatic Backpan Compensation to Simplify Tough Following Shots.
- The Flight Head Has a Unique Ability to Dutch, Pan, Tilt and Zoom with a Single Operator. The Auto-Robot Crane Allows Remote Control of the Crane Arm.
- Gyrostabilized Head Corrects the Horizon, while Allowing Motion of the Head's Base.
- Operates with Hand Wheels or Joy Stick.
- Can Be Used with a Variety of Motion Picture and Video Cameras, Including Panavision 65 mm Cameras
- Trained Tech Necessary with Every Rental

*It is advised that the user of Chapman/Leonard equipment check with the manufacturer for the latest updates on *all* equipment.

Figure 17.1a Flight head

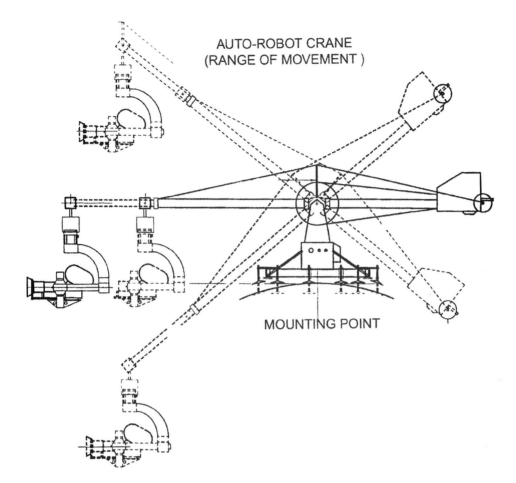

AUTO-ROBOT CRANE
(RANGE OF MOVEMENT)

MOUNTING POINT

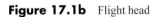

*It is advised that the user of Chapman/Leonard equipment check with the manufacturer for the latest updates on *all* equipment.

Figure 17.1b Flight head

FLIGHT HEAD and AUTO-ROBOT CRANE
(Four Axis Gyrostabilized System)
Maximum Payload: 120 lb. (54.5 kg)
Unit Weight 1,500 lb. (681.8 kg)

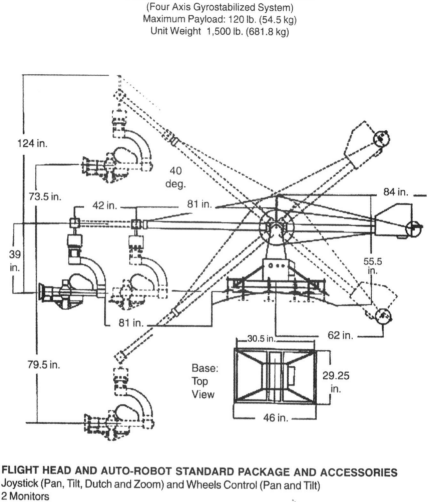

FLIGHT HEAD AND AUTO-ROBOT STANDARD PACKAGE AND ACCESSORIES
Joystick (Pan, Tilt, Dutch and Zoom) and Wheels Control (Pan and Tilt)
2 Monitors
Preston FiZ Lens System
8 Batteries (10 Hours) - For Flight Head
4 Batteries (20 Hours) - For Auto Robot
Cables (up to 130 ft.)
3 Chargers -110 ac
Battery Maintainer
Padding Kit
Straps
Transport Cart
Shipping Cases
Wireless Intercom w/3 Headsets
Wireless Intercom Headset (w/ Item #8200)
Flight Head Shock Absorber - 3 Axis
Chapman/Leonard Battery Pack
Chapman/Leonard Battery Charger - 110v
Chapman/Leonard Battery Charger - 220v

*It is advised that the user of Chapman/Leonard equipment check with the manufacturer for the latest updates on *all* equipment.

Figure 17.1c Flight head

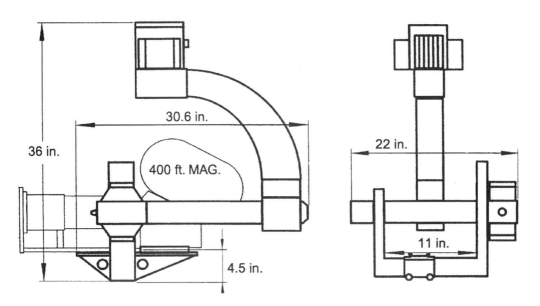

FLIGHT HEAD
(Three Axis Gyrostabilized Remote Head)
Maximum Payload: 66 lb. (30 kg)

FLIGHT HEAD SYSTEM STANDARD PACKAGE AND ACCESSORIES
Joystick (Pan, Tilt, Dutch and Zoom) and Wheels Control (Pan and Tilt)
2 Monitors
Preston FiZ Lens System
8 Batteries (10 Hours)
Cables (up to 130 ft.)
3 Chargers -110 ac
Battery Maintainer
Shipping Cases
Wireless Intercom w/3 Headsets
Wireless Intercom Headset (w/ Item #8200)
Flight Head Shock Absorber - 3 Axis
Chapman/Leonard Battery Pack
Chapman/Leonard Battery Charger - 110v
Chapman/Leonard Battery Charger - 220v

*It is advised that the user of Chapman/Leonard equipment check with the manufacturer for the latest updates on *all*
equipment.

Figure 17.2 Flight head

FLIGHT HEAD
(Third Axis Gyrostabilized Remote Head)

SPECIFICATIONS

Height	36 in.	91.5 cm
Width	22 in.	55.9 cm
Depth	30.6 in.	77.7 cm
Weight	55 lbs.	25 kg
Shipping Weight for Complete System	850 lbs.	386.4 kg
Payload Capacity (Recommended)	66 lbs.	30 kg
Range of Movement:		
Pan	Unlimited	
Tilt	75º Positive to 165º Negative	
Roll	95º Left or Right	
Maximum Usable Focal Length	250 mm	
Mounting Base	Standard Mitchell	
Dynamic Stabilization Error	No more than 3 Arc Minutes	
Maximum Angular Speed	120 Degrees / sec.	
Maximum Angular Acceleration	120 Degrees / sec. / sec.	
Regular Current	2.5 amps	
Operating Temperature	14º F to 122º F	
Power Supply:		
AC	110 / 220 v	50 - 60 Hz
DC	22 - 32 v	
Regular Current	2.5 amps	
Operating Temperature	14º F to 122º F	
Setup Time	Approximately 1 Hour	

OTHER FLIGHT HEAD FEATURES

- The Flight Head Can Be Mounted on Lenny Arms, Super Nova & Apollo Mobile Cranes, for Increased Versatility in Camera Movement, Especially with Dual Axis Movements.
- The Flight Head Can Be Mounted on the Auto-Robot Crane. This Setup Can Be Mounted on Cars,Boats and Cranes.
- The Flight Head Offers Automatic Backpan Compensation to Simplify Tough Following Shots.
- The Flight Head Has a Unique Ability to Dutch, Pan and Tilt with a Single Operator. The Auto-Robot Crane Allows Remote Control of the Crane Arm.
- Gyrostabilized Head Corrects the Horizon, while Allowing Motion of the Head's Base.
- Operates with Gear Head or Joy Stick.

Figure 17.2 *(Continued)* Flight head

Hot head (remote)

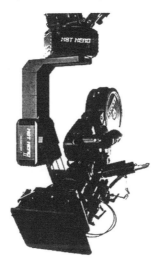

HOT HEAD
REMOTE CAMERA
(with Preston System)

SPECIFICATIONS

	Hot Head S/NTS		HD Hot Head	
Height	2 ft. 3 in.	68 cm	2 ft. 3 in.	68 cm
Width	1 ft. 3 in.	37 cm	1 ft. 7 in.	47 cm
Depth	11 in.	27 cm	11 in.	27 cm
Weight	44 lbs.	20 kg	48 lbs.	22 kg
Total Shipping Weight	374 lbs.	170 kg	410 lbs.	186 kg
Load Capacity	154 lbs.	70 kg	176 lbs.	80 kg
Voltage	24v DC		24v DC	
Maximum Speed	2.5 sec. per 360°		2.5 sec. per 360°	
Minimum Speed	17 min. per 360°		17 min. per 360°	
Number of Slip Rings	34		34	
Number of Limit Switches	2 Tilt & Pan		2 Tilt & Pan	
Riser Size	4.38 in.	11.11 cm	4.38 in.	11.11 cm
Riser Size	8.63 in.	21.9 cm	8.63 in.	21.9 cm

OTHER HOT HEAD FEATURES

- Rotates 360° with Most Types of Film and Video Cameras
- Can Be Used with Film Magazines up to 1,000 ft. in Size
- Rotates a Continuous 360° Pan and Tilt with Lenses up to 10:1
- Smooth Pan and Tilt with Your Choice of Handwheel or Joystick
- Joystick Control System Offers One Man Pan/Tilt, Zoom and Focus
- F.I.Z. Controls Come with Witness Camera, Viewing Monitors and Mobile Control Cart
- Works on All Types of Crane Arms
- Smooth, Silent Performance
- Remote Head Technician Available upon Request
- Can Be Used with a Variety of Motion Picture and Video Cameras

*It is advised that the user of Chapman/Leonard equipment check with the manufacturer for the latest updates on *all* equipment.

Figure 17.3 Hot head

Kenworthy Snorkel camera systems (remote)

The Kenworthy Snorkel (Figure 17.4) is the perfect device to maneuver. It is a specially designed tube with the mirror attached to one end. It was designed to travel through close areas. For example, suppose you are shooting a fast-food commercial. After an extreme close-up of a hamburger, you want to then rotate to a huge cup in frame, then to the fries. The Snorkel will help you shoot in such tight areas. The downside is its extremely heavy weight (about 350 pounds). You will probably need to mount it on a small stage crane; whatever you mount it on, make sure when you first set up the Snorkel system so that the unit can handle the weight. Fortunately, the Snorkel system always comes with an able technician. Not only will the Snorkel get into tiny places, it also delivers its own look (almost a three-dimensional effect) for film, I am told. Other pieces of equipment are available, but this one is a major problem solver.

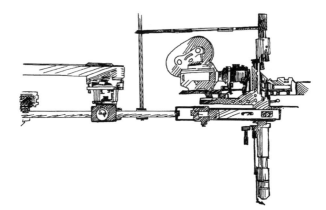

Figure 17.4 Kenworthy Snorkel camera systems (remote)

Libers III (remote)

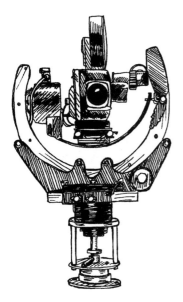

Figure 17.5a Libers III (remote)

Figure 17.5b Libers III (remote) monitor

Oppenheimer Spin-Axis 360 head (remote)

The Spin-Axis 360 Head (Figure 17.6) is the all-new motorized third-axis system from Oppenheimer Camera Products of Seattle. The system is lightweight, exceptionally robust, and built to a standard that allows it to carry virtually any modern 35 mm, 16 mm, or video camera.

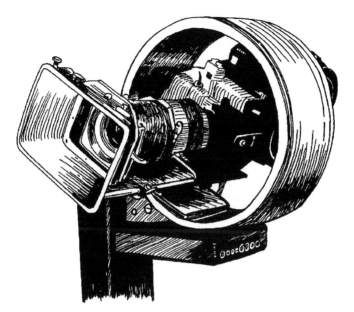

Figure 17.6 Oppenheimer Spin-Axis 360 head (remote)

Pearson fluid head

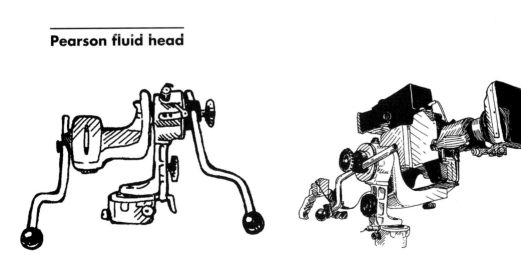

Figure 17.7 Pearson fluid head **Figure 17.8** Pearson fluid head

Power pod (remote)

POWER POD
(REMOTE CAMERA SYSTEM)

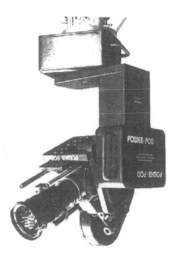

SPECIFICATIONS

Height (w/o Riser)	1 ft. 7 in.	48 cm
Width	11 1/4 in.	29 cm
Depth	1 ft. 4 3/4 in.	43 cm
Weight	40 lbs.	18 kg
Shipping Weight w/ Case for Complete System	492 lbs.	224 kg
Load Capacity (Recommended)	60 lbs.	27 kg
Voltage	12, 24 & 30 v DC	
Maximum Speed	3 sec per 360°	
Minimum Speed	16 min. per 360°	
Number of Slip Rings	4 rated at 9 amps	
Number of Limit Switches	1 Tilt Access	
Riser Size	300 mm & 150 mm	

OTHER POWER POD FEATURES

- Rotates 360° with Most Types of Film and Video Cameras
- Works on All Types of Arms
- Can Be Used with Film Magazines up to 1000 ft. in Size
- Smooth, Silent Performance
- Can Rotate a Continuous 360° Pan and Tilt with Lenses up to 10:1
- Smooth Pan and Tilt with Your Choice of Handwheels or Joystick
- F.I.Z. Controls Come with Witness Camera and Viewing Controls
- Trained Technician Available upon Request
- Can Be Used with Arriflex and Panavision 65mm Cameras

*It is advised that the user of Chapman/Leonard equipment check with the manufacturer for the latest updates on *all* equipment.

Figure 17.9 Power pod (remote)

Weaver/Steadman fluid head

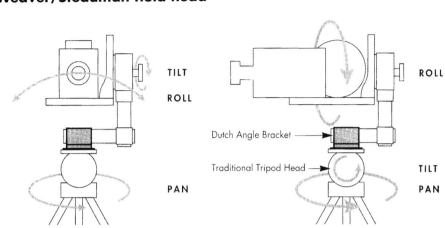

Figure 17.10a Weaver/Steadman head

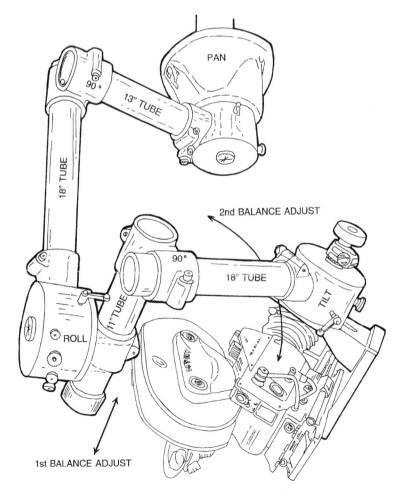

Figure 17.10b Weaver/Steadman head

Weaver/Steadman's "ds Remote™" (remote)

WEAVER STEADMAN'S "ds Remote™"
CAMERA SYSTEM
(with Preston System)

SPECIFICATIONS

2-Axis Height (Minimum Configuration)	2 ft. 1 in.	63.5 cm
2-Axis Width (Minimum Configuration)	1 ft. 9 in.	53.4 cm
2-Axis Depth (Minimum Configuration)	1 ft.	30.5 cm
3-Axis Height (Minimum Configuration)	2 ft. 8 in.	81.3 cm
3-Axis Width (Minimum Configuration)	2 ft. 2 in.	66 cm
3-Axis Depth (Minimum Configuration)	2 ft. 1 in.	63.5 cm
2-Axis Weight	61 lb.	27.7 kg
3-Axis Weight	93 lb.	42.3 kg
2-Axis Payload Capacity (Recommended)	120 lb.	54.5 kg
3-Axis Payload Capacity (Recommended)	90 lb.	40.9 kg
Electronic Limit Switches (Both Directions)	Pan, Tilt & Roll	
Pan, Tilt & Roll Movement	360° Continuous	
Speed Range (Pan, Tilt & Roll)	3 sec. to 24 hr.	
Number of Slip Rings	120	
Mounting Base	Standard Mitchell	
Outputs at Camera	BNC 75 Ohm (x3)	
	12 volts @ 2 amps for video (x2)	
	12 or 15 volts @ 10 amps peak (x2)	
	24 or 30 volts @ 15 amps peak	
Lens Control Systems	Preston Fi+Z and Arri Lens Control	
Outputs Spare for Client's Use	Two Channels 2 amps	
	Five Channels 2 amps	
Link between Head & Controls (Single Cable Capability)	50 ft. - 800 ft	15 m - 244 m
Supply Voltage Range	48 volts DC, 90-240 volts AC	
Power for Head @ 48 volts DC	1.6 - 10 amps Peak	

OTHER WEAVER STEADMAN FEATURES

- Rotates 360° with All Common Film & Video Camera
- Can Be Used with All Common 1,000 ft. Film Magazines
- F.I.Z. Come with Witness Camera & Viewing Controls
- Can Be Used with Arriflex & Panavision 65mm Cameras
- Open Side Chassis for Tight Camera Positioning
- User Friendly, Quick, Simple Setup and Arrangement
- Modular Components for Optimal Size & Camera Placement
- Can Rotate a Continuous 360° Pan, Tilt and Roll with Lenses up to 10:1
- Smooth Pan, Tilt and Roll with Your Choice of Handwheels or Fluid PTR

- Pan, Tilt & Roll Movement in Any Direction
- Trained Tech Available upon Request
- Works on All Types of Arms
- Smooth, Silent Performance
- Powers Arriflex 435 at High Speed
- Instant Record and Playback

*It is advised that the user of Chapman/Leonard equipment check with the manufacturer for the latest updates on *all* equipment.

Figure 17.11 Weaver/Steadman's "ds Remote™" (remote)

18 *Field operation*

The first part of this book is an introduction to the equipment used daily in the making of motion pictures, videos, and even still photographs all over the world. This portion of the book examines how some of the equipment is assembled and operated. Remember that old Hollywood saying, "There are ten ways to do a job in Hollywood, and usually they are all correct." These field operations pictured are only one or two ways of doing them. When you, the reader, look at the photos here along with the accompanying text, you should be able to see how a job was engineered, and then you can modify it to accomplish your needs and complete your process. This will give you a chance to learn some more/maybe different ways of doing the things.

As a new person in any field, how many times have you said to yourself, "Just show me how to do it," then "give me a chance?" So now I am showing you how. The "old salts" in the film industry may say, "That's not how I do it!" But they will all agree, "It is in fact, one of the many ways it can be accomplished." That being said . . .

Look, I cannot give you precise "step by step" instructions on everything, so I am giving you the next best thing, "pictures." I will fill in my "two cents" along the line as I go. Look, learn, practice with a trained professional. (Get in touch with some of them "old salts" out there.)

Throughout this new field operation section, I will attempt to show you many things that you will need to know, if you want to work in this ever-changing industry. Below are some of the things I will show you. But before we get started, let me explain something you most likely already know. You will not get "All you need to know" for this or any other book. You must get "Hands on" training. The old saying is true here, "How do you get to Carnegie Hall?" Practice, Practice, Practice. Now we go . . .

PHOTO FINISH! One of the "MANY" ways it can be accomplished . . . shown in photos!

How to build a dance floor (for the dolly)

First we need a cart full of pre-cut pieces of 4 ft. × 8 ft. × 3/4 in. birch plywood.

We use birch plywood because of its excellent strength, stiffness and resistance to creep. Each side has a smooth surface. If handled correctly, it will last a season or two. No knots, cracks, or checks. (Grade "A" plywood will work just as well if you cannot afford birch. It's cheaper.)

A professional tip

Always try to use birch or use A/C plywood or A/D plywood for dolly track. (STANDARD PRACTICES)

Figure 18.1 Dance floor wood cart

Figure 18.2a Dance floor wood cart stacking

Figure 18.2b Dance floor "cuts" markings

The cart pictured is used by the dolly grip Gerrit Garretsen. His requirements are as follows:

6) 4 × 8 ft. birch plywood sheets (birch has two very smooth, no knot surfaces).
2) 4 × 6 ft. birch plywood sheets with plastic covers.
2) 4 × 4 ft. birch plywood sheets with plastic covers.
2) 2 × 8 ft. birch plywood sheets with (4) plastic covers.
2) 2 × 6 ft. birch plywood sheets with plastic covers.
2) 2 × 4 ft. birch plywood sheets with plastic covers.
2) 4 ft. PIES with plastic cover.
1) 3 ft. PIE with plastic cover.
1) 2 ft. PIE with plastic cover.

1) 1 ft. PIE with plastic cover.
2) 2 × 4 ft. birch plywood sheets with plastic covers.
1) 1 × 8 ft. birch plywood sheets with plastic cover.
1) 30 in. × 8 ft. birch plywood sheet with plastic cover.
1) 36 in. × 8 ft. birch plywood sheet with plastic cover.
1) 18 in. × 8 ft. birch plywood sheet with plastic cover.
1) 30 in. × 4 ft. birch plywood sheet with plastic cover.
1) 36 in. × 4 ft. birch plywood sheet with plastic cover.
1) 12 in. × 4 ft. birch plywood sheet with plastic cover.

This is the "PERFECT" cart for him. Of course he has more standing by if needed, but this will fill 95% of all his needs. I have to tell you, "It works very well."

By all means, build the cart the way you want and need. Garretson's cart is just a submission to consider.

Leveling the sub-floor

Let's say that a "SET WALL" has been removed for reverse access for filming. Notice the carpet's edge. This will present a problem in "leveling" your floor unless you use a shim (A riser) about the same thickness.

Figure 18.3 Wall removed shows edge of carpet meeting studio floor

Figure 18.4 Edge of carpet meeting studio floor (close-up)

A lot of dolly grips use ABS plastic for shimming (Figure 18.5) (aka Sintra plastic sheeting).

Figure 18.5 ABS plastic for shimming

ABS plastic comes in several size sheets. We usually order the 4 × 8 × 1/4 in. thick to start with. Then we will cut the sheet to the sizes we use most (see list).

Lay the plywood

Now we lay the plywood on the carpet and the temporary (ABS/Sintra) shim.

Figure 18.6 Left: carpet; right: plastic, top plywood

ABS/Sintra

Now it's ready for ABS/Sintra plastic covering.

Figure 18.7 Plywood ready for plastic tops

Here (below) we lay a top ABS/Sintra layer, making sure we "separate" or "split" as many of the plywood butt joints as possible. This will/should prevent "dipping." (Causes unwanted shaking or moving of the camera as we roll across it.)

Figure 18.8 "Split" as many of the plywood butt joints as possible

Figure 18.9 "Transitional" surface

Here is what we are trying to achieve, a "transitional" surface. (Notice the "Split" line or "Butt Joint" of the plywood next to the 4 × 4 label.) This "should" lessen the chance of dipping or shaking (about 95% of the time).

Here is another little trick that can help you offset the seams of the plywood base to the plastic covering. Use a 1 in. × 3 in. × 4 ft. stick under the excess overlap.

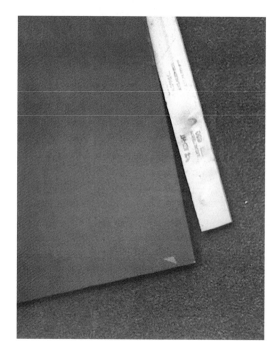

Figure 18.10 A 1 × 3 stick for bracing an end piece

Simply shift the covering 3 in. down or up the board, then install the stick. Now we tape it all together with "Low Tact" paper tape. We use this blue tape because it is cheaper and works better that 2 in. photo black tape to peel up.

Figure 18.11 Taping the seams

Dance floor wedges

Cut yourself a couple of full-size wedges down to 3/4 in. thick at their highest point. This will be about two-thirds of a standard wedge now. Place them at the edge of the dance floor and roll on up.

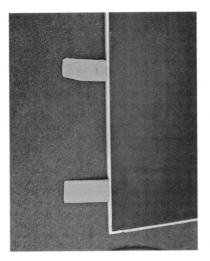

Figure 18.12 Ramps provided to get dolly up smoothly on dance floor

We do not normally "see" the dance floor during the shot (notice I said "normally"). But if the dance floor is "in the shot," then by all means "dress it out" with black tape. You will be amazed at what you can "cheat" or "get away with" while filming.

Setting your dolly marks

Marks are pieces of (tabbed) tape that the dolly grip lays down as the actor enters the scene. We always have a "START" mark. This is usually referred to as position #1.

I laid my first FLOOR mark (I always use yellow for #1 position). Note: it can be any color tape you like.

Figure 18.13 Start mark

Note: notice that the mark is "IN-LINE" with the hub or center of the dolly rear wheel. (This is kind of a standard practice here in Hollywood. It certainly works for me.) Some dolly grips use laser pointers.

Figure 18.14 Laser pointer mount on front of dolly

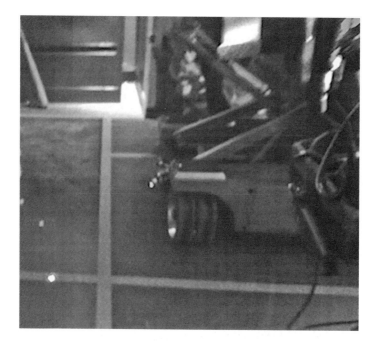

Figure 18.15 Lasers in action

Some use the front wheel. As the actor moves from their first position to the next, we track (move) the dolly with them.

Here, I laid my second FLOOR mark. I always use orange for #2 position and so on . . .

Figure 18.16 Position #1 and #2

Note: sometimes your mark colors may be the exact same as the actor's marks. In that case I will sometimes "double up" my colors as show. (Use whatever combination you can think of.)

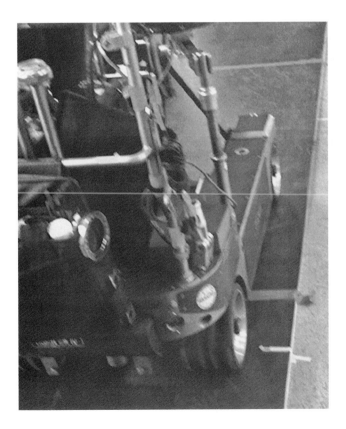

Figure 18.17 Doubled up, shown here (notice the "tone/hue" light/dark difference)
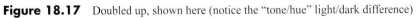

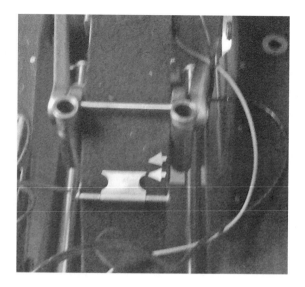

Figure 18.18 Light: yellow; dark: orange

Notice position #1 (Yellow)
Position #2 (Orange).

Accessorize your dolly

Below I have my tape "marks" at the ready. The rest are on top of my HD monitor. Note: if you are going to become a dolly grip, buy yourself a great monitor. You need to see exactly what the camera operator sees. This will make your job easier.

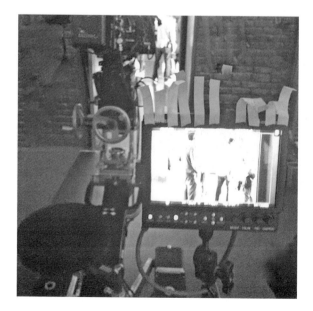

Figure 18.19 Dolly grip monitor

An exterior tee marker

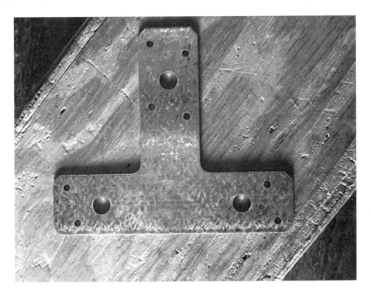

Figure 18.20 Made from Simpson tie

Figure 18.21 Simpson tie with colored tape

Dollies

Here are a few other ways to get that movement in the shot. (Remember the saying, "There are ten ways to do a job in the film industry and they all work.")

The following photos will give the reader a "how we do that" look at things.

Laying dolly track

Okay, here's one of the many, many ways of laying dolly track. I will set up a scenario and explain how to lay the dolly track to accomplish the scene.

The shot will take place in the early morning, about 7:00 a.m. You will be filming a woman in a bathrobe exiting her front door to get the morning newspaper, which is lying on her driveway. She will walk down her walkway and across a wide driveway. As she is walking, she spots some trash that has blown onto her sidewalk. She will stop, bend down, pick it up, and then move to her trash can which is next to the side of her home on the other side of the driveway. She will then walk back toward her front door, she will stop once again, bend down, pick up her newspaper, then walk into her home.

Your job is to set up the dolly track of the lady's front lawn approximately 15 ft. away from the front of her house, parallel with the sidewalk. The yard has about a 15-degree slope downhill, toward the street. The home was built on a small hill, so the front yard also has an upward incline as well.

Mark the camera positions; this means that you, along with the director of photography (DP), will place a mark on the ground where the camera will first see the young lady exiting her front door. This is position number one. Since you're on the grass lawn at the start, I suggest that you drive a camera wedge or half a clothespin into the ground as a marker (something that won't get kicked out of the ground or be moved accidentally). This marker will be planted directly under the position of the lens. The director of photography will probably be using a tool called a viewfinder. It is nothing more than a camera lens mounted to a handheld viewing device. While the DP is framing their position, you will measure the height of the lens from the ground, to the "center" (focal plane) of the lens. This is the position where the DP will see everything at the beginning of the shot. Have the director of photography walk to the final position, which will be considered the end mark (the opposite end of the track). This end of the track is now on the driveway. (Mark this end with chalk.) Measure the lens height again. You can give yourself a note on the ground written in chalk here. ("Lens height is . . .") This may or may not be position number two. The reason I say this is, remember that the lady stopped for a moment to pick up a piece of trash from her lawn. This may be your first stop. You may have an arm down (lower the camera with her bending down, then up to the original height as she stands). This is where it gets a little funny. You could call your first position your "start" position, or position number one. Your first stop is actually your second camera or lens position. Once again, the reason I say this is that throughout that particular scene you will probably hear the assistant director say, "Everybody back to one." This will be the start position for the dolly. Your first mark "after the camera moves" is camera position number one. You will just have to figure out what is meant. A quick and easy fix is to ask, "Do I go to the very start of the track, or do I go to my first stop mark?" What is usually meant in this situation is to go back to the very first position in which the actor is first seen (also called first positions). There, was that not clear as a bell? I say this semi-jokingly, but believe me this sort of thing happens. Be prepared, not pissed. (It's art, not a factory operation.) Well, I digress once again.

Now that you have found out what the scene is and what the action is, you're ready to lay your track. As you are aware from my illustrations, dolly track comes in various shapes and lengths. You will be using round tube track that comes in 8 ft. lengths.

When laying down the track, ensure that the track is "straddling" the marks you have put down. The marks are now in the "center" of the track. Once the dolly is mounted on the track, the camera head will sometimes offset the lens a little forward of the mark. This is a minute difference, but it is a difference. I recommend a short rotating offset to adjust the lens in or out/left or right. This offset will give you enough adjustment of the camera lens. This adjustment is sometimes referred to as wiggle room. Now, let's get down to laying the track on the uneven surface (the hilly lawn).

When you're laying out your track, you must allow extra track for the length of the dolly. Say that the dolly base is 4 ft. long. I would lay 5 ft. of extra track for the base. Now you must determine whether the dolly will roll "head first" or "tail first." The head end is the end of the dolly where the camera is mounted. Now you will know on which end to put the additional track for the dolly base.

Latch your sections of track. Lock them together with the buckles provided. Start leveling your track from the highest position of the track. Remember, the house has been a built on a hill. Just "rough in" the track, by an eyeball level, at this point. Once again, remember that the yard slopes toward the street and inclines up a hill. Find the highest point of contact. Start here. I recommend you place a wedge under the tracks' crossbar. This wedge will be used for "tweaking," or leveling, the track. Now level only one side of the track for the entire length on the highest side. This is a good start. You may have to prop it up temporarily with apple boxes, blossom blocks, and/or wedges. Remember, we are just "roughing it in." Once you have a ballpark level (close to correct), start leveling to the high side. I find that if you get the high rail (the track rail) in perfect alignment, you can easily raise or lower the opposite rail. I also find that if I adjust only the joints first, it is much easier. Then you fill in the rest of the crossbars of the track. Once the track is "true," level, you will put the dolly on the track.

Installing the dolly on the track

If you can use a starter track (ramps) to roll the dolly up and onto the track, have another person (a grip) stand on the track rails. This person will accomplish two things. First, the weight of that person will hold the track down and in place while you are pushing the dolly up the ramps and onto the track. Remember the track is not anchored to the ground. It may shift while putting the dolly on the track. (Trust me, it will shift.) Second, your helper can help you pull the dolly on the track. Once the dolly is safely on the track, either by ramps or by lifting and setting it on the rails, you will then level the head. This is accomplished by adjusting knobs on the dolly's head.

A professional tip

Get the feel of each dolly. Turn the knob a few times to become familiar with the hydraulics of each dolly and the lifting beam (arm up and arm down). (NICE TO KNOW)

A professional tip

If you are asked to work the dolly, don't roll over any cable because it may throw off the pin registry (the interior movement of the film camera). It can also cause damage to the dolly. (STANDARD PRACTICES)

Making a correction

Say that we are filming the previously mentioned scene for a television show. Let's say that an actor has missed his mark. (Like that will ever happen.) As a camera crew (the dolly grip/the camera operator/the focus puller), we are allowed to make small adjustments to realign the shot, during the take, without cutting the camera. These adjustments are called corrections. This is mostly done on TV shows. I have not made any corrections on any feature films myself, but I suppose it can be accomplished as well. The same is true for a 30-second commercial. On commercials, for the most part, the shots have to be as perfect as they can be.

A professional tip

All direction references are made from the perspective of what the camera sees. (NICE TO KNOW)

Camera left is to the camera's left side, as if you are looking through the eyepiece. (NICE TO KNOW)

Camera right is to the camera's right side, as if you are looking through the eyepiece. (NICE TO KNOW)

Marks

Actors have marks. Dollies have marks. A camera assistant/focus puller has marks. Everyone has to hit his or her mark, at the same time for the most part. Like most dolly grips, I will put a tab of tape on the ground at the center of my rear wheels. I then have my perspective for my hard mark. I can also align my dolly (like a gun sight) on an object, such as an arm of a chair, if the floor is going to be seen in the shot. I will usually start my dolly moving very slowly as the actor begins his motion. Then I will adjust my speed accordingly. By giving a slow, gentle start (this is referred to as feathering), it should not be detected on camera. Feather your starts. A good start and stop should virtually be undetectable during a scene. Sometimes the director may want the scene to "breathe." A slow, gentle, undetectable movement of the camera accomplishes this.

Next time you watch something, look for a slow movement of the background while staying constantly on the foreground subject. This movement adds a breath of life to the scene.

Courtesy grease cover

Figure 18.22 Courtesy cover

We will use a courtesy cover made from "show card" covered with gaffer/grip tape.

This will prevent any "grease" getting on the camera operator's clothes (much appreciated).

Figure 18.23 Tape covered show card (courtesy cover) use for a grease cover

Figure 18.24 Courtesy cover in position

A complement of tapes (dog collar)

Here I use a "quick release" dog collar to hold my tapes.
A stinger (extension cord) to charge my dolly.

Figure 18.25 Complement of tapes

Figure 18.26 Stinger (extension cord) made from ZIP cord

Setting dolly planks

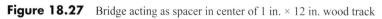

Figure 18.27 Bridge acting as spacer in center of 1 in. × 12 in. wood track

Pictured are two planks of one inch by twelve inches (1 in. × 12 in. by 16 ft./2.54 cm × 30.48 cm × 489 cm) used for dolly track. In between are "spacers" or a "bridge" that is inserted for the proper width. The spacer/bridge does a dual job.

1. It works to separate the board to "almost" the required width/spread of the dolly ("24-1/2 in. (62 cm) on center is the standard spread of most dolly wheels for track).
2. It allows the dolly grip to load/mount the planks from the side, if the grip is unable to load/mount from either end.

Just use a few extra pieces of 1 in. × 12 in. (2.54 cm × 30.48 cm). I carry two cut pieces of planks (cut to 9-1/2 in. [24.13 cm] wide by 12 in. [30.48 cm] long) for just this reason.

Rolling track cart

Figure 18.28 Dolly track at the ready on cart

You can use a "doorway dolly" with two push handles on it. Then load it with:

Track, track wheels (in boxes), 1 in. × 12 in. × 12 ft. (2.54 cm × 30.48 cm × 365.76 cm) foot planks, 1 in. × 12 in. × 8 ft. (2.54 cm × 30.48 cm × 243.84 cm) foot planks, wedges, and blossom blocks.

Dolly tricks of the trade that will help you

Here is a little trick I learned from Dolly Grip Eric Zucker. I call it the "EZ" footrest. It works great in tight places where a large dolly sideboard may be too big.

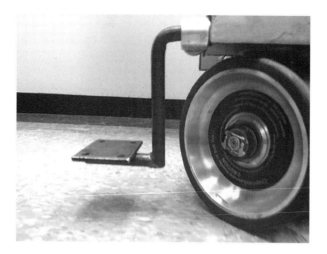

Figure 18.29 EZ footrest

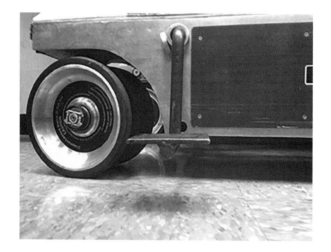

Figure 18.30 EZ footrest on front side of dolly

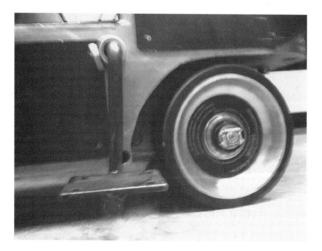

Figure 18.31 EZ footrest on rear side of dolly

Stake bed racks (grip manufactured)

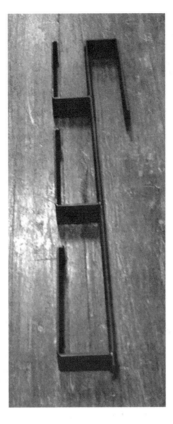

Figure 18.32 Stake bed racks

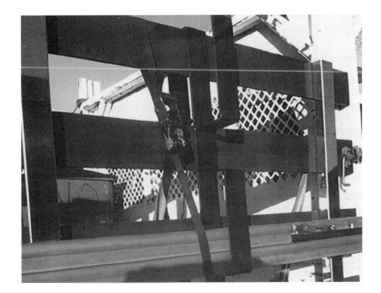

Figure 18.33 Stake bed racks with tie down strap (not road safe)

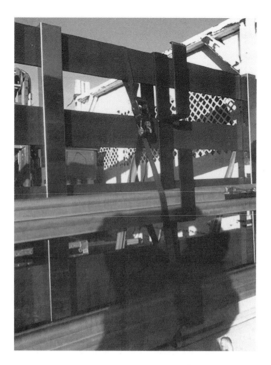

Figure 18.34a Stake bed racks with tie down strap over dolly track (not road safe)

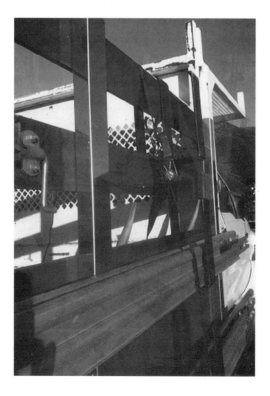

Figure 18.34b Stake bed racks with tie down strap over dolly track (another view; not road safe)

These racks are very handy. Notice the "LIP" on the rack's end. They help prevent the track from bouncing out (NEVER use this set-up on public streets; closed locations only).

Ladder rack set-up

Here is another way of doing the same thing.

Figure 18.35a Dual cab five ton/with stake bed (not road safe)

Ladder rack using #3 grip clips (closed location only)

Figure 18.35b Dual cab stake bed with ladder on side (not road safe)

Simply use a grip clip and then hang the ladder on it.

Figure 18.36 #3 or #4 grip clip used as ladder rack (not road safe)

Make sure you tie it off for travel.

Figure 18.37 Grip clip used as ladder rack (another view; not road safe)

Figure 18.38 A safety tie-off (not road safe; another view)

The "Putter Scooter" (aka butt dolly)

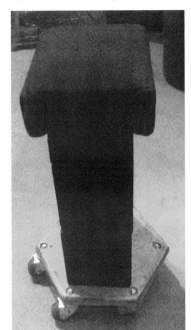

Figure 18.39 Putter Scooter

With "saddle" (butt pads)

You can adjust the height by attaching apple boxes atop one another. Velcro holds them in place (grip manufactured).

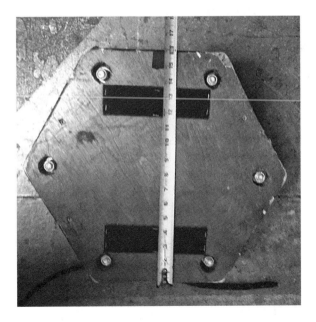

Figure 18.40a Velcro strips for attaching Putter Scooter to base

Figure 18.40b Velcro strips for attaching Putter Scooter to base (7-1/2 in. long)

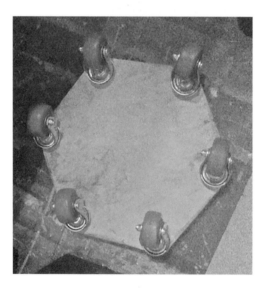

Figure 18.41a Base (underside of) 'wheelie' board

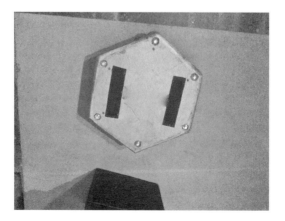

Figure 18.41b Base (working side of) 'wheelie' board

Pictured upside down so you can see how to build your own.

Figure 18.42 Velcro on 'special' apple box bottom/base

Velcro on box bottom.
The bottom is pictured upside down so you can see how to put the Velcro tape on it.

Other butt scooters (Putter Scooters) (grip manufactured)
The Studebaker

This handy little roller box was the invention of cameraman Daryl Studebaker. It will accommodate an apple box perfectly. It is designed to allow the cameraperson to move (correct) his or her position to get a better angle on a shot or avoid blockage if the actor should miss his mark by a few inches. It works perfectly.

Figure 18.43 Putter Scooter (Harbor Freight/auto parts store)

Figure 18.44 Putter Scooters using modern equipment base and adapters

Butt rail dolly (four foot long shown)

This is a combination of Speed Rail® and rubber troughs from modern studio equipment (grip manufactured).

Figure 18.45 Butt rail dolly on track (correct position)

Figure 18.46 Rails design

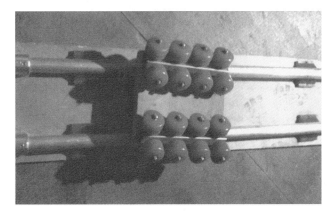

Figure 18.47 Butt rail dolly wheels (shown upside down)

Shopping cart dolly

Figure 18.48 Shopping cart dolly with three-way level head

Figure 18.49 Shopping cart dolly with anti-slip/skid tape

Figure 18.50 Shopping cart dolly with three-way level head

Figure 18.51a Shopping cart dolly with Steadicam operator

Figure 18.51b Garfield mount and arm for Steadicam

How it works!

Dolly ramps

Figure 18.52 Ramp

Figure 18.53 Ramp cutouts

Figure 18.54 Ramp cutouts (close-up view)

With the use of this ramp (grip manufactured), it makes an easy transition for the dolly. Plus it can be used elsewhere.

Protective caps for dolly track (made from PVC)

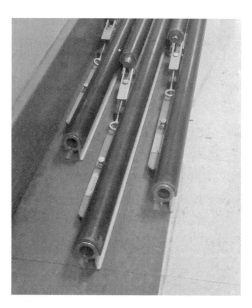

Figure 18.55 Protective caps for dolly track (made from PVC)

Pretty simple trick, really. Just cut a slot/section of the plastic pipe away, then press on over the rail.

Figure 18.56 Protective caps for dolly track (made from PVC; close-up view)

Quick tricks
Rainproof your microphone

(grip manufactured)

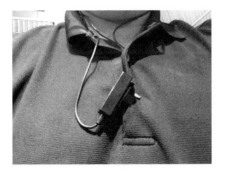

Figure 18.57 Rainproof your microphone

Figure 18.58 Rainproof your microphone with rubber glove fingertip

Figure 18.59 Rainproof your microphone with rubber glove fingertip/thumb

Figure 18.60 Rainproof your microphone with rubber glove fingertip over microphone

Truck load chart

Just make up a "LOAD" chart and put it at the tailgate. This helps the day-hire (and you) know what is next when loading the truck.

Figure 18.61 Load list for loading truck

Make a city skyline on a set

On more than one occasion, a director of photography may (will) ask for something, anything out the back window of a set. Here is a "quick fix." It's made from "foam core and tape."

Figure 18.62 Make a city skyline

Figure 18.63 What the city skyline will look like to camera

What it really is and what it will look like! (Other ways of making a mock-up city skyline.)

Figure 18.64 Foam-core cutout with cuts of diffusions, mounted on C-stand (back side shown)

Figure 18.65 Before adding cuts of diffusions

Aircraft on flatbed

Mock-up airplane on a drivable flatbed with outriggers.

Figure 18.66 Mock-up airplane on a drivable flatbed

We traveled up and down a road shooting slightly upwards. The clouds in the sky made the aircraft look like it was flying. The entire structure was gimbaled. Tilt, pan, and twist.

Cover unwanted sprinklers

Figure 18.67 Someone forgot to check for timers for sprinkler system (bad boo-boo, bad)

Figure 18.68 A grip, 'quick fix!' (cones and/or sandbags, etc.)

Or use whatever is close (sandbags, etc.).

Shower cap

The plastic caps are great "dust" covers when not shooting.

Figure 18.69 Shower caps are great "dust" covers

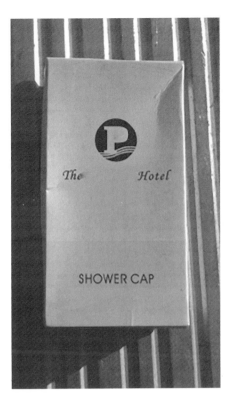

Figure 18.70 Shower caps in box

Hiding a frame's edge

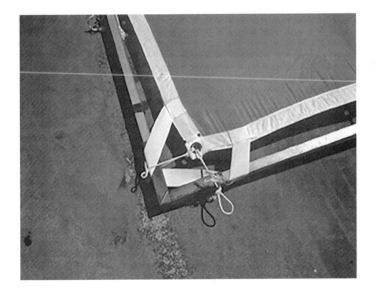

Figure 18.71 Hiding a frame's edge (normal configuration)

Here a few methods to hide the frame shadow.

Figure 18.72 Frame sock or boot cover

We use a sock. It's a cover designed to fit over the frame's edge.

Figure 18.73 Cover/boot with 'safety' pins

We then safety pin it on to prevent it from blowing off.

Figure 18.74 Frame with 'clip-on' branches

Used one (1) 6 ft. artificial Christmas tree limb.

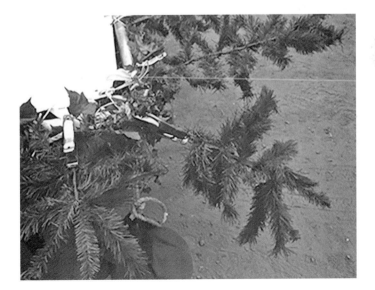

Figure 18.75a Notice grip clip and safety ties

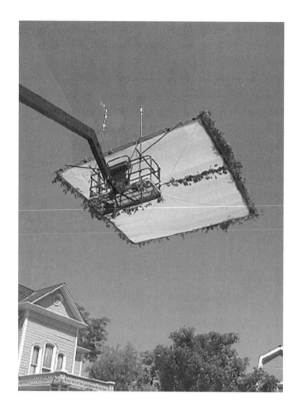

Figure 18.75b Frame 'safely' in air over objects/people

Clipped on with grip clips and safety ties.

Tying down an easy-up leg

Figure 18.76a Easy-up sun/rain shade

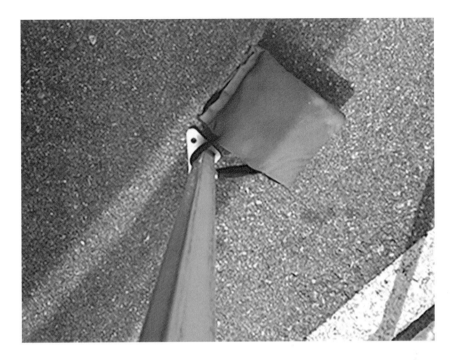

Figure 18.76b Easy-up foot through sandbag strap

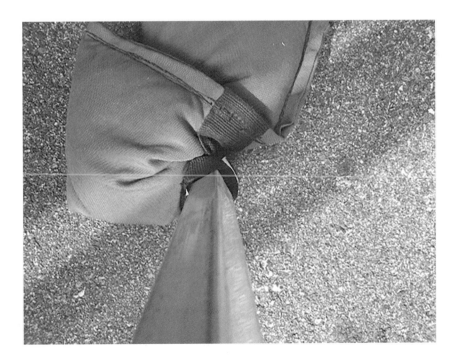

Figure 18.77 Twisted to grab leg tight around easy-up leg

Put leg through sandbag handle, twist.

Proper bagging ("see, the full weight is off the ground")

Figure 18.78 Proper bagging

Figure 18.79 This works, but most of the weight is lying on the ground

This works, but not as well. (Notice where most the weight of the bag is in Figure 18.79? It's on the deck.)

Wind stick on floppy flag

Figure 18.80 Wind stick on floppy flag (Rusty's 'location' hat made the picture)

Figure 18.81 Grip clip and 1 × 3 lumber

Use a 1 in. × 3 in. × 4 ft. stick and two grip clips.

Push pin in crouch tip (for ready use)

Figure 18.82 Pins at the ready

Tape shim

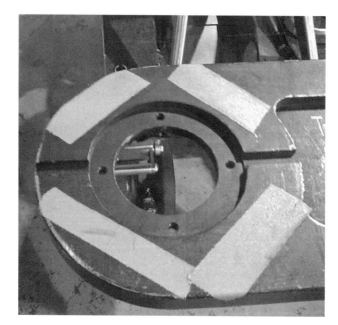

Figure 18.83 Tape tabs on offset

Apply a little grip tape as a shim. Double layer if needed.

High-roller transport

Figure 18.84a High roller riding on another (a two for one transport)

Figure 18.84b High roller knob/knuckle, hooked on another

Roll one – carry one. Make sure that the bottom riser knob is loose, allowing it to spin freely.

Camera safety shields

Figure 18.85 Safety shield

Made from Lexan plastic. Used next to camera.

Making diffusion frames

Using Velcro for Kino-flow door.

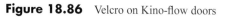

Figure 18.86 Velcro on Kino-flow doors

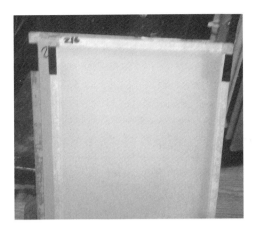

Figure 18.87 Velcro on grip-manufactured Kino-flow frames

The frames are made from common do-it-yourself material you can get at any large hardware store.

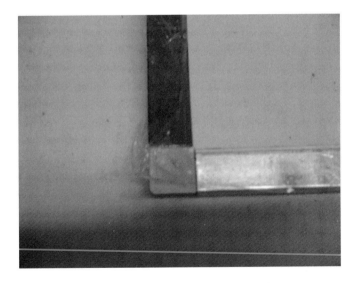

Figure 18.88 ATG or snot tape

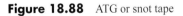

Figure 18.89 From common hardware store materials kit

The "BACK" side of the frames have MAGNETS or magnetic strips "GLUED" on (dark are on edge) or round dot magnets.

Figure 18.90 Appling snot tape on frame

Figure 18.91 Magnets "glued" on aluminum frame

Figure 18.92 Roll of ATG/snot tape

Now apply ATG tape to opposite side, and then apply gel/diffusion.

Figure 18.93 Roll of ATG/snot tape roll with frame

The top edge shows a magnet strip already glued on.
Note: They can also be attached with "BINDER" clips.

Figure 18.94 Before installing a diffusion frame

Figure 18.95 With diffusion frame

Using newspapers at a "cutter and light diffusion" (clever!)

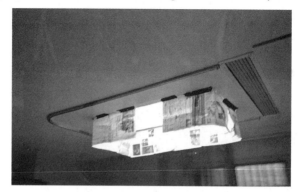

Figure 18.96 Paper tape and newspaper

Chinese lamps with "rubber dip" blackout paint on top

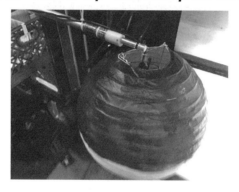

Figure 18.97 Chinese lamps

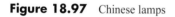

More tricks
Bus roof mount (key grip: Rocky Ford)

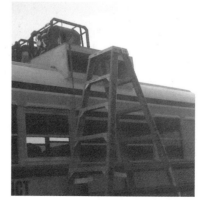

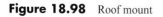

Figure 18.98 Roof mount

Figure 18.99 Roof mount base

Notice the "tie down" straps run down "between" the windows, out of the camera's view.

Plumber's putty

Some grips use plumber's putty to dull a surface if they don't wish to use dulling spray. The just make a "ball" or "hotdog" and roll it over the surface. It works very well.

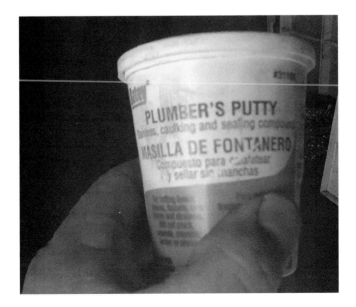

Figure 18.100 Plumber's putty

Figure 18.101 Plumber's putty in canister

Cutting rope

This part may seem silly to some, but if you do this wrong, you have one big mess on your hands.

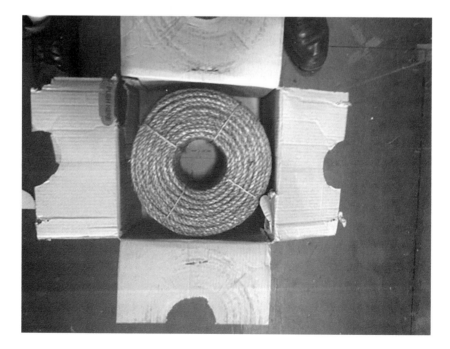

Figure 18.102a Open a new box of rope

Figure 18.102b When received

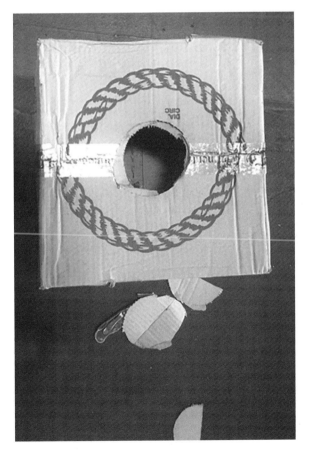

Figure 18.102c Punch out holes

Figure 18.102d Open up box

Figure 18.102e What you should see

Open the rope box fully.

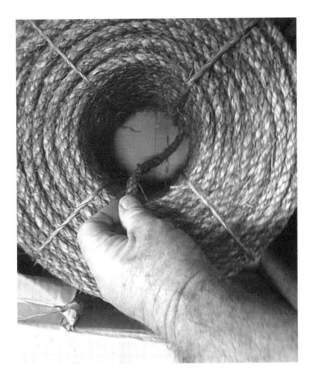

Figure 18.103 Locating 'START' end

Find end in the bottom.

The start end of the rope will be on the bottom of the roll. It has to come up, through the center of the spool.

Pull to top.

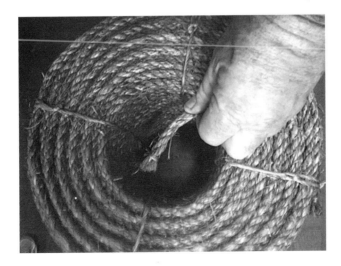

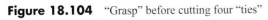

Figure 18.104 "Grasp" before cutting four "ties"

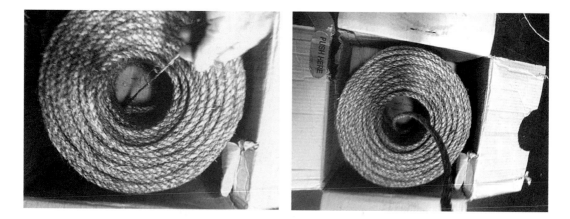

Figure 18.105 Remove all ties **Figure 18.106** Ready to pull out from box

Cut retaining twine. Pull out to half the length, wrap around object, back to box to acquire the full length you desire. Repeat as many times as needed.

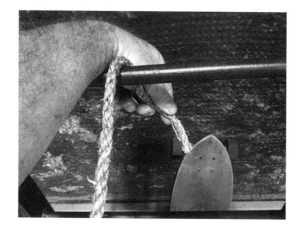

Figure 18.107a Wrap rope over immoveable object

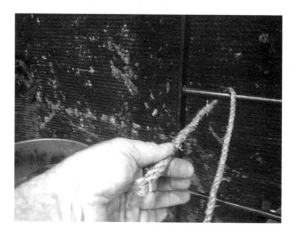

Figure 18.107b Ladder rung shown/used as immoveable object

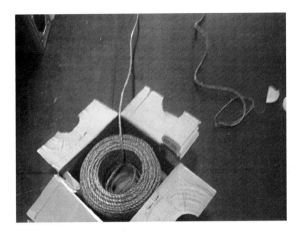

Figure 18.108 Pull rope as you return to box

Use a tennis ball as a safety cover

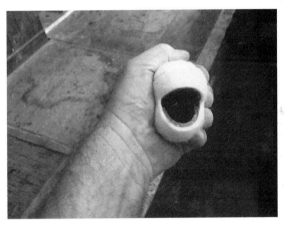

Figure 18.109 Slit, cut into a tennis ball (use all safety measures before cutting)

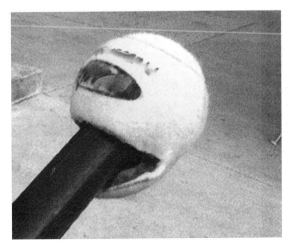

Figure 18.110 How it works

Wall seams

Figure 18.111a Tape as wall seam

Figure 18.111b Before installation

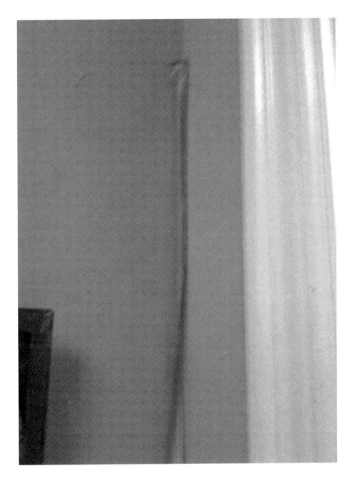

Figure 18.112a Installing

Figure 18.112b Blend/smooth in to perfection

We use painter's tape in the corners for quick wall removal.
Peel and stick. Paint several strips.

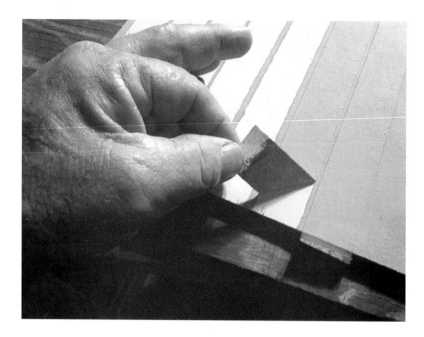

Figure 18.113 An example of "tape" at the ready on paint board

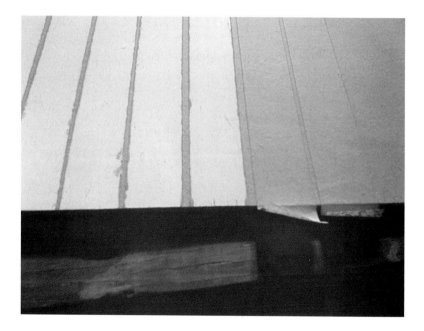

Figure 18.114 Notice small gap between tape strips

Use wood under feet (on any lawn)

Figure 18.115 Courtesy board

Figure 18.116 A true professional (doesn't damage property)

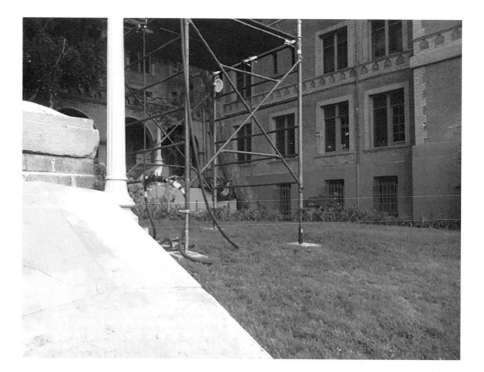

Figure 18.117 Wood under feet of parallels

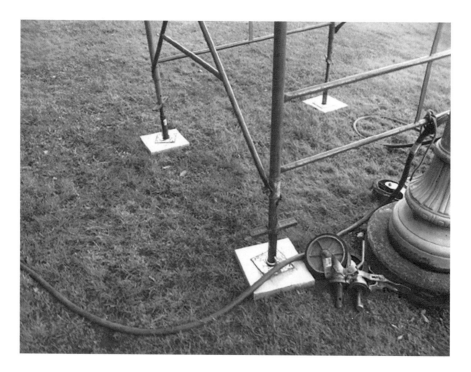

Figure 18.118a Put wood blocks under feet

Figure 18.118b Plywood footing

If wood is not placed under the feet, it may (will) sink into the ground. This gives it a larger footprint.

Mark your equipment

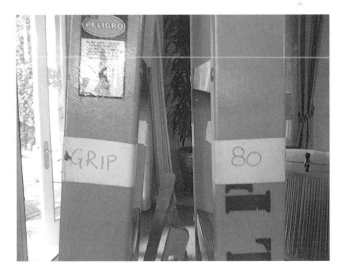

Figure 18.119 Mark your equipment

Just don't!

Don't ever do this!!! (Lean pins against a wall.) It shows that you're a rookie, lazy, and do not care about other people's property.

Figure 18.120 DO NOT LEAN AGAINST WALLS!!!

If you must lean it, turn it on its edge. Let the cloth rest against the wall. Always try to "PAD" it first.

Another don't!

Figure 18.121 Don't lean smaller flags against larger flags; "BAD" (when it falls over, it punches through all the flags)

Because when it falls it will punch through the other flags! (Figure about $50 per "repaired" net.)

Don't be a pig!

Figure 18.122a Good example of really bad work!!!

(Notice the leftover food bowl.)

As you can see, some things really get under my skin. If you worked for me, I would probably just fix the problem. (I might not even say anything to you.) BUT, don't expect a call back.

Figure 18.122b Notice material against wall behind flag?

Figure 18.122c Notice pin direction?

Blue screen: building the structure

(Finished Product)

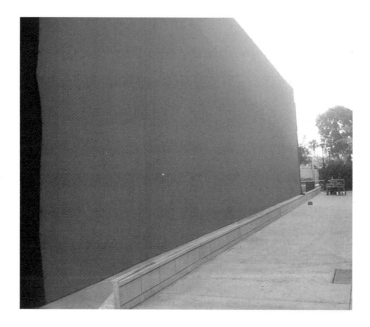

Figure 18.123 Blue/green screen on frame (working side)

Now I'll show you how it was built so perfectly.
(Rigging structure behind a blue screen.)

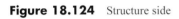

Figure 18.124 Structure side

Figure 18.125 Another example of a structure

Tying down a platform system

Platform harnessed to blocks of cement.

Figure 18.126 Tying down a platform system

Figure 18.127a Tying down a platform system on blocks

Figure 18.127b Tying down a platform system on blocks (another view)

Setting a "wag" flag

We had to extend the flag way out there, so we used a second gobo arm and braced it with a third arm and a clamp with a pin. Bracing an extremely long reach.

Freshly painted floor protection

Figure 18.128 Lay out board at the ready

We use "lay out" board (cardboard) on green painted floor to walk on. They come in 4 × 8 sheets. There are also "rolls" of cardboard or "butcher paper" to use as well.

Figure 18.129 Lay out board working/protecting floor surface

A "walk and talk" scene

Figure 18.130 Two grips carry a 12 ft. × 12 ft. frame

Notice the two grips carrying a 12 ft. × 12 ft. frame. They're using it as a sunlight diffuser.

Figure 18.131 Grip carries a 4 × 4 bounce

Here the grip is carrying a 4 × 4 "breadboard."

The cloud

The cloud used in a walk-and-talk scene.

Figure 18.132 Cloud/balloon controlled by ropes

Movie trucks

The next few pictures are photos of the different-style trucks we use in the moviemaking industry. A lot of times you may (will) be told, "Go to the stake bed, then the ten-ton, and get this and that."

A professional tip

Most equipment trucks are usually no higher than 12 ft. 6 in., and most telephone or electrical wires are no lower than 13 ft. 6 in., but this is not written in stone: "Measure it safely." (NICE TO KNOW)

Let's start off with something tasty.

Catering truck

Figure 18.133a Catering truck

Figure 18.133b 5-ton truck (dual-style, side-by-side, rear wheels)

Figure 18.133c 1-ton truck (production/cube truck)

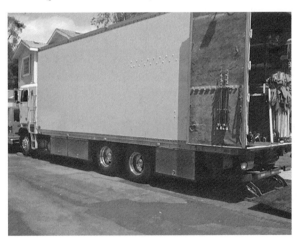

Figure 18.134 10-ton truck

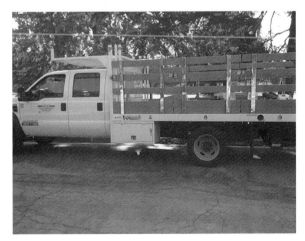

Figure 18.135 Stake-bed truck

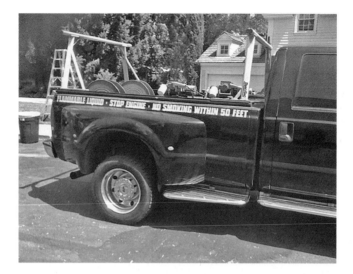

Figure 18.136a Called a dually truck (side-by-side rear wheels)

Figure 18.136b Notice tandem-style rear wheels on truck

Figure 18.136c Tandem axle vehicle

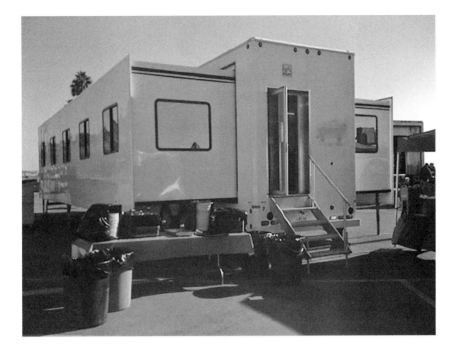

Figure 18.137 Lunch box truck (air-conditioned eating area)

Called a hoodie! (simply a tug and a trailer)

Used to carry equipment around the studio lots.

Figure 18.138 Called a hoodie!

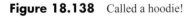

Green screen

I will now explain what the grip contributes to the computer-generated image (CGI) process. First we need to build a screen frame. Then we will skin it with the screen. This is accomplished by using blue or green, it really does not matter what color it is. (The color of the screen is usually called for by the director of photography.) First, we build the frame (pictured later), then we "rag" (skin) it.

Figure 18.139 Green screen for CGI (notice the palm trees in "New York")

Figure 18.140 Notice the seams; we cover them with a Velcro-backed material

Figure 18.141 Velcro will attach itself to the green screen material

Figure 18.142 Velcro sewn on seam cover strips

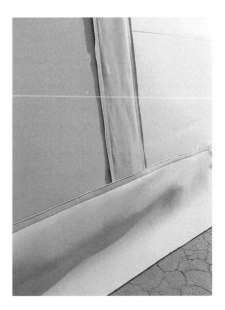

Figure 18.143 Seam cover strips

Figure 18.144 Rolling A-frame

Figure 18.145 Green screen held on with speed clips

Figure 18.146 Rolling A-frame base built from Speed Rail™ corners, 90-degree crosses, and casters/rollers

Figure 18.147 One hundred running feet of green screen

Figure 18.148 Plywood under stands (prevents damage to track)

Figure 18.149 Working side, large frame

Figure 18.150 Blackout cloth to prevent light leak

Figure 18.151 Grip clips on ribbon to prevent tears in the blacks

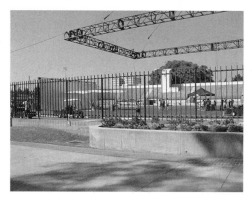

Figure 18.152 Box truss

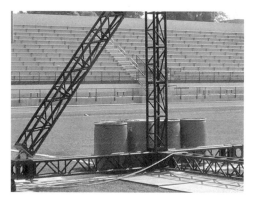

Figure 18.153 Water-filled drums to act as "weight" against the wind

Mounts

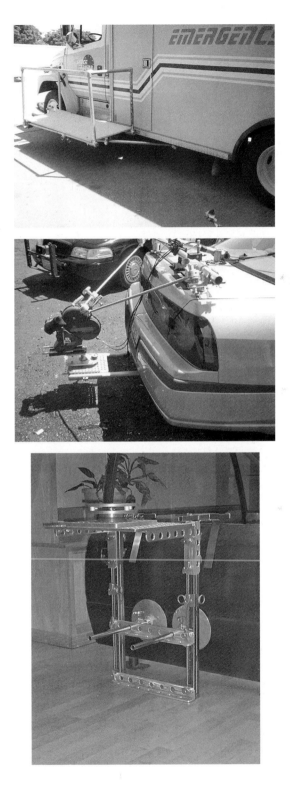

Figure 18.154 Assorted camera mounts

The following pictures show one of many ways to rig cars. I use a lot of starter plugs from Modern Studio Equipment.

Figure 18.155 Finished product

Figure 18.156 Plug sample

Figure 18.157 What it looks like with the starting "foot," a 3/16 pitch threaded rod that is 3/8 in. in diameter welded to a steel foot – this has worked just fine for many years. From Modern Studio Equipment.

Figure 18.158 The undercarriage of a car will usually have several holes to "get a bite" using starter plugs

Once the foot is in the hole, simply screw it tight. The more plugs (base), the safer it will hold. Always allow for ground clearance. Remember, the car will bounce on its springs/struts, possibly scraping the ground. I try to build mine to be "bulletproof." This simply means as strong as possible. I have a little saying: "Plan for the worst, hope for the best." Build it strong. Someone's life may be at risk here if you do not pay attention to the details.

Figure 18.159 Hood mount foot pad (mouse pad)

Figure 18.160 I used starter plugs (note the padding under straps)

Figure 18.161 Crank-type motorcycle strap *through* the tube attached to the undercarriage

Figure 18.162 Finished product

Figure 18.163 Lip clamp (Modern Studio Equipment)

Figure 18.164 Notice pad/starter plug in Speed Rail™ fitting

Figure 18.165 Notice pad

Figure 18.166 Bracing using C-stand arms

Figure 18.167 Hostess tray (car side camera mount)

Figure 18.168 Adjustable (Modern Studio Equipment)

Figure 18.169 Super grip with starter plugs

Figure 18.170 Small super grip with baby pin (Modern Studio Equipment)

Pump the gold knob/plunger until the red line is no longer visible. This "should" ensure that it is holding. It is a good practice to pull lightly toward the side on the pin/plug to ensure it is sucked on to the flat surface. Always "pump it up" before it travels. Check that there is not red showing on the plunger.

Figure 18.171 Channel (V) with threaded (3/8–16 pitch) threads for "starter plugs"

Above: Used on tube frames ("motorcycle/bicycles") held in place by worm/ban clamps.

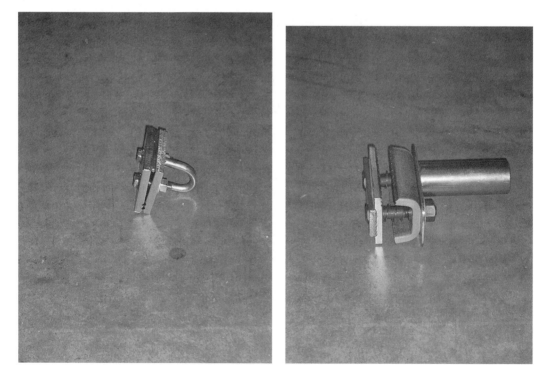

Figure 18.172 Pinch clamp for tie-down

Figure 18.173 Starter unibody pinch clamp fits most speed rail fittings

Above: Used to clamp on under cars with unibody construction. Unibody construction is basically a seam on the bottom of a welded car body (Modern Studio Equipment).

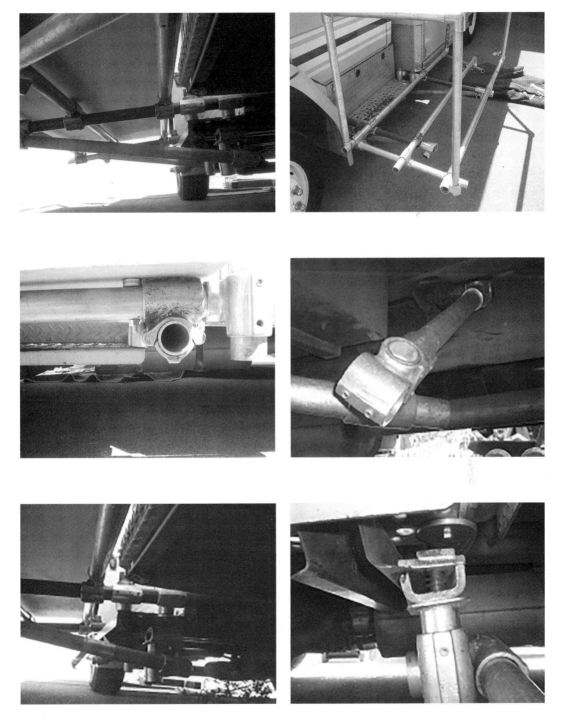

Figure 18.174 Rigging an auto/truck with Speed Rail™ and pinch clamps

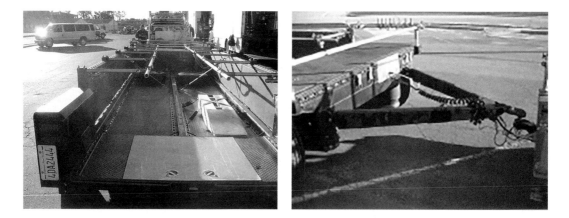

Figure 18.175 This is how it will arrive. It is attached like any heavy-duty trailer.

Figure 18.176 Air bags to raise or lower trailer

Figure 18.177 Lowering controls

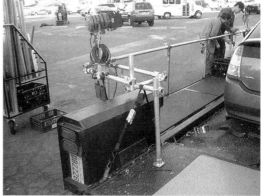

Figure 18.178 Lower is *very* desirable

Figure 18.179 Rigging a back light for passenger's head

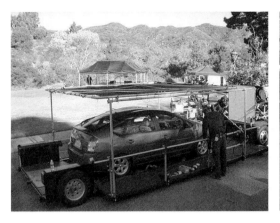

Figure 18.180 Building a cover on an insert trailer (helps control the hard sunlight)

Figure 18.181 Wings up

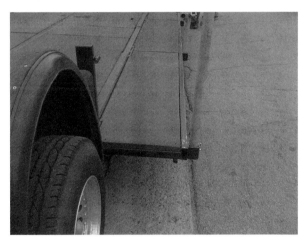

Figure 18.182 With the wings out. About 12 ft. or so wide with both sides out.

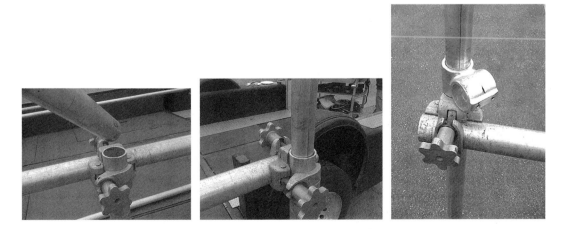

Figure 18.183 Slide the tubes inside the upright tubes. Now install a cross and secure it to the trailer by tying it down.

Figure 18.184 Baby pin grid clamp

Figure 18.185 Junior receiver grid clamp

Figure 18.186 Swivel cross grid clamp

The insert trailer

These were various pictures of different shots, but it should give you an idea of how to create something like this. With the cover (black) in place, we can have some control of the natural light. We black out the vertical uprights for reflections.

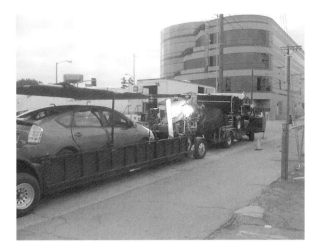

Figure 18.187 Insert trailer ready to travel

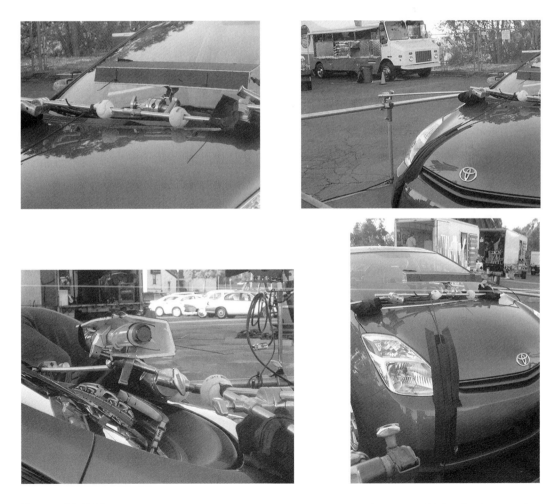

Figure 18.188 Rigging a Kino flow eye light. The tennis balls are used to prevent hitting the glass or paint. Notice the black cloth under straps.

Figure 18.189 Tent on traveling insert car (tied and strapped down)

Figure 18.190 Notice sash (rope) tying down corners

Figure 18.191 Everything has a safety tie on it

Figure 18.192 Wrong work shoes

Hard gels

Here is an example of using a plastic neutral density (ND) to darken the window to be able to see out of it while filming. Without using this process, the windows would read "BRIGHT." It would appear

Figure 18.193 ND on left and center windows. Nothing on right window.

as a glare. We call this being blown out. The sheets are cut to size, peeled of their protective paper, and set into place. The sheets are held in place by a little tab of black paper tape or some ATG tape. (See "Temporary" tapes in the three-pane picture.) Use 1 in. photo black tape along the entire edge of the plastic. This will "box it in" and NOT show on film. In essence, it becomes the frame of the window.

Figure 18.194 Hard gel covered with paper for transport

Figure 18.195 Center window; install with paper covering on one side, then peel

Dollies

Here are a few other ways to get that movement into the shot.

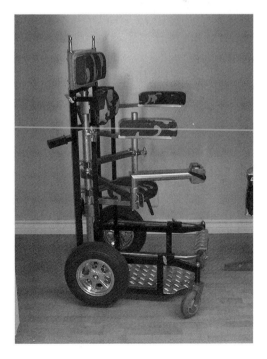

Figure 18.196 Wheelchair (Modern Studio Equipment)

Figure 18.197 This chair works perfectly

Figure 18.198 The bowling ball shot

Figure 18.199 Camera mount (Modern Studio Equipment)

Figure 18.201 Rolling trash can full of wedges

Figure 18.200 Rolling dolly track cart

Figure 18.202 Makeshift dolly using channel wheels 4 × 4 plywood and apple boxes (adapting, making things work)

Figure 18.203 Channel wheels used on dolly on track (normal usage)

Figure 18.204 Studebaker roller box

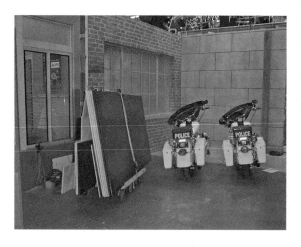

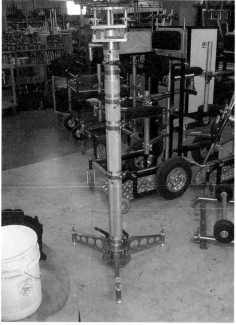

Figure 18.205 Rolling dance floor cart (4 × 8 ply-wood and 1/4 plastic covers). The wheel in center is larger. This allows tipping up or down to roll over objects such as cable.

Figure 18.206 Bazooka (Modern Studio Equipment)

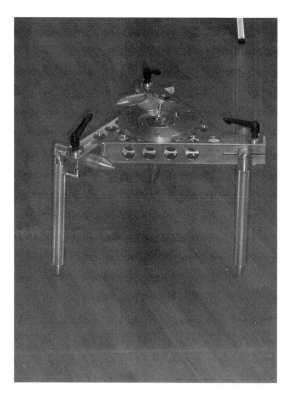

Figure 18.207 Dexter-style spider legs (Modern Studio Equipment)

Figure 18.208 Low-rolling cheese plate (Modern Studio Equipment)

Figure 18.209 Spring-loaded Mitchell plate base (used to bounce camera *during* filming) for earthquakes/crashes (Modern Studio Equipment)

Figure 18.210 Spider rolling camera mount (Modern Studio Equipment)

Figure 18.211 Low-profile rolling camera mount (Modern Studio Equipment)

Figure 18.212 Cheese plate-covered "electric" (golf) cart (running/bicycle shots), very quiet (Modern Studio Equipment)

Figure 18.213 Adjustable riser using Speed Rail™ (Modern Studio Equipment)

Figure 18.214 Checking the cloud movement

Figure 18.215 View "from the perms"

Rigging on stage and location
The perms

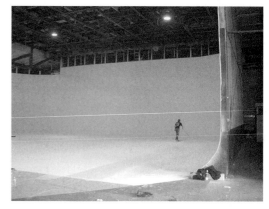

Figure 18.216 The stairs up

Figure 18.217 A stage with a cyclorama

The perms/rafters

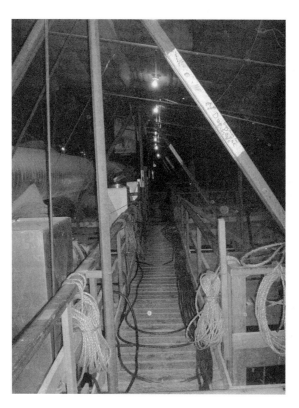

Figure 18.218 This is what the perms walk might look like when you are just starting the build day. By the time it is ready, it will probably be filled with a lot of electrical cables and other things. It gets very crowded up there. Be careful.

Figure 18.219 Rigging a chain motor rigged for lifting to the perms

Figure 18.220 Finished product (cleaned up)

Figure 18.221 Start like this

Figure 18.222 Loop at the center

Figure 18.223 Loop all the way through center

Figure 18.224 Back flip over coil of rope

Figure 18.225 Flipped over coil of rope

Figure 18.226 Pull down

Figure 18.227 Ready and safe!

Figure 18.228 Safety harness on steel cable (fall protection)

Figure 18.229 Cable attached to the perms

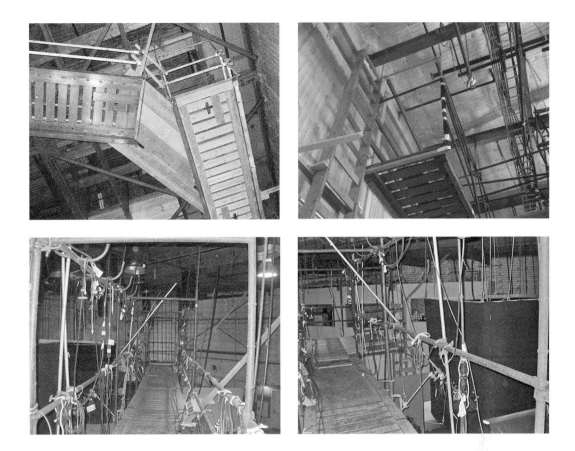

Figure 18.230 Green beds

Figure 18.231 Hung from the perms by chain

Figure 18.232 View from "the beds"

Figure 18.233 2 × 4 braces to prevent swinging (aka the kicker)

Figure 18.234 The kicker

Figure 18.235 Attached high to perms

Figure 18.236 Attached to hand rail

Meat ax

Figure 18.237 Pivot point

Figure 18.238 Adjusting handle

Figure 18.239 Deck poles

Figure 18.240 Shoved into hole

Figure 18.241 Meat ax (made with gobo head)

Figure 18.242 Ladder to green bed from floor

Rigging

Figure 18.243 Day/night curtain on grid pipe system rail

Figure 18.244 Curtain/backing switcher

Figure 18.245 Grid pipe system rail

Figure 18.246 Stairway to "nowhere"

Figure 18.247 1000 H paper diffusion

Figure 18.248 Rolling plugs (moving set walls)

Mock-up cockpit

Figure 18.249 A mock-up cockpit for filming

Figure 18.250 Actual nose cone

Figure 18.251 A cutaway section

Figure 18.252 Mock-up frame holding fuselage

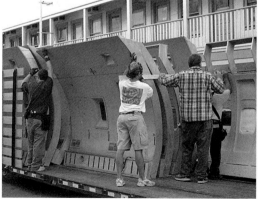

Figure 18.253 Traveling to location

Set bracing

Figure 18.254 Stage wall. Notice the blocks of wood nailed to brace/ground.

Figure 18.255 Hog trough horizontal brace strong back

Set snow

Figure 18.256 Fake snow groundcover blanket. This will be laid on the ground, then fake snow or actual ice snow will cover it. I show this so that you as a filmmaker will know what you are working with or around.

Figure 18.257 Yellow line: *four* feet wide!

Figure 18.258 Never put equipment here (safe passage)

Sets

Figure 18.259 What the camera will see

Figure 18.260 This is what the camera will *not* see

Figure 18.261 Spare walls stand by (called *scene docking*)

Figure 18.261 (*Continued*) Spare walls stand by (called *scene docking*)

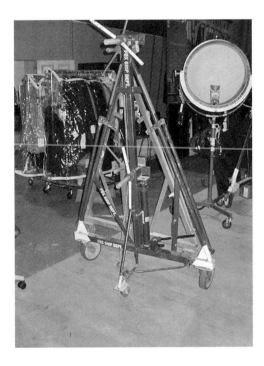

Figure 18.262 Rolling wall jacks with hydraulic lifts

Figure 18.263 Using a tennis ball as a safety cover

Figure 18.264 Cleats nailed to stage wall

Figure 18.265 Wild wall (easy removal); aka flyaway wall

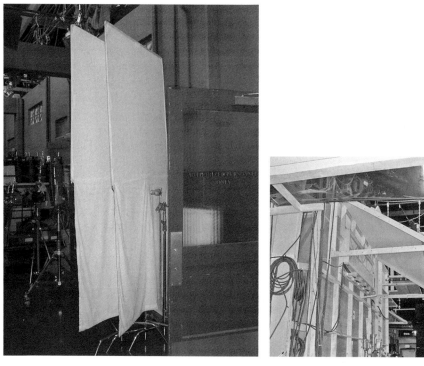

Figure 18.266 Bleached muslin floppies (bounce)

Figure 18.267 (Bounce) 4 × 8 foam core

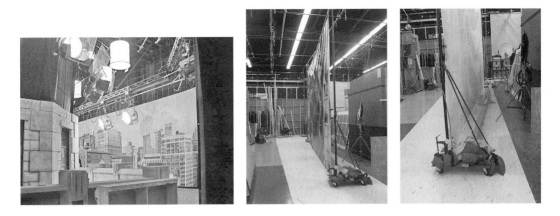

Figure 18.268 Translight hung from the perms (a), and on sailboats (b) and (c)

Figure 18.269 False ceiling

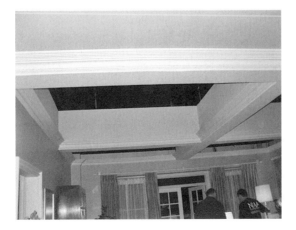

Figure 18.270 False ceiling removed

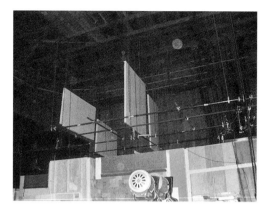

Figure 18.271 False ceiling hanging from perms

Figure 18.272 Lifting sticks used to move cloth-covered frame ceiling panels

Figure 18.273 Pulling a set window

Figure 18.274 Glass in storage (note the big X for safety)

Figure 18.275 Refro seal cloth (fire-retarding/proof cloth)

Figure 18.276 Refro seal cloth working

Rigging on location

Rigging of the face of a building

Figure 18.277 Steel pipe brace extended through windows that have been anchored inside

Figure 18.278 Brace/kicker to sliding chain motor

Figure 18.279 Secured to columns with straps and box truss. Wood prevents scarring the pillar.

Figure 18.280 The "p-ton" at work

Figure 18.281 Water truck for wet downs

Figure 18.282 Water tank to film underwater scenes

Figure 18.283 Ladder mount (Modern Studio Equipment)

Figure 18.284 Excellent to use. Ensure that the electric power is off. Remove standard base light bulb, screw into socket, hang a "Very Lite Lighting Unit" (Modern Studio Equipment)

Figure 18.285 Mitchell base cheese plate (Modern Studio Equipment)

Building a cove to black out a window/porch

Figure 18.286 Bracing a blackout cloth from wind

Figure 18.287 Speed Rail frame™

Figure 18.288 Black cloth

Figure 18.289 Arrow points where to enter

Rigging a lamp on parallels

Figure 18.290 How to safety tie down a lamp on a set of parallels

Figure 18.291 Rubber mat used to cover electric cables

High hat package

Figure 18.292 High hat package: 2 each apple boxes, 2 flags, 2 stands, 6 grip clips, 2 6 ft. piece of Duvetyn, 2 sound blankets, 2 sandbags dulling spray, Streaks 'n' Tips sprays, 6 wedges (compliments to Key Grip Jerry Day and his great crew in Local #80)

Figure 18.293 Fly swatter with plastic ivy (breaks up the frame edge)

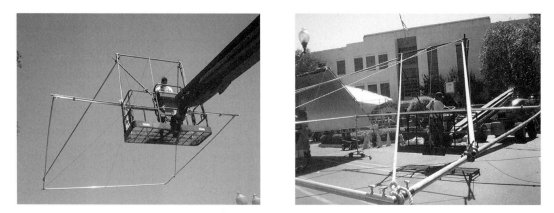

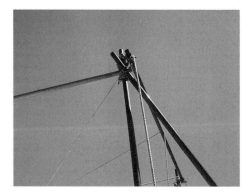

Figure 18.294 Fly swatter with flip down or side flip

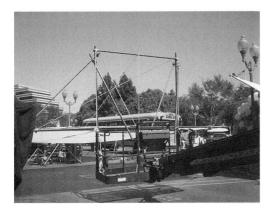
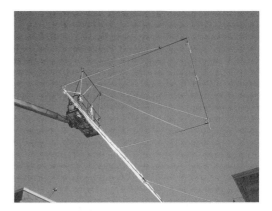

Figure 18.294 Bracing for fly swatter frame

The cloud

The cloud is currently available in two densities. A single-stop and double-stop balloon are offered. The basic cloud unit is a 20 ft. × 20 ft. × 3.5 ft. balloon that can be attached on any of its four vertical [3.5 ft.] faces to make whatever square or rectangle shape is desired. A large variety of configurations have been used to date – 20 × 40, 20 × 60, 20 × 80, and 40 × 40, to name a few. The cloud is a helium-filled balloon that is square in shape rather than the typical spherical balloons that are commonly associated with lighting balloons. The cloud has no illumination filament in it; its main functions are those of diffusion and bounce. A 20 × 20 cloud has approximately 85 lb. of positive lift. The cloud is made up of what is essentially a grid cloth that has been treated to make it more suited to holding helium.

Figure 18.295 The flying diffusion (called the cloud)

Figure 18.296 Bounce boards (corners cut to get closer to camera lens)

Figure 18.297 Large rain covers made for carts and lamps

Making a burrito roll

Figure 18.298 Roll one end

Figure 18.299 Tuck into pocket end

Figure 18.300 Mirror on your tape measure. Used to find lens flares (hold in front of lens).

19 *A professional's tips on the trade*

- A dollar bill is 6 inches long. (NICE TO KNOW)
- Always carry earplugs in your personal bag. (NICE TO KNOW)
- Always wear your safety goggles when drilling. (SAFETY PRACTICES)
- An average credit card is 3-3/8 in. long and 2-1/4 in. wide. You now have a second measuring device in your pocket. (NICE TO KNOW)
- Answer all requests made over the radio by repeating what is needed. For example, suppose the key grip calls out, "Give me a baby plate, a C-stand arm, and a postage stamp single." You should then reply, "One baby plate, a C-stand arm and head, and a 10 × 12 open-ended single. Roger. Flying in." BUT, don't become annoying. After a short time a simply copy is ok. You have to judge when the time is correct. (NICE TO KNOW)

This example illustrates that both parties involved know what is needed. The key grip knows that the call was transmitted, and your acknowledgment confirms that it was received. Communication is a major player in the movie industry. I do not want to be redundant, but I do want to drive home key points that will aid you and make you look a little better than the next person who wants the job or during the next callback if they shrink the crew. The grip department is a team. I am not advocating upstaging your peers, but I am saying that you must give it your all. (STANDARD PRACTICES)

- Before removing any set wall, check to see if the "seams have been cut," or if there are any lights or braces on it. (STANDARD PRACTICES)
- Blackouts (drops) (e.g., 6 ft. × 6 ft., 12 ft. × 12 ft., or 20 ft. × 20 ft. or larger) will be destroyed by the chlorine in pools. I have been told that there is something in the fire retardant that has a reaction to the chlorine. Don't use in pools. (NICE TO KNOW)
- Carry wood or lumber with one end high and the other end low in order not to smack anyone. (NICE TO KNOW)
- Catwalks are sometimes referred to as decks, greens, or perms. Perm is short for permanent, because these catwalks or walkways are permanent fixtures suspended above a studio set. Using the term greens or green beds (because they're often painted green) for the catwalks is actually incorrect. The studio catwalk is in fact "the decking or flooring" of the perms, and the greens are built temporarily to "hang" from the perms. (NICE TO KNOW)
- Charlie bars are long wooden sticks usually 3 to 4 feet long with different widths, ranging from 1 in. wide to approximately 6 in. wide. They are made from LuAnn (thin plywood) or 1/8 in. to 1/4 in. thick plywood. A 3/8 in. pin is attached for mounting a C-stand. Charlie bars work great as gobos, flags, or shadow-makers to make a soft shadow, such as a windowpane or whatever is needed. (NICE TO KNOW)

Circle your screws in set walls if it's a flyaway wall (removable wall). All walls can in fact be removed, but the ones designed "to be moved" are referred to as "flyaway". (STANDARD PRACTICES)

Clip a show card to a flag to create a support backing for the card for setting in it in a stand. (STANDARD PRACTICES)

Copy your passport, driver's license, and Social Security card. Keep them in a safe place. You will usually have to provide a copy of these items for payroll purposes – either your passport or your license and Social Security number. (NICE TO KNOW)

Count the length of a rope by the span measurement of your arms. (Measure from fingertip to fingertip with arms spread eagle.) Now grab rope and start to loop it after each span count. For example: a 6 ft. span means ten loops, which is approximately 50 to 60 ft. It's a ballpark measurement. (NICE TO KNOW)

Cut two full wedges to 3/4 in. at their highest point. This is a great way to get the dolly onto a grip built dance floor. (STANDARD PRACTICES)

Don't move, and don't talk to or make eye contact with actors, during filming. (STANDARD PRACTICES)

Ensure that all electrical open ends are taped off. An electrician will or should do it. (SAFETY)

Ensure that the lawn sprinklers have been turned off if there is a self-timing watering system. (NICE TO KNOW)

Hammer the tip of the nail (tap it upside down) before driving it into a piece of lumber. It helps prevent the wood from splitting. (NICE TO KNOW)

Here is something for you to chew on as a grip: "Say what you mean, mean what you say, but do not say anything mean." Mom was right; if you do not have anything nice to say, do not say anything. I can promise you this: if and when you do let your mouth run, it will come back to bite you in your behind in this or any business. (NICE TO KNOW)

I recommend an Estwing hammer. Get a straight claw type, which is easier for pulling nails. I use a smooth face. (I don't want to leave marks.) (NICE TO KNOW)

I recommend that you carry carabiner clips in your toolbox. They are handy when you want to send several things up high, say to the perms. Tie a bowline and just clip on the carabiner. You now have a quick release. (NICE TO KNOW)

I recommend that you get yourself a personal headset. There are two good types. One is like what the Secret Service uses; the headset wraps over one ear with a clip-on mike to attach to your shirt. The other type has an over-the-ear headset with a mike attached. (NICE TO KNOW)

If a lamp is hung overhead, make sure the electrician, gaffer, or grip puts a safety on it. (STANDARD PRACTICES)

If the need does arise, a grip can put a metal scrim in a C-stand and set it in front of the light, as opposed to installing the metal scrim in the light itself. (NICE TO KNOW)

If the screw bit driver spins in the head of the screw while driving it in, it is not what is called normal to surface, or a 90-degree angle. Don't let it grind. It will round out the slot. (NICE TO KNOW)

If you are mounting a camera on a car, find out whether the car is strip painted (temporary latex paint applied over the original paint). (STANDARD PRACTICES)

If you are on location and a sprinkler system comes on, quickly put sandbags on the heads closest to where you are shooting. (NICE TO KNOW)

If you can afford it, buy yourself an electric rotozip. It is an excellent tool to cut a little mouse hole in a set wall. Save the panel that you cut out and tape it to the back of the set wall near the hole in case it has to go back in. (NICE TO KNOW)

If you have a scuba card, photocopy it, because you may have to fax a copy to production every now and then, so they can rent equipment. (NICE TO KNOW)

If you have to decide whether something is safe or not, it is not safe. There should never be any doubt about safety. I cannot emphasize this enough. (NICE TO KNOW)

If you need an exact measurement to be marked on a piece of wood to be cut, don't use the beginning or tip of your tape measure. Measure from the number then subtract an inch. (NICE TO KNOW)

It's up to you if you put a lanyard (short cord) on your tools in your pouch. Some folks make a small loop that goes over their wrist while working high in the perms, green beds, or from a tall ladder.

There are two schools of thought on this issue: if you drop the tool, it should not fall. If you fall and the lanyard gets hung up, it could be a different problem. (NICE TO KNOW)

Know all your exits on stage. (NICE TO KNOW)

Know the placement of all fire extinguishers on the set. (NICE TO KNOW)

Let's say that a screw is stuck in a piece of wood. Here is a trick that sometimes works to loosen the screw. Put the hand-driven screwdriver tip squarely (90 degrees) into the slots on the head. Apply a counterclockwise pressure with one hand, and tap the top of the screwdriver handle with a hammer lightly with the other while you are turning it. If you cannot get enough counterclockwise pressure on the handle while trying to unscrew it, grab the shank (shaft) of the screwdriver with a pair of vise grips. This should give you more turning pressure. Keep tapping while applying counterclockwise pressure. (NICE TO KNOW)

Lexan is sometimes used for explosion-proofing a camera. It is also used for coffee tables and bank security. (NICE TO KNOW)

Listen like a field mouse, but be ready to spring like a leopard when needed. This proves two things: (1) you are paying attention (good for points), and (2) you can anticipate what is needed (better for callbacks). Trust me on this. This practice works for any profession. (NICE TO KNOW)

Make sure you have an up-to-date passport. I had mine for ten years and never used it. Then wham! I filled it up in a short time and had to get a second one. Jobs just pop up sometimes. Production loves to see that you have your stuff together. It makes for a lasting impression. I play a little game; it's called anticipation. Everyone is impressed with a person who is together. I know I harp a lot, but if just one thing from this book makes you look good, then I feel you have gotten your money's worth. I will eagerly share what little experience I have to anyone who wants to help him or herself. But like most things in life, there are no free rides! (NICE TO KNOW)

Never enter a stage if there is a red light flashing. This means they are rolling film. (NICE TO KNOW)

Never knock, talk down, or disrespect any crewmember you are working with or have worked with. You may have to work with them again. (NICE TO KNOW)

NEVER safety, rig, or tie off any equipment to a fire sprinkler line. (Safety)

Never walk in the ozone without a full body harness and fall protection strap. Above all, be safe. (Safety)

Only buy quality tools. Cheap ones will fail you when you need them most (I promise you this). (NICE TO KNOW)

Order a box of crutch tips (so-called due to their use for things that lack a tip) as a quick repair for stand legs that might scratch a set floor. Such locations include set stages and "practical" locations, such as a house, office building, or any place you could damage the floor. (STANDARD PRACTICES)

P.O.V. (point of view) is what a person sees from his or her perspective. (NICE TO KNOW)

Place a flag far enough away from a light to prevent burning, or use black wrap on the flag. (STANDARD PRACTICES)

Place neutral density gel inside a lampshade or wall sconce glass to reduce light if no dimmer is used. (NICE TO KNOW)

Play the sag load (that is, the weight of the light unit that is being rigged) when you rig it. Add a little extra pull or push, and then let it sag into place. (STANDARD PRACTICES)

Poor man's light process: cut a 4 ft. × 8 ft. piece of foam core to 4 ft. × 4 ft. and cut different shaped holes in it. Put it on a gobo arm like a windmill. Shine a light through the holes as it spins on the C-stand (gobo) arm threads.

Poor man's vehicle process: put a lever under the frame of the car and pump it up and down while filming. It gives the effect of movement.

Practice walking off a measured distance. Do this four or five times, then note how many steps it took. You'll be able to walk off an area and get a ballpark measurement after you calculate what each step represents. I usually err on the long side if measuring for track. It is better to have a little extra

than to be short. This doesn't mean you shouldn't have the right tools for the job, but this is a quick fix when you need it. (NICE TO KNOW)

Purchase and mark your own personal headset for the walkie-talkies that are used on set. (NICE TO KNOW)

Put a safety rope or cable on all lights that are hung. (STANDARD PRACTICES)

Put a Styrofoam cup over a sprinkler head in a building to deflect heat from a lamp under it. (NICE TO KNOW)

Put a tiny tab (about an inch) of ATG tape on the baby plate back to help hold it in place while you put in the screw. (NICE TO KNOW)

Put pads under everything that touches the vehicle. (STANDARD PRACTICES)

Put tape tabs on the gel, then staple or pushpin the gel up. This prevents tearing. (NICE TO KNOW)

Put the back lifting bars in Fisher #10, and then stand on them; this will offset the weight enough to lift up the front of the dolly to get up a curb. (NICE TO KNOW)

Rebar covers (covers the ends of metal rods) are the red, orange, or yellow plastic covers seen at construction sites. They can also be used as safety tips on any protruding objects, such as C-stand arms. You can also make another protective cover by cutting a slice into a tennis ball and placing it on the object. (NICE TO KNOW)

Safety all objects (lights, clamps, etc.) so that they will swing away from the center of the set toward the set wall if they fall. This will prevent it, we hope, from hitting the talent. (NICE TO KNOW)

Sometimes it is wise to cover a painted surface with foam core to deflect the direct heat from a lamp. A heat shield will reduce heat, but it is better to be overprotective. (NICE TO KNOW)

Sometimes the key grip is considered the unofficial safety expert. (NICE TO KNOW)

Spray oil or talc powder on the dolly wheels as you roll the dolly up and down the track. This will transfer the lubricant to the needed area and make less of a mess. (NICE TO KNOW)

Tape foam core to the back of bead board to give it rigidity in a windy area. This will help prevent the bead board from breaking in half. (STANDARD PRACTICES)

Tape the feet of metal stands if they do not have factory plastic feet. (NICE TO KNOW)

Tape the gel to the face of the frame on a xenon (high-density lamp); try not to touch the glass with your hand, since this will leave oil from your fingers on the glass that heats up, causing the unit to burn out more quickly. (STANDARD PRACTICES)

Tennis balls make excellent safety tips on stands or any protruding object on which they will fit after being punctured. (NICE TO KNOW)

The grips will usually rig the condor (cherry-picker) with the mounts (candle stick or condor rail mount), and the electricians will rig the lights into the mounts. They work together to ensure safety. (NICE TO KNOW)

The proper angle of an extension ladder is 4 to 1 (i.e., for every 4 feet the length of the ladder is extended, its base should be moved 1 foot away from the wall.) Have someone "spot" you (hold the ladder). (STANDARD PRACTICES)

The spread of most folks' arms is pretty close to their height (measure your span and see). This means that you'll always have a tape . . . well, handy. (NICE TO KNOW)

The yellow or red lines 4 ft. from stage walls on stage or indicate the "no block zone." This zone must be left free and clear in case the stage fills with thick black smoke, preventing people from seeing where they are or how to get out. The 4 ft. "no block zone" allows people to make their way to any wall and feel their way to an emergency exit. (STANDARD PRACTICES)

To cut a gel, such as a neutral density (ND), for the inside of a lampshade that will be seen on camera, here's a trick that will help. Roll the shade on a flat piece of ND while marking the gel with a marker. The shape will fit pretty close with just a little trimming. (NICE TO KNOW)

Now just apply a little dab of ATG tape to the inside of the lampshade, and this will hold the gel in place. (NICE TO KNOW)

To get rid of unwanted glare from the glass of a picture frame, angle the picture on the wall by means of a ball of tape or a Styrofoam cup that is placed behind the picture to tilt it outward, downward, or sideways. It will look strange to your eyes, but the camera will record it as hanging flat. (STANDARD PRACTICES)

To get the feel for each dolly: turn the knob a few times to get the "feel" of the hydraulics of the dolly. Raise and lower the arm by lifting the beam up and down a few times. (STANDARD PRACTICES)

To give the light effect that cars or people are casting shadows on a subject, create a windmill that has a center-mounted pin. Now cut out 3 in. × 36 in. slots from a 4 ft. × 4 ft. piece of foam core, and then spin it slowly in front of a movie lamp. (NICE TO KNOW)

To lift up the front of a dolly to get up over a curb, put the back lifting bars in Fisher #10 (camera dolly), then stand on them. This will offset the weight enough to raise the front of the dolly. (NICE TO KNOW)

To make a fast rain hat for the camera and lights, use a gelled frame, which is usually available. Make sure you angle the rain hat so that the water runs to the rear and side. (NICE TO KNOW)

Never let the rain hit the glass of the lamps. When using a gel as a temporary rain hat, aim the gel side up and the frame side down; this way it will not fill with water and cause the gel to separate from the frame. (STANDARD PRACTICES)

To make a hard shadow, pull the fennel lens (the front glass) from a light. This is a trick used by electricians, and you can suggest it if they don't already know how to do it. (NICE TO KNOW)

To make a single or double reduce more light, wing (turn) the net's open ends away from its parallel position, laying it almost 45 degrees to 80 degrees from the light. (NICE TO KNOW)

To make safety reflectors for rope, put tape tabs hanging down about 8 to 10 in. long, double them over, and tape them to themselves. This is so a person does not trip or get caught by the neck. (NICE TO KNOW)

To measure approximately how much time is left before the sun sinks behind a mountain or building at sunset, extend your hand and arm toward the sun, place your lower fingers on top of the horizon or mountain range, then count the number of fingers between the horizon line and the bottom of the sun. The thickness of each finger represents about 10 to 15 minutes. It's just a ballpark guess, but this really works. Be sure to wear your shades! Also, do not do this if your eyes are sensitive. Remember: never look directly at the sun. (NICE TO KNOW)

To pan means to rotate the camera right or left. (NICE TO KNOW)

To prevent a tarp from blowing up and down or lifting (flexing in the wind), I always add additional ropes every 10 feet when the tarp or solid is dead hanging (vertical), or I use an X-shaped pattern of ropes across the top and the bottom when the solid (rag) is flown in a horizontal position. A 1/4 in. hemp rope is fine to use. (NICE TO KNOW)

To prevent unwanted steam from coming from the actor's mouth during a take, have the actor suck on some ice for a few moments. This helps prevent steam. (NICE TO KNOW)

To reduce a bright spot on a translight (e.g., a spotlight in the picture), cut a neutral density (ND) gel to the approximate shape and tape it on with cellophane or ATG tape tabs. Clean it up before you roll it up and send it back. You can also use Bobinett material. (NICE TO KNOW)

To reduce unwanted light from a fluorescent light tube, you can tape 1 in. to 2 in. of black photo tape right on the tube. This will act as a flag as well. (NICE TO KNOW)

Use a #1 grip on your tool belt to hold your gloves. (NICE TO KNOW)

Use a can of Dust-Off (held upside down) to blow away chalk lines. (NICE TO KNOW)

Use a gobo arm to stop gel from blowing. Press the gobo arm lightly against the center of the gel, putting enough pressure to stop the gel from flexing in the wind and creating unwanted sound problems. (NICE TO KNOW)

Use a metal scrim to draw a circle on foam core or a show card. (NICE TO KNOW)

Use a rubber-coated lead in a swimming pool. It can be rented from the Fisher Dolly Company or a crane company. (NICE TO KNOW)

Use aluminum foil or black wrap (black foil) as a heat stopper. A sheet may be laid on top of a light to act as a heat shield to prevent blistering paint or cracking windows (if it is used behind a light). (NICE TO KNOW

Use florists' frogs (bases for flower arranging) on foam core and a show card. They look like 20 #4 nails standing tips up in a lead base. We use a range of sizes, from 1 in. to 4 in. They are round, square, or rectangular, but it does not matter what the base shape is, as long as they fit into the area needed. (NICE TO KNOW)

Use low-tack blue tape. It sticks great and is easy to remove without pulling the paint off. It comes in several widths. Most paint stores have it. It is sometimes called seven-day tape, because its adhesive will not leave any gummy residue. When it is peeled off after sticking to a surface for a week, there is nothing left behind. (NICE TO KNOW)

Use ND gel inside a lampshade or wall sconce glass to reduce light if no dimmer can be used. (NICE TO KNOW)

Use photo mount spray to attach gels to windows. This is a great way to make a gel stay in place when gelling in a high-rise building. (NICE TO KNOW)

Use Photo Mount™ spray to attach gels to windows. This is a great way to make a gel stay in place when gelling in a high-rise building.

Use sunglasses if no contrast filter is around to check for cloud. Hold them at arm's length and look at the reflection only of the sky and the clouds in the shaded glass. Never look directly at the sun! (NICE TO KNOW)

Use whatever is available to get the shot. I once needed a long dolly shot in front of a peru (a small swamp boat) in the Louisiana swamps. The actor would be standing in his small craft and using a long rod to push himself off the swamp floor. It was supposed to be a slow-paced movement. The director wanted a long, slow move down the center of the bayou. A boat would rock, creating unwanted camera action; instead, I used two floating platforms that were square and flat-bottomed. I placed the camera, the cameraperson, and the camera assistant on the camera platform, which was tied to the front platform where the excess camera gear and two grips were. A 600 ft. rope was tied to a tree down the bayou. I pulled the rope, setting the pace asked for by the cameraperson. I am not telling you this to show how clever I am, but rather to illustrate that filmmaking is never a perfect world. (NICE TO KNOW)

Use p-tons (little spikes with rings or holes on them) in cracks in asphalt for tie-offs. (NICE TO KNOW)

When bringing equipment into a house, building, trailer, or other structures, most doors open toward the visible hinge (unless it's a double swing hinge), so allow for reduced clearance unless the door opens a full 180 degrees. (NICE TO KNOW)

When called for, the grips sometimes call a flag a solid instead of a flag, but it means the same thing. (NICE TO KNOW)

When carrying a combo stand with a reflector on it, use a sandbag as a shoulder pad. This way you have your bag right there once you have set your stand. (NICE TO KNOW)

When cutting a piece of wood with a skill or circular saw, raise the blade so that only the tips of the blade will protrude through the wood while cutting. This will help prevent the blade from binding in the wood. (NICE TO KNOW)

When deciding the difference between a bleached and unbleached muslin by eye, the bleached will appear very white, like a sheet, and the unbleached will appear almost like the color of light beige. The Kelvin difference is about 800 degrees, I am told. (NICE TO KNOW)

When drilling aluminum, drill at a higher speed. Ensure that your drill bit is perpendicular to the surface. This position is called normal to the surface (90 degrees or a right angle). (NICE TO KNOW)

When flying a rag in a frame or just hanging it, face the ribbon (the color canvas edge that supports the grommets) of the single, double, or silk away from the camera. (NICE TO KNOW)

When hanging a backing or translight on a stage, you may not have any place to tie off the grommets from the sides. Here's a trick that works. Drop a rope from the perms about 3 ft. from each side

of the backing or translight, and then nail the rope to the floor. Make the rope as tight as possible. Now tie off the backing sides from the grommets to the rope. (NICE TO KNOW)

When pushing the dolly, watch the actor with your peripheral vision. Look at your stop marks and watch the camera operator for any signals, such as a hand gesture to go up or down or in or out. (NICE TO KNOW)

When there is a need for safety, a grip or anyone can yell, "Cut!" (NICE TO KNOW)

When using 12 ft. × 12 ft. or 6 ft. × 6 ft. silk, place it with the seam up; otherwise the seam's shadow may show on the actors or product. (NICE TO KNOW)

When you are working on a set, I suggest that you wear dark clothing to avoid reflection problems. (NICE TO KNOW)

When you break down a setup, always realign the knuckles on the stand, preparing them to be ready to go back into action. (STANDARD PRACTICES)

When you measure doors to determine whether they are wide enough to pass equipment through, be sure to watch out for the hinged side of the door, which makes the doorway smaller than it at first appears. For example, Bank of America's 70 in. double-wide door may actually be only 54 in. when it is open. Always measure a door in the position it will be in when you are going through it. (NICE TO KNOW)

When you push the dolly, always put down a tape mark every time you park the dolly. A lot of times the DP will say, "Hey Mike, go to that last mark." I will usually have three or four different color tapes pre-torn with tabs ready for such an occasion. (NICE TO KNOW)

When you see a light being carried to a set, you should anticipate that it would need a flag. Get a flag just the size of the unit or larger, plus a C-stand and a sandbag. It is better to have it close and look like you're doing your job than to be told, "Run and get me a flag." (Remember, always bring a C-stand and bag as well.) (NICE TO KNOW)

When you see a safety problem, always point it out to your boss. (NICE TO KNOW)

When you skin an empty frame (install gel or filters), please clean up your mess after you (and anyone else) have finished. We don't want to get the blame for any gel scraps or a messy work area. (NICE TO KNOW)

When you use sailboats (weighted base with a telegraphic tube with a pulley and rope attached to the upper end) for backings (and sometime translights), you should use a rope to tie the center off high in the perms to keep it from sagging. (NICE TO KNOW)

Wooden clothespins are sometimes called bullets or C-47s. (NICE TO KNOW)

Wrap all rope and cable in a clockwise direction. This way the next technician will wrap it in the same direction, preventing tangles. Wrap rope in a 2 ft. loop and cable in a 14 in. to 16 in. loop – about the size of a basketball hoop. (NICE TO KNOW)

Your attitude is of major importance in this business. I have hired one person over another even if the person I hired was a little less qualified. Why? Attitude! I need, and the film industry needs, people who can work hard and sometimes long hours, under really tough conditions. I am not saying you have to be a saint, but if you don't like it when it gets tough, let somebody else do it for you – and they will reap the rewards for their hard labor. (NICE TO KNOW)

Glossary

Here are some terms or words that you might hear daily in the course of your work in the film and television business. A few of these words may be exclusive to the grip department, but for the sake of understanding the overall flavor of a working set, you should be aware of some general words that are used almost daily. Here is an example: You are a grip who was asked to work the sticks for the camera department. The AD yells, "Tail slate!" or you may hear "Grab a Gary Coleman, with a postage stamp, and put an ear on the third zip light" or "Lamp right next to the egg crate, then drop some beach on that hog trough before they pull the buck." "Say what?" you ask. This glossary will help you decipher such terminology.

180° RULE When two people are filmed in a sequence, there is an invisible line between them and the camera. Crossing the line can make it appear that the two people suddenly switched places.

3200 K The color temperature of tungsten.

ABBY SINGER The shot before the last shot. (Named after a real first assistant) director

AGE This technique is used to make a new object, such as a mailbox, look older and to create a used look for things such as old clothes or a sign.

ALAN SMITHEE Name used when a director wants to disassociate themselves with a film. They may use this common pseudonym.

AMBIANCE Sound recorded in the area where the filming was done. This "quiet" sound is added to set the mood of a scene.

ART DIRECTOR The art director designs and constructs a motion picture set.

ASPECT RATIO The frame proportions. In 35 mm, 1.33 is known as the Academy Aperture.

ASSISTANT CAMERA Also called the first AC. ACs work closely with the camera operator, pulling focus and changing lenses. There is sometimes a second AC. The seconds will operate the slate and load the magazines as well as a host of other duties.

ASSISTANT DIRECTOR The assistant to the director. Also called the first AD. ADs run the set through the scheduling of actors and the shooting days. If there is a second AD, she will sign the actors in and out.

ASSOCIATE PRODUCER An assistant to the producer. Will sometimes be the intermediary between the producers at the film crew.

AVAILABLE LIGHT Natural Light that is available for filming.

BABY 1,000-watt lamp.

BACKING A scenic piece behind a set window or open door; also called a drop. A photographed or painted canvas background used on movie or video sets seen outside windows or doors.

BACK TO ONE Go to your start position.

BAIL The U-shaped metal arm that a movie lamp sits on. The bottom of the "U" has either a male pin or female receiver for attachment to a stand or hanger device.

BARNDOORS Adjustable metal doors or flaps on the sides of lights that can be used to keep light from going everywhere.

BARNEY A blanket/box or container that is placed over a camera to reduce the noise be emitting while filming.

BASE CAMP The place where all the production vehicles are located – sort of like a mobile headquarters.

BASTARD SIDE A term used for stage right.

BATTENS Two pieces of wood (1 × 3 in. or 2 × 4 in.) attached to the top of a cloth drop or backing in a sandwich configuration to hold it up.

BEACH Slang for a sandbag.

BEAVER BOARD Usually an eighth apple box with a baby plate nailed onto it used for placing a lamp at low angles; also called a skid plate.

BECKY A fixed-length mount bracket much like a trombone. The wall attachment has feet that are the only things that adjust. The receiver is a fixed height (about a foot down using the bottom pin).

BELLY LINES Ropes strung (usually about 10 ft. apart) under a large silk, grifflon, or black.

BEST BOY Also called the second. Acts as a foreman, usually for a key grip or the gaffer on a film. There is a best boy (or girl) for the grip department as well as the lighting department.

BLACKS Drapes used to hide or mask areas not to be shown on film or stage.

BLOCK AND FALL A rope-and-pulley system that allows a heavy object to be lifted with less pulling force.

BLOCKING A rehearsal for actors and camera movement.

BOOGIE WHEELS Wheels that do not usually come standard with a dolly. They are used to adapt a dolly to a specialty track, such as a pipe dolly, sled dolly, or tube track. Several types or sets of boogie wheels are available.

BOOTIES Surgical-style paper shoes worn over street shoes when walking on a dry painted surface to prevent mars or scuffs.

BOSS PLATE A metal plate attached to the stage floor of a set to hold a set wall or scenery in place.

BOTTOMER Flag off or block unwanted light from the bottom of a light source; also called a bottom shelf.

BOUNCE Light that has been redirected first. It is directed onto foam core, a show card, or any other surface and redirected (bounced) onto the subject. (See fill light.)

BRACKETING Several different camera F-stops are used for different effects.

BRANCH-A-LORIS A limb or branch from a tree placed in front of a light to create a pattern.

BROWNIE Nickname for the camera.

BRUTE A carbon arc lamp that runs on 225 amps.

B-TEAM The stand-ins used for blocking and lighting a scene.

BUCK Usually refers to a car that has been cut in half or the roof cut off for filming the inside of the vehicle, such as showing a center console or dashboard.

BULL PEN Slang word used for the area where all the grip equipment is staged (set up); also called staging area. It is usually located as close as possible to the set.

BUTTERFLY KIT Assorted nets, silks, solids, and grifflons used for light control; generally, they are mounted on 5 × 5 ft. or 6 × 6 ft. frames. Frames 12 × 12 ft. or 20 × 20 ft. are also commonly called butterfly kits, although they more accurately are described as overhead kits. The term butterfly now generally means a kit containing one each of a single, double, silk, solid, frame, and grifflon.

CAMERA LEFT A direction to the left of what the camera sees.

CAMERA OPERATOR The person doing the physical shooting of a camera. It may or may not be the director of photography, depending on the budget.

CAMERA RIGHT A direction to the right of what the camera sees.

CANS Headsets used to hear what is being recorded for the film.

CASTING DIRECTOR The person who works with the director and the producer, who helps obtain actors for the film project.

CEILING PIECE A frame built from flat 1 × 3 in. lumber with luan gussets covered on one side with muslin cloth (usually seamless).

CELO A cucoloris made of wire mesh material used to create a pattern of bright and dark spots when placed in front of a light.

CGI Computer-generated imagery is the application of the field of computer graphics or, more specifically, 3D computer graphics to special effects in film, TV, commercials, simulation generally, and printed media.

CHANGING BAG A double-chambered black bag with a zipper on one end and two elasticized arm holes on the other side, used for loading film into magazines.

CHARLIE BAR A strip of wood, 1 to 6 in. wide × 3 ft. long, with a pin attached that is used to create shadows on an object (long, thin flags; gobos).

CHEATING Avoiding an object for a better shot – moving it from the camera's view.

CHECKING THE GATE Inspecting the camera pressure plate, which holds the film in place, for any film chips, dirt, or debris. This task is conducted after each scene.

CHERRY-PICKER See condor.

CHROMATRAN Looks like a giant photographic slide that is lit from the back. Chromatrans come in all sizes, from small to 30 × 100 ft. or larger. They are usually pictures of city landscapes, but they can be countrysides, airports, whatever. There are daytime and nighttime chromatrans/translights. They are usually transported rolled up in a large cardboard tube and hung from grommets.

CLAPBOARD Also known as a slate or the "sticks." The clapper. An information board showing some information identifying a shot. It is filmed at the beginning of a take. If at the end, it is held upside down denoting such.

CLAPPER/LOADER Another name for a camera assistant.

CLEAR LUMBER Lumber without knots in it; it is normally used for dolly track.

CLEAT A point at which to tie off a rope; usually an X-shaped or cross-shaped piece of wood nailed to a stage floor.

CLOTHESLINE When a rope or cable is strung about neck height (like the old clothesline days). If a clothesline is needed, always hang some tape from it to mark it visually so no one gets hurt.

COLOR TEMPERATURE The warmth or coolness of a light is measured in degrees Kelvin. Daylight is considered 5600 K (blue), and 3200 K is a tungsten (or white) light.

COME-A-LONG A hand-cranked cable that can pull heavy objects closer together, like a wrenching block and fall.

CONDOR Machines with a telescoping arm, which will also boom up, down, left, or right; also called a cherry-picker. Used frequently for lighting platforms.

CONTINUITY DEPARTMENT Also known as the script person.

CORRECTION MOVE Movement of the camera to unblock or get a better angle on a shot.

COUNTERMOVE As the actor is walking in one direction, the camera will move in the opposite direction.

COURTESY FLAG A flag set for the director, director of photography, talent, agency, or anyone who needs shading.

COVE When you tent a window or doorway to make it night during the day.

CRAFT SERVICES A table of food set out for the entire film cast and crew.

CROSSING A term yelled out by anyone who crosses in front of a lens when there is not any filming going on but the cameraperson is looking through the eyepiece; it is considered a courtesy to the cameraperson.

CUE CARDS Large words sometimes written on a 3 × 3 ft. piece of cardboard so that the actor can be helped with their lines.

CUT Refers to setting a flag in front of a light to cut or remove the light from an object. There are two types: (1) a hard or sharp cut, which produces a hard shadow close to the object; and (2) a soft cut, where the flag or scrim is held closer to the light source.

CYC-STRIPS One or several lamps placed in one housing fixture.

DAILIES Film shot the previous day which is shown to the director, cameraperson, and crew so they can review that day's work to ensure that no reshoots are necessary. Sometimes called rushes.

DAPPLE Shadow effect made with a branch with leaves on it.

DAY-PLAYER A crew member who is called to work daily. Told day by day if he or she is needed the next day.

DEAL MEMO A written paper describing the compensation you have agreed to for your service.

DECK POLES Pointed sticks about 4.5 ft. long that are stuck in the holes along green beds (chain-hung working platforms from the rafters, aka perms) and to which arms and flags are attached.

DEPTH OF FIELD An additional area in focus. Depth of field increases as the iris is closed. There is more depth of field the wider the lens.

DIFFUSION A white sheet of material used on light to soften the shadows. Examples: 1000 H paper, 250, 251, 216, just to name a few.

DINGO A small branch-a-loris.

DIOPTER Part of the view-finding system that can be adjusted to compensate for your particular eyesight.

DIRECTOR The person in charge of the dialogue and the action that takes place being filmed. Brings the written word to life on film.

DIRTY SHOT When shooting a shot that the audience can see a piece of the actor that is not talking.

DIT A digitographer, or digital imaging technician, works in collaboration with a cinematographer on work flow, systemization, signal integrity, and image manipulation, to achieve the highest image quality and creative goals of cinematography in the digital realm.

DOLLY GRIP The person who operates the dolly during the filming of the scene. Works closely with the camera operator and the first assistant camera.

DOWN STAGE Closer to the camera or audience.

DP Director of photography. Controls the look of the film. Works with the gaffer by citing what lights to be placed where. They are sometimes called the cinematographer.

DUTCH ANGLE/ANGLE To lean the camera sideways, either left or right, to film in that position.

EAR A flag mounted on the side of a light to block light; also called a sider.

EARS ON Turn on your hand-held walkie-talkie.

EASY-OUT Tool that looks like a reverse drill and is used to get out broken bolts. After drilling with a small bit, put the easy-out in the hole and twist out.

EDITOR Splices together the film, adding selected music and sounds as needed.

EGG CRATE A soft light control frame that directs light without allowing it to spill off the subject. Looks sort of like a rectangle box with several dividers spaced evenly in it.

ELECTRICIAN A crewmember assigned to the electrical department.

EMULSION A thin layer of silver attached to the film base which, when exposed, creates the film image.

ESTABLISHING SHOT The opening shot of a new scene. This tells the viewers where everything is about to take place and introduces the audience to the space in which the forthcoming scene will take place.

EXECUTIVE PRODUCER The person who arranges for financing of a film project.

EYE LIGHT The eyes are given a sparkle light; also called an obie light.

EYELINE MATCH To ensure that characters look like they are looking correctly at an object by cutting between two shots.

E-Z-UP A pop-up-style tent that is usually 8 × 8 ft. or 10 × 10 ft., though both larger and smaller sizes are available.

FEATHER Effect achieved by setting a flag in front of a light source; moving the flag closer to or farther away from the source will feather, soften, or harden the shadow on the surface of an object.

FILL LIGHT Light added to the opposite side of a subject to fill in the shadows made from the key light.

FILM NOIR Literally "dark or black film"; it describes a film that features dark, brooding characters. Also corruption, detectives, and the dirty side of the city.

FIRST TEAM The talent, the actors that will be filmed, the A-team.

FLARE When a light shines into the camera lens, it will flare or cause a glare on the film.

FLASHING Term called out before someone takes a flash photo; this lets the gaffer know that one of his lights has not burned out.

FLOAT A FLAG To handhold a flag as the camera is moved, to float with the camera and block unwanted light flares. A floater is a handheld flag or net that moves with an actor during a take.

FLOOD Spreads light to the overall subject.

FLOPPY A 4 × 4 ft. floppy-type flag made of a white-out bounce material; excellent for bounce/fill.

FLYING IN The object asked for is being fetched in an extremely quick manner.

FLYING THE MOON A bunch of lights hung on pipes shaped into a box frame. A muslin (rag) cover is wrapped around the frame, and it is flown over an exterior location by a cable on a crane.

FLY IT OUT Pull it out of the scene.

FOLEY ARTIST The sound effects artist who works on a special soundstage, where sound effects are recorded. These effects should match action in the film, such as a car crash, a window being smashed, or any other sound effect needed.

FOURTH WALL An imaginary line or plane that separates the action of the movie from the audience.

FRAME LINE The edges (top or bottom or sides) of what the camera will pick up.

FREEBIE A film project for which the crew usually receives no pay. (It is a way to give something back to the industry for being so good to you.)

FRENCH FLAG A black metal or plastic flag attached to the camera used to shade the lens.

FRESNEL The glass lens in front of a movie lamp used to spread or focus the light.

F-STOP A measurement of the lens aperture. Lenses are rated by speed (how much light they can gather); a lens that can film with a minimum of F/1.4 is considered faster than a lens that films with a minimum of F/8; for example, F/1.4 requires less light for a correct exposure, and F/8 requires more light for a correct exposure.

FULLER'S EARTH Used to make blowing dust in the background or to dust down or age a person or object.

GAFFER Head electrician.

GAFFER TAPE Adhesive tape similar to duct tape; also called grip tape or cloth tape.

GANG BOX An electrical box with four to six outlets. Also called a lunch pail.

GARY COLEMAN A short C-stand, about 20 in. tall.

GATE The opening in a camera behind the lens. This is where a single frame of film is exposed.

GATOR A 4-wheel drive vehicle that production uses while working in sandy areas such as a beach or rough terrain. Also called a John Deere or mule.

GEL Transparent cellophane material used for changing the color of a light, either for visual effect or for film exposure correction.

GHOST LIGHT A single large light bulb mounted on its own wooden stand. Usually left on a stage that is not being used because it is believed to keep friendly spirits illuminated and evil spirits away and because it helps people see the set objects lying on an unlit stage.

GOBO HEAD A clamping device for holding equipment; also called a grip head or C-stand head.

GRAZE Go to the craft services food table.

GREEK IT OUT To disguise a word to make a logo unrecognizable. For example, Coke might become Ooko AA Cola.

GREENBEDS Platforms hung from chains from the rafters called perms.

GRIP The worker who is responsible for moving equipment, assisting the lighting department, and in general helps the entire production team. Sort of an expert handyman on set. Commonly referred to as "intelligent muscle" (quoted to Mike Uva by cameraman David Shore). (PS: Loved that man.)

GRIP HEAD A C-stand head used as a clamping device; also called a gobo head.

GRIP RADIO TALK "10–100" means you are going to the restroom; "10–4" means you understand; "What's your 20?" is asking where are you?

GRIP TAPE Adhesive tape similar to duct tape; also called gaffer tape or cloth tape.

GRIPTRICTION When a member of a film crew works as a grip and an electrician at the same time. This is usually nonunion.

HAIR IN THE GATE When a piece of debris or film chip is lodged in the corner of the pressure plate gate. In case that chip or bit of debris may have scratched the film emulsion, the last shot is reshot (sort of like insurance).

HAND SHOES Leather gloves.

HARDMARKS Permanent objects or tape marks placed by the camera assistant.

HEADACHE Duck! Something has fallen from overhead.

HEMP Rope, usually 1/4 to 1 in.

HERO The product featured in a commercial, such as a perfectly prepared hamburger, a toy, or a color-corrected label. Whatever it is, it is perfect (hero) for the shot for filming a commercial.

HIGHLIGHT Used to brighten an area of an object or to emphasize an interesting part with light.

HI HAT A support mount used for filming with the camera very low to the ground.

HISTORY Something that has been removed from the set or lost; it is only a memory, gone, a vapor.

HMI Halogen Metal Incandescence. A light balanced for day light. (H, mercury; M, metals; I, halogen components). Metal halide lamp that usually burns at 5600 K (also known as blue light).

HODS A bead board, three-side light bounce, usually made from polystyrene (bead board). About 18 in. long × 12 in. wide, with a 12 × 12 in. cap on one end.

HOG TROUGH An L- or V-shaped brace made with two sticks of 1 × 3 in. lumber; used when nails, screws, or glue must be applied. The brace makes an otherwise flimsy piece of 1 × 3 in. board stronger by giving it a backbone.

HOLLYWOOD IT hand holding a reflector, flag, or whatever that may move with the shoot.

HOT SET Don't move anything, because more filming is to be done.

IDIOT CHECK Before leaving a location, sending a grip out to search for any equipment that may have been left behind on a set after a shoot was finished.

INCANDESCENT LAMP A lamp with a 3200 K temperature (also called white light).

INSERT SHOT A close-up of a detail in the scene.

INTERVALOMETER A device that attaches to the camera for filming single exposures.

IRIS A mechanism in a lens to control the amount of light striking the film.

JUICER Electrician, sparks.

JUNIOR A 2,000-watt lamp.

KEY LIGHT The main light on the subject, as opposed to highlighting that only lights a particular area of a subject.

KICK A sparkle off an object or person that may be desirable or may require removal.

KILL THE BABY Turn off the 1-kilowatt lamp.

KNEE CAPS Heads up! Equipment coming through.

KODAK MOMENT A chance to take a picture with the talent (actors and actresses). Same as a photo op.

LACE-OUT Laying out of equipment so it can be easily counted, such as during a prep or wrap day on a stage or when returning from a shoot.

LANYARD Cord attached to a tool so it cannot be dropped when it is being used high in overhead perm.

LAST LOOKS Called out by the first assistant director for the crew members to do the finishing touches on the actors.

LAY-OUT BOARD An inexpensive cardboard that comes in 4 × 8 ft. in size, used to lay on the floor or protect walls from dings and scratches.

LEAK A small amount of light that has gotten past the flag or gobo.

LEGAL MILK CRATE Not stolen from a store; a crate that has been rented or bought.

LENSER A shade for the lens, such as a flag or a shade attached to the camera (called an eyebrow).

LEXAN Plastic material that comes in 4 × 8 ft. sheets in many different thicknesses (e.g., 1/8 in., 1/4 in., 1/2 in., 1 in.); used to protect cameras and personnel from explosions. It is optically clear and highly recommended.

LIMBO TABLE A table that has a 90-degree sweep; usually used for product shots. The back part stands straight up and then curves 90 degrees to form a table, on which the product is placed.

LINE OUT! Called out from overhead when a rope or line is let out.

LINE PRODUCER The person who is in control of the film's cost. Approves expenditures for items such as the crew, the locations, and the actors.

LOCATION MANAGER The person who negotiates an agreement with the owners of a piece of property. These managers will also ensure that there is parking as close to the location as possible. They work with the city officials to schedule shooting. They are also responsible for ensuring that the locations are not damaged during filming.

LOCATION SCOUT The heads of each department will travel before the shooting days to each location to ensure the logistics and artistic considerations.

LOCATION SOUND The sync sound tone that was recorded at the shoot.

LOCKED-DOWN SHOT A camera is immobilized while filming. Usually used for effect shots.

LONG LENS A focal length greater than 25 mm in 16 mm, or 50 mm in 35 mm.

LOSE IT Remove something from the set or from the surrounding area; it is no longer needed.

LUAN Plywood-like material, usually about 1/8 in. thick, which is used to make set walls; can be a three-ply timber, which is still lightweight, paintable, and stainable. It is sometimes referred to as Philippine mahogany.

MAKE IT LIVE Set the object in place.

MARTINI SHOT Last film shot of the day. Slang for the next shot is "in a glass" (the wrap shot).

MATTE BOX A shade that goes around the lens. The matte box often has filter holders for square glass filters.

MICHAEL JACKSON Taken from his song "Beat It"; means get out of the way.

MICKEY MOLE A 1,000-watt lamp.

MICKEY ROONEY Nickname for a slight creep of the dolly; a small, slow movement.

MIGHTY MOLE A 2,000-watt lamp.

MIXER The head of the sound department. Will ensure the recording of the sound either in a stage or on location and sometimes in postproduction.

MOLELIPSO A 1,000- to 2,000-watt lamp mainly used for performances; the spotlight.

MONTAGE A sequence of shots strung together to quickly convey information.

MOS A film that is shot without sound, which is added later. One legend is that "Mit Out Sound" is a story about a German director asking for a shot to be filmed without sound by saying "mit out sound."

MOUSE The shadow of a microphone.

MULE A 4-wheel drive vehicle that production uses while working in sandy areas such as a beach or rough terrain. Also called a John Deere or Gator.

MULLIONS Strips of wood that hold panes of glass in a window; provide a French window effect.

ND (NEUTRAL DENSITY) FILTER A soft, rolled gel; also comes in large plastic sheets as well as small glass rings for the camera. It is used to reduce the brightness of a lamp or light source (sort of like sunglasses).

NECK DOWN Slang term for being hired from the neck down (don't think, just do).

NEGATIVE FILL A black surface used to remove unwanted light close to the actor.

NET The use of scrims (nonelectrical dimmers) to reduce the light shining on an object in small amounts.

NEW DEAL Staring on a new setup when a scene is finished.

NG No good.

NODAL POINT The dead center of the camera lens if the camera was to rotate in a 360-degree twisting motion.

NOOK LIGHT A 650- to 2,000-watt light, on average.

OBIE LIGHT A small light placed just on top of the camera to add a sparkle to the talent's eyes or used as a fill light.

OFF BOOK This is an actor who has totally memorized their lines. Does not need the script.

ONE 'ER When only one film take is filmed and there are no follow-up shots or second takes. Then the director says "let's move onto the next shot."

ONE-LINER A breakdown of the script that tells the crew what scenes will be shot that day; it provides scene numbers and a bit of the story line or actions that will occur.

ONSTAGE Move toward the center of the set or stage.

OPERATOR Camera operator; can also be the director of photography (DP), but usually these are two different people in film production.

OVERCRANKING Speeds up the frame rate of film through the camera; when the film is processed and projected at normal speed (24 frames per second [fps]), the action appears in slow motion.

OVERHEAD KIT Usually a 12 × 12 ft. or 20 × 20 ft. set of one each of a single, double, silk, solid, frame, and grifflon. Commonly referred to as a butterfly kit, although the term overhead kit is more descriptive.

OZONES Open areas between the wood beams that make up the perms. This is the area that we throw ropes over to rig lights or green beds or to set wall tie-offs.

PAN Rotate the camera left or right.

PARABOLIC REFLECTOR The part of the lamp behind the glove (light bulb) used to gather and reflect the light onto a subject.

PHOTO FLOOD GLOBES Normal-looking light bulbs that give off a brighter light (but have a short useful life).

PHOTO OP A chance to have your picture taken with someone you would like to be seen with, such as an actor or actress.

PICK-UPS Additional photography needed to finish a movie or video.

PICTURE CAR The actual car being filmed.

PIPE GRID A series of pipes, most often connected together for rigidity, that are usually hung by chains above a movie set.

PIPELINE A movie project in production.

PLAYBACK Video recording of a scene just shot.

POOR MAN'S PROCESS Can mean filming a stationary vehicle by passing a light, shadow, or background object by it, giving the impression that the vehicle is in motion; other techniques that work well include slightly shaking the vehicle or moving a lever under the frame of the car to give it a small jolt every so often.

POV Point of view. What a person sees.

PRACTICAL A fixture (light) in frame such as a table, floor, or wall lamp.

PREP To prepare for a job – for example, to check out the equipment or camera to ensure that they are in good working order for the job that is about to begin.

PRESSURE PLATE The metal plate that holds the film in place as it is run through the camera to be exposed.

PRIME LENS A lens is one with a single focal length. A prime lens is usually sharper.

PRINCIPAL The lead actor or actress.

PRODUCER The person who brings a production together. He or she may arrange for financing, hire a director, and help with the casting of actors. The producer is directly responsible for the operation of the shooting on a day-to-day basis.

PRODUCT PLACEMENT A product such as the main brand of beer or soda pop is prominently placed in the frame so that the audience will read the names easily.

PRODUCTION ASSISTANT Usually referred to as the PA. The PA provides all-around assistance for every department, not just the production department. On a personal note, the PA helps a production run more smoothly.

PRODUCTION CORDINATOR The person who oversees the hiring of crew, or equipment, or even securing location hotels.

PRODUCTION DESIGNER The person responsible for getting the proper props, costumes, and decorations and helps determine the look of the movie.

PRODUCTION MANAGER The dealmaker who will set up housing for the crew, make a deal with the rental company, and manage the budget. Usually referred to as the PM.

PRODUCTION OFFICE The main office on most productions that ensures that the crew gets paid, and that the locations are secured and paid for. Anything that has to do with the making of a movie or video is run through this office.

PRODUCTION REPORT A daily report turned into the executive producers so that they know what went on, on the set, on a day-by-day basis.

PRODUCTION SOUND A sync sound is wild track or room tone that was recorded at the shoot.

PROPERTY MASTER The head prop person. Responsible for all props used on a set.

PROSTHETIC MAKEUP The process of transforming an otherwise normal person into a monster, or a legless or armless character in a movie through the use of prosthetics, such as latex rubber or foam.

P-TON A sharp, flat peg with a ring welded to it for tying off a rope. It can be hammered into small cracks in cement or asphalt without inflicting much damage.

PULL BACK This shot is when the camera physically moves away or zooms out.

PUSH IN This shot is when the camera moves towards or zooms on an object. Opposite of a pull back.

PYROTECHNICIAN The person in charge of all explosives on a set.

QUARTZ LIGHT A halogen light or tungsten light. The color temperature is usually 3200 K.

RAGS Any of the following are referred to as rags because they do not usually have a permanent frame affixed to them: muslin (bleached or unbleached), nets (single or double), silk, solid, or grifflon.

REEFING A way to properly fold a large rag (i.e., grifflon, black, or any material that requires folding).

REVERSE SHOT The shot from the reverse side of the previous shot. A reaction shot.

RIGGERS Technicians who will install pipes, lighting, set a set wall to be filmed on later.

ROOM TONE Recording of the silence of a room.

ROPE WRENCH A knife for cutting rope.

ROUNDIE-ROUND Another word for a reverse shot.

SAG Screen Actors Guild. A union for actors.

SAILBOATS Used to hoist or fly a backing or translight, making it mobile.

SCAB PATCH Two 2 in. × 4 in. × 16 ft. pieces of lumber, for example, are laid end to end to total 32 ft. long, and a third equal-length piece of lumber is laid equally on the split line where the two 2 × 4s touch together. Also, a patch laid over a hole, like a bandage. Both examples are called scabbing. A sandwich is the same as a scab patch, except that it is nailed onto two sides with two pieces of scab lumber.

SCENE DOCK A storage place for several wall flats. You can also temporarily store a removed wall on a set next to a working wall with hog troughs or set braces.

SCENIC ARTIST An artist who could paint a wall or canvas and make it look like a jungle or a freeway in the background.

SCOUT Go to different places or locations to check out an area.

SCRIMS Set material or wire mesh that is put right in front of a light.

SCRIPT SUPERVISOR The person that must watch each and every scene, checking the timing, how long each shot took, and who was in the shot, while taking detailed notes about what took place during the action of each and every actor being filmed.

SEAMLESS PAPER A wide roll of paper used for a background, such as that used in a portrait shot.

SECOND STICKS The slate is smacked again to mark it a second time because the first time was not recorded.

SECOND UNIT The second unit is an entirely separate film shooting unit that is usually smaller than the first film unit, which is normally called the principal shooting unit. The second unit will film additional shots needed for the project being filmed.

SET CONSCIOUSNESS Be aware of what is where on the set. (This will make or break you. If you are not aware of where your equipment is when it is called for, you can look pretty bad.)

SET DECORATOR The person who actually decorates a set with appropriate objects for the story-line. This will make a scene look real to the viewing audience.

SET DESIGNER Works closely with the production designer to achieve their vision of what a set should look like for a particular movie or scene.

SHARPIE A felt-tipped marker.

SHEAVE The wheel in a pulley on which the rope or wire rides.

SHOOTING SCRIPT A script used for the real filming.

SHOT LIST A list of particular shots needed for the day's filming.

SHUTTER SPEED A measurement of time that allows light to hit a single frame of film.

SIDER A flag mounted on the side of a light to block light; also called an ear.

SKID PLATE Usually, an eighth apple box with a baby plate on it that is used for setting lamps at low angles; also called a beaver board.

SLATE Also known as sticks. A board; either plastic or electronic, held in front of the cameras while they are rolling at the beginning or the end of each scene. Written on the board are the scene number, take number, the director's name, the picture's name, and the director of photography's name. The slate will also have the date and whether it is interior or exterior, day or night.

SLEEPER TRACK Framing track made from 4 × 8 ft. frames constructed from straight (not warped), kiln-dried lumber; used under the dolly or crane track to reinforce the foundation of the track for the dolly.

SLOW IT DOWN (Take it down, knock it down.) Reduce something; usually refers to bringing down the intensity of a light.

SNOOT A device shaped like a funnel or coffee can hooked on the front of a lamp.

SOC Society of Operating Cameramen. An honorary organization composed of women and men camera operators.

SOFFIT The outcropping of a set wall or header where a movie light can be set.

SOFT A gentle, pleasing light.

SOFT LIGHT Ranges from 650 to 4,000 watts, on average; also known as a zip light.

SOLDIER-UP Set up more stands in rows, ready for action.

SOUND STAGE A large building that is usually soundproofed with no windows for the making of movies. This building allows for security, controlling of the light, and controlling the outside elements of weather.

SPAN SET A loop of extremely strong material wrapped around a frame or beam that is hoisted up by a winch or crane; comes in 1 ft. to 20 ft. loops but can be larger upon request.

SPARK Electrician, juicer.

SPEC SCRIPT A script sent out to studios for consideration. No commission is paid at this point!

SPEED The cameraperson and soundperson may call this out when they have their equipment running at the desired speed or operating revolutions per minute (rpm) for filming.

SPILL Directing a light or natural sunlight onto an object and allowing the light to spill or leak off that object onto something else.

SPOT To direct all light to one point on the subject.

SPOT METER A meter for taking a reflective light reading.

SPREADER A three-leg attachment that attaches to the bottom of a tripod to keep the legs from collapsing (spreading) outward.

SQUEEZER An electrical dimmer.

SQUIB A small explosive device (which can be activated accidentally by pressing the talk button on your walkie-talkie); used by special effects crews to make bullet holes or cause other damage during a scene.

STAND-INs A person or persons used for lighting, as well as blocking (rehearsing) the scene to be filmed. Stand-ins are also known as the "B" team. The "A" team are the actors themselves.

STATIC SHOT No movement of the camera other than just rolling film.

STEVEDORE A hand truck.

STINGER A nickname for an extension cord.

STORYBOARDS Cartoon-like drawings of the sequence of a shoot that indicate the required camera angles or framing.

STRONG BACK A horizontal L-shaped 1 × 3 used on the back of a set wall for reinforcement.

STUDIO ZONE An area usually 25 to 30 miles away in a circular direction that is considered a reasonable driving range so that no payment has to be made to the technicians or actors to reach this set. Outside of this zone, a charge is paid per mile driven from the edge of the zone.

STUNT COORDINATOR The person who will set up the stunt and works out the action with the stunt players. Is responsible for ensuring the safety of all involved, in, on, or around the stunt that takes place.

SYNC When a sound recording and a picture are lined up ("in sync").

TABLE IT To set something on or parallel to the ground, such as a reflector or 12 × 12 ft. frame.

TAG LINES Ropes usually made of 1/4 in. hemp that are tied to a lamp hanger (trapeze); used to pan or tie off a lamp, as well as to tie off rags on frames.

TAIL SLATE Hitting the camera sticks after a scene has been shot. The slate is turned upside down, with the wording facing the lens, and then the hinged sticks are slapped together; also called tail sticks.

TAKE A scene that has been shot.

TAKE DOWN Reducing the light on an object through the use of nets, scrims, or dimmers or by wasting or spilling some of the light.

TALENT The actors.

TEASER Used to cut light (e.g., a flag).

TELEPROMPTER A device for the actors to read their lines that are fed to them via a monitor.

TIGHT ON A close-up.

TILT Move the camera up and down in a tilting motion.

TOENAIL To put either a nail or screw in the edge of an object to secure it temporarily in place.

TOGGLE The vertical 1 × 3 board on the back of a movie set wall.

TOPPER A flag, for example, used to block unwanted light from the top of a light source; also called a top shelf.

TRACK SYSTEM An overhead track used to hang backings that can be easily moved, changed, or replaced.

TRACKING SHOT The camera is placed on a dolly and is moved during filming.

TRANSPORTATION CAPTAIN This is the person who ensures everyone, and every piece of equipment gets to the location. And is responsible for movement of the vehicles on a movie set.

TREATMENT A script that is abridged. Only a summary of each scene is proposed. May be just snippets of dialogue.

TRUSS A triangular metal structure used to span a large area; sometimes called a rock-and-roll truss. Lights can be hung from trusses.

TURN ON TWO BUBBLES Turn on two lights in the same lamp.

TWEENIE A 650-watt lamp.

UNDERCRANK Running the camera slower.

UNDERCRANKING Shooting a camera at less than 24 frames per second. When projected onscreen at 24 frames per second, the action will appear faster.

UNIT PRODUCTION MANAGER The person who controls the day-to-day finance and operation on a movie set. Also referred to as the UPM.

UPSTAGE Move toward the back of the set or stage. (Term comes from older stages that had a higher, or raked, upward incline toward the rear or back wall, away from the audience.)

VERTIGO EFFECT Sometimes referred to as "contrazoom." The technique Alfred Hitchcock created in the film *Vertigo*. It involves zooming in while tracking backwards.

VIDEO ASSISTANCE The person who sets up a small video system referred to as a video tap. The person then records everything that the camera sees while broadcasting a live picture to the director, via a television monitor.

WAFF To lightly fan, smoke, or move a curtain sheet. To create the effect of a breeze, with a hand fan.

WALLA Sound that is recorded of a crowd such as in a large auditorium or several dinner guests at a party. Used as ambient background sound.

WALL BRACE A metal rod, the ends of which are flattened and have holes drilled through them; used to attach a set wall to a wood-slatted floor. Also, a hog trough can be used.

WALL FLAT A scenic covered wall usually made from 1 × 3 in. lumber covered in a thin plywood-type material called Luan.

WALL JACK A two-wheeled brace or jack used to transport a large set wall.

WALL SCONCE A lamp hung on a wall; a practical fixture.

WARNER BROTHERS An extreme close-up of a person; cropping a little off the top of the actor's head with a shadow or by the camera lens.

WASTE Shining all the light on an object, then slowly turning the light so some of the light misses or falls off of the object.

WATCH YOUR BACK Yelled by someone carrying equipment and approaching someone from behind.

WHIP-PAN A fast pan of the camera that blurs the motion.

WIG-WAG A red flashing light outside of a stage that indicates that filming is going on.

WILD SOUND Non-sync sound. Is recorded to supplement the sync takes.

WILD WALL or WILD CEILING Walls or ceiling panels that can be moved individually.

WING Setting an object such as a flag in front of a light and then moving it away or closer in a semi-circular motion.

WIPE An image that moves across the frame during filming; used to hide a cut during editing.

WRANGLER The person who is in charge of all animals used during filming.

WRAP Putting away all equipment or quitting for the night. Go home.

XENON A daylight balanced projection lamp. It is very, very bright.

ZIP CORD A lightweight cord that looks like an extension cord. It comes in different gauges and colors, usually black, white, or brown, but can be ordered in other colors.

ZOOM LENS A variable lens that has different focal lengths.

Conversion chart

1 YARD = 36 INCHES = 0.914 METER

1 METER = 39.37 INCHES = 1.093 YARDS

1 INCH = 2.54 CENTIMETERS

12 INCHES = 1 FOOT = 30.48 CENTIMETERS

1 MILE = 1.609 KILOMETERS

1 KILOMETER = 621 MILES
1 OUNCE = 0.028 GRAM
16 OUNCES = 1 POUND = 453.59 GRAMS
1 GRAM = 0.002 POUNDS
1 GRAM = 0.035 OUNCES
1 POUND = 0.454 KILOGRAMS
1 KILOGRAM = 2.205 POUNDS
1 GALLON = 3.785 LITERS
1 QUART = 946 LITERS = 2 PINTS
4 QUARTS = 1 GALLON = 8 PINTS
1 PINT = 473 LITER

Canadian versus USA grip equipment terms (some . . . not all)

USA	Canadian
Apple Boxes	GRIP LIFTER
ATG Tape	DOUBLE SIDED
Baby Plates	750 PLATE
Bar Clamp Adapter Pin	FURNY
Basso Block	
Batten Clamps	
Bazooka	
Bead Board Holder	STYRO
Big Ben Clamp	
Cable Crossovers	
Camera Wedge	
Cardellini Clamp	CARDY
C-Clamp Tree Branch Holder	
C-Clamps (Speed-C)	
C-Clamps W/Pin	BESSEY
Chain Vise Grips	Gs
Cheeseboro Clamp Swivel	
Clipboard	
Condor Bracket	
Cribbing	LUMBER
Crowder Hanger	
Cucoloris – Celo or Wood	
Cup Blocks	
Cyc Cyclorama/Sweep/Limbo Wall	
Doorway Dolly	
Drop Ceiling Scissor Clamp/Cable Holder	
Drop-Down, 45-Degree Angle	
E-Fan	
Elephant Doors on Stage	
Empty Frames	

USA	Canadian
Fingers and Dots	
Flag Box/Scrim Box	
Flags and Cutters	BRUTES SOLIDS
Flexarms	
Furniture Clamp	
Furniture Pad	
Gaffer Grip	GATOR
Garfield Mount Steady Cam Arm (on Dolly)	
Grid Clamp (Jr.)	
Grifflon	
Grip Clip	SPRING CLAMPS
Grip/Electrical Stage Box	
Grip Helper	
Grounding Rod/Spike/Ford Axel	
Hand Truck	
Heads	
HEADS*Fluid*Gear*Remote*Weaver-Steadman	
K-Rails	
Ladder	
Ladder Pod	
Lifts-Articulating-Knuckle Boom/Condor/Cherry-Picker/Lift-Genie /Scissor	
Light Adapter (Standard Base)	
Mafer Clamp	
Matt Pipe Adapter Baby	
Matt Poles	
Meat Ax	
Miniboom	
Muscle Truck	
No-Nail Hanger	
Norm's Pin	
Offset Arms	
Parallels	
Pipe Clamp, Junior	
Pipe Dolly	
Pipe Grid	
Pony Pipe Clamp	
Poultry Bracket (Matthews)	
Putter Scooter/Butt Dolly	
Putty Knife	

USA	*Canadian*
Reflector	FLECKY BOARD
Reflector (Combo/Light) Stand	
Safety cable	
Sandbag	BODY DOUBLE
Scrims	
Scrims – Grip	
Single	
Double	
Silk	POLY
Side Arms	
Speed Wrench	
Stair Blocks	
Stand Adapter Pin	
Stand Extension Pin	
Stands	
C-Stands	
Low Boy Stand	
Reflector stand	
Overhead Stand	
Steel Deck	
Studio Grip Arm	
Swivel Plate	
Taco Cart	ROLLER CART
T-Bone	
Telescoping Hanger-Stirrup	
Tent – Stake	BULL PRICKS
Track Buckles (Fisher Dolly)	
Track (Fisher Dolly-Round)	
Track Starter Ramp (Chapman Dolly – Round)	
Translight (Back)	
Trapeze	
Tri-Pod – Sticks	
Trombone	
Tube Stretcher	
Turtle	
Umbrella	
Vehicles	
Cube Van/Truck/Production/ 1 Ton	
5 Ton Truck	
10 Ton Truck	

USA	*Canadian*
15 Passenger Fan	
Forty Footer	
Production Trailers	
Wall Bracket (Set)	
Wall Plate – Junior	
Wall Sled	
Wall Spreader	
Wedge	
Wig-Wag Shooting Light	
Forty-Footer Grip Truck	MOTHER SHIP
Expendables	
ATG Tape	
Baby Powder	
Bead board	
Black wrap	

Gripping solutions

BM3.1 Cleat

Sometimes you need a "cleat" to tie off a very light lamp or tag line. You can quickly make your own using the back of the standing set wall. Simply cut a piece of 1 × 3 in. lumber and screw it on the corner section of the 2 × 2 ft. square panels sections.

BM3.2 Prevent marring

A quick way to put feet on a ladder to prevent "Marring." Simply use paper booties (on most sets). If none is available, use some Duvatyne (a bit costly, but whatever works in a pinch).

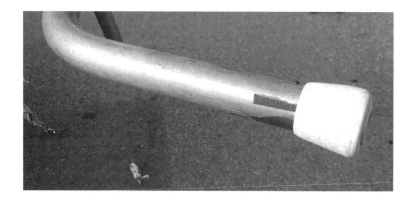

BM3.3 Crutch tips

Crutch tips for the feet on stands. "Usually" a 1 in. (2.54 cm) works on "most" of the C-Stands. (They also work very well on several lighting stands. I personally order a hundred count each of a few sizes of the crutch tips. (Remember: three per stand.) They are a lot cheaper than scratching a surface and it shows you are a professional. BTW, you can also use the pre-cut tennis ball. (Usually on most sets as "Safety" tips/guards.) Tape, Duvatyne, and paper booties work as well. Trust me when I say, these are some of the small actions that will get you "invited" back on another job. I cannot stress it enough, everyone is watching you . . . don't get paranoid . . . it's a good thing when you're doing your job well! (BTW, are you available next week? I have this huge job, lots of money and . . .).

BM3.4 Bag of crutch tips

BM3.5 Travel packs

Sometimes you have to make up "Travel Packs!" A little bit of needed gear from each department gets put in a production van for a "Quick" secondary location. Here is a quick way to protect flags and nets from being damaged (built out of some used foam-core). Also, mark the contents on the box (remember, you may know what's where, but the "entire" crew may not). I always ask myself . . . what if . . .? (What could happen if . . .) You have to constantly be thinking "SAFETY!" for the entire crew. They trust you. Keep that trust and a great reputation! It is what brings you back . . . over and over . . . and over again. My first time on a set as a guest grip (newbie) was in 1976 . . . and I am "still going." You can replace me any day now.

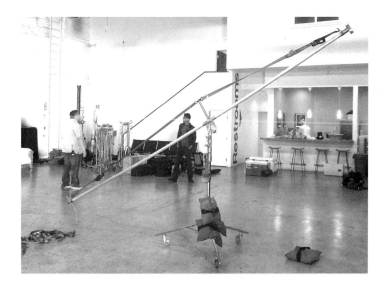

BM3.6 Menace arm

A "menace" arm (one of several ways to build it). (Don't build this or use ANY EQUIPMENT unless you are properly trained on it. Items usually never fall UP, but they can fall over.

BM3.7 Junior receiver

The "end" pieces used to mount a lamp. (Baby pin 5/8ths and junior receiver 1-1/8 in. opening and safety cable.)

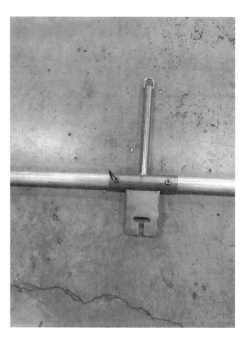

BM3.8 Sleeve

The center point sleeve and spade with riser rod mass for tie-offs.

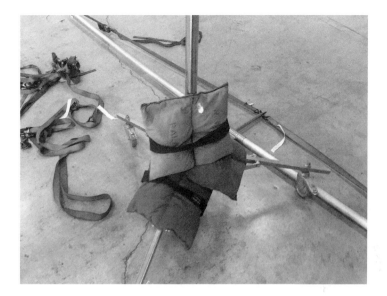

BM3.9 Sandbags

Many bags are GOOD!

BM3.10 Clean it up!

Clean up your straps!

BM3.11 End product

It should look something like this.

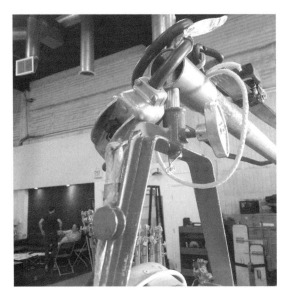

BM3.12 Safety

Safety rope and "THE SPRING" from a C-47 clothespin.

BM3.13 One gallon = 3.78541 liters

A 1-gallon (3.78541-liter) plastic bottle becomes a tool.

BM3.14 C-47

Great for holding C-47s (clothespins).

BM3.15 Low rider

Low boy or low rider set-up.

BM3.16 Pipe dolly

Do it yourself pipe/sled dolly.

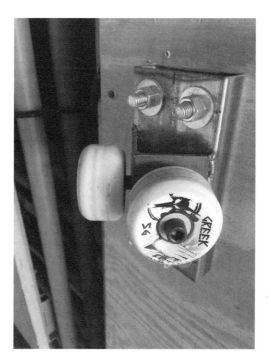

BM3.17 Dolly

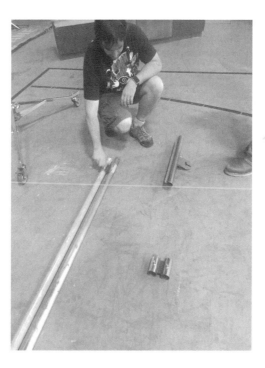

BM3.18 Over/under sleeves

Over/under sleeves. They can be used to make a menace arm stronger.

BM3.19 Stud/grub nut

A 3/8-in. diameter stud/grub nut or knuckle, using a 3/16-in. Allen wrench.

BM3.20 End product

What it looks like.

BM3.21 Grommet ties

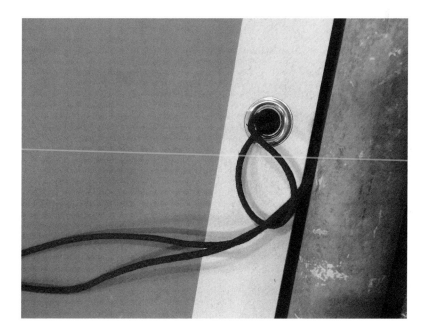

BM3.22 Loops

Grommet ties and loops

BM3.23 Tie-off

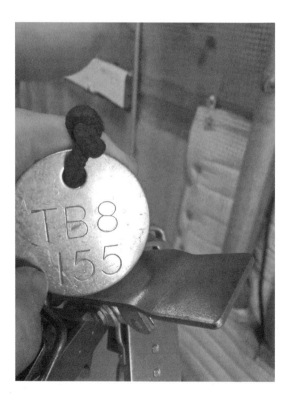

BM3.24 Fisher Track Buckle

Fisher Track Buckle identity tags. The TB stands for "Track Buckle." The number eight that follows indicates the count (how many) clips or buckles are on that rope. The number: #155 is the indicator to which item went with which dolly order.

BM3.25 Removing the creases

Taking the creases out of a blue-screen backdrop, using a steamer.

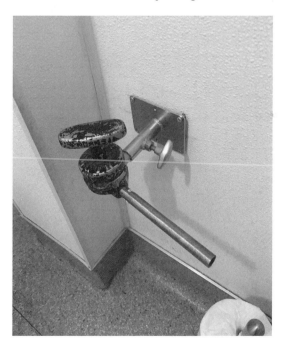

BM3.26 Thinking cap

Wins the award for most creative in a desperate and needed situation.

BM3.27 Well?

Need I say more?

Grip self-test

If you were taking one of my film classes I would give you this grip test the very first day we met for class after the introduction, and thank you after the session was completed.

The looks on my students faces are usually . . . stunned! "What the heck is this instructor/grip doing? We don't know this stuff . . . yet!"

Exactly!

It's a simple process, really. The students take my test using a RED pen for the answers. Then we put the test aside until the course is finished. We now take the same test using a GREEN pen for the answers. Now the student "knows" how much they have leaned.

This validates their hard work.

Now, you the student/reader should really take this test. Read the book – then take the test again. You will be pleased at what you learned. I'm willing to bet you learn, at the very least, twenty-five things. See for yourself.

Grip test #1

1. Whose job is safety on the set?
 A. The assigned safety officer.
 B. All personnel.
 C. The grip department.
 D. The fire chief of the city you are filming in.
2. What is a good rule of thumb when sandbagging a C-stand?
 A. That's not my job.
 B. One bag only is needed, ever.
 C. No bags are needed if the stand is properly set.
 D. 1 riser up = 1 bag, 2 risers up = 2 bags, etc.
3. What leg should the sandbag (ballast) be placed on?
 A. The longest leg.
 B. The highest leg
 C. The one opposite the weight (flag).
 D. The fourth leg – always.
4. What is a good practice to use on an exterior shoot, when setting a 4 × 4 flag?
 A. Only film in 15 mph or lower winds.
 B. Use a combo stand with a 4 1/2 in. gobo/grip head for stability.
 C. Never film near airports, ever.
 D. Use smaller flags for safety always.
5. Why does the film industry use Duvatyne in the making of flags?
 A. Duvatyne material is treated with a fire retardant.
 B. It is cheaper than silk.
 C. It is the darkest black material available.
 D. Because it was designed by the famous key grip, John, I know it all.

6. When using cable, what is considered a good practice when applying a cable lock or micro-sleeve to cable for a heavy object?
 A. Use two locks or sleeves for safety.
 B. Use only steel locks.
 C. Gaffer's tape will do nicely.
 D. Use only aircraft cable 7 × 7 × 19 strand.

7. What is a good practice when skinning an empty frame?
 A. Use only leather.
 B. Mark the corner of the gel with a marker, denoting what the gel is on the frame.
 C. Always make up two sizes.
 D. Use only paper tape.

8. Can aluminum sleeves and steel cable be joined together for long-term use?
 A. Yes.
 B. Not recommended. Aluminum and steel are antagonistic metals. Putting them together will cause both to corrode much more quickly than normal.
 C. Does not matter. Just get the job over with already.
 D. Does it have to be steel cable?

9. Which knot is considered a dead hang knot?
 A. Hangman noose.
 B. Bowline.
 C. Square knot.
 D. Clove hitch.
 E. Both A and B.

10. What is a trucker's knot used for?
 A. They tie off trucks on hills.
 B. Rubber knots that are on the grip truck tires.
 C. To secure cargo tightly with a quick release.
 D. Bulging muscles in the driver's forearms.

11. What's a limbo table?
 A. A table without any legs.
 B. It is used to dance on, like a dance floor.
 C. A coffee table on a hot set.
 D. A flat table with a 90-degree curve upwards for shooting products on.

12. When does a grip work the sound slate/sticks?
 A. When asked by the sound department?
 B. When he has achieved key grip status.
 C. Emergency filming only!
 D. Never, ever, nil.

13. What's a catwalk?
 A. An exterior walkway of a tall building – aka a ledge.
 B. An area above a set, for lights, greens, or whatever.
 C. The place where only small grips can climb.
 D. There is no such thing as a catwalk.

14. What is sometimes referred to as snot tape?
 A. 2 ft. photo tape.
 B. A runny nose.
 C. Double-sided gummy tape aka =ATG tape (automatic tape gun tape).
 D. Foam carpet tape.

15. What is the average size of a rag that fits a 12 × 12 ft. frame?
 A. 12 × 12 ft.
 B. 8 × 8 ft.
 C. 11 ft. 6 in. × 11 ft. 6 in.
 D. 10 × 12 ft.
16. Why is there usually a 4 ft. yellow or red perimeter line painted around the interior of a stage?
 A. For staging grip gear.
 B. Camera is assigned this space only.
 C. So the producer does not have to step over any equipment.
 D. In case of fire with heavy smoke, you can crawl to the wall and feel your way to the exit.
17. When is it time to suggest safety to the key grip?
 A. Place a note in the safety concerns box.
 B. Suggest safety only to the producer.
 C. As you see a need.
 D. Just fix it yourself.
18. What is an onkey bonk?
 A. Scissors.
 B. A platypus.
 C. A baby plate.
 D. A C-stand.
19. What's a hard mark?
 A. Water stains on glass.
 B. A really tough stop for an actor to hit while acting.
 C. A tape mark on the deck or a fixed object on set.
 D. Two pounds of rocks used on all movie sets.
20. What is the recommended minimum number of ropes tied on a 20 × 20 ft. frame set vertical?
 A. 1
 B. 17
 C. 4
 D. 12
21. How many rungs in a 4 ft. ladder?
 A. 6
 B. 3 + a top
 C. 5
 D. 8
22. Whose job is it to safety a camera hot head?
 A. The fire safety officer.
 B. The production assistant.
 C. The director of photography.
 D. Usually the grip helping the assistant cameraman.
23. Who levels props?
 A. Grip.
 B. Set people.
 C. Prop people.
 D. Any of the above.
24. Who can put a metal scrim in front of a light?
 A. A grip can, using a C-stand.
 B. The electrician.

 C. The gaffer.

 D. Any of the above.

25. What is one hugely important thing when mounting a crane on track?
 A. The track is level.
 B. Use on hard rubber wheels.
 C. Cranes do not go on track.
 D. Use only PVC schedule 40 track.

Grip test #2

1. Name three types of rain hats.
 A. Answers B, C, and D.
 B. An umbrella will work.
 C. You can use a 4 × 4 frame with gel or visqueen on it.
 D. Any material that is safe, and will protect the lamp.

2. What should you check for before removing a flyaway set wall?
 A. Seams in the corners.
 B. Lights mounted on the flyaway wall.
 C. Answers A, B, and D.
 D. Any reinforcing or cross bracing of said wall.

3. What is a must when flying a lamp over a set?
 A. Use only 5-pound lamps and under.
 B. Put a safety rope or cable on it.
 C. Ensure that the doors are safely on it.
 D. Both B and C.

4. What is Lexan sometimes used for?
 A. Coffee tables.
 B. Windows in banks.
 C. Answers A, B, and D.
 D. Explosion proofing a camera for a shot.

5. Whose voice should all new grips listen for?
 A. Key.
 B. Gaffer.
 C. DP.
 D. All of them.

6. Why do we tape foam core to bead board?
 A. Used this way to replace show card.
 B. To prevent the bead board from breaking in half.
 C. Used as a filter on lights.
 D. This is really not recommended.

7. What's is "recommended" (highest) when building a single tower of parallels on flat feet or wheels?
 A. 12 ft.
 B. 6 ft.
 C. At 18 ft. or higher, put safety ropes or braces on it.
 D. 24 ft.

8. What is a cyclorama?
 A. A roller rink.
 B. A circular stage.
 C. A 60 ft. high × 60 ft. wide × 60 ft. long stage.
 D. A set wall with a curved bottom to meet the floor. No corners.

9. What are bullets?
 A. Rubber bands.
 B. C-47s.
 C. 9 mm rounds.
 D. All the above.
10. What's a platypus?
 A. An onkey bonk, also known as a bead board holder.
 B. Vice grips with wide plates attached to the mouth.
 C. Special locking-holding device for foam core/show card.
 D. All of the above.
11. What's a bump/kiss?
 A. A dent in a dolly track.
 B. Usually found at a wrap party.
 C. Usually money given as a bonus.
 D. Flown by Goodyear.
12. What does "hold the work" mean?
 A. Work quietly.
 B. Time your working so as not to disturb the action.
 C. Stop all work.
 D. None of the above.
13. What should you do if your pager goes off during a take?
 A. Turn if off quickly and look over your shoulder at someone else.
 B. Never let this happen.
 C. Think about finding a new line of work.
 D. All of the above.
14. What does clear the eye line mean?
 A. Remove your mascara.
 B. Look dead into the lens.
 C. Don't look or stand in the eyeline of the actor or actress.
 D. Wipe the actor's or actress's glasses off.
15. What is a clapper loader?
 A. The audience on drugs.
 B. Camera assistant.
 C. Special effects machine.
 D. Noisy camera for TV.
16. What if the fourth grip notices a problem on a hot set, who does he tell?
 A. The third grip.
 B. The key grip.
 C. The script girl or AD.
 D. Any of the above.
17. What is a hot set?
 A. A movie set doing a fire effect.
 B. A set in which filming has been started, then stopped, and then filmed on again later.
 C. A set with huge hot light shining on it.
 D. No one allowed on set.
18. What does MOS stand for?
 A. Means = Move Out Side for next take.
 B. Roll the sound machine.
 C. Supposedly mitt out sound – no sound recording.
 D. None of the above.

19. What does second sticks mean?
 A. Two sticks or stands needed on set.
 B. Chinese dinner for two.
 C. Means roll the camera a second time.
 D. Hit the stick together a second time in front of the camera for sound.
20. When is it ok to talk to an actor or actress that you are working with?
 A. During a MOS take, since no sound is rolling.
 B. Use your own discretion.
 C. After work! Always!
 D. Call him or her with their number from the call sheet.
21. What's a taco cart?
 A. Lunch wagon.
 B. A three-wheeled dolly.
 C. A flag box.
 D. Grip or lighting supplies on a rolling cart.
22. Who is sometimes the unofficial safety expert on set?
 A. AD.
 B. Key grip.
 C. Gaffer.
 D. Director.
23. Who is responsible for the crane once the camera is put on it and it is loaded?
 A. PA.
 B. Director.
 C. Dolly/crane grip.
 D. None of the above.
24. Who rigs the camera on the crane?
 A. The grips and the camera department.
 B. Props department.
 C. The art department.
 D. The director.
25. When can a grip yell cut during a filming of a scene?
 A. When safety is involved.
 B. Never.
 C. Anytime.
 D. When he has written the script.

Grip test #3

1. Who tells the grip what the next shot or set-up will be?
 A. The director.
 B. The AD.
 C. The cameraman.
 D. All of the above.
2. How many degrees off level can a crane on track wheels be, and still be considered safe?
 A. 0 degrees.
 B. 18 degrees.
 C. 51 degrees.
 D. 14 degrees max.
3. What does the book say about the degree allowable for the Tulip crane to off level on pneumatic wheels?

A. 5 degrees.

B. 18 degrees.

C. 51 degrees.

D. 14 degrees max.

4. What could possibly happen if a light does not get bagged or safety tied?

A. Blow up.

B. Fall over.

C. Not work.

D. The stand knuckles could slip.

5. Who can and will usually safety a light hung overhead?

A. Grips.

B. Electricians.

C. The gaffer.

D. Any of the above.

6. How many grips does it take to screw in a light bulb up into a socket overhead? (FREE)

A. Union – three.

B. Non-union – one.

C. Does it have to be a light bulb?

D. Grips aren't used to screwing anything up.

7. Who will usually rig a light on an auto mount?

A. The grips.

B. The PAs.

C. The electricians.

D. A and C are correct.

8. When is it "not" a good time to talk on set?

A. Pre-rigging.

B. Setting a flag.

C. While filming.

D. Calling for help.

E. All of the above except D.

9. Who drives the insert car?

A. The grip.

B. The director.

C. The insert car driver.

D. None of the above.

10. Who puts shielding (Lexan) in front of a camera?

A. The prop department.

B. The grip department.

C. The camera department.

D. Home Depot.

11. When is it a good time to recommend an optical flat?

A. During shoots with flying debris possible.

B. For special effects shots, such as green screen.

C. For shooting mountain and ocean shots.

D. When using a yellow filter.

12. Who removes the set walls?

A. Art department.

B. Set department.

C. Grip department.

D. Any of the above.

13. When do you lead up (balance out) a stage crane?
 A. Only when you use it.
 B. After the camera crew has sat on the seats and buckled up.
 C. In the morning.
 D. Never use lead.
14. What is a crab dolly?
 A. A wagon.
 B. A hand truck.
 C. A dolly where the wheels can turn and roll sideways, as well as forward and back.
 D. Dolly that only hauls loads of fish.
15. When could you use a western dolly?
 A. On a sandy beach.
 B. To get equipment up a mountainside.
 C. To roll over gravel.
 D. All of the above.
16. Will a polecat hold the weight of a 2,000-watt lamp?
 A. Possibly but not recommended.
 B. Anytime.
 C. Only if you nail the cups to the wall.
 D. Only a 12k or larger will work.
17. What is a pre-rig?
 A. Loading a special effects rig.
 B. Setting a light on top of a building.
 C. Rigging on stage or location in advance of a shoot day.
 D. None of the above.
18. When can a C-stand be used as a menace arm?
 A. To support a small lamp.
 B. To hold a branch.
 C. To extend over a person or set.
 D. Any of the above.
19. What is the difference between a gobo arm and a century-stand arm?
 A. One is longer than the other.
 B. There is not any difference.
 C. Two different pieces of equipment entirely.
 D. Four inches longer on the Gobo stand arm.
20. Can a C-stand arm be used in a hi-hi roller?
 A. On occasion.
 B. Yes.
 C. Never.
 D. If in an emergency.
21. Can a Jr. Riser be used in a hi-hi roller?
 A. Yes, sometimes.
 B. Use only with a spud adapter.
 C. Only if you don't have parallels.
 D. Never.
22. What should be done to a C-stand arm that protrudes outward from the stand?
 A. Put a safety indictor on it.
 B. Cut it off.
 C. Use only the proper length arm.
 D. Never use in this configuration. Unsafe!

23. What's a mombo-combo?
 A. Huge hi roller.
 B. A 20 in. C-stand.
 C. A combo stand.
 D. A baby plate.
24. What are channel wheels (troughs) used for?
 A. Used on a television set.
 B. Only news crews use these wheels.
 C. Block wheels on square track.
 D. Special wheels for use under a crab dolly on round track.
25. Which is proper power for the Fisher #10 dolly?
 A. 12 volt DC.
 B. 24 volt AC.
 C. 90–240 volt AC or DC.
 D. 110 volt only.

Grip test #4

1. What is the max power used on a Chapman dolly?
 A. 110 AC.
 B. 240 DC.
 C. 480 DC.
 D. 880 DC.
2. What is the minimum power used on a doorway dolly?
 A. 110 volt DC.
 B. 110 volt AC.
 C. 90 to 240 volt AC or DC.
 D. Usually only grip power.
3. Can a Chapman stage crane use DC power?
 A. Yes.
 B. No.
 C. Only up to 110 volt DC.
 D. 240 volt DC only.
4. Name two dollies that have a back-up hand pump.
 A. Fisher #10 and Chapman Pee Wee.
 B. Doorway and Western Dolly.
 C. Crab and Ice Dolly.
 D. They don't use hand pumps.
5. Why do we use cup blocks?
 A. To drink out of.
 B. To prevent movement.
 C. Elevate things.
 D. B and C.
6. What should a grip be concerned with when rigging a camera on a car?
 A. Strip painting.
 B. Denting the car.
 C. The horsepower.
 D. A and B.
7. Who rigs lights in a condor?
 A. The art department.

 B. Grips.

 C. Electricians.

 D. B and C are correct.

8. What is a good rule of thumb when loading a cherry picker?

 A. Never exceed 500 lbs.

 B. Never exceed 750 lbs.

 C. Never exceed 1,000 lbs.

 D. Read directions for max weight requirements.

9. When is it acceptable to ride the hood of a car during the filming of a scene?

 A. If rigged properly, it will be safe enough.

 B. This is not a good practice.

 C. Ok if it is built in Japan, or a massive gas burning automobile.

 D. On a VW Bug only.

10. What are the four common sizes of apple boxes?

 A. $1 \times 12 \times 20$ in., $2 \times 12 \times 20$ in., $4 \times 12 \times 20$ in. and $8 \times 12 \times 20$ in.

 B. 2 in., 9 in., 14 in., and 22 in. $\times 8 \times 8$ ft.

 C. $3 \times 3 \times 3 \times 3$ ft.

 D. Does it have to be an apple box?

11. What is a pancake's other name?

 A. 1/4 orange.

 B. 1/8 apple box.

 C. Dust and moisture.

 D. Flower and water = flapjack.

12. What does feather a flag mean?

 A. Scrape the edge.

 B. Wing the flag away from or close to the lamp.

 C. Use a white solid.

 D. Cut a hole in it.

13. What should a grip do when asked for a single 18×24 in. scrim?

 A. Bring it quickly.

 B. Bring in a larger one also.

 C. Bring in an 18×24 in. double also.

 D. Bring a flag.

14. What is a cookie?

 A. Aka = a chocolate chip.

 B. A chief.

 C. A flag.

 D. A cut-out pattern of wood or screen.

15. What does it mean to lose the cookie in front of a light?

 A. Remove it.

 B. Add a second cookie.

 C. Add a single to it.

 D. Go eat.

16. What is the hole used for in a pin on a baby plate?

 A. Bad weather.

 B. A safety wire or pin safety.

 C. To tie to the lamp.

 D. Drywall screw hole.

17. What should be inspected on a baby pin?

 A. The base plate.

 B. The pins weld.

 C. The safety hole.

 D. Rental price.

18. What is negative fill?

 A. Reduces light on one side.

 B. Adds fill light.

 C. Will not help filming.

 D. Nothing.

19. What is opal?

 A. A gem.

 B. Diffusion for a light.

 C. A car.

 D. Means, OK, pal, aim light. Now, you're a gem.

20. What's a dance floor?

 A. Found in most bar rooms.

 B. Plywood flooring for a dolly move.

 C. $1 \times 3 \times 12$ in. wide lumber.

 D. Very thin plexiglass.

21. How can you tell a bleached muslin from an unbleached muslin?

 A. It will be written on the bag.

 B. The rental house is never wrong.

 C. One has more of a yellow tint or coloring to the material; unbleached = more yellow.

 D. The rental price is different.

22. What's a floppy 4 x 4 floppy?

 A. 2×3 ft. flag.

 B. 4×4 ft. net.

 C. 4×4 ft. plywood.

 D. 4×4 ft. flag with 4×4 ft. of extra material attached.

23. How many layers of material is a double net?

 A. 1

 B. 2

 C. 2 + 2

 D. 5 layers

24. What happens when too many nets are used together?

 A. It lets more light in.

 B. Never use in this configuration.

 C. Use only silks.

 D. A moray pattern will show in shadow form.

25. When is a T-bone right? (FREE)

 A. After a long hard day at work.

 B. On a date with someone you really want to impress.

 C. Use this as a metal stand to set a light at ground level.

 D. All of the above.

Grip test #5

1. What might you use to make a window pattern shadow show on a wall?

 A. 1×3 ft. lumber.

 B. Empty frame and tape.

 C. Actual window.

 D. Any of the above.

2. What's a wall sconce?
 A. A donut stuck to a wall.
 B. A floor lamp.
 C. A wall-mounted lamp.
 D. None of the above.
3. What is one way that you might take down a bare light bulb in a scene?
 A. Unscrew it.
 B. Remove the entire light fixture.
 C. C.T.O. the light fixture's base.
 D. Lightly spray a dark Streaks 'n' Tips spray on it.
4. What's ATG tape used for?
 A. Attaching gel to frame.
 B. Attaching 1000 H paper to a window.
 C. Both A and B are correct.
 D. Installing carpet.
5. Why is photo black tape preferred over black masking tape?
 A. It has a non-reflective matte surface back with a black gummy sticky side.
 B. It is cheaper to use.
 C. You can get it at any store.
 D. None of the above.
6. What is grifflon used for?
 A. Negative fill.
 B. Bouncing light.
 C. A rain hat.
 D. All of the above.
7. What's a Charlie bar used for?
 A. A gobo arm.
 B. A C-stand.
 C. Girly bar.
 D. A wooden stick used to make a thin shadow.
8. What is a cutter used for?
 A. Carving beef.
 B. None of these answers is correct.
 C. Used as a gobo.
 D. A whisky drink.
9. What's a lavender used for?
 A. Cuts light in half.
 B. Going out on Friday nights.
 C. Used as fill light.
 D. Reduces direct light by about 10% to 20%.
10. What is a high roller?
 A. A Las Vegas gambler.
 B. A C-stand.
 C. A large baby pin.
 D. heavy-duty stand used for heavy objects.
11. What stand might you use in heavy wind over 10 feet up?
 A. A C-stand.
 B. A blade stand.
 C. A high roller.
 D. A combo stand.

12. What could you use if a turtle stand was not available?
 A. A skid plate.
 B. A C-stand.
 C. A sandbag.
 D. All of the above.
13. What type of ladder is recommended with electrical work?
 A. Steel.
 B. Aluminum.
 C. Fiberglass.
 D. PVC.
14. What should be used on a house beam when using a bar clamp on it?
 A. Tissue paper always.
 B. Christmas wrapping.
 C. Two pieces of cribbing.
 D. One wedge.
15. What are two other names for C-stands?
 A. Gobo stand.
 B. Century stand.
 C. Blade stand.
 D. A and B are correct.
16. How many gobo arms are there on a C-stand?
 A. 1
 B. 2
 C. 3
 D. 11
17. What is a speed rail grid?
 A. A race track.
 B. Pipes hung above a movie set for lighting it.
 C. An electric grid used for high voltage lighting.
 D. Car on the freeway at a full stop.
18. What's a triple-header?
 A. Three ball games in a row.
 B. Three baby pins on a single bar used for lighting.
 C. Three lights on one pin.
 D. Three combo stands.
19. What could I use to make a combo stand into a baby light stand?
 A. Cut off the legs.
 B. A spud adapter.
 C. Build a skid plate.
 D. None of the above.
20. When would a putty knife be used?
 A. Fixing holes in the walls left by lousy grips.
 B. Used in knife throwing acts.
 C. Used to attach a small lamp to the pin on the putty knife, pressed or wedged in a crack.
 D. Answers A and B are both correct.
21. What is a lollipop?
 A. A combo stand.
 B. A sucker given to a small child.
 C. A 4 1/2 in. gobo head that fits into a 1 1/8 in. receiver.
 D. Two metal plates held together by a bolt 1 × 3/8 in. × 16 pitch.

22. What are five nicknames for a grip clip?
 A. Pony clamp.
 B. Handy clamp.
 C. Hargrave.
 D. Metal hand clamp.
 E. Number 1, 2, 3, or 4.
 F. All of the above.
23. What's a lenser?
 A. A flag used to shade the lens.
 B. An eyebrow.
 C. A handheld flag.
 D. All of the above.
24. Can a baby plate be used in a hi-hi roller?
 A. Sometimes.
 B. Never.
 C. Yes.
 D. What's a baby plate?
25. Can a baby offset be used in a hi-hi roller?
 A. Yes.
 B. No.
 C. Only Jr. offsets are allowed.
 D. If under 2 lbs.

Grip test #1

Grip test #1 answers

1. B
2. D
3. C
4. B
5. A
6. A
7. B
8. B
9. E
10. C
11. D
12. A
13. B
14. C
15. C
16. D
17. C
18. B
19. C
20. C
21. B
22. D
23. D

24. D
25. A

Grip test #2

Grip test #2 answers

1. A
2. C
3. D
4. C
5. D
6. B
7. C
8. D
9. D
10. D
11. C
12. C
13. D
14. C
15. B
16. D
17. B
18. C
19. D
20. B
21. D
22. B
23. C
24. A
25. A

Grip test #3

Grip test #3 answers

1. D
2. A
3. A
4. B
5. D
6. A, B, C, and D, works as well (FREE)
7. D
8. C
9. C
10. B
11. A
12. C
13. B
14. C

15. D
16. A
17. C
18. D
19. B
20. B
21. A
22. A
23. A
24. D
25. C

Grip test #4

Grip test #4 answers

1. A
2. D
3. B
4. A
5. D
6. D
7. D
8. D
9. B
10. A
11. B
12. B
13. C
14. D
15. A
16. B
17. B
18. A
19. B
20. B
21. C
22. D
23. B
24. D
25. A, B, C, D works as well (FREE) (Although C is the best answer!)

Grip test #5

Grip test #5 answers

1. D
2. C
3. D
4. C

5. A
6. D
7. D
8. C
9. D
10. D
11. C
12. D
13. C
14. C
15. D
16. A
17. B
18. B
19. B
20. C
21. C
22. F
23. D
24. C
25. A

Index

Page numbers in *italics* indicate a figure on the corresponding page.